MICHELANGELO &
THE POPE'S CEILING

OTHER BOOKS BY ROSS KING

BRUNELLESCHI'S DOME
DOMINO
EX-LIBRIS

MICHELANGELO &
THE POPE'S CEILING

ROSS KING

WALKER & COMPANY
NEW YORK

First published in the United States of America in 2003 by Walker Publishing Company, Inc., by arrangement with Chatto & Windus, Random House, 20 Vauxhall Bridge Road, London SW1V 2SA, England.

For information about permission to reproduce selections from this book, write to Permissions, Walker & Company, 435 Hudson Street, New York, New York 10014

Library of Congress Cataloging-in-Publication Data available upon request
ISBN 0-8027-1395-5

Art credits: The Vatican: pages ii, 115, 234, 264, and 274. Uffizi Gallery, Florence: pages 2, 5, 53, and 139. Mary Evans Picture Library, London: pages 4, 7, 90, 136, 160, 175, 190, 207, 215, and 288. Tafeln, Erster Teil, Munich 1901: pages 18 and 19. Collection of the Earl of Leicester, Holkham Hall, Norfolk/Bridgeman Art Library: page 24. Accademia, Venice: page 25. Scala: pages 26 and 98. Gerry Images: page 30. Biblioteca Comunale, Siena: page 59. The British Museum, London: pages 60, 153, 220, 261, and 293. The Metropolitan Museum of Art, New York, Purchase, Joseph Pulitzer Bequest, 1924: page 82. AKG, London: page 104. The Royal Collection of Her Majesty Queen Elizabeth II: page 116. Casa Buonarroti, Florence: page 154. Louvre/© Photo RMN— C. Jean: page 159. Archivio Buonarroti, Florence: page 165. Bayerische Staatsbibliotheck, Munich: page 178. Ambrosiana, Milan: pages 184–85. Gabinetto Nazionale Delle Stampe, Rome: page 259. Alinari: page 311.

Book design by Maura Fadden Rosenthal/Mspace

Visit Walker & Company's Web site at www.walkerbooks.com

Printed in the United States of America

10 9 8 7 6 5 4 3 2 1

For Melanie

CONTENTS

ACKNOWLEDGMENTS

I wish to thank Professor George Holmes and Dr. Mark Asquith, both of whom generously took the time to read the manuscript and offer comments and advice. My agent, Christopher Sinclair-Stevenson, likewise read manuscript drafts and provided his usual doses of enthusiasm and support. Cristiana Papi assisted with several translations from sixteenth-century Italian. My brother, Dr. Stephen King, doggedly hunted down and photocopied some elusive library material for me, and Reginald Piggott provided the maps and drawings. Lynne Lawner, thanks to a chance conversation, guided me to sources I would not otherwise have discovered.

My editor, Rebecca Carter, deserves special mention. She encouraged the project from the outset and then steered it with patience and expertise through numerous drafts to completion. I also wish to thank George Gibson for his assistance and generous support.

I must also thank the curators and staff of the following institutions: the Bodleian Library; the British Library; the London Library; the Taylor Institution Library of Oxford University; and the Western Art Library of the Ashmolean Museum, now housed in the elegant new surroundings of the Sackler Library.

Finally, I wish to thank Melanie Harris, among numerous other reasons, for her companionship in Florence and Rome.

THE SUMMONS

THE PIAZZA RUSTICUCCI was not one of Rome's most prestigious addresses. Though only a short walk from the Vatican, the square was humble and nondescript, part of a maze of narrow streets and densely packed shops and houses that ran west from where the Ponte Sant'Angelo crossed the Tiber River. A trough for livestock stood at its center, next to a fountain, and on its east side was a modest church with a tiny belfry. Santa Caterina delle Cavallerotte was too new to be famous. It housed none of the sorts of relics—bones of saints, fragments from the True Cross—that each year brought thousands of pilgrims to Rome from all over Christendom. However, behind this church, in a small street overshadowed by the city wall, there could be found the workshop of the most sought-after artist in Italy: a squat, flat-nosed, shabbily dressed, ill-tempered sculptor from Florence.

Michelangelo Buonarroti was summoned back to this workshop behind Santa Caterina in April 1508. He obeyed the call with great reluctance, having vowed he would never return to Rome. Fleeing the city two years earlier, he had ordered his assistants to clear the workshop and sell its contents, his tools included, to the Jews. He returned that spring to find the premises bare and, nearby in the Piazza San Pietro, exposed to the elements, one hundred tons of marble still piled where he had abandoned it. These lunar-white blocks had been quarried in preparation for what was intended to be one of the largest assemblages of sculpture the world had ever seen: the tomb of the reigning pope, Julius II. Yet Michelangelo had not been brought back to Rome to resume work on this colossus.

Michelangelo was thirty-three years old. He had been born on the sixth of March 1475, at an hour, he informed one of his assistants, when Mercury and Venus were in the house of Jupiter. Such

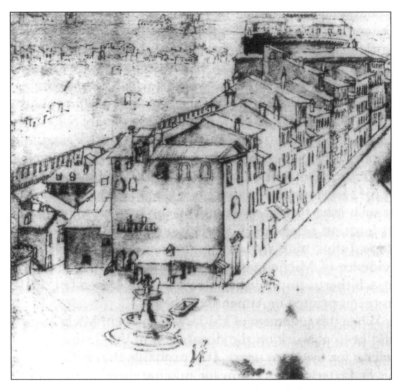

The Piazza Rusticucci, with the Castel Sant Angelo in the background.

a fortunate arrangement of the planets had foretold "success in the arts which delight the senses, such as painting, sculpture and architecture."[1] This success was not long in coming. By the age of fifteen the precociously gifted Michelangelo was studying the art of sculpture in the Garden of San Marco, a school for artists fostered by Lorenzo de' Medici, the ruler of Florence. At nineteen he was carving statues in Bologna, and two years later, in 1496, he made his first trip to Rome, where he soon received a commission to sculpt the *Pietà*. His contract for this statue boldly claimed it would be "the most beautiful work in marble that Rome has ever seen"[2]—a condition he was said to have fulfilled when the work was unveiled to an astonished public a few years later. Carved to adorn the tomb of a French cardinal, the *Pietà* won praise for surpassing not only the sculptures of all of Michelangelo's contemporaries but even those of the ancient Greeks and Romans themselves—the standards by which all art was judged.

Michelangelo's next triumph was another marble statue, the *David,* which was installed in front of the Palazzo della Signoria in Florence in September 1504, following three years of work. If the *Pietà* showed delicate grace and feminine beauty, the *David* revealed Michelangelo's talent for expressing monumental power through the male nude. Almost seventeen feet in height, the work came to be known by the awestruck citizens of Florence as *Il Gigante,* or "The Giant." It took four days and considerable ingenuity on the part of Michelangelo's friend, the architect Giuliano da Sangallo, to transport the mighty statue the quarter mile from his workshop behind the cathedral to its pedestal in the Piazza della Signoria.

A few months after the *David* was finished, early in 1505, Michelangelo received from Pope Julius II an abrupt summons that interrupted his work in Florence. So impressed was the pope with the *Pietà,* which he had seen in a chapel of St. Peter's, that he wanted the young sculptor to carve his tomb as well. At the end of February the papal treasurer, Cardinal Francesco Alidosi, paid Michelangelo an advance of one hundred gold florins, the equivalent of a full year's salary for a craftsman. The sculptor then returned to Rome and entered the service of the pope.[3] So began what he would later call "the tragedy of the tomb."

Papal tombs were usually grand affairs. That of Sixtus IV, who died in 1484, was a beautiful bronze sarcophagus that had been nine years in the making. But Julius, a stranger to all modesty, had envisioned for himself something on an entirely new scale. He had begun making plans for his sepulchre soon after his election to the papacy in 1503, ultimately conceiving of a memorial that was to be the largest since the mausoleums built for Roman emperors such as Hadrian and Augustus.

Michelangelo's design was in keeping with these tremendous ambitions, calling for a freestanding structure some thirty-four feet wide and fifty feet high. There were to be over forty life-size marble statues, all set in a massive and highly detailed architectural setting of pillars, arches, and niches. On the bottom tier a series of nude statues would represent the liberal arts, while the top would be

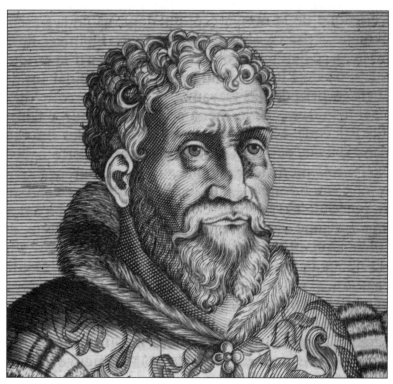

Michelangelo

crowned by a ten-foot-high statue of Julius wearing the papal tiara. Besides an annual salary of 1,200 ducats—roughly ten times what the average sculptor or goldsmith could expect to earn in a single year—Michelangelo was to receive a final payment of 10,000 more.✱

Michelangelo began this daunting project with energy and enthusiasm, spending eight months in Carrara, sixty-five miles northwest of Florence, supervising the quarrying and transport of the white marble for which the town was famous, not least because both the *Pietà* and the *David* had been carved from it. In spite of several

✱The ducat, a 24-karat gold coin, was the standard currency throughout most of Italy. To give a sense of its value: The average annual salary of a craftsman or a tradesman amounted to roughly 100 to 120 ducats per year, while a year's rent on a good-size painter's workshop in Rome or Florence would have cost ten to twelve ducats. The ducat was of the same value as the florin, the standard currency in Florence, which it replaced later in the sixteenth century.

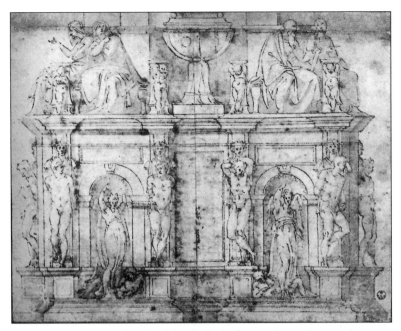

A copy of one of Michelangelo's sketches for Pope Julius's tomb.

mishaps in transit—one of his cargo boats ran aground in the Tiber, and several others were swamped when the river flooded—by the start of 1506 he had transported more than ninety wagonloads of marble to the square before St. Peter's and moved into the workshop behind Santa Caterina. The people of Rome rejoiced at the sight of this mountain of white stone rising in front of the old basilica. No one was more excited than the pope, who had a special walkway built to connect Michelangelo's workshop with the Vatican and thereby facilitate his visits to the Piazza Rusticucci, where he would discuss his magnificent project with the artist.

Even before the marble had arrived in Rome, however, the pope's attentions were being distracted by a much larger enterprise. Originally he had planned for his sepulchre to stand in a church near the Colosseum, San Pietro in Vincoli, only to change his mind and decide it should be installed instead in the grander setting of St. Peter's. But soon he realized that the old basilica was in no fit state to accommodate such an impressive monument. Two and a half centuries after his death in 67 C.E., the bones of St. Peter

had been brought from the catacombs to this location beside the Tiber—the spot where he was believed to have been crucified—and the basilica that bears his name constructed over them. By a sad irony, this great edifice housing the tomb of St. Peter, the rock on which the Christian Church was founded, therefore came to occupy a low-lying patch of marshy ground in which, it was said, there lived snakes large enough to eat babies whole.

These undesirable foundations meant that, by 1505, the walls of the basilica were leaning six feet out of true. While various piece-meal efforts had been made to rectify the perilous situation, Julius, typically, decided to take the most drastic measures: He planned to have St. Peter's demolished and a new basilica built in its place. The destruction of the oldest and holiest church in Christendom had therefore started by the time Michelangelo returned from Carrara. Dozens of ancient tombs of saints and previous popes—the inspiration for visions, healings, and other miracles—were smashed to rubble and enormous pits twenty-five feet deep exca-vated for the foundations. Tons of building materials cluttered the surrounding streets and piazzas as an army of 2,000 carpen-ters and stonemasons prepared themselves for the largest con-struction project seen anywhere in Italy since the days of ancient Rome.

A design for this grand new basilica had been put forward by the pope's official architect, Giuliano da Sangallo, Michelangelo's friend and mentor. The sixty-three-year-old Sangallo, a Florentine, boasted an impressive list of commissions, having designed churches and palaces across much of Italy, among them the Palazzo Rovere, a splendid residence built in Savona, near Genoa, for Julius II. Sangallo also had been the favorite architect of Lorenzo de' Medici, for whom he had designed a villa near Florence at Poggio a Caiano. In Rome he had been responsible for making repairs to the Castel Sant'Angelo, the city's fortress. He had also repaired Santa Maria Maggiore, one of Rome's most ancient churches, and gilded its ceiling with what was said to be the first gold ever brought back from the New World.

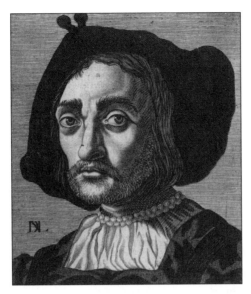

Donato Bramante

So confident was Sangallo of gaining the commission to rebuild St. Peter's that he uprooted his family from Florence and moved it to Rome. He faced competition for the design, however. Donato d'Angelo Lazzari, better known as Bramante, had a collection of equally prestigious works to his credit. Hailed by his admirers as the greatest architect since Filippo Brunelleschi, he had built churches and domes in Milan and, after moving to Rome in 1500, various convents, cloisters, and palaces. To date, his most celebrated building was the Tempietto of San Pietro in Montorio, a small classical-style temple on the Janiculum, a hill south of the Vatican. The word *bramante* means "ravenous," making it an apt nickname for someone with the sixty-two-year-old architect's overweening aspirations and vast sensual appetites. And the voracious Bramante saw, in St. Peter's, the chance to exercise his considerable abilities on a larger scale than ever before.

The competition between Sangallo and Bramante had repercussions for virtually every painter and sculptor in Rome. A Florentine who had lived and worked for many years in Rome, Sangallo was the leader of a group of artists—among them his brother and nephews—who had migrated south from Florence to vie for commissions from the pope and his wealthy cardinals. Bramante, a native of Urbino, had

come to Rome more recently, though since his arrival he had been cultivating friendships with artists who hailed from various other Italian towns and cities, promoting them as a counterpoise to the Florentines whose careers Sangallo was attempting to advance.[4] Much was at stake in the competition to design St. Peter's, since to the victor would accrue wide-ranging powers of patronage as well as an enviable influence at the papal court. Late in 1505, Bramante's faction dramatically seized the upper hand when the pope accepted his design for a huge, domed structure in the shape of a Greek cross, rather than the one submitted by Sangallo.

If Michelangelo was disappointed by his friend's failure to secure the commission, the rebuilding of St. Peter's had an almost immediate effect on his own work. The tremendous expense involved meant that the pope abruptly put the tomb project on hold—a change of heart that Michelangelo learned about the hard way. After shipping his one hundred tons of marble to Rome, he was left with freight charges of 140 ducats, a substantial sum which he needed a bank loan to pay. Having received no money since the one hundred florins more than a year earlier, he decided to seek reimbursement from the pope, with whom he happened to dine in the Vatican one week before Easter. To his alarm, during this meal he overheard the pope informing two of his other guests that he had no intention of spending another ducat on marble for the tomb—a shocking turnabout given his earlier zeal for the project. Still, before taking his leave of the table Michelangelo was bold enough to broach the subject of the 140 ducats, only to be fobbed off by Julius, who instructed him to return to the Vatican on Monday. Then, however, he was spurned a second time when the pope declined to grant him an audience.

"I returned on Monday," Michelangelo later recalled in a letter to a friend, "and on Tuesday and on Wednesday and on Thursday. . . . Finally, on Friday morning I was turned out, in other words, I was sent packing."[5] A bishop, witnessing these proceedings with some surprise, asked the groom who repulsed Michelangelo if he realized to whom he was speaking. "I do know him," answered the

groom, "but I am obliged to follow the orders of my superiors, without inquiring further."[6]

Such treatment was too much for a man unaccustomed to the sight of doors closing in his face. Almost as renowned for his moody temper and aloof, suspicious nature as he was for his amazing skill with the hammer and chisel, Michelangelo could be arrogant, insolent, and impulsive. "You may tell the pope," he haughtily informed the groom, "that from now on, if he wants me, he can look for me elsewhere."[7] He then returned to his workshop—"overwhelmed with despair," he later claimed[8]—and instructed his servants to sell all of its contents to the Jews. Later that day, the seventeenth of April 1506—the eve of the laying of the foundation stone of the new basilica—he fled from Rome, vowing never to return.

Pope Julius II was not a man one wished to offend. No pope before or since has enjoyed such a fearsome reputation. A sturdily built sixty-three-year-old with snow-white hair and a ruddy face, he was known as *il papa terribile,* the "dreadful" or "terrifying" pope. People had good reason to dread Julius. His violent rages, in which he punched underlings or thrashed them with his stick, were legendary. To stunned onlookers he possessed an almost superhuman power to bend the world to his purpose. "It is virtually impossible," wrote an awestruck Venetian ambassador, "to describe how strong and violent and difficult to manage he is. In body and soul he has the nature of a giant. Everything about him is on a magnified scale, both his undertakings and passions."[9] On his deathbed, the beleaguered ambassador claimed the prospect of extinction was sweet because it meant he would no longer have to cope with Julius. A Spanish ambassador was even less charitable. "In the hospital in Valencia," he claimed, "there are a hundred people chained up who are less mad than His Holiness."[10]

The pope would have learned of Michelangelo's flight almost immediately, since he had spies not only at the city's gates but in the countryside as well. Thus, barely had Michelangelo bolted from his workshop on a hired horse than five horsemen set off in pursuit of him. They tracked the runaway sculptor as his horse took him north along the Via Cassia, past tiny villages with posting inns where, every few hours, he changed his mount. After a long ride through the darkness, he finally crossed into Florentine territory, where the pope had no jurisdiction, at two o'clock in the morning. Tired, but believing himself beyond the pope's reach, he alighted at a hostel in Poggibonsi, a fortified town still twenty miles from the gates of Florence. No sooner had he arrived at the hostel, however, than the horsemen appeared. Michelangelo stoutly refused to return with them, pointing out that he was now in Florentine territory and threatening to have the five of them murdered—a daring bluff—should they attempt to seize him by force.

But the couriers were insistent, showing him a letter, bearing the papal seal, that ordered him to return immediately to Rome "under pain of disfavour." Michelangelo still refused to obey, but at their request he wrote a response to the pope, a defiant letter informing Julius that he did not intend ever to return to Rome; that in exchange for his faithful service he had not deserved such maltreatment; and that since the pope did not wish to proceed with the tomb, he considered his obligations to His Holiness at an end. The letter was signed, dated, and passed to the couriers, who found themselves with little choice but to turn their horses around and ride back to face the wrath of their master.

The pope would have received this letter as he prepared to lay the basilica's foundation stone, which was made, ironically, from Carrara marble. Among those assembled for the ceremony on the edge of the vast crater was the man whom Michelangelo believed had been responsible for bringing about his sudden fall from grace: Donato Bramante. Michelangelo did not think that financial considerations alone explained why the pope had lost interest in having his tomb carved; he was convinced that a dark plot was afoot, a conspiracy in

which Bramante was seeking to thwart his ambitions and destroy his reputation. In Michelangelo's eyes, Bramante had persuaded the pope to abandon the project by warning him that it was bad luck to have one's tomb carved during one's lifetime, and had then proposed an altogether different commission for the sculptor, a task at which he knew Michelangelo could not possibly succeed: frescoing the vault of the Sistine Chapel.

THE CONSPIRACY

EXCEPT FOR THE fact that the two men were both brilliant, accomplished, and enormously ambitious, a more striking contrast would have been difficult to find than that between Michelangelo and Bramante. The extrovert Bramante was muscular and handsome, with a prominent nose and a wild shock of white hair. Though sometimes arrogant and sarcastic, he was an unfailingly merry and generous companion, cultivated and quick-witted. Born the son of a farmer, he had become extravagantly rich over the years, developing along the way a love of luxury that his detractors complained was unimpeded by any moral sense.[1] While Michelangelo lived modestly in his small workshop behind the Piazza Rusticucci, Bramante entertained his friends in more sumptuous lodgings at the Palazzo del Belvedere, the papal villa on the north side of the Vatican, from whose windows he could inspect the growth of the new basilica of St. Peter's. One of his best friends was Leonardo da Vinci, to whom he was affectionately known as "Donnino."

The story of Bramante's plot to force on Michelangelo the hopeless task of frescoing the vault of the Sistine Chapel came from the pen of Michelangelo's devoted pupil, Ascanio Condivi, a painter from Ripatransone, near Pescara on the Adriatic coast. Though undistinguished as an artist, Condivi became part of Michelangelo's circle soon after arriving in Rome around 1550, sharing the great man's house and, more important, his trust. In 1553, when his master was seventy-eight, Condivi published his *Life of Michelangelo*. Since this biography was written, according to its author, from the "living oracle" of Michelangelo's speech,[2] art historians have suspected that it was composed with the authorization—and probably even the active participation—of Michelangelo himself, making it in effect his autobiography. Fifteen years after its publication, another of

Michelangelo's friends and admirers, Giorgio Vasari, a painter and architect from Arezzo, revised the 50,000-word biography of Michelangelo in his *Lives of the Painters, Sculptors, and Architects,* originally printed in 1550, taking on board many of Condivi's accusations about Bramante and thereby confirming the architect's role as villain.

Michelangelo was never averse to pointing fingers or casting aspersions. Distrustful and intolerant of others, especially other talented artists, he could take offense or make enemies, it seemed, at the drop of a hat. Influenced by Michelangelo's version of events, Condivi and Vasari therefore sought to explain the origins of the Sistine Chapel commission by spinning tales of dark intrigue. Bramante pressed the fresco project on Julius "with malice," Condivi insisted, "in order to distract the pope from projects of sculpture."[3] According to this account, the architect resented Michelangelo's unsurpassed skill as a sculptor and feared that, if completed, the pope's giant sepulchre would make absolute and unassailable his reputation as the world's greatest artist. Bramante anticipated that Michelangelo would either refuse the Sistine commission, and in so doing incur the ire of the pope, or else fail miserably in his attempt through lack of experience. In either case, he would drastically undermine both his reputation and his position at the papal court in Rome.

As work started on St. Peter's, Michelangelo had therefore come to believe that its architect-in-chief was determined to thwart his artistic career—and even, perhaps, to have him murdered. Shortly after his midnight flight to Florence, he wrote to Giuliano da Sangallo with dark hints about a murder plot against him. His rude treatment by the pope was not, he informed Sangallo, the only reason for his unceremonious departure. "There was something else besides," he told his friend, "which I do not want to write about. It is enough that I had cause to think that if I remained in Rome, my own tomb would be sooner made than the pope's. This, then, was the reason for my sudden departure."[4]

One of the supposed reasons for Bramante's conspiracy to sab-

otage the tomb project—as well as, perhaps, to have Michelangelo murdered—was that he feared the latter would expose his shoddy workmanship at St. Peter's. According to Condivi, Michelangelo believed he could prove that Bramante, a notorious spendthrift, had squandered the funds allotted to him for the project, forcing him to use cheaper materials and construct inadequate walls and foundations—cutting corners, in other words, in such a way that the building would be structurally unsound.[5]

It was not unknown for artists to get embroiled in fights or even murders. According to a legend in Florence, Domenico Veneziano was beaten to death in a jealous rage by another painter, Andrea del Castagno.* Michelangelo himself had been on the receiving end of a blow from Pietro Torrigiano, another sculptor who punched him so hard on the nose, following a dispute, that Torrigiano later recalled, "I felt the bone and cartilage crush like a biscuit."[6] Even so, it is difficult to accept Michelangelo's fears about Bramante—an ambitious but, by all reports, peaceable man—as anything other than either an outlandish fantasy or a fabricated excuse for his hasty departure from Rome.

If the books by Condivi and Vasari constitute self-serving autobiographies of Michelangelo, embroidering certain facts to show how the sculptor managed to reign supreme in the arts despite the machinations of envious rivals such as Bramante, other evidence offers a slightly different version of events. In the spring of 1506 the pope was indeed considering Michelangelo for work in the Sistine Chapel. But Bramante's part in the affair was quite unlike the one suggested by Michelangelo or his faithful biographers.

*Art historians have cast serious doubts on this legend, for Castagno appears to have died (of the plague) several years before his supposed victim. But the tale of the murder—which was said to have taken place in the 1450s—was reproduced in a number of treatises published both before and during Michelangelo's lifetime.

One Saturday evening a week or two after Michelangelo's flight from Rome, Bramante joined the pope for a dinner at the Vatican. The meal was no doubt a merry one, for both men were notable bon viveurs. Julius liked to gorge himself on eels, caviar, and suckling pig, which he would wash down with wines from Greece and Corsica. Bramante was equally fond of supper parties, at which he often entertained guests by reciting poetry or improvising on the lyre.

When the meal was finished, the two men got down to the business of examining drawings and plans for new buildings. One of Julius's main ambitions as pope was to recapture the grandeur that was Rome. Rome was known as *caput mundi,* the "capital of the world," but when Julius was elected in 1503 this title was wishful thinking. The city was a vast ruin. The Palatine Hill, where the palaces of the Roman emperors had once stood, was a mass of shattered rubble among which peasants tended their vineyards. The Capitoline Hill was known as the Monte Caprino because of the goats grazing on its slopes, and the Forum as the Campo Vaccino, or "Cow Pasture," after its own herds of livestock. Vegetables grew in the Circus Maximus, where 300,000 ancient Romans had once watched chariot races. Fishmongers sold their wares from inside the Portico of Octavia, and the tanners had established themselves in the underground vaults of Domitian's Stadium.

Everywhere broken columns and collapsed arches could be seen, the toppled remnants of a mighty—but vanished—civilization. The ancient Romans had raised more than thirty triumphal arches, of which only three remained. Their freshwater had been supplied by eleven aqueducts, of which only one, the Acqua Vergine, still worked. Forced to take their own water from the Tiber, modern Romans had built their houses beside the river, into which they piled their rubbish and drained their sewage. Every so often the river would flood, swamping their homes. Disease was rife. Malaria came from the mosquitoes, plague from the rats. The area around the Vatican was especially unhealthy since it was close not only to the Tiber but also to the even more noxious waters in the moat encircling the Castel Sant'Angelo.

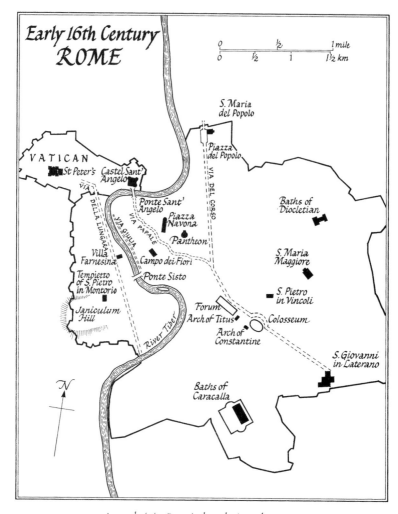

A map depicting Rome in the early sixteenth century.

With Bramante's help, Julius proposed to rectify this dire situation by constructing a series of impressive buildings and monuments that would make Rome both a worthy seat for the Church and a more hospitable place for residents and pilgrims alike. Julius had already commissioned Bramante to widen, straighten, and pave the streets on either side of the Tiber—a necessary improvement since in wet weather Rome's roads turned into muddy quagmires in which mules sank up to their tails. The ancient sewers, meanwhile, were either repaired or replaced, and the Tiber dredged to improve both navigation and sanitation. A new aque-

duct was built to carry freshwater from the countryside to a fountain constructed by Bramante in the middle of the Piazza San Pietro.

Bramante also began to beautify the Vatican itself. In 1505 he had started designing and supervising the construction of the Cortile del Belvedere, the "Belvedere Courtyard," a 350-yard-long annex to the Vatican that would connect the palace with the Palazzo del Belvedere. Included among its features would be arcades, courtyards, a theater, a fountain, space for bullfights, a sculpture garden, and a nymphaeum, a "temple of nymphs." Bramante also began making plans for various other additions and improvements to the palace, among them a wooden dome for one of its towers.

Another building project in the Vatican was especially dear to the pope's heart because it involved alterations to a small chapel built by his uncle, Pope Sixtus IV, from whom it took its name. In his desire to rebuild and restore Rome, Julius was following in the footsteps of Sixtus, whose reign (1471–84) had witnessed certain improvements to the streets of Rome, the restoration of a number of its churches, and the construction of a new bridge across the Tiber. But the most important of Sixtus's projects had been a new church in the Vatican Palace. The Sistine Chapel served as a place of worship for a body known as the *capella papalis,* or Papal Chapel, which convened to celebrate Mass every two or three weeks. The Papal Chapel consisted of the pope and about two hundred senior ecclesiastical and secular officials, including cardinals, bishops, and visiting princes or heads of state, as well as various members of the Vatican bureaucracy, such as chamberlains and secretaries. Besides serving as a place of worship for this corporate body, the Sistine Chapel had another vital function, since it was used by the cardinals for their conclaves to elect a new pope.

Work had begun on the Sistine Chapel in 1477. The architect was a young Florentine named Baccio Pontelli, who designed the building's proportions to match exactly those given in the Bible for the Temple of Solomon in Jerusalem, since the chapel is twice

A reconstruction of the exterior of the Sistine Chapel from
Ernst Steinmann's Die Sixtinische Kapelle.

as long as it is high, and three times as long as it is wide (130 feet
long × 43 feet wide × 65 feet high).[7] Besides being a new Temple
of Solomon, the chapel was also a formidable fortress. The walls
at the base were ten feet thick, and all the way around the top ran
a walkway from which sentinels could keep watch over the city.
There were arrow-slits for archers and special holes through
which, if the need arose, boiling oil could be poured on attackers
below. A series of rooms above the vault served as living quarters
for soldiers and, later, as a prison.

It comes as no surprise, given this robust design, that Pontelli
worked mainly as a military architect, having apprenticed under
Francesco di Giovanni, known as Francione, an architect who
invented a type of bastion to protect castles against the new
threat of cannonballs. As soon as he finished the Sistine Chapel,
Pontelli was commissioned to design what became the most
advanced fortress of its day, outside Rome at Ostia Antica, on the

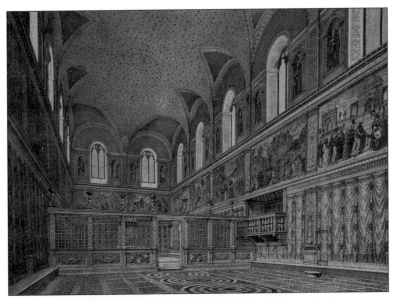

A reconstruction of the interior of the Sistine Chapel showing its original ceiling, from Ernst Steinmann's Die Sixtinische Kapelle.

Tiber near the coast.✱ That particular fortress—whose sturdy battlements bear more than a passing resemblance to those of the Sistine Chapel—was meant to repel invasions from the Turks. The new chapel was intended to repel, among others, the unruly Roman mob. Sixtus knew their violence firsthand, having been stoned after his election in 1471.

Sixtus started a war with the Republic of Florence, a rival city-state, at almost the same time that work began on the new chapel. By the time the war was finished, in 1480, so too was the chapel, and as a gesture of goodwill Lorenzo de' Medici sent a number of painters to Rome to fresco its walls. The leader of the group was the thirty-one-year-old Pietro Perugino; the rest of the team consisted of Sandro Botticelli, Cosimo Rosselli, his pupil Piero di Cosimo, and Michelangelo's future master, Domenico Ghirlandaio, then about thirty-three years of age. Later they

✱Under a later pope, Innocent VIII, Pontelli became the inspector general of the fortifications in the Marches, where he built three more fortresses: at Osimo, Iesi, and Offida. But Pontelli also worked on the basilica of Santi Apostoli in Rome, commissioned by Cardinal Giuliano della Rovere, who became Pope Julius II.

were joined by Luca Signorelli, also a talented and experienced frescoist.

The walls of the chapel were divided by the artists into six panels, which corresponded to the bays beneath the windows. In each of these panels one of the painters and his workshop painted a fresco some twenty feet long by a dozen feet high. Scenes from the life of Moses were portrayed on one wall of the nave, those from the life of Christ on the other. Higher up, a frieze of thirty-two brightly garbed popes ran around at the level of the windows, while the vault was decorated with a motif of gold stars on a bright blue field. This kind of starry Heaven was common on cupolas and vaults, especially in churches. Indeed, for the previous millennium it had been one of the most ubiquitous decorations in Christian art.[8] The vision of Heaven in the Sistine Chapel was painted not by one of Perugino's team but by a less-well-known artist named Piermatteo d'Amelia, a former apprentice to Fra Filippo Lippi. What Piermatteo's starry sky lacked in originality, it made up for in color, since he used in abundance the two brightest and most costly pigments in the fresco painter's palette, gold and ultramarine.

The new chapel officially opened in the summer of 1483, several months after the frescoes were completed. Twenty-one years later, in the spring of 1504, a few months after Julius was elected pope, a series of ominous cracks appeared in the vault. This structural failure was not the fault of Baccio Pontelli, whose tremendously thick walls and rigid vault ensured a sturdy building. However, the chapel was plagued by the same problem as St. Peter's: the subsidence of the underlying soil. The south wall had begun to bow outward and, in so doing, threatened to pull the ceiling apart.

The Sistine Chapel was immediately closed while Giuliano da Sangallo inserted a dozen iron bars into the masonry of the vault in the hope of holding the walls together. More iron rods were placed under the floor to arrest the shifting foundations, after which, in the autumn of 1504, the chapel reopened. In the course of the restoration, however, the rooms that once served as quarters for soldiers had to be destroyed. These rooms were not the only part of the

chapel to suffer. The cracks in the vault were blocked up with bricks and then plastered over, leaving a jagged white scar that traced its way across the northwest corner of the ceiling fresco, interrupting the expanse of blue sky painted by Piermatteo d'Amelia.

The damaged vault of the Sistine Chapel was a prominent topic of conversation between the pope and Bramante during their dinner in the Vatican. A third party present on that occasion, a Florentine master mason named Piero Rosselli, reported their exchange in a letter to Michelangelo.[9] Rosselli informed Michelangelo that the pope had told Bramante that he planned to send Giuliano da Sangallo to Florence to fetch him, at which point he would commission Michelangelo to fresco the chapel's vault.[10] Bramante responded that Michelangelo would refuse this commission. "Holy Father, nothing will come of it," the architect explained, "because I have talked of it much to Michelangelo, and he has said to me many times that he does not wish to attend to the chapel." According to Bramante, Michelangelo had insisted that "he did not wish to attend to anything but the tomb and not to painting."[11]

Rosselli then reported how Bramante went on to carefully outline how the sculptor was simply not the man for the job. "Holy Father," he told the pope, "I believe he does not have enough courage and spirit for it, because he has not done too many figures and, above all, the figures are high and in foreshortening, and this is another thing from painting at ground level."[12]

Bramante knew what he was talking about since, unlike Michelangelo, he had executed numerous murals in his long career. After training as a painter in Urbino under Piero della Francesca, one of the greatest masters during the middle decades of the fifteenth century, he had painted frescoes in both Bergamo and Milan, including one in the Sforza Castle. He had also fres-

coed the Porta Santa, a gate on the east side of Rome near the Lateran Palace.

Michelangelo, on the other hand, had little experience with a paintbrush despite the fact that he, like Bramante, had originally trained as a painter. At the age of thirteen he had been apprenticed to the Florentine painter Domenico Ghirlandaio, whose surname, "garland seller," refers to his father, a goldsmith who specialized in making fashionable garlands for ladies' hair. Michelangelo could not have hoped for a better master. Not only was Ghirlandaio enterprising and well connected, he was also a brilliant draftsman and a skillful and prolific painter. So great was his love of painting that he dreamed of frescoing every inch of the walls encircling Florence—fortifications that were more than five miles in circumference and, in places, forty-seven feet high.

A member of the team of artists who painted the walls of the Sistine Chapel, Ghirlandaio produced numerous frescoes during his twenty-year career. However, his magnum opus was the *Lives of the Virgin and of St. John the Baptist,* executed in the Tornabuoni Chapel in Santa Maria Novella, Florence, between 1486 and 1490. This commission was almost unprecedented in size, encompassing a total painted surface of 5,900 square feet. Its execution required a small army of assistants and apprentices. Luckily, Ghirlandaio ran a large workshop that included his brothers Davide and Benedetto as well as his son, Ridolfo. It is known that Michelangelo was among his apprentices as he painted the Tornabuoni Chapel because in April 1488, two years into the project, Michelangelo's father, Lodovico Buonarroti, signed a contract with him.[13] This apprenticeship was supposed to last for three years; in the end, it probably lasted no more than one, for soon afterward Lorenzo de' Medici asked Ghirlandaio to recommend pupils for the Garden of San Marco, the school in which he planned to train students in both sculpture and the liberal arts. Ghirlandaio promptly offered his new apprentice.

Relations between Ghirlandaio and Michelangelo were, it seems, far from amicable. An envious man, Ghirlandaio once shipped his talented younger brother Benedetto to France on the pretext of

developing his skills, when in fact—so the story goes—he simply wished to banish him from Florence so that he, Domenico, could reign supreme. Similar motives might have persuaded him to send Michelangelo to the Garden of San Marco, where pupils studied sculpture instead of painting. According to Condivi, the pair fell out when Ghirlandaio, jealous of Michelangelo's brilliance, refused to lend him one of the model-books from which the apprentices made copies in charcoal and silverpoint as part of their training.[14] Late in life Michelangelo took revenge on his former master by disingenuously claiming that he learned nothing at all from Ghirlandaio.

Between the end of Ghirlandaio's tutelage and the Sistine Chapel commission, Michelangelo hardly touched a paintbrush. The only work he is known for certain to have painted before 1506 is the *Holy Family* done for his friend Agnolo Doni, a circular painting that measured less than four feet in diameter.[15] However, he had taken one significant—but aborted—stab at fresco painting. In 1504, soon after the marble *David* was completed, he had been hired by the government of Florence to fresco one wall of a council room inside the Palazzo della Signoria. The opposite wall was to be decorated by another Florentine artist with an equally illustrious reputation, Leonardo da Vinci. Then age fifty-two, Leonardo held the field in painting, having recently returned to Florence after almost two decades in Milan, where he had painted his celebrated *Last Supper* on the wall of the refectory in Santa Maria delle Grazie. These two men—by far the most renowned artists of the age—were thereby thrown into direct competition.

This artistic duel was made even more compelling by their well-known dislike of each other. The surly Michelangelo had once taunted Leonardo in public for having failed in his attempt to cast a giant bronze equestrian statue in Milan. Leonardo, meanwhile, had made it clear that he had little regard for sculptors. "This is a most mechanical exercise," he once wrote, "accompanied many times with a great deal of sweat."[16] He further claimed that sculptors, covered in marble dust, looked like bakers, and that their homes were both noisy and filthy, in contrast to the

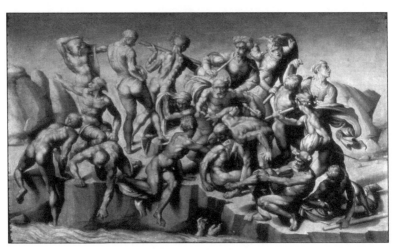

A copy of the central section of Michelangelo's cartoon for
The Battle of Cascina *by Bastiano da Sangallo.*

more elegant abodes of painters. All of Florence awaited the outcome.

The frescoes, at twenty-two feet high and fifty-four feet long, were to be almost double the size of Leonardo's *Last Supper.* Michelangelo was commissioned to paint *The Battle of Cascina,* depicting a skirmish fought against the Pisans in 1364, while Leonardo was to illustrate *The Battle of Anghiari,* showing a Florentine victory over Milan in 1440. Michelangelo set to work making sketches in a room given to him in the Dyers' Hospital in Sant'Onofrio, while his distinguished competitor worked a safe distance away in Santa Maria Novella. After toiling in great secrecy for several months, both emerged in early 1505 with the fruits of their labors: full-size chalk drawings that revealed, in bold strokes, the overall design of their compositions. Such large-scale drawings, which were to serve as templates for the two frescoes, were known as "cartoons" after the large sheets of paper, called *cartone,* on which they were sketched. Exhibited to the public, these two 1,100-square-foot drawings caused an outbreak of almost religious fervor in Florence. Tailors, bankers, merchants, weavers, and, of course, painters—all flocked to Santa Maria Novella, where the two cartoons were displayed together like holy relics.

Michelangelo's cartoon featured what would become his trademark: muscular nudes in frantic but graceful gyrations. He had chosen to illustrate a scene leading up to the battle, when a false

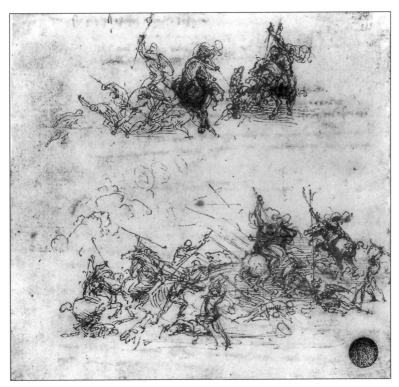

Leonardo's drawing for The Battle of Anghiari.

alarm was sounded to test the readiness of Florentine soldiers as they bathed in the Arno, resulting in a mad scramble of naked men onto the riverbank and into their armor. Leonardo, on the other hand, concentrated on equestrian rather than human anatomy, showing mounted soldiers battling for a fluttering standard.

Transferred in color to the walls of the Hall of the Great Council—a vast chamber supposedly constructed with the help of angels—these two scenes would have created, without doubt, one of the greatest artistic wonders of the world. Alas, after such a promising start, neither fresco was ever completed, and the duel between these two famous sons of Florence, each at the summit of his powers, failed to come off. Michelangelo's fresco, in fact, was never even started. No sooner had he finished his magnificent cartoon than, in February 1505, he was ordered to Rome by the pope to sculpt the tomb. Leonardo made a tentative start on *The Battle of Anghiari,* but his experimental method of painting failed drastically

Mantegna's ceiling fresco for the Camera degli Sposi *in the ducal palace at Mantua, completed in 1474.*

when the colors began dripping from the wall. Chastened by this humiliating failure, he lost his appetite for the work and soon afterward returned to Milan.

The enthusiastic reception given to the cartoon for *The Battle of Cascina* may have been one reason why Julius, who, a year later, was looking for someone to fresco the vault of the Sistine Chapel, decided to give the job to Michelangelo. However, since the fresco for the Palazzo della Signoria was never actually started, let alone finished, Michelangelo had no meaningful recent experience in a medium so difficult that it could tax even the ingenuity of Leonardo da Vinci. Bramante knew that Michelangelo not only lacked valuable experience in the tricky art of fresco but also understood little of the technique by which frescoists created illusionistic effects on high, curved surfaces. Painters of vaults, such as Andrea Mantegna, would portray bodies in a receding perspective—lower limbs in the foreground, heads in the background—so

that they appeared to be suspended in the air above the spectator. Mastery of this virtuoso method of foreshortening, often known as *di sotto in sù* (from below upward), was notoriously difficult. According to one of Michelangelo's contemporaries, *di sotto in sù* was "a more formidable task than any other in painting."[17]

It is hardly surprising, then, that Bramante should have protested at the granting of the Sistine commission to a relative novice. Contrary to Michelangelo's alleged suspicions, he seems to have been determined to avert a disaster from unfolding on the vault of one of the most important chapels in Christendom.

Piero Rosselli did not agree with Bramante's assessment of Michelangelo's talents and intentions. He claimed in his letter that at this point he could listen to Bramante's aspersions no longer. "I broke in and said something very rude to him," he boasted to Michelangelo. He then rose, he said, to a loyal and spirited defense of his absent friend. "Holy Father, he has never spoken to Michelangelo," he insisted, referring to Bramante, "and if anything he has just told you is true, I would like you to cut off my head."[18]

Reading the letter at home in Florence, Michelangelo may have felt Bramante had slurred him, especially in light of the comment that he lacked the "courage and spirit" to attack the job. But he could hardly have disputed the architect's other points. It was for these very reasons, in fact, and because he desperately wished to work on the tomb, that painting the chapel's vault presented such an undesirable prospect. Added to that, the fresco appeared to be a much less important commission than the papal tomb, since ceilings of chapels were usually allotted to assistants or lesser-known artists. Wall paintings attracted all of the prestige and attention, not those on vaults.

No firm decision regarding the commission seems to have been made during the pope's dinner with Bramante. Still, Julius was anxious for Michelangelo to return to Rome. "If he does not come," he mused to his architect, "he does one wrong, therefore I think he will come back in any case." Rosselli agreed. "I believe he will return when Your Holiness wishes," he assured the pope as the conversation concluded.[19]

THE WARRIOR POPE

POPE JULIUS II was born Giuliano della Rovere in Albissola, near Genoa, in 1443. The son of a fisherman, he studied Roman law in Perugia, where he was ordained as a priest and then entered the city's Franciscan friary. His career took a dramatic turn in 1471, when his father's brother, a noted scholar, was elected Pope Sixtus IV. Anyone lucky enough to be the nephew of a pope could usually count on rapid promotion. The word *nepotism* comes, in fact, from *nipote,* Italian for *nephew.* But even in an age of shameless nepotism, when popes vigorously promoted their nephews (who were often, in fact, their sons), Giuliano enjoyed a meteoric rise through the Church hierarchy. He was made a cardinal at the age of twenty-eight, then collected a succession of prestigious posts: abbot of Grottaferrata, bishop of Bologna, bishop of Vercelli, arch-bishop of Avignon, bishop of Ostia. It was only a matter of time, it seemed, before he was elected pope.

The only setback to Giuliano's seemingly unstoppable rise had been the election to the papacy of his bitter rival, Rodrigo Borgia, who became Pope Alexander VI in 1492. After Alexander stripped Giuliano of his numerous offices and tried to poison him, the ambi-tious cardinal thought it wise to decamp to France. It was destined to be a long exile, for Alexander did not die until the summer of 1503, after which Pius III was elected. But Pius ruled for only a few weeks before dying in October, and in the conclave in the Sistine Chapel that ended on the first of November 1503, the seemingly inevitable happened, and Giuliano della Rovere was elected pope—though not before offering bribes to his colleagues (most of whom both hated and feared him) to ensure a positive result.

Alexander VI had been a notoriously debauched character, fathering at least a half-dozen children and consorting in the Vatican

with mistresses and prostitutes.[1] He was even rumored to have pursued an incestuous affair with his daughter, Lucrezia Borgia. Julius was not a voluptuary on nearly the same scale, but his ecclesiastical rewards had likewise been at odds with his more worldly nature. Though the Franciscans observed strict vows of chastity and poverty, as a cardinal Julius had adopted a casual attitude toward both pledges. He used the vast wealth from his preferments to build himself three palaces; in the garden of one, Santi Apostoli, he assembled an unrivaled collection of antique sculpture. He fathered three daughters, including Felice, a celebrated beauty whom he married off to a nobleman and ensconced in a castle north of Rome. He discarded her mother in favor of his next mistress, a famous Roman courtesan named Masina. From one of his various lovers he contracted syphilis, a new disease that, according to one observer, was "very fond of priests—especially very rich priests."[2] Despite this ailment, however, and despite also the gout from which he suffered as a result of his rich diet, His Holiness was in the rudest of health.

Once elected pope, Julius devoted his considerable energies less to his own personal ambitions and more toward ensuring the power and glory of the papacy. Like Rome, the papacy had been in a dire state when he ascended the throne. Its authority had been gravely weakened by the Great Schism, the period from 1378 to 1417 in which rival popes ruled in Rome and Avignon. More recently, Alexander VI's wild extravagance had drained the Church's finances. Julius had therefore set about collecting taxes with ruthless efficiency, halting devaluation of the currency by minting a new coin, and punishing counterfeiters. He also bolstered revenues by creating and then selling ecclesiastical offices, a practice known as simony (and a sin whose practitioners Dante had placed in the eighth circle of Hell, where they were buried upside down and had their feet roasted by flames). In 1507 Julius promulgated a bull offering indulgences, which meant people could pay to reduce the time their friends or relatives spent in Purgatory (usually calculated at 9,000 years). All of the funds accruing from this controversial measure were earmarked for the building of St. Peter's.

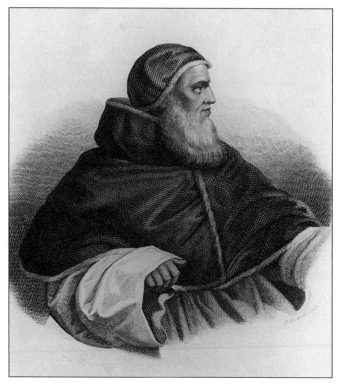

Pope Julius II by Locatelli.

Julius further planned to replenish the Church's coffers by recovering control over the Papal States, many of which were either in open revolt against the Church or else had been usurped by ambitious foreign powers. The Papal States were a loose collection of properties—cities, fortresses, large chunks of land—over which the Church traditionally claimed political authority. Besides being the representatives of Christ on Earth, popes were also temporal princes with the powers and privileges of any other monarch. Only the king of Naples governed more land in Italy than the pope, who had dominion over as many as one million people.

Julius took his role of prince very seriously. In one of his first acts after his election he sent to neighboring states stern warnings to hand back all papal lands. He had the Romagna particularly in mind, a collection of small principalities running southeast of Bologna. Though these principalities were ruled by local lords who were, in name at least, vassals of the Church, a few years earlier Cesare

Borgia, the son of Alexander VI, had tried to create a dukedom for himself in the region through assassinations and brutal campaigns of conquest. On the death of his father, Cesare's power collapsed and the Venetians swept into the Romagna. At Julius's insistence they eventually handed back eleven fortresses and villages but stubbornly refused to part with Rimini and Faenza. Besides these cities, two others, Perugia and Bologna, were of concern to the pope, since their rulers, Gianpaolo Baglioni and Giovanni Bentivoglio, ran foreign policies independent of Rome despite owing their allegiance to the pope. *Il papa terribile* was determined to have all four cities firmly back under his control. In the spring of 1506, therefore, Julius began preparing himself for war.

Despite Piero Rosselli's assurances to the pope over the dinner table, Michelangelo showed no signs of quitting Florence. He refused to return to Rome with his friend Giuliano da Sangallo, the emissary dispatched to fetch him. However, he instructed Sangallo to inform the pope that he was "more than ever ready to continue the work," and that if His Holiness was agreeable he would execute the tomb in Florence rather than Rome, forwarding the statues as he finished them. "I shall work better here and with greater zeal," he told Sangallo, "as I shall not have so many things to think of."[3]

Michelangelo's preference for Florence over Rome was understandable enough. In 1503 the city's Wool Guild had built a commodious workshop to his specifications in Via de' Pinti, where he was supposed to execute a dozen eight-foot-high marble statues for the cathedral of Santa Maria del Fiore—work that, along with *The Battle of Cascina,* had to be sacrificed for the pope's tomb. Altogether, an incredible thirty-seven statues and reliefs of various sizes awaited his attention in this workshop—more than enough work to keep both himself and his small team of assistants busy for

the rest of their lives. Besides the twelve statues for the cathedral in Florence, he had been hired to decorate an altar in Siena's cathedral with fifteen marble statuettes of various saints and apostles. Working on the pope's tomb in Florence, rather than Rome, would presumably have given him the chance to fulfill some of these obligations.

Michelangelo was content to stay in Florence for another reason: His large and extended family—his father, brothers, aunt, and uncle—lived in the city. He had four brothers in all. His mother had produced five boys at regular two-year intervals before dying in 1481, when Michelangelo was six. The oldest of the boys was Lionardo, followed by Michelangelo, then Buonarroto, Giovansimone, and, finally, Sigismondo. Their father, Lodovico, had remarried in 1485 but became a widower again when his second wife died in 1497.

The Buonarroti clan lived in modest circumstances. Michelangelo's great-grandfather had been a successful banker, piling up a considerable fortune that his grandfather, an unsuccessful banker, proceeded to squander. Lodovico was a low-ranking civil servant who lived mainly on an income from inherited farmland at Settignano, in the hills above Florence. Michelangelo's earliest years were spent on this farm, where his wet nurse was the wife of a local stonemason, a circumstance to which he attributed his skill with the hammer and chisel. In 1506, the family was renting out the farm and sharing a house in Florence with Michelangelo's paternal uncle, a money changer named Francesco, and his wife, Cassandra. Michelangelo's older brother, Lionardo, had entered the priesthood, but the younger trio—whose ages ranged from twenty-five to twenty-nine—all still lived at home. Buonarroto and Giovansimone worked as assistants in a wool shop. Sigismondo, the baby of the family, was a soldier. All of them were in no doubt that their fortunes rested squarely on the shoulders of their talented brother.

During his self-imposed exile from Rome, Michelangelo lived at home, working on the various statues in his workshop in Via de' Pinti and tinkering with his huge cartoon for *The Battle of Cascina*. As

if this work were not enough, he also began making plans to tackle a commission even more daunting than the pope's tomb. Accepting an offer from the sultan Bayezid II, he hoped to travel to Constantinople and build a 1,000-foot-long bridge—the world's longest—over the Bosporus, thereby linking Europe and Asia.✢ If the pope did not wish to pay for his services, a host of other patrons certainly did.

Julius, meanwhile, impatiently bided his time. Two months after the sculptor's flight, he sent to the Signoria, the political executive of Florence's new republican government, a brief that, in its allowances for the artistic temperament, seems remarkably tolerant in tone, if somewhat condescending:

> Michelangelo the sculptor, who left us without reason, and in mere caprice, is afraid, we are informed, of returning, though we for our part are not angry with him, knowing the humours of such men of genius. In order then that we may lay aside all anxiety, we rely on your loyalty to convince him in our name, that if he returns to us he shall be uninjured and unhurt, retaining our Apostolic favour in the same measure as he formerly enjoyed it.[4]

Michelangelo was unmoved by this guarantee of safety, and the pope was forced to send yet another request to the Signoria. Still Michelangelo defied the order, presumably because no mention was made of any plans for the tomb. By now the leader of the Florentine republic, Piero Soderini, began to lose patience, fearing the episode might end with the papal armies descending on Florence. "There must be an end to all of this," he wrote sternly to Michelangelo. "We are not going to be dragged into a war and risk the whole State for you. Make up your mind to go back to Rome."[5]

✢Michelangelo no doubt got the idea for this project from Leonardo da Vinci, who had written to the sultan several years earlier with a proposal to build a bridge linking Europe with Asia. Neither bridge was ever built. The sultan rejected Leonardo's design as unrealistic, but in 2001 the artist Vebjorn Sand constructed a scaled-down, 220-foot-long version of the bridge to span a Norwegian motorway, proving the design would have worked.

But Michelangelo paid no more attention to Soderini than he had to the pope.

At this point, in the dog days of the summer, the pope was suddenly distracted from the problem of his runaway artist by the first of his campaigns to rid the papal domains of their usurpers. On the seventeenth of August 1506 he announced to his cardinals a plan to lead an army, in person, against the rebel fiefdoms of Perugia and Bologna. The cardinals must have been thunderstruck. It was unheard of for a pope, the vicar of Christ, to lead an army into battle. Julius's second announcement left them even more stupefied: They too would join the charge into battle. Still, no one dared object, not even when a comet appeared in the sky above Rome with its tail pointing toward the Castel Sant'Angelo—a sure sign, it was said, that evil times lay in store.

Julius was undaunted by the omen, and for the next week Rome bustled with preparations. Finally, before dawn on the morning of the twenty-sixth of August, after an early Mass, he was borne in his litter to the Porta Maggiore, one of Rome's eastern gates, where he gave a blessing to those who had risen to cheer him on his way. With him were five hundred knights on horseback and several thousand Swiss infantry armed with pikes. Twenty-six cardinals accompanied them, together with the choir from the Sistine Chapel and a small army of secretaries, notaries, chamberlains, auditors—a good part of the Vatican bureaucracy. Also among the company was Donato Bramante, who served, among his other duties, as the pope's military architect.

From the Porta Maggiore the procession snaked into the scorched countryside beyond the walls of Rome. More than 3,000 horses and mules were needed to carry the mountains of baggage. At the head of this long column was the consecrated Host: not the thin white wafer of modern times but a large, cakelike medallion that had been baked in an oven and stamped with inspiring scenes of the Crucifixion and the Resurrection.

The army made good time despite such a cumbersome entourage, breaking camp two hours before sunrise each morning and covering

seven or eight miles by nightfall. Along the way the pope and Bramante inspected various castles and fortifications. When the procession reached Lake Trasimeno, eighty miles to the north, Julius stopped for a day to indulge his two favorite pastimes, sailing and fishing. He had loved sailing ever since he earned money as a boy by transporting onions in a boat from Savona to Genoa. Now his Swiss foot soldiers pounded their drums and tooted their trumpets along the shore as he whiled away the hours on the lake. Further mixing business with pleasure, he took time to visit his daughter Felice and her husband in their castle. Even so, after less than a fortnight his troops had gained the steep hills and plunging valleys of Umbria and come within striking distance of their first target: the walled, hilltop city of Perugia.

For the past few decades Perugia had been ruled by the Baglioni, a family notable even in the gory annals of Italian politics for their violent mayhem. So hideous was one of their massacres that Perugia's cathedral was later washed with wine and reconsecrated in the hope of removing the taint of blood from the city. But not even the murderous Baglioni clan wished to cross swords with the pope. Gianpaolo Baglioni, the lord of Perugia, swiftly surrendered to Julius, and on the thirteenth of September the city gates swung open without a drop of blood being shed. The pope and his entourage entered to the sound of tolling bells and a cheering populace. It was a homecoming of sorts, since as a young man Julius had taken holy orders in Perugia. Triumphal arches were hastily erected, and people thronged the streets as, preceded by the Blessed Sacrament, Julius was carried to the cathedral in the papal chair, every inch the conquering hero.

So pleased was the pope with this bloodless victory that he began entertaining plans of leading a Crusade to liberate both Constantinople and Jerusalem. But first other duties beckoned. He remained in Perugia for only a week before setting off for Bologna, striking east through a pass in the Apennines and making for the Adriatic coast. Progress this time was slow because the weather had turned inclement. By the end of September the tops of the

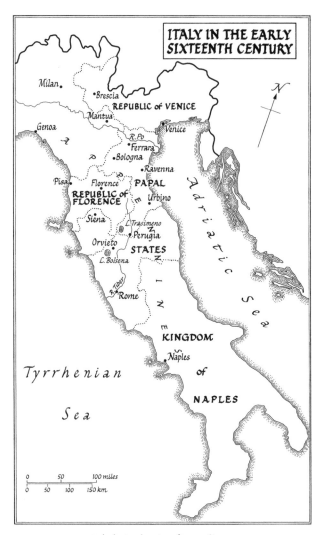

Italy during the reign of Pope Julius II.

Umbrian hills lay deep in snow, and the narrow roads through the valleys turned treacherous in the rain, causing the packhorses to stumble and the spirits of the cardinals and papal retainers—who were accustomed to the good life in Rome—to sink. At one point Julius was even forced to ascend a steep stretch of muddy road on foot. After a journey of 150 miles they finally reached Forlì, where the pope suffered the indignity of having his mule stolen by a local thief. Soon afterward, word arrived that Giovanni Bentivoglio and his sons, the self-proclaimed rulers of Bologna, had fled to Milan.

The Bentivoglio family were, if anything, more savage and unruly than the Baglioni. For all that, they were highly popular with the people of Bologna. After a coup by their rivals a few decades earlier, their supporters had hunted down and murdered the conspirators, then nailed their hearts to the doors of the Bentivoglio palace. But now the Bolognese did not hesitate to welcome the pope through their gates. His entry was even more spectacular than the one into Perugia two months earlier. Once more he was carried through the streets in the papal chair, wearing a tall, pearl-encrusted tiara and a purple cope shot through with gold thread and glittering with sapphires and emeralds. As in Perugia, triumphal arches were erected over streets that thronged with spectators, whose celebrations, complete with bonfires, lasted for three days. The legend of the "Warrior Pope" was born.

Following the pope's arrival in Bologna, his likeness was fashioned in stucco and erected in front of the Palazzo del Podestà. But Julius longed for a more permanent memorial and, accordingly, made plans for an enormous bronze statue of himself that would loom over the porch of the church of San Petronio and proclaim to the people of Bologna his lordship over their city. And to cast this enormous bronze statue—which would stand fourteen feet tall—he naturally wanted Michelangelo. If the sculptor refused to paint the vault of the Sistine Chapel, Julius reasoned, then perhaps he would execute a sculpture.

Yet another summons, the fourth, was promptly sent to Florence, this time ordering Michelangelo to appear before the pope in Bologna.

PENANCE

THE POPE'S MOST trusted friend and ally was a man named Francesco Alidosi, the cardinal of Pavia. The thirty-nine-year-old Cardinal Alidosi had been a favorite of Julius ever since, years earlier, he had foiled Rodrigo Borgia's plot to have him poisoned. However, the handsome, hook-nosed Alidosi had few other friends and supporters in Rome, mainly because of his supposed immoral behavior. It was said by his numerous enemies that he consorted with prostitutes, dressed up as a woman, seduced boys, and dabbled in the occult. Yet Cardinal Alidosi did have one other sympathizer, for he was one of the few people in Rome whom Michelangelo was prepared to trust. A great lover of the arts, Alidosi had been instrumental in bringing him to Rome in 1505 to carve the pope's tomb, and Michelangelo seems to have come to regard him as his protector and ally in the treacherous world of Vatican politics.[1]

One reason for Michelangelo's refusal to return Rome had been his fear that he would not be left "uninjured and unhurt," as the pope had promised. Whether he actually feared for his life at the hands of Bramante is doubtful, but he did have good reason to fear the wrath of Julius. Before the summer ended he had therefore appealed to the pope's trusted lieutenant for a written guarantee of his safety.

The cardinal, who had accompanied Julius on his military expedition, duly provided Michelangelo with a written assurance, and with this in his pocket the sculptor finally rode north to Bologna, also bearing a letter from Piero Soderini that proclaimed him "an excellent young man, in his own art without a peer in Italy, and perhaps even in the Universe." However, Soderini's letter also cautioned that Michelangelo's nature "is such that he requires to be drawn out by kindness and encouragement."[2]

The pope received Michelangelo in Bologna at the end of November, more than seven months after he had fled Rome.

Begging pardon from Julius was not a pleasant experience, as various of his enemies would soon discover. Michelangelo got off lightly, though the reunion was nonetheless a stormy one. One of the papal equerries, spotting Michelangelo during Mass in San Petronio, escorted him across the piazza to the pope's residence in the Palazzo de' Sedici. His Holiness was at dinner.

"You were supposed to come to us," bellowed the disgruntled pontiff, "and you have waited for us to come for you."[3]

Falling to his knees, Michelangelo begged forgiveness and explained that he had simply been enraged by his unfair treatment after returning from Carrara. The pope made no reply, at which point a well-meaning bishop, having been urged by Soderini to put in a good word for Michelangelo, leaped to the sculptor's defense.

"Your Holiness must disregard his offense," he told Julius, "because he offended through ignorance. Painters, outside of their art, are all like that."[4]

The pope may have been exasperated by the "humours of such men of genius" as Michelangelo, but as a patron of artists he did not take kindly to the implication that all of them were uncouth and ignorant. "You are the ignoramus and the wretch," he roared at the bishop, "not he. Get out of my sight and go to the devil." When the astonished bishop failed to vacate the room, he was driven away "with jabs by the pope's attendants."[5]

And so artist and patron were reconciled. There was, however, one minor problem. Michelangelo refused to work on the giant statue. Casting in bronze, he informed the pope, was not his profession. Julius, however, would hear no excuses. "Set to work," he ordered the sculptor, "and cast it over and over again until it succeeds."[6]

Bronze casting was a difficult business. Like fresco painting, it required much experience, and casting a life-size statue, let alone one fourteen feet tall, could take many years, as Antonio del Pollaiuolo

discovered when he spent nine years on the sepulchre for Sixtus IV. The process required a model made from seasoned clay—what would form the statue's core—to be covered with a layer of wax. The artist added his sculptural details to the wax, which was then coated with several layers of a paste made from, among other ingredients, cow-dung and burned ox-horn. Bound with iron hoops, this bulky mass was baked in a furnace until the clay hardened and the melted wax drained through holes, or "risers," drilled in the bottom of the statue. Molten bronze would then be poured through another set of tubes, the "runners," to replace the coat of wax. After the bronze solidified over the clay base, the husk of cow-dung and ox-horn was cracked open and the statue emerged, ready to be chiseled and polished.

Such, at least, was the theory, though the practice was prone to all sorts of mishaps and delays. The right kind of clay needed to be found and properly seasoned to prevent it from cracking, and the bronze had to be heated to exactly the right temperature or else it would curdle. For a variety of reasons, one of which was the sheer size of the work, Leonardo da Vinci had failed in his attempts to cast a bronze equestrian for Lodovico Sforza, the duke of Milan. But at least Leonardo was trained in the art of casting bronze, having worked for many years in the studio of Andrea del Verrocchio, a leading Florentine goldsmith. Michelangelo, on the other hand, did not exaggerate when he claimed that bronze casting was not his profession. He may have received some instruction in casting metals in the Garden of San Marco but, by 1506, he had executed only a single bronze figure: a four-foot-high *David* commissioned in 1502 by the French *maréchal* Pierre de Rohan.✱ He had little more experience at casting bronze, in other words, than he did at painting frescoes.

As with the Sistine Chapel decorations, Julius did not trouble himself with minor details such as Michelangelo's lack of experi-

✱This work, completed about the same time as the much larger and more famous marble *David,* was sent to France and eventually disappeared. It probably suffered the fate of summons bronze statues over the centuries and was melted down, during wartime, to make cannon.

ence. He was determined to have his statue, and so Michelangelo, who dared not flee the pope a second time, was given a studio behind San Petronio and set to work. The statue was clearly a test for him, not merely of his sculptural skills but also of his loyalty to the pope.

The next year was a miserable one for Michelangelo. He was unhappy with his cramped lodgings, having discovered how he was obliged to share his bed with three other men. He found the wine available in Bologna not only expensive but also of an inferior kind. Nor was the weather to his liking. "Since I have been here," he complained as summer arrived, "it has only rained once and has been hotter than I ever believed it could be anywhere on earth."[7] And he was still convinced that his life was in danger, for not long after arriving in Bologna he wrote to his brother, Buonarroto, "Anything might happen to shatter my world."[8] His supposed enemy, Bramante, was still in Bologna, and he noted uneasily that, with the papal court in town, the dagger makers had been inundated with business. Bologna was also full of bands of ruffians and disgruntled supporters of the exiled Bentivoglio clan, making it a violent and dangerous place.

After two months, Julius visited the workshop to inspect the clay model. Michelangelo then wrote home to Buonarroto: "Pray God it may go well for me, because if it goes well I hope to have the good fortune to be in favour with this pope."[9] Regaining favor with the pope meant, of course, that he might be allowed to resume work on the papal tomb.

Work on the statue, however, did not begin at all well. Michelangelo hoped to have it ready for casting by Easter, but progress was slowed when, around the time of the pope's visit, he fired a pair of his assistants: Lapo d'Antonio, a stone carver, and a goldsmith named Lodovico del Buono, known as Lotti. Michelangelo found especially irksome the younger of the two, Lapo, a forty-two-year-old Florentine sculptor. "He was a deceitful good-for-nothing fellow who did not do what I wanted," he wrote home to Florence.[10] In particular, he resented how his assistant was noising it about Bologna that he, Lapo d'Antonio, was working in full

partnership with Michelangelo. The pair did have some justification in seeing themselves as Michelangelo's equals rather than mere underlings. Each was at least ten years his senior, and Lotti had apprenticed under the great Antonio del Pollaiuolo. Michelangelo held Lotti in higher esteem, and his experience and expertise must have been crucial. But he had been corrupted, Michelangelo felt, by the poisonous Lapo, and so both men were sent packing. Given that Lapo and Lotti had been his bedmates, the dispute must have made for disagreeable evenings in the small workshop behind San Petronio.

Michelangelo's situation in Bologna was soon to deteriorate even further. No sooner had Lapo and Lotti been dismissed than the pope departed, claiming Bologna was bad for his health. As if to reinforce his point, the plague broke out soon afterward, and on its heels came rebellion. With the pope on the road back to Rome, the Bentivoglio family and their supporters, emboldened, tried to recapture the city. Ordinarily, Michelangelo took to his heels at the faintest whiff of gunpowder; now he was forced to remain in his studio as violent skirmishes were fought outside the city walls. It must have crossed his mind that the Bentivogli, if they returned, would hardly look generously on the fact that he was sculpting their archenemy. But within a few weeks the exiles were beaten back, at which point they turned their efforts to a plot—equally unsuccessful—to have Julius poisoned.

In early July 1507, little more than six months after beginning work, Michelangelo attempted to cast his giant statue. The end product failed because the bronze had not been melted properly, resulting in a statue that had feet and legs but no trunk, arms, or head. A delay of more than a week ensued as the furnace was cooled down and then dismantled so that the solidified bronze could be removed, reheated, and poured into the mold for a second attempt. Michelangelo blamed one of his new assistants, Bernardino d'Antonio, for the disaster, claiming that "either through ignorance or by accident" he had failed to raise the furnace's temperature sufficiently.[11] He broadcast Bernardino's dis-

grace so widely that the shamed assistant went about Bologna with his head lowered.

The second casting reached a happier conclusion, and Michelangelo spent the ensuing six months chiseling, polishing, and retouching the statue, then preparing the porch of San Petronio for its installation. The statue should have been a personal triumph for him. Fourteen feet tall and weighing 10,000 pounds, it was one of the largest statues cast since antiquity. It was almost exactly the same height, in fact, as the equestrian statue of the emperor Marcus Aurelius that stood in front of the basilica of San Giovanni in Laterano—the bronze statue against which all others were measured.* Furthermore, he had defied the skeptics who, a year earlier, had doubted his ability to accomplish the mammoth task. "The whole of Bologna was of the opinion that I should never finish it," he boasted to Buonarroto.[12] And, having completed the task, he was once more, presumably, in the good graces of the pope. Even before finishing the statue he began exchanging letters with Giuliano da Sangallo and Cardinal Alidosi, his two strongest allies and supporters in Rome, expressing the hope that he would be allowed to continue with the tomb.

Nevertheless, modeling and casting the statue had exhausted Michelangelo. "I am living here in the greatest discomfort and in a state of extreme fatigue," he wrote to Buonarroto as he finished the work. "I do nothing but work day and night, and have endured, and am enduring, such fatigue that if I had to do the work over again I do not believe I should survive."[13] He longed to return to Florence, a tantalizingly close fifty-mile journey across the Apennines. But his patience was tried still further by the pope's orders that he remain in Bologna until the statue was actually in place above the church's door. The papal astrologers eventually decreed the twenty-first of February 1508 to be the most auspicious date for its installation. Only then was Michelangelo permitted to return to Florence,

*In 1538 Michelangelo would erect this statue in its present position in the Piazza del Campidoglio in Rome.

though not before his assistants in Bologna had arranged a small party in his honor. Michelangelo's delight in returning home was not even denied when he fell from his horse while riding back through the Apennines.[14] However, no sooner had he arrived in Florence than a summons arrived from the pope, ordering him back to Rome—but not, as it transpired, to resume work on the tomb.

CHAPTER 5

PAINTING IN THE WET

ON THIS DAY, May 10, 1508, I Michelangelo, sculptor, have received on account from our Holy Lord Pope Julius II five-hundred papal ducats toward the painting of the ceiling of the papal Sistine Chapel, on which I am beginning work today."[1]

By the time Michelangelo wrote this note to himself, roughly a month had passed since his return to Rome. During that time, a contract for the painting of the vault had been drawn up by the pope's friend and confidant, Cardinal Alidosi, who was continuing to serve as an intermediary between the temperamental Julius and his equally temperamental sculptor. He had been in close contact with Michelangelo regarding the bronze statue, exchanging a number of letters with him and then overseeing the installation of the finished project on the porch of San Petronio.[2] Satisfied with the results achieved in Bologna, the pope therefore left to his trusted cardinal the task of arranging many of the details for this new and much larger commission.

The contract written by Cardinal Alidosi, now lost, stated that the sculptor (as Michelangelo usually took pains to describe himself) would be paid a total of 3,000 ducats for his work on the ceiling, triple the amount he was paid for casting the bronze statue in Bologna. Three thousand ducats was a generous amount—double the sum that Domenico Ghirlandaio had been paid to fresco the Tornabuoni Chapel in Santa Maria Novella. It was also thirty times as much as a qualified artisan, such as a goldsmith, could expect to earn in a single year.* However, it was still a good

*Michelangelo had paid the troublesome Lapo d'Antonio eight ducats per month, or the equivalent of a salary of ninety-six ducats per year, for assisting him with the bronze statue in Bologna.

deal less than Michelangelo had been offered to sculpt the tomb. Furthermore, he would need to use these funds to pay for his brushes, pigments, and other materials, including the rope and wood to build a scaffold. He would also be required to fund a team of assistants and outfit his house in the Piazza Rusticucci to accommodate them. All of these overheads would, of course, eat swiftly into his payments. For instance, of the 1,000 ducats allotted for the bronze statue of Julius, he was left at the end, after paying out for his materials, assistants, and lodgings, with a paltry profit of exactly 4½ ducats.[3] And whereas the bronze statue had required fourteen months of work, it was clear that frescoing the vault of the Sistine Chapel would take much longer.

Michelangelo did not actually start painting by the middle of May. The execution of a fresco, especially one comprising 12,000 square feet, took a great deal of planning and forethought before the first stroke of paint could be applied. The art of fresco enjoyed such esteem precisely because it was so famously difficult to master. Its myriad obstacles are reflected in the Italian expression *stare fresco,* meaning "to be in a fix or a mess." Many artists besides Leonardo da Vinci (who failed so spectacularly with *The Battle of Anghiari*) had found themselves in a fix when confronted with a wall or vault to paint. Giorgio Vasari, himself an experienced frescoist, claimed that most painters could succeed in tempera and oil, but only a few triumphed at fresco. It was, he contended, "the most manly, most certain, most resolute and durable of all the other methods."[4] One of his contemporaries, Giovanni Paolo Lomazzo, likewise saw fresco as a distinctly masculine pursuit, insisting that tempera painting, in comparison to fresco, was the domain of "effeminate young men."[5]

The technique of painting on wet plaster was already known in Crete in the second millennium B.C.E., and centuries later the Etruscans, and then the Romans, used it to decorate walls and tombs. But the art of fresco assumed a particular currency in central Italy from the last half of the thirteenth century, when towns and cities like Florence were gripped by a building boom the likes of which had not been seen since the days of the Roman emperors.

In Florence alone, at least nine major churches were built or begun in the second half of the thirteenth century. If in northern Europe (which had just undergone its own building spree) the new Gothic cathedrals were brilliantly decorated with tapestries and stained-glass windows, frescoes became the order of the day in Italy. The hills around Florence and Siena possessed in abundance the necessary ingredients: limestone, marble, and sand, as well as the clays and minerals needed to make pigments. And like the Sangiovese grape, used in making Chianti, frescoes were well suited to the dry, scorching Tuscan summers.

The particular technique of fresco employed throughout the Renaissance was similar to that used by both the Etruscans and the Romans, having evolved around 1270, not in Florence but in the Roman workshop of a painter named Pietro dei Cerroni, nicknamed Cavallini (Little Horses). Cavallini enjoyed a lengthy and celebrated career in both fresco and mosaic, living to the grand age of one hundred even though, it was said, he never covered his head in winter. His style and technique influenced the first great exponent of fresco during the Renaissance, a Florentine named Giovanni Cenni di Pepi, who was known unflatteringly as Cimabue (Ox-Head) because of his ugliness. Hailed by Giorgio Vasari as "the first cause of the renovation of the art of painting,"[6] Cimabue won fame in Florence with frescoes and other paintings that decorated several of the new churches, including Santa Trìnita and Santa Maria Novella. Then, in about 1280, he traveled to Assisi to execute his masterpieces, fresco cycles in both the upper and lower churches of San Francesco.*

Cimabue was assisted, and eventually eclipsed, by a young painter, the son of a peasant, whom legend states he first met on the road between Florence and the nearby village of Vespignano:

*Cavallini himself might have worked in the upper church of San Francesco, about whose frescoes there are numerous unresolved questions of attribution. Some art historians credit him with two of the church's frescoes—*Isaac Blessing Jacob* and *Isaac and Esau*—therefore making him the so-called Isaac master. Vasari claims that Cimabue painted these particular frescoes, while other art historians point to Giotto.

Giotto di Bondone. After Cimabue's death, Giotto painted further frescoes in San Francesco and even moved into his master's house and workshop in the Borgo Allegri (Joyful Road)—so named because the people in the neighborhood had reacted with a near-hysterical exuberance when one of Cimabue's paintings was borne in procession from his studio to be shown to the visiting King Charles of Anjou. Giotto schooled numerous pupils in the techniques learned from Cimabue. One of the most talented of these pupils, Puccio Capanna, learned the hard way that fresco was an occupation fit only for those made of the sternest stuff. Vasari reported that his life was cut short after he fell ill "by reason of labouring too much in fresco."[7]

The technique of fresco was as simple in conception as it was difficult in execution. The term *fresco,* meaning "fresh," comes from the fact that the painter always worked on fresh—that is, wet—plaster. This called for both good preparation and precise timing. A layer of plaster, known as the *intonaco,* was troweled to a thickness of about a half inch over another coat of dried plaster. *Intonaco,* a smooth paste made from lime and sand, provided a permeable surface for the pigments, first absorbing them and then sealing them in the masonry as it dried.

The design of the painting was transferred to this patch of wet plaster from the cartoon. Fixed to the wall or vault with small nails, the cartoon served as a template for a particular figure or scene. Its design would be transferred by one of two methods. The first, called *spolvero,* involved perforating the lines of drawing on the cartoon with thousands of little holes through which a charcoal powder would be sprinkled, or "pounced," by striking the cartoon with the pounce bag and thereby leaving on the plaster an outline that was then reinforced in paint. The second, much quicker, method required the artist to trace over the chalk lines on the cartoon with the point of a stylus, leaving marks on the fresh plaster beneath. Only then would he set to work with his paints and brushes.

The science behind fresco painting involved a series of simple chemical combinations. The *intonaco* was, chemically speaking, calci-

um hydroxide. The first step in making calcium hydroxide was to heat limestone or marble in a kiln—the practice responsible for the loss of so many of Rome's ancient monuments. The fire drove off the stone's carbonic acid and turned it into a white powder known as quicklime (calcium oxide), which then turned into calcium hydroxide when soaked, or "slaked," in water. For the Renaissance painter, calcium hydroxide was the magical ingredient behind the art of fresco. Once it had been mixed with sand and applied to the wall, the series of chemical transformations gradually reversed themselves. First the water evaporated from the mixture; then the calcium oxide reacted with carbon dioxide in the atmosphere to form calcium carbonate, the main component of limestone and marble. Thus, in a short space of time the smooth paste spread across the wall by the plasterer's float had turned back into stone, locking the colors in crystals of calcium carbonate. A frescoist therefore did not need to dilute his pigments with anything other than water. The various binding agents used in tempera painting—egg yolk, glue, gum tragacanth, and even sometimes earwax—were unnecessary for the simple reason that the pigments were set in the *intonaco*.

Ingenious the technique may have been, but the potential for disaster dogged the painter's every step. One major problem concerned the time available to paint the *intonaco*, which stayed wet, depending on the weather, for no more than twelve to twenty-four hours. Since after this period the plaster no longer absorbed the pigments, it was laid down only in an area that the frescoist could complete in a single day, known as a *giornata* (day's work). The large surface of a wall or vault would therefore be divided into anything from a dozen to several hundred of these *giornate*, all varying widely in size and shape. Ghirlandaio, for example, divided the huge surface of the Tornabuoni Chapel into 250 of these units, meaning that a typical day saw him and his apprentices paint an area roughly four feet by five feet—the dimensions of a good-size canvas.

The frescoist was therefore forced to work against the clock to complete each *giornata* before the plaster hardened, a fact that made working in fresco radically different from painting on canvas or

panel, which, since they could be retouched, tolerated even the most lax and procrastinating artist. Titian, for example, tinkered endlessly with his canvases, making changes and corrections throughout his life, sometimes adding as many as forty separate coats of paint and glaze, the final layers of which he then smeared with his fingertips so the picture looked impulsive.

Michelangelo would have no such luxuries of time and retrospection in the Sistine Chapel. To speed their work, a number of frescoists adopted the habit of working with a brush in each hand, one charged with dark paint, the other with light. The quickest brushes in Italy supposedly belonged to Amico Aspertini, who began frescoing a chapel in the church of San Frediano in Lucca in 1507. The eccentric Aspertini painted with both hands at once, his pots of paint swinging from a belt at his waist. "He looked like the devil of San Maccario with all those flasks of his," chortled Vasari, "and when he worked with his spectacles on his nose, he would have made the very stones laugh."[8]

Nevertheless, it would take the speedy Aspertini more than two years to paint the walls of the chapel in San Frediano, which were considerably smaller than the vault of the Sistine Chapel. And Domenico Ghirlandaio, despite his large workshop, had spent almost five years on his frescoes in the Tornabuoni Chapel. As this chapel also had a smaller surface area than the Sistine Chapel, Michelangelo would have realized that his new commission could take many years to complete.

One of the first tasks facing Michelangelo was the removal of the plaster on which Piermatteo d'Amelia's damaged fresco had been painted. It was sometimes possible to paint one fresco over the top of another through a technique known as *martellinatura,* in which the surface of the old fresco was roughened with the pointed end of a

martello, or hammer, so that the plaster for the new fresco would adhere to that of the old, over which it was then painted. But this was not the method adopted with Piermatteo's fresco. The whole of his starry sky was to come crashing down to Earth.

Once Piermatteo's old fresco had been chiseled from the vault, an undercoat of fresh plaster, called the *arriccio,* would be spread over the entire ceiling to a thickness of roughly three-quarters of an inch, filling various gaps and irregularities such as the joints between the masonry blocks and creating a smooth surface over which, when the time finally came to paint, the *intonaco* could be spread. The process entailed both removing tons of old plaster from the chapel and carrying into it hundreds of bags of sand and lime to mix the *arriccio.*

The major task of hacking Piermatteo's fresco from the masonry and laying the *arriccio* for the new one was given by Michelangelo to a fellow Florentine, Piero Rosselli, the man who had defended him against the slurs of Bramante. A sculptor and architect in his own right, the thirty-four-year-old Rosselli was well qualified for the job. He was also a close friend of Michelangelo's, addressing him in his letters as *charisimo fratello,* or "dearest brother."[9] Michelangelo paid him eighty-five ducats for his work, which kept him and his team of plasterers busy for at least three months, until the end of July.

The destruction of Piermatteo's starry Heaven required an elevated platform that would allow Rosselli's men to work their way as quickly as possible from one end of the chapel to the other. This scaffold needed to span a width of forty-four feet and rise some sixty more above the floor, not to mention proceed down a chapel 130 feet in length. Michelangelo and his team would need a similar sort of staging if their paintbrushes were to reach every inch of the vault's surface. What worked for the plasterers would clearly work for the painters, and so it was logical for Michelangelo and his assistants to inherit Rosselli's scaffold. But first this structure needed to be designed and built. A good deal of the eighty-five ducats paid to Rosselli was therefore spent on timber.

Frescoes always called for staging of some sort. The usual solu-

tion, especially for walls, was to devise the kind of ground-supported wooden scaffold used by masons, complete with ladders, ramps, and platforms. Wooden structures of this type must have been built in the bays between the windows of the Sistine Chapel when Perugino, Ghirlandaio, and the others painted their frescoes on the walls. The ceiling of the Sistine Chapel presented much more of a problem. The scaffold would have to rise to a height of around sixty feet, yet somehow leave the aisles clear for the priests and pilgrims as they observed ceremonies beneath. For this reason alone, a ground-based scaffold—one whose supports would unavoidably block the aisles—was unworkable.

Assorted other practicalities also demanded attention. Any scaffold would have to be both robust and spacious enough to accommodate the teams of assistants and their equipment, including buckets of water, heavy bags of sand and lime, and the large cartoons that had to be unrolled and then transferred to the ceiling. Safety was an issue as well. The dizzy heights of the chapel meant that anyone who ascended the scaffold faced a serious occupational hazard. Fresco painting occasionally produced casualties, such as the fourteenth-century painter Barna da Siena, who was said to have fallen almost one hundred feet to his death while frescoing *The Life of Christ* in the Collegiata in San Gimignano.

The scaffolding of the Sistine Chapel clearly called for the talents of no ordinary *pontarolo,* as the scaffold maker was known. Piero Rosselli was equipped for the job, having made his name as an engineer as well as a sculptor and architect. Ten years earlier he had devised a system of pulleys and cranes to recover from the Arno a sunken block of marble that had been promised to Michelangelo. However, in the first instance the pope brought in Donato Bramante. If this development displeased Michelangelo, ushering into the project the unwelcome presence of his supposed enemy, ultimately he turned it to his advantage by humiliating Bramante when the architect failed to find a viable solution. Bramante had hit on the unusual idea of suspending wooden platforms from ropes anchored in the vault, which therefore needed to

Michelangelo's diagrammatic sketch for the scaffolding.

be pierced with a series of holes. This plan may have addressed the problem of keeping the scaffolding clear of the floor, but it left Michelangelo with the greater predicament of how to fill in the unsightly holes once the ropes were removed. Bramante dismissed the problem, saying that "he would think of that afterwards, and that it could not be done otherwise."[10]

For Michelangelo, this improbable scheme was merely the latest example of the architect's bungling. After protesting to Julius that Bramante's plan could not work, Michelangelo was told by the pope to build the scaffold however he saw fit. And so, in the midst of his various other preparations, Michelangelo found himself tackling the problem of the scaffold's design.

Though Michelangelo possessed far less experience as an engineer and builder than Bramante, he did have aspirations in this area. Not least of these was his proposal, hatched in the dark days of 1506, to build the huge bridge across the Bosporus. Spanning the Sistine Chapel, by comparison, surely seemed a small matter. Fittingly, his design for the scaffold ultimately produced a sort of bridge, or rather a series of footbridges that spanned the chapel from the level of the windows.[11] Holes were drilled some fifteen inches deep into the masonry immediately over the uppermost

cornice, a few feet above the heads of the thirty-two frescoed popes. These holes were used to anchor short wooden brackets, rows of cantilevers known in the building trade as *sorgozzoni* (literally, "blows to the throat"). The brackets supported a number of stepped arches, built to the same profile as the ceiling, that served as linked bridges across the void, giving the painters and plasterers decks on which to work as well as access to every part of the ceiling. The scaffold extended only half the length of the chapel, or across the first three bays between the windows. Thus, when Rosselli's men finished with the first half of the chapel they were required to dismantle the arches and construct them anew in the second—a process that Michelangelo would have to repeat when he came to paint.

A simple but resourceful solution to the problem, this scaffold also proved a more economical structure than Bramante's. Condivi claims that, once the scaffold had been erected, Michelangelo found himself with a surplus of rope, not having required the enormous lengths purchased for Bramante's suspended platforms. He therefore donated the superfluous material to the "poor carpenter" who had helped build the scaffolding.[12] The carpenter then promptly sold the rope and used the money as dowries for two of his daughters, thereby providing a fairy-tale ending to the legend of how Michelangelo trumped Bramante.

Since Michelangelo's ingenious scaffold left the floor clear, it was business as usual in the Sistine Chapel during the summer of 1508, with Rosselli and his men hacking out the old plaster and spreading the new while religious ceremonies were celebrated below. Predictably, problems arose with this arrangement. Barely a month into the job, Rosselli's workmen were chastised for their disruptive labors by Paride de' Grassi, the new *magister caerimoni-*

arum (papal master of ceremonies). De' Grassi, a nobleman from Bologna, was a ubiquitous figure in the Sistine Chapel. He was the man in charge of preparing it for Mass and other ceremonies, making sure there were candlesticks on the altar, for example, and charcoal and incense in the thurible. He also supervised the officiating priests, watching to see that they consecrated and then elevated the Host in the accepted fashion.

Querulous and impatient, de' Grassi was a stickler for detail. He would complain if either the hair or the sermon of a priest was too long, or if a worshiper was sitting in the wrong place or—a common problem—making too much noise. No one escaped his ruthless eye for detail, not even the pope, many of whose antics exasperated him, though the master of ceremonies was usually wise enough to keep his annoyances private.

On the evening of the tenth of June, de' Grassi ascended from his office below the chapel to discover that it was impossible to chant vespers for the vigil of the Pentecost on account of the dust stirred up by the workmen. "On the upper cornices," he wrote angrily in his diary, "construction was going on with the greatest dust, and when so ordered the workmen did not cease, about which the cardinals complained loudly. I myself argued with several workmen, and they did not cease. I went to the pope, who was almost disturbed with me because I did not warn them twice, and made a defense for the work. The pope then sent in succession two of his chamberlains, who ordered the work to stop, which was barely done."[13]

Piero Rosselli and his men must have been working very long hours if they managed to disturb vespers, which was always chanted at sunset. In the middle of June the sun would not have set before nine o'clock. And if Julius defended the plasterers, as de' Grassi resentfully observed, then he must have approved of such tactics— which may explain why Rosselli's men dared stand up to the cardinals and the master of ceremonies.

Time would certainly have been of the essence. The *arriccio* needed to dry completely before the *intonaco* could be laid, not least because the rotten-egg smell of wet *arriccio* was considered bad for

a painter's health, especially in a confined space. A period as long as several months, depending on the weather, therefore had to elapse between the laying of the *arriccio* and the start of work on the fresco itself. Rosselli was probably trying—at the behest of both Michelangelo and the pope—to apply the *arriccio* as swiftly as possible so that it might have the hot summer months in which to dry. Furthermore, Michelangelo would also have wanted to begin work, if possible, before winter. Painting was virtually impossible in the frigid temperatures brought to Italy by a winter wind, the *tramontana,* which blew south from the Alps. If the *intonaco* was too cold, or if it froze, the colors did not absorb properly and so flaked off.

If Rosselli did not have the vault ready for painting by October or November, Michelangelo's work would have had to wait until February. Impatient and anxious for results, the pope would not have looked favorably on such a delay. Thus, during the summer of 1508 Rosselli and his team worked well into the evenings, the din of their hammers and chisels drowning out the chanting of the choir a few yards below.

THE DESIGN

AS PIERO ROSSELLI and his men demolished Piermatteo d'Amelia's old fresco, Michelangelo was busy designing the new one. He was working according to a plan provided by the pope, since Julius had requested a specific pictorial scheme for the vault. It is unclear whether the pope himself was the author of this design or if he developed it in consultation with an adviser. Michelangelo claimed in a note to himself that he was working "according to conditions and agreements"[1] laid down by Cardinal Alidosi, a statement suggesting that the cardinal, for one, was closely involved.[2]

It was normal practice for a patron to stipulate the subject matter of a work. Painters and sculptors were regarded as craftsmen who worked according to precise instructions from whoever was paying the bill. Domenico Ghirlandaio's contract with Giovanni Tornabuoni is a classic example of how a patron went about commissioning a large fresco cycle from an artist.[3] Tornabuoni, a wealthy banker, drew up a contract outlining virtually every detail of the decoration of the chapel in Santa Maria Novella that bears his name. Little was left to Ghirlandaio's imagination. Not only was the painter instructed as to which scenes should be painted on which wall, he was also given their exact order and dimensions. He was told which colors to use, and even the date on which to begin painting. Tornabuoni demanded large numbers of figures in the scenes, including all sorts of birds and animals. Ghirlandaio, a diligent craftsman, was happy to indulge his patron's whims, and his frescoes teem with life—so much so that some of the scenes are, in the words of one celebrated art historian, "as overfilled as the sheets of an illustrated newspaper."[4] In one scene Ghirlandaio even painted a giraffe. This exotic creature was probably painted from life, since in 1487 Lorenzo de' Medici's

garden was home to an African giraffe until, unused to the cramped spaces of Florence, it banged its head on a beam and died.

The artist of Michelangelo's time therefore bore little resemblance to the romantic ideal of the solitary genius who would conjure original works of art from the fathoms of his own imagination, unfettered by the demands of the marketplace or patron. Only in a later century could a painter like Salvator Rosa, born in 1615, haughtily refuse to follow the orders of his patrons, telling one of them, who had been too specific with his requests, to "go to a brickmaker, as they work to order."[5] In 1508, the artist, like the brickmaker, worked to the demands of his patron.

Given these practices, Michelangelo cannot have been surprised when, in the spring of 1508, he was presented by the pope with a detailed scheme for the decoration of the Sistine Chapel. The images that Julius had in mind were considerably more complex and involved than Piermatteo's star-spangled Heaven. He gave the artist instructions to paint the Twelve Apostles above the windows of the chapel and to cover the remainder of the ceiling in an interlocking geometric pattern of squares and circles. Julius seems to have been fond of such kaleidoscopic patterns, which imitated ancient Roman ceiling decorations such as those at Hadrian's villa, at Tivoli, which had become a site of intense interest in the latter half of the fifteenth century. During the same year he had commissioned two similar schemes from a pair of other artists: one from Pinturicchio for the vault of the choir that Bramante had recently completed in the church of Santa Maria del Popolo, and another for the ceiling of the Stanza della Segnatura, the room in the Vatican Palace into which he intended to move his library.

Michelangelo made a number of drawings in a diligent attempt to come up with an arrangement of patterns and figures to please the pope. In search of inspiration, he even seems to have appealed, around this time, to Pinturicchio. The wine-loving Bernardino di Betto, better known because of his gaudily ornamental style as Pinturicchio (Rich Painter), was probably the most experienced frescoist in Rome, having by the age of fifty-four decorated numer-

A drawing by Giuliano da Sangallo of a design on a ceiling in Hadrian's villa at Tivoli.

ous chapels throughout Italy. He probably worked on the walls of the Sistine Chapel itself as an assistant to Pietro Perugino. Pinturicchio did not actually begin his fresco until September 1508, but it is quite possible that he was producing drawings that Michelangelo saw earlier in the summer. In any case, Michelangelo's first drawings for the Sistine ceiling look suspiciously like Pinturicchio's design for the choir vault at Santa Maria del Popolo.[6]

However, Michelangelo was clearly still not satisfied with his efforts. His main problem with the proposed scheme was that, apart from the Twelve Apostles, there was very little scope for him to explore his interest in the human form. He added winged angels and caryatids to the design, but these conventional figures were merely part of the geometric scenery and, as such, both a far cry from the sinewy, writhing nudes of *The Battle of Cascina* and a poor substitute for the abandoned papal tomb, for which he had hoped to carve a series of naked, struggling supermen. Faced with such an uninspiring design, Michelangelo must have felt his appetite for the commission dwindle still further.

Accustomed by now to hearing complaints from Michelangelo, the pope would not have been terribly surprised when, sometime in the early summer, the artist stood before him with yet another

One of Michelangelo's early designs for the Sistine Chapel ceiling.

objection. Audaciously outspoken as ever, he complained to the pope that the design proposed by His Holiness would prove a *cosa povera* (poor thing).[7] Julius appears, for once, to have acquiesced without much argument. He merely shrugged his shoulders and then, according to Michelangelo, gave him free rein to design his own program. "He gave me a new commission," the artist later wrote, "to do what I liked."[8]

Michelangelo's claim that he was given carte blanche by the pope must be viewed with suspicion. For a pope to hand over to a mere artist—even to an artist of Michelangelo's reputation—the complete pictorial program for the decoration of the most important chapel in Christendom would have been, to say the least, highly unusual. Theological experts were nearly always brought in to advise on the content of such decorative schemes. The theological sophistication of the frescoes on the walls of the Sistine Chapel, for example—a series of erudite parallels between the lives of Moses and Christ—could not possibly have been devised by a group of painters who had neither been taught Latin nor studied theology. The Latin inscriptions above the frescoes were in fact composed by the papal secretary, a scholar named Andreas Trapezuntius, and the team also received instructions from the formidably bookish

Bartolomeo Sacchi, known as Platina, the first keeper of the newly founded Vatican Library.[9]

If there was an adviser for the vault's ambitious new design, the leading candidate for the role, besides Cardinal Alidosi, would have been the prior general of the Augustinian Order, Egidio Antonini, more usually known, after his place of birth, as Egidio da Viterbo.[10] The thirty-nine-year-old Egidio was certainly equipped for the task. One of the most learned men in Italy, he was fluent in Latin, Greek, Hebrew, and Arabic. However, the real source of his fame lay in his fiery sermons. A sinister-looking figure in black robes, with unkempt hair, a black beard, flashing eyes, and pale skin, Egidio was the most spellbinding orator in Italy. Testament to his amazing powers of eloquence is the fact that even Julius—famed for dozing off fifteen minutes into a sermon—managed to stay awake during his rousing two-hour orations. The silver-throated Egidio was the pope's greatest propagandist, and since the ceiling was intended by Julius to be seen, like a number of his other commissions, as a glorification of his reign, Egidio's ability to find prophetic references to Julius in the Old Testament would have recommended him for the job.

No matter who invented them, the designs for the fresco would have required approval from the ominously named *haereticae pravitatis inquisitor* (master of the sacred palace), the pope's official theologian. In 1508 the office was filled by a Dominican friar named Giovanni Rafanelli. The master of the sacred palace was always a Dominican. Because of their fervor, Dominicans were punningly known as *domini canes* (hounds of the Lord), and over the centuries the popes had used them for unpleasant tasks such as collecting monetary levies and staffing the Inquisition. One of the order's more notorious members was Tomás de Torquemada, who burned more than 2,000 heretics at the stake after the Inquisition was revived in Spain in 1483.

It was Rafanelli's job to choose the preachers for the Sistine Chapel, censor their sermons if need be, and snuff out any sign of heresy. Anyone selected by him for the honor of preaching in the Sistine Chapel, even Egidio da Viterbo, had to submit beforehand

a copy of his text for inspection. Rafanelli even had the power to interrupt in midsermon and remove from the pulpit any preacher who strayed into controversial territory. In these duties he was sometimes assisted by Paride de' Grassi, who was always vigilant for any sort of theological impropriety.

Someone with Rafanelli's concern for orthodoxy in the Sistine Chapel would certainly have taken an active interest in Michel-angelo's work. Even if Rafanelli had no actual creative input, the painter must at least have discussed his project with him at various stages, possibly showing him drawings and cartoons. Interestingly, however, there is no evidence that Michelangelo—never one to keep his annoyances private—was bothered by the master of the sacred palace or, for that matter, by any other theologian who might have tried to interfere with his plans. This fact, as well as certain telling details on the ceiling itself, might indicate that Julius did indeed allow Michelangelo to do as he pleased.

Michelangelo would certainly have been better prepared than most artists of his day when it came to conceiving rich and complex pictorial programs. For about six years he was schooled in grammar, though not in Latin, by a master from Urbino, at the time a celebrated center of culture to which the wealthy Roman and Florentine families sent their children to be educated. More important, when he went to the Garden of San Marco, at the age of about fourteen, he studied not only sculpture but also theology and mathematics under a number of brilliant scholars. Among these luminaries were two of the greatest philosophers of the age: Marsilio Ficino, the leader of the Accademia Platonica who had translated into Latin both Plato and the hermetic texts; and Giovanni Pico, the count of Mirandola, a student of the cabala and the author of *Oration on the Dignity of Man*.

Just how much Michelangelo rubbed shoulders with the literati is unclear. Ascanio Condivi is vague, merely stating that one of Michelangelo's earliest surviving sculptures, the *Battle of the Centaurs*— a marble relief featuring nude, contorted figures in combat—was carved on the advice of another of the Garden of San Marco's teach-

ers, Angelo Ambrogini. Better known by the pen name Politian, Angelo was an impressively learned scholar even by the lofty standards of Lorenzo's school, having translated the first four books of *The Iliad* into Latin by the age of sixteen. Condivi asserts that Politian loved the young artist "very much and, although there was no need, urged him on in his studies, always explaining things to him and providing him with subjects."[11] But what degree of interchange might actually have existed between this famous scholar and an adolescent sculptor remains a matter of conjecture.[12] Nevertheless, there is little doubt that Michelangelo received enough education to play an active part in the conception of a new design for the ceiling.

As the new scheme was developed over the summer of 1508, Michelangelo must gradually have warmed to the commission. In place of the abstract pattern of interlocking squares and circles, he composed a much more ambitious layout that would allow him to concentrate his talents on the human form in the same way as he had in *The Battle of Cascina*. However, the 12,000 square feet of space awaiting his brush was considerably more complex than the flat wall that had confronted him in Florence. Besides extending the length of the vault, his fresco for the Sistine Chapel needed to incorporate the four large sail-shaped fields, called pendentives, in the corners of the chapel, where the vault met the walls. It also had to encompass eight smaller triangular spaces, or spandrels, that projected above the windows. As well as the vault, Michelangelo would be painting the uppermost reaches of the four walls, the crescent-shaped areas (known as lunettes, or "little moons") above the windows. Some of these surfaces were curved, others flat; some were large, others small and awkward. Michelangelo therefore faced the dilemma of how to arrange his fresco across these inconvenient subdivisions.

The vault raised by Baccio Pontelli was made from blocks of tufa that featured a bare minimum of ornamental stonework. Michelangelo instructed Piero Rosselli to chisel away some of the existing masonry—small decorations such as moldings and acanthus capitals—on the pendentives and in the lunettes. He then set about cre-

ating his own divisions by composing an imaginary architectural background for the fresco, a series of cornices, pilasters, ribs, corbels, caryatids, thrones, and niches that recalled those planned for Julius's tomb. Besides giving the impression from the floor of rich sculptural decoration, this fictive setting, known as a *quadratura,* incorporated the awkward pendentives, spandrels, and lunettes into the rest of the vault and provided him with a series of distinct fields onto which he could paint his scenes.

Along the length of the vault would be nine rectangular panels divided by imitation marble ribs and separated from the rest of the ceiling by a painted cornice. Below the cornice, Michelangelo envisioned a series of figures seated on thrones set in niches. These thrones were a leftover from the first scheme, since originally he had intended to fresco the Twelve Apostles here. Below these thrones, in the spaces around the windows, came the spandrels and lunettes, which provided him with a series of pictorial fields running around the base of the vault.

With this framework established, Michelangelo needed to settle the new subject matter. The New Testament theme of the Twelve Apostles seems to have been quickly abandoned in favor of scenes and characters taken from the Old Testament. The apostles were replaced on their thrones by twelve prophets, or rather by seven prophets from the Old Testament and five sibyls from pagan mythology. Above these figures, in the rectangular panels running along the spine of the vault, would be nine episodes from the Book of Genesis. The spandrels and lunettes, meanwhile, would feature portraits of the ancestors of Christ—a rather uncommon subject— and the pendentives four more scenes from the Old Testament, David slaying Goliath among them.

The choice of scenes from Genesis is a revealing one. Such illustrations were popular in sculptural reliefs, and Michelangelo was familiar with a number of examples, most notably those by the Sienese sculptor Jacopo della Quercia on the massive central door of the church of San Petronio in Bologna. Carved from Istrian stone between 1425 and 1438, the year of Quercia's death, the

reliefs on the Porta Magna (Great Door) show numerous scenes from Genesis, including *The Drunkenness of Noah, The Sacrifice of Noah, The Creation of Eve,* and *The Creation of Adam.*

Quercia sculpted these scenes during the same years that another artist, Lorenzo Ghiberti, was casting the second of his two sets of bronze doors for the baptistery of San Giovanni in Florence, which featured similar scenes from the Old Testament. Michelangelo was such a great admirer of Ghiberti's bronze doors that he is said to have christened them the Porta del Paradiso (Door of Paradise). He seems to have admired Quercia's work on the Porta Magna just as deeply. Having seen the reliefs on San Petronio for the first time in 1494, he would have familiarized himself with them while casting his bronze statue in Bologna in 1507 and then supervising its installation directly above the Porta Magna. Quercia's images were therefore fresh in his mind as he designed his fresco in the summer of 1508, and the nine Genesis scenes planned for the Sistine Chapel were clearly inspired by the work of both Quercia and Ghiberti. Their scenes from the Old Testament are, in fact, the nearest precedent for his own decorative scheme—a fact lending further credence to Michelangelo's claim that he did as he pleased.[13]

Michelangelo's tremendous ambitions revealed themselves in this new scheme. One of the largest assemblies of images ever planned, it would ultimately involve more than 150 separate pictorial units and include more than three hundred individual figures. By rejecting as a "poor thing" the scheme suggested by the pope, he had committed himself to an even more exacting project, one that would pose an enormous challenge even for someone whose fame rested on his ability to execute gigantic works of art.

THE ASSISTANTS

TOWARD THE END of May 1508 a friar in the convent of San Giusto alle Mura, just outside the walls of Florence, received a letter from Michelangelo. Fra Jacopo di Francesco was a member of the Gesuati, a religious order (not to be confused with the Jesuits) founded in 1367. Their convent was one of the most beautiful in Florence, boasting an exquisite garden as well as paintings from the hands of Perugino and Ghirlandaio. It was also a hive of industry. Unlike the Dominicans, who had abandoned manual labor, the Gesuati were dedicated workers. The monks busily distilled perfumes and prepared medicines, and in a room above their chapterhouse they manufactured stained-glass windows in a roaring furnace. These windows were so beautiful and of such high quality that they were sold to churches throughout Italy.

Even more than their stained-glass windows, the friars of San Giusto alle Mura were famous for their pigments. Their colors— their blues in particular—were the best and most sought after in Florence. Many generations of Florentine painters had come to San Giusto alle Mura for their azurite and ultramarine. Leonardo da Vinci was only one of the most recent. His contract for the *Adoration of the Magi,* begun in 1481, included the stipulation that he acquire all of his pigments from the Gesuati and no one else.

Michelangelo seems to have known Fra Jacopo personally. He had probably dealt with the Gesuati a few years earlier when he painted his *Holy Family* for Agnolo Doni, since he used azurite for the sky and, in the robe of the Virgin Mary, a brilliant ultramarine.[1] From Rome, he wrote to Fra Jacopo requesting samples of blue pigments, explaining, "I have to have certain things painted here" and requesting "a certain amount of fine quality azure."[2]

The expression "to have certain things painted" indicates how

Michelangelo was prepared to take a hands-off role in the actual frescoing of the ceiling. His letter to Fra Jacopo shows that at this early stage he considered delegating much of the work on the ceiling to assistants or apprentices, much in the manner of Ghirlandaio. Michelangelo was still hoping to work on the tomb, and to that end he had written himself a memo, soon after his return to Rome, stating that he needed an immediate payment from the pope of four hundred gold ducats, together with regular payments of one hundred ducats a month to follow.[3] These hoped-for ducats were not for the frescoes of the Sistine ceiling but, rather, for the pope's tomb. Remarkably, Michelangelo was still dreaming of the giant sepulchre even at the very moment when Cardinal Alidosi was drawing up the contract for him to fresco the vault. With the tomb project in mind, he had brought with him to Rome a sculptor named Pietro Urbano, who had assisted with the bronze statue in Bologna.[4]

In this same memorandum Michelangelo wrote that he was expecting the arrival from Florence of a number of other assistants—men to whom he may have hoped to delegate the task of painting much of the ceiling. Still, Michelangelo would have required assistance even if he had decided to take a more active role, since painting in fresco always involved teamwork. Besides, not having worked in fresco for almost twenty years, he needed a team of assistants to familiarize him with the various procedures.

By nature a solitary worker, Michelangelo had a strong distrust of assistants, especially after the episode with Lapo in Bologna. He therefore entrusted their recruitment to his oldest friend, a Florentine painter named Francesco Granacci. Michelangelo, who chose his friends with extreme care, respected Granacci's opinions more than anyone else's. "There was no one with whom he was more willing to confer touching his works or to share all that he knew of art at that time," claimed Vasari.[5] Michelangelo and Granacci went back a long way, having both grown up in Via dei Benticcordi, near Santa Croce, and then studied together in Ghirlandaio's workshop and the Garden of San Marco. Granacci, the older of the two, had apprenticed with Ghirlandaio first, and it was on his advice that

Michelangelo also entered the workshop, giving him credit, in a way, for the shape of Michelangelo's career.

Though he had been one of Ghirlandaio's best pupils, by the age of thirty-nine Granacci had failed to fulfill his early promise. While Michelangelo redefined the possibilities of sculpture with one masterpiece after another, Granacci plodded through a series of competent but uninspired panel paintings, most in the style of Ghirlandaio. Eventually, he came to specialize in theatrical scenery, triumphal arches for parades, standards for ships, and banners for churches and knightly orders.

Granacci may have failed to distinguish himself because he was a relaxed, unambitious, and even rather lazy character. "Allowing but few cares to oppress him, he was a merry fellow," reports Vasari, "and took his pleasures with a glad heart."[6] This love of easy living and aversion to physical discomfort are reflected in the fact that he worked almost exclusively in tempera and oil, never in the more difficult medium of fresco.

This lack of desire for glory, together with his carefree spirit, were exactly what Michelangelo found appealing. Threatened by more talented and ambitious artists—by rivals such as Leonardo and Bramante—Michelangelo always felt safe with Granacci, who happily acknowledged his supremacy and, according to Vasari, strove with "incredible attention and humility to be always following that great brain."[7] It was this kind of loyal, unwavering support that Michelangelo required for the Sistine Chapel. He did not need Granacci to help with the fresco itself—that would be left to the other assistants. He wanted him, instead, as his trusted lieutenant, a second in command who would not only recruit and pay the assistants but also supervise Piero Rosselli and aid with various additional duties such as procuring pigments and other supplies.

Granacci showed no signs of his usual laziness when it came to helping his old friend. Soon after Michelangelo arrived back in Rome, Granacci dispatched the names of four painters willing to assist in the Sistine Chapel: Bastiano da Sangallo, Giuliano Bugiardini, Agnolo di Donnino, and Jacopo del Tedesco. They were

Francesco Granacci from Vasari's Le vite di più eccelenti pittori, scultori e architettori.

not painters of the same caliber as the team that had painted the Sistine Chapel's walls a generation earlier, but all were competent and experienced. Not surprisingly, all four came from the Florentine workshops of either Domenico Ghirlandaio or Cosimo Rosselli, meaning they had been well trained in the art of fresco. A number were even veterans of the Tornabuoni Chapel. Most crucially, they had the recent experience with fresco that Michelangelo lacked. All of this, combined with the fact that he had known the four of them for many years, must have reassured Michelangelo.

The first members of the team probably arrived at the workshop in the Piazza Rusticucci at some point in late spring, shortly before Piero Rosselli began removing the old plaster from the vault. However, one of the painters on the list, the youngest member of the group, a twenty-seven-year-old artist and architect named Bastiano da Sangallo, may have been in Rome already. Nicknamed Aristotile because of his supposed resemblance to an antique bust of Aristotle, Bastiano was the nephew of Giuliano da Sangallo, a fact that would have automatically recommended him to Michelangelo. Too young to have studied with Domenico Ghirlandaio himself, who died in 1494, he had trained under the painter's son, Ridolfo, then joined the workshop of one of Michelangelo's rivals, Pietro Perugino.

Bastiano's tenure as one of Perugino's assistants was short-lived. In 1505, while working with Perugino on an altarpiece, he saw Michelangelo's *Battle of Cascina* displayed in Santa Maria Novella. In comparison to the dazzling virtuosity of this cartoon, the work of Perugino suddenly seemed trite and old-fashioned. Perugino's paintings had once been renowned for their *aria angelica et molto dolce*— "angelic air and great sweetness"[8]—but in the violent, muscle-bulging figures of *The Battle of Cascina* Bastiano knew he had glimpsed the future of painting. Entranced by Michelangelo's brave new style, he had abruptly abandoned Perugino's workshop and began copying Michelangelo's cartoon instead. Perugino's commissions in Florence soon evaporated, and a year later, at age fifty-six, he left the city for good—the sweetness and grace of the quattrocento overpowered by the Herculean new forms created by Michelangelo.*

After leaving Perugino's workshop, Bastiano came under the influence of yet another of Michelangelo's rivals. Moving to Rome to live with his brother Giovan Francesco, an architect in charge of quarrying stone and burning lime for St. Peter's, he took up architecture himself. He studied first with Giovan Francesco and then Donato Bramante—ironically, the man whose plan for St. Peter's was accepted over his uncle Giuliano's. Still, the connection to Bramante did not seem to trouble Michelangelo. Since Bastiano did not have as much fresco experience as the other members of the team, Michelangelo may have wanted him precisely for his architectural expertise. An architect would have been helpful, for example, in designing the illusionistic architectural elements that Michelangelo wished to include in his fresco.

Giuliano Bugiardini was another former apprentice from the Ghirlandaio workshop. Exactly the same age as Michelangelo, he

*Bastiano's copy of the central portion of Michelangelo's cartoon also had happier repercussions. Over thirty years later, long after Michelangelo's cartoon had disappeared, Bastiano used his own drawing—on the advice, apparently, of Vasari—to make an oil painting for Francis I, the king of France. It is solely because of this painting (now in Holkham Hall, Norfolk) that anyone knows what *The Battle of Cascina* might have looked like.

was old enough to have worked as an apprentice with Ghirlandaio in the Tornabuoni Chapel. If the underwhelming Francesco Granacci did not threaten Michelangelo, Bugiardini would have worried him even less. He must have been a competent painter if he had trained under Ghirlandaio, but Vasari portrayed him as an inept artist and something of a simpleton, describing how the hapless Bugiardini, while painting a portrait of Michelangelo, placed one of his subject's eyes in his temple. Later, he supposedly spent the better part of a decade racking his brains over the design of an altarpiece showing the martyrdom of St. Catherine, even managing to botch the job after Michelangelo showed him how to foreshorten the figures.

As with Granacci, it was personality more than artistic prowess that may have recommended Bugiardini to Michelangelo. He possessed, Vasari claims, "a certain natural goodness and a sort of simplicity in his mode of living, free from all envy and malice."9 Because of his good nature, Michelangelo called him Beato (happy or blissful), a nickname that might also have been an ironic reference to a considerably more talented (but equally good-humored) Tuscan painter, Fra Angelico, sometimes known as Beato Angelico.

The forty-two-year-old painter named Agnolo di Donnino came from the workshop of Cosimo Rosselli, with whom he had been close friends until Rosselli's death a year or two earlier at the age of sixty-eight. The oldest member of the group, Agnolo may have apprenticed with Rosselli as early as 1480, when he was fourteen, and therefore he might have assisted him on the walls of the Sistine Chapel. Agnolo also had more recent experience in the medium, having executed several frescoes at San Bonifazio, a foundling hospital in Florence. An extremely diligent worker, he constantly reworked his drawings, seldom putting them into execution, with the result that he would eventually die in poverty. He was known as Il Mazziere (the card dealer), a nickname that possibly suggests another reason for his slow work and impecunious death. But it also indicates that, like the pleasure-loving Granacci and the amiable Bugiardini, he was a sociable and convivial character.

The fourth assistant mentioned by Granacci was Jacopo di Sandro, sometimes known as Jacopo del Tedesco, or Jacopo "of the German," which suggests Teutonic blood even though his father had the decidedly Italian name Sandro di Chesello. Jacopo had also been a member of the Ghirlandaio workshop. Little is known of his early career, though he had been active as a painter for at least a decade. Granacci refers to him by his first name only, indicating that he was as well known to Michelangelo as the other men. Unlike the other men, though, he voiced a specific concern about traveling to Rome and assuming the task of assisting in the chapel. "Jacopo," wrote Granacci, "would clearly like to know what he is to be paid."[10]

In fact each man would be paid a lump sum of twenty ducats, ten of which could be kept as compensation if any of them traveled to Rome but, for whatever reason, decided not to assist Michelangelo. The offer was not particularly tempting. Michelangelo had paid Lapo d'Antonio, his assistant in Bologna, a salary of eight ducats per month. Twenty ducats was therefore the amount a qualified artisan could earn in only two or three months. This modest sum suggests that Michelangelo did not intend to employ his assistants for the whole of the project, which would clearly require several years of work at least. Instead, it seems he planned to hire them for only a short duration, consulting with them at the start of the job and then replacing them with cheaper labor once the work had begun.

One can therefore understand Jacopo del Tedesco's concerns. A certain amount of self-sacrifice was required to leave Florence, relinquish the chance of gaining other commissions, relocate to Rome, and work as only one of a number of assistants, all for a fairly humble salary, and possibly for only a very brief period of time.

Yet soon enough Jacopo set aside whatever reservations he had— something that both he and Michelangelo would live to regret—and by the summer of 1508 he and the other assistants were in place. Hard on their heels came Francesco Granacci, arriving to start managing Michelangelo's affairs in Rome.

THE HOUSE OF BUONARROTI

MICHELANGELO INHERITED LITTLE from his father except hypochondria, self-pity, and a snobbish conviction that the Buonarroti were descended from a noble and ancient family. In fact, it was Michelangelo's firm belief that the Buonarroti were direct descendants from the princely house of Canossa.[1] This was no small claim. The house of Canossa boasted as its most illustrious forebear Matilda of Tuscany, the "Great Countess," a wealthy and learned woman who spoke Italian, French, and German, composed her letters in Latin, collected manuscripts, and owned most of central Italy. Married, until his murder, to Godfrey the Hunchback, she lived in a castle near Reggio nell'Emilia and, at her death in 1115, willed all of her vast lands to the Holy See. Later in life Michelangelo would treasure in his archives a letter by which the existing count of Canossa—a considerably less impressive figure than Matilda—craftily confirmed his kinship with the artist, addressing him as "messer Michelle Angelo Bonaroto de Canossa."[2]

As an old man, Michelangelo would claim that his sole aim in life had been to help the house of Buonarroti regain its former eminence. If so, his attempts to restore the family to glory were continually undermined by the antics of his four brothers, and sometimes by those of his father, Lodovico. However, in Lodovico's opinion it was Michelangelo himself who had first threatened to bring the Buonarroti name into disrepute when he decided to become, of all things, an artist. Ascanio Condivi reported that when Michelangelo first began to draw he was "quite often beaten unreasonably by his father and his father's brothers who, being

impervious to the excellence and nobility of art, detested it and felt that its appearance in their family was a disgrace."[3]

Lodovico's horror at discovering an artist in the family is explained by the fact that painting was not considered a suitable occupation for a gentleman. Since they worked with their hands, painters were considered mere craftsmen, enjoying about the same social standing as tailors or boot makers. For the most part they came from humble families. Andrea del Sarto was, as his name suggests, the son of a tailor, while the father of the gold-smith Antonio del Pollaiuolo—as his name also suggests—raised chickens. Andrea del Castagno began life herding cattle, the job at which the young Giotto was supposedly occupied when he was discovered by Cimabue.

It was because of these sorts of associations, then, that Lodovico, so proud of his ancestry, had been unwilling to apprentice his son to a painter, even to one with Domenico Ghirlandaio's reputation. Though Ghirlandaio went on to execute the largest fresco of the quattrocento, he also earned his living by taking on more humble tasks such as painting hoops for baskets.

By 1508, however, it was not Michelangelo but his brothers who were undermining the family reputation, particularly Buonarroto and Giovansimone, aged thirty-one and twenty-nine, respectively. The lowly status of these two brothers, who toiled in the wool shop of Lorenzo Strozzi, was a humiliation to Michelangelo. For the past year he had been promising to buy the pair their own shop. In the interim, he sensibly urged them to learn the trade so that when the time came they could succeed in the enterprise. But Buonarroto and Giovansimone had more ambitious plans: They wanted their older brother to find positions for them in Rome.

It was with this in mind that, in the heat of early summer, Giovansimone headed south for Rome. A year earlier he had hoped to visit his brother in Bologna, but on that occasion Michelangelo had succeeded in putting him off with stories—not entirely exaggerated—of plague and political upheaval. This time it seemed there was no stopping him.

Rome must have presented an enticing prospect to Giovansimone since his older brother was, after all, an intimate of the pope. Still, it is unclear what sort of position he expected Michelangelo to find for him. While Florence had been made wealthy through the wool trade, Rome had no equivalent industry and so there was little work to be found. The city was populated mainly by priests, pilgrims, and prostitutes. Under Julius II it may have become a magnet for artists and architects, but Giovansimone had no experience in these fields, let alone talent. A restless young man, ambitious but erratic, he had trouble applying himself to anything. Unmarried, he still lived in his father's house—to which he contributed precious little toward his keep—and frequently clashed with his father and brothers.

Unsurprisingly, the visit to Rome proved fruitless for Giovansimone and annoying to his older brother. Busy making sketches and other preparations for the Sistine ceiling, Michelangelo could only have found his presence a hindrance. Worse still, Giovansimone had not been long in Rome before he fell seriously ill. Michelangelo feared the young man had come down with the plague. "I think he will soon be returning to Florence, if he does as I advise," he wrote to Lodovico, "because I think the air here does not agree with him."[4] The bad air of Rome would become a convenient excuse for Michelangelo whenever he wished to rid himself of unwanted family members.

Giovansimone eventually recovered from his illness and, at Michelangelo's urgings, returned to Florence. But no sooner had he departed than Buonarroto began making noises about a visit of his own. He had journeyed twice to Rome when Michelangelo was carving the *Pietà* a decade earlier. He must have liked what he saw, since over the next few years he became determined to land a position in Rome—or, rather, to have Michelangelo land one for him. Early in 1506 he had written to his older brother, asking him to "look for an opening" for him. Michelangelo had not been encouraging. "I should not know either what to find or what to look for," he pointedly replied.[5]

Buonarroto, a more trustworthy character than Giovansimone, was Michelangelo's favorite brother. Michelangelo wrote to him more often than to his other brothers, addressing his letters, rather grandly, to "Buonarroto di Lodovico di Buonarrota Simone." While in Rome he wrote home to Florence, on average, every few weeks, usually to either Buonarroto or his father, who carefully preserved the letters, which were invariably signed "Michelangelo, sculptor, in Rome." Since there was no public postal service in Italy, all of these letters were carried privately, either by friends traveling to Florence or on the mule trains that left Rome every Saturday morning. Letters to Michelangelo were delivered not to his workshop but to his bank in Rome, Balduccio's, from where he retrieved them. He valued news from home, frequently berating Buonarroto for failing to correspond more regularly.[6]

Buonarroto was eventually dissuaded from making the journey to Rome because Michelangelo claimed he needed him to look after affairs for him in Florence, including purchasing an ounce of red lake, a pigment made from the fermented root of the madder plant. Buonarroto's dreams of visiting Rome again, like his dreams of owning a wool shop, were put on hold.

Michelangelo's brothers were not the only members of the family to cause him worry in the summer of 1508. In June, he had learned that Francesco Buonarroti, his father's older brother, had passed away. One of the uncles who used to beat Michelangelo after he declared his intention to become a painter, Francesco had not made a particular success of his own life. A money changer by trade, he had run a modest business from an outdoor table beside Orsanmichele and, whenever it rained, from an indoor table in a nearby cloth cutter's shop. He had married a woman named Cassandra around the same time that Lodovico married Michelangelo's mother, after which the

two brothers set up home together with their wives. On Francesco's death, Cassandra suddenly announced that she planned to sue Lodovico and his family for the return of her dowry, which probably amounted to roughly four hundred ducats.*

For Michelangelo, this lawsuit must have felt like a betrayal by someone who had been his surrogate mother, while for his father it came as an unwelcome financial blow. Much as the cash-strapped Lodovico wished to keep the dowry, his sister-in-law had a clear-cut legal right to it.[7] In Florence, as elsewhere, dowries always reverted back to a wife on the death of her husband, enabling the widow to make a second marriage if she wished. Cassandra's age meant she stood little chance of attracting a new husband,[8] so life on her own must have appealed more than that in the Buonarroti household. For the past eleven years she had been the only woman in the Buonarroti home, and with her husband dead she evidently had no wish to remain with her in-laws.

Legal battles over dowries were common, but as widows had the law on their side they almost always won their cases. Lodovico thus informed Michelangelo that, as one of his uncle's heirs, he had to renounce his right to Francesco's estate or else face being made responsible for his debts, including the repayment of Cassandra's dowry, if and when the lawsuit went against them.

Giovansimone's visit and illness, as well as the death of his uncle and the lawsuit of his aunt, were irritating intrusions as Michelangelo attempted to create his design for the vault of the chapel and organize his team of assistants. No sooner had Giovansimone recovered than Michelangelo suddenly found himself with yet another invalid on his hands. Besides Urbano, he had brought with him from Florence an assistant named Piero Basso. Basso, or "Shorty," was a carpenter and jack-of-all-trades who had been a longtime employee of the Buonarroti family.[9] Born of humble

*Lodovico's first wife, Francesca, the mother of Michelangelo, had brought 416 ducats into the marriage. His second marriage, in 1485, brought him a larger dowry of 600 florins.

stock in Settignano, he had worked for many years at the Buonarroti farm, supervising construction work on their house, among various other duties, and in general acting as a steward for Lodovico. Michelangelo brought him to Rome in April to help build the scaffolding and perhaps also to assist Piero Rosselli with clearing the old plaster from the vault. Equally vital were his duties in Michelangelo's workshop, where he served as a household servant, ordering his master's affairs and running various errands.

However, Basso was sixty-seven years old and in frail health. Like Giovansimone, he had found the scorching Roman summer too much to bear and by the middle of July had fallen seriously ill. Michelangelo was distressed not only by Basso's illness but also by the fact that as soon as he was able the old man returned to Florence. Michelangelo clearly felt he had been betrayed by his family's faithful old retainer.

"I must inform you," he wrote in an ill temper to Buonarroto, "that Piero Basso fell ill and left here on Tuesday, whether I would or no. I was put out about it, because I am left alone and also because I'm afraid he may die on the way." He therefore asked his brother to find someone to replace Basso, "because I cannot remain alone, besides which, no one trustworthy is to be found."[10]

Michelangelo was not alone, of course, since Urbano and the four other assistants were in Rome. But he still needed someone to manage his household affairs by performing menial tasks such as buying food, preparing meals, and keeping the workshop running smoothly. Fortunately, Buonarroto found a young boy, whose name history fails to record, to fill the role. It was a common practice for a painter or sculptor to employ such an errand boy in the workshop. Known as a *fattorino,* he would be given food and lodging in lieu of a salary. What is unusual about the child dispatched to Rome is that someone of such tender years should have made the journey. Obviously, Michelangelo's preference for Florentines— and his distrust of Romans—extended as far down the workshop hierarchy as the *fattorino.*

The *fattorino* left Florence a few days before someone else who

was also recruited by Buonarroto. Michelangelo had recently received from a man named Giovanni Michi a letter offering his services and stating that he would be available, if needed, to do anything "useful and honourable." Michelangelo quickly sent Buonarroto a letter, asking him to deliver it to Michi. Buonarroto duly tracked him down, confirmed that he was indeed available for service, and reported that Michi would leave in three or four more days, once he had settled his affairs in Florence.

Little is known about Giovanni Michi. He probably trained as a painter, since in 1508 he was working in the church of San Lorenzo—possibly on frescoes in the north transept—and he certainly had connections in the artistic community in Florence.[11] Unlike the other assistants, though, he was unknown to Michelangelo and, presumably, Granacci.[12] Michelangelo was willing to take a chance on him, however, and so Michi arrived in Rome in the middle of August, completing the team of assistants.

At the end of July, as the ailing Piero Basso departed for Florence, Michelangelo received a letter from his father. Lodovico Buonarroti had clearly learned from Giovansimone something of the hectic working habits, as well as the anxieties, of his talented second-born son. Concerned for his son's health, Lodovico wrote of his regret that Michelangelo had agreed to accept such a gargantuan task. "It seems to me that you work too much," he observed, "and I understand that you are unwell and very unhappy. I wish you could avoid these projects, because when you are worried and unhappy it is difficult to do well."[13]

All of this may have been true, but by now the Sistine project was well under way and could not be "avoided." With the assistants in place, Francesco Granacci returned to Florence to purchase more pigment samples. Before leaving, he paid Piero Rosselli for the last

time. The removal of the old fresco and the plastering of the vault were now complete. In less than three months, Rosselli and his team of workmen had built a scaffold, hacked the plaster from 12,000 square feet of ceiling, and replaced it with a new coat of *arriccio*. The pace at which they had worked was nothing short of phenomenal. With this major task finished, the vault of the Sistine Chapel was ready for painting.

THE FOUNTAINS OF THE GREAT DEEP

FRESCO PAINTING CALLED for numerous preparatory stages, but among the most vital and indispensable were the drawings by which designs were worked out and then transferred to the wall. Before a single stroke of paint could be applied to the vault of the Sistine Chapel, Michelangelo needed to produce hundreds of sketches to establish both the intricate body language of the characters and the overall composition of the various scenes. The poses for many of his figures, including the dispositions of their hands and expressions on their faces, were composed through six or seven separate studies, which means he may have executed over 1,000 drawings in the course of his work on the fresco. These ranged from tiny scribbles—thumbnail sketches called *primo pensieri,* or "first thoughts"—to dozens of highly detailed, larger-than-life cartoons.

Michelangelo's drawings for the ceiling, fewer than seventy of which survive, were done in a variety of media, including silverpoint. This method, which Michelangelo had learned in Ghirlandaio's workshop, involved drawing with a stylus on paper whose surface was specially prepared with thin layers of white lead and bone dust (made from table scraps) mixed together and bound with glue. The roughened surface of the paper scraped from the stylus small deposits of silver which rapidly oxidized, leaving behind fine gray lines. Since this was a slow and precise medium in which to work, for more rapid sketches Michelangelo used both charcoal and bister, the latter a brown pigment prepared from soot and applied with either a quill or a brush. He also made more careful drawings in red chalk, or hematite, a new medium whose use had been pioneered a decade earlier by Leonardo da Vinci in his

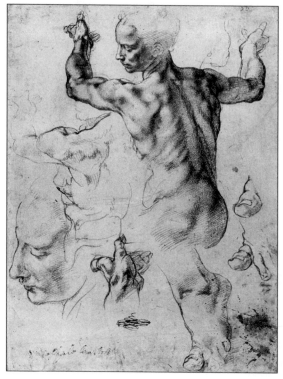

One of Michelangelo's sketches for the Libyan sibyl done in red chalk.

studies for the apostles in *The Last Supper.* Its brittleness was perfect for small, finely detailed drawings, and its warm color provided an expressive range that Leonardo exploited to great effect in the faces of his apostles, and that Michelangelo would use with equally dazzling virtuosity to show the gradations of tone along anatomically exact knots of muscle.

Michelangelo worked on the first of these sketches as Piero Rosselli prepared the vault. He seems to have finished his first stage of drawing around the end of September, after working on his designs for four months, exactly the same amount of time he had spent sketching plans for the much smaller *Battle of Cascina.* By this point he had probably made drawings for, at most, only the first few scenes. His habit for the Sistine Chapel would be to produce sketches and cartoons only as he needed them—that is, only at the last possible minute. After making designs for and then frescoing one part of the ceiling, he would go back to the drawing

board—quite literally—and begin making sketches and cartoons for the next.[1]

By the first week of October Michelangelo was finally ready to paint. At this point a rope maker named Domenico Manini, a Florentine working in Rome, received a payment of three ducats for rope and canvas delivered to the Sistine Chapel. Suspended beneath the scaffold, the canvas would perform the vital task of preventing paint from dripping onto the chapel's marble floor. Even more important, from Michelangelo's point of view, the sheet of canvas would prevent anyone on the floor of the chapel from seeing the work in progress. He may well have been suspicious of public opinion, since stones had been thrown at *David* after it was removed from his workshop near the Duomo. In 1505 his cartoon for *The Battle of Cascina* was executed amid great secrecy in his room in Sant'Onofrio, from which all but the most trusted friends and assistants were banned. Presumably, the same sort of regime prevailed in the workshop behind the Piazza Rusticucci, with no one privy to the drawings except his assistants and, perhaps, the pope and the master of the sacred palace. Michelangelo intended the fresco to remain a mystery to the people of Rome until, in his own good time, he decided to unveil it.

To begin their work each day, Michelangelo and his assistants climbed a forty-foot ladder until, reaching the top of the windows, they mounted the lowest planks of one of the bridges. The steps of the scaffold took them another twenty feet to its top. Railings may have been erected to protect them from a fall, while the sheet of canvas served another welcome purpose: screening the sixty-foot drop beneath the scaffold. Scattered about the decks would have been the tools of their trade: trowels, pots of paint and brushes, as well as buckets of water and bags of sand and lime that had been winched onto the scaffold. Illumination came from the windows as well as from the torches that Piero Rosselli's men had used as they labored late into the evening. A few feet above the men's heads curved the vault of the chapel, an immense, grayish white expanse awaiting their brushes.

The first task on any day was, of course, the application of the *intonaco*. The ticklish matter of mixing the plaster was probably left to one of Rosselli's men. Painters knew from their apprenticeships how to make and spread plaster, but in practice most of the work was done by a professional plasterer, or *muratore*, not least because making plaster was a disagreeable chore. For one thing, the quicklime was so corrosive that it was sprinkled on corpses to hasten their decomposition and therefore lessen the stench around churchyards. Also, it was hazardous when slaked, since calcium oxide generated a tremendous heat as it expanded and then disintegrated. This task was vital, because if the quicklime was not properly slaked it could damage not only the fresco but also—such was its corrosive power—the stonework of the vault.

Once the calcium hydroxide had formed, the job became merely toilsome. The mixture needed to be stirred with a spade until the lumps were gone and a paste or putty had formed. The paste was kneaded and mixed with sand, after which more stirring was required until an ointmentlike consistency was achieved; further stirring was then needed to prevent cracks and crevices from appearing when the plaster was left to stand.

The *intonaco* was applied with a trowel or float to the area specified by the artist. After spreading it, the plasterer wiped the fresh plaster with a cloth, sometimes one in which a handful of flax was tied. This removed the marks of the trowel and roughened the wall slightly so the paint would adhere. The *intonaco* was then wiped again, this time more gently with a silk handkerchief in order to remove grains of sand from the surface. An hour or two after it was spread—time enough to transfer the designs from the cartoons—the *intonaco* formed a skin on which the paint could be applied.

In these early days, Michelangelo must have acted something like a foreman, delegating tasks to his various assistants. At any one time there could have been five or six men on the scaffold, a couple grinding pigments, others unfurling cartoons, still others at the ready with paintbrushes. The scaffold seems to have provided a commodious and convenient place for all of them to work. As it

was clear of the vault for the whole of its span by about seven feet, it allowed them to stand erect as they worked. Applying the *intonaco* or spreading the paint simply required them to lean backward slightly and extend their arms upward.

Contrary to myth, then, Michelangelo did not fresco the ceiling while lying prone on his back—a picture lodged as solidly in the public mind as the equally inaccurate one of Sir Isaac Newton sitting under the apple tree. This misconception stems from a phrase in a short biography of Michelangelo titled *Michaelis Angeli Vita*, written in about 1527 by Paolo Giovio, the bishop of Nocera.[2] Describing Michelangelo's posture on the scaffold, Giovio used the term *resupinus*, which means "bent backward." But the word has frequently—and erroneously—been translated as "on his back." It is difficult to imagine how Michelangelo and his assistants could have worked under such conditions, let alone how Rosselli's men might have cleared 12,000 square feet of plaster while lying flat on their backs in a narrow crawl space. Michelangelo was to encounter numerous obstacles and inconveniences as he worked on the fresco. The scaffold, however, was not one of them.

Michelangelo and his team painted, for the most part, from east to west, starting near the entrance and moving toward the sanctum sanctorum, the western half reserved for the members of the Papal Chapel. But they did not begin in the space immediately above the entrance, rather some fifteen feet to the west, on a portion of the ceiling above the second set of windows from the door. Here Michelangelo planned to paint the apocalyptic episode described in the Book of Genesis, chapters six to eight: Noah's Flood.

Michelangelo began with *The Flood* for a number of reasons, first and foremost, perhaps, for its inconspicuous location. His lack of experience in fresco made him wary of starting with a more promi-

nent scene, one more likely to strike the visitor's eye as he or she entered or, more critically, that of the pope as he occupied his throne in the sanctum sanctorum. Second, this scene was one for which he no doubt had some enthusiasm, given that his previous work—most notably *The Battle of Cascina*—had already prepared him for it. It was with this scene in mind that in the middle of August he had sent money to Florence to purchase the azure ordered from the Gesuati monks in San Giusto alle Mura—pigments which he would use to color the rising floodwaters.

Michelangelo's *Flood* illustrates the story of how, soon after the Creation, God began to regret having created humankind. Because of their determined wickedness, he decided to destroy everyone except Noah, the "just and perfect man," a farmer who had reached the ripe old age of six hundred. He instructed Noah to build from gopher wood a boat three hundred cubits long, fifty cubits wide, and three stories high, with one window and one door. Into this vessel went a pair of every type of living creature, together with Noah's wife, sons, and daughters-in-law. Then, the Bible records, "the fountains of the great deep burst forth."[3]

Obvious similarities to the figures and actions in *The Battle of Cascina* suggest that this earlier work was still very much in Michelangelo's mind when he planned *The Flood.* Indeed, a number of poses from *The Battle of Cascina* repeat themselves, with some variation, in this later scene.[4] It made perfect sense for Michelangelo to draw upon his previous experiences when he came to design the ceiling in 1508, given that *The Battle of Cascina* had created such a sensation three years earlier, and given that recycling a few of these earlier poses meant a slight reduction in an enormous workload. Michelangelo also reused figures from another of his previous works, since one of the characters in *The Flood*—the nude man trying to board the small, overcrowded boat—holds exactly the same jackknifed pose as one of the warring figures in *The Battle of the Centaurs,* carved over fifteen years earlier.

Like these two other works, Michelangelo's *Flood* is crowded with human bodies. It portrays a bleak, windswept waterscape in

which dozens of nudes—men, women, and children—beat a retreat from the deluge. Some make their way in orderly fashion to a patch of high ground on the left of the panel; others shelter beneath a fluttering, makeshift tent on a rocky island; and still others, equipped with a ladder, do their best to storm the ark. The ark itself is in the background, a rectangular wooden vessel with a pitched roof and a window from out of which leans the bearded, red-robed Noah, seemingly oblivious to the calamity that surrounds him.

Although *The Flood* gave Michelangelo the chance to indulge to the full his passion for throngs of doomed figures in dramatic, muscle-straining poses, he also added more homely touches in the shape of people rescuing humble possessions. One of the women balances on her head an upturned stool laden with loaves of bread, pottery, and a few pieces of cutlery, while, nearby, two naked men carry bundles of clothing and a frying pan. Michelangelo would no doubt have witnessed similar scenes of evacuation whenever the Tiber or the Arno flooded. Having no embankments, the Tiber routinely burst its banks, deluging the surrounding areas under several yards of water in a matter of hours. Michelangelo himself had firsthand experience of salvaging possessions from floodwaters when, in January 1506, heavy rains overflowed the Tiber, submerging a cargo of marble he was unloading from a barge at the port of Ripa, two miles downstream from the Vatican.

Despite the expertise of the assistants, work on the fresco does not seem to have begun well, for no sooner had the panel been completed than a large part of it had to be redone. Corrections, known quaintly as *pentimenti* (repentances), always presented a frescoist with serious problems. Someone working in oil or tempera simply painted over his errors, but the frescoist was not able to repent so easily. If he realized the mistake before the *intonaco* dried, he could scrape the plaster from the wall, apply it afresh, and resume work; otherwise he was forced to take his hammer and chisel to the dried plaster and remove the whole of the *giornata*—which is precisely what Michelangelo did. Or, rather, he removed a

dozen or more *giornate,* destroying more than half of the scene—including the whole of the left-hand side—and started anew.[5]

The reasons for the destruction of a good part of this scene are unclear. Michelangelo may have been unhappy with his design for the figures on the left-hand side, or he may have changed or refined his fresco technique after a few weeks on the job. But since this act involved taking a hammer to almost a month's work, it must have been disheartening to all concerned.

The only part of the fresco left intact after the obliteration was that showing the group huddled fearfully under their tent on the rock. These figures are therefore the earliest surviving part of the ceiling. They are the work of many hands, showing how at this early stage Michelangelo made full use of his assistants, though it is uncertain exactly who painted which part of the fresco. The only bit of *The Flood* Michelangelo is known for certain to have painted himself is the pair of figures on the edge of the rock: the sturdy old man grasping in his arms the lifeless body of a young man.

Repainting the left-hand side of the fresco took a total of nineteen *giornate.* Allowing for feast days and Masses, this work must have been spread over almost four weeks, taking the team toward the end of November, dangerously close to the time when cardinals reached for their fur-lined hoods, and fresco painters, if the weather worsened, were obliged to put away their brushes for weeks on end.

Work on *The Flood* had proceeded at a frustratingly slow pace. Not counting the destroyed work, the scene took, in all, twenty-nine *giornate.* These *giornate* were relatively small, averaging less than seven square feet, or roughly one-third of a typical day's work in the Tornabuoni Chapel. Even the scene's largest *giornata* was a mere five feet long by three feet high, still well under the average of Ghirlandaio's workshop.

One reason for this slow rate, besides Michelangelo's inexperience, was the sheer number of human figures in *The Flood.* Frescoing the human form was more time-consuming than a landscape, especially for someone who used elaborate, unusual poses and strove for anatomical accuracy. Faces, especially, demanded attention. The

quicker method of making incisions in the cartoon—that is, trac-
ing its outlines onto the plaster with a point of a stylus—could be
used for a scene's larger and less explicit details, such as arms, legs,
and draperies. But frescoists almost always transferred facial fea-
tures from cartoons through the more precise but slower technique
of *spolvero*, which involved sprinkling charcoal onto the plaster
through the perforations in the cartoon's outlines. Curiously, how-
ever, when painting *The Flood*, Michelangelo and his team used
spolvero everywhere, forsaking incision entirely,[6] even though win-
ter was fast approaching.

Floods always had a blunt meaning for Michelangelo. An intensely
pious man, he never failed to view violent meteorological events as
punishments from a wrathful God. Many years later, after autumnal
rains had flooded both Florence and Rome, he would comment
woefully that the catastrophic weather had lashed the Italians "on
account of [their] sins."[7] One source for this fire-and-brimstone
pessimism—and an inspiration behind his depiction of *The Flood*—
was a figure from his impressionable youth, the Dominican friar
Girolamo Savonarola.

Probably best known as the man who ignited the "bonfire of the
vanities," the incineration of a sixty-foot-high pile of "vanities" and
"luxuries" in the middle of the Piazza della Signoria,✝ Girolamo
Savonarola came to Florence from Ferrara in 1491, at the age of
thirty-nine, to serve as the prior of the Dominican convent of San
Marco. Under Lorenzo de' Medici, Florence celebrated the ancient
cultures of Greece and Rome. Plato was translated and studied, the
university taught Greek, preachers quoted Ovid from the pulpit,

✝There were in fact two of these *brucciamenti della vanità*: one on the seventh of
February 1497, and another on the twenty-seventh of February in the following year.

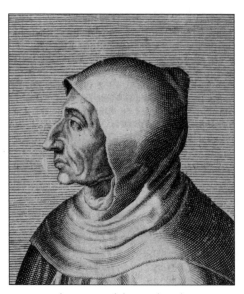

Girolamo Savonarola by Esme de Boulonois.

the populace frequented Roman-style bathhouses, and artists such as Sandro Botticelli depicted pagan rather than religious subjects.

These classical splendors and obsessions offended Savonarola, who believed this mania for the antique world was turning the young men of Florence into sodomites. "Abandon, I tell you, your concubines and your beardless youths," he thundered from the pulpit. "Abandon, I say, that abominable vice that has brought God's wrath upon you, or else woe, woe to you!"[8] His solution to the problem was a simple one: Sodomites should be burned along with the vanities. And by *vanities* he meant not only chessboards, playing cards, mirrors, fancy clothing, and bottles of perfume. He also exhorted the people of Florence to throw onto his bonfire their musical instruments, tapestries, paintings, and copies of books by Florence's three greatest writers: Dante, Petrarch, and Boccaccio.

The adolescent Michelangelo was soon under the spell of this fanatic, whose sermons he would reread throughout his life. Savonarola was a man for whom, Condivi wrote, Michelangelo "always had great affection," and decades later he claimed he could still hear the friar's voice.[9] Lean and pale, with black hair, intense green eyes, and thick eyebrows, Savonarola had held all of Florence in his thrall in the spring of 1492 as he preached hair-raising ser-

mons from the pulpit of Santa Maria del Fiore, recounting blood-curdling visions in which daggers and crosses appeared to him in the thunderous, darkened sky above the city. The message of these visions was crystal clear: Unless the Florentines mended their ways, they would be punished by a wrathful God. "O Florence, O Florence, O Florence," he cried like one of the Old Testament prophets to which he was always comparing himself, "for your sins, for your brutality, your avarice, your lust, your ambition, there will befall you many trials and tribulations!"[10]

As it happened, the friar's prophecy was fulfilled in due course. Two years later, bent on claiming the throne of Naples for himself, Charles VIII of France had swept across the Alps with an army of more than 30,000 men. Savonarola compared this massive invasion force—the largest ever to set foot on Italian soil—to the waters of a great flood. "Behold," he cried from the pulpit on the morning of the twenty-first of September 1494, "I shall unloose waters over the earth!" Comparing himself to Noah, he cried that if the people of Florence wished to escape these floodwaters they needed to take refuge in the Ark—the cathedral of Santa Maria del Fiore.

The impact of this sermon on the people of Florence was electric. "So full of terrors and alarms, cries and lamentations" were Savonarola's sermons, wrote one observer, "that everyone went about the city bewildered, speechless and, as it were, half-dead."[11] Their fearful demeanors earned the friar's followers the nickname Piagnoni, or "Snivelers." The Medici were soon expelled from Florence, and in November Savonarola's "Scourge of God"—the short, scrawny, hook-nosed, ginger-bearded Charles VIII—entered the city on horseback. Charles stayed for eleven pleasantly hospitable days before departing for Rome to confront Pope Alexander VI, a man whose decadence made that of Florence pale in comparison. As if on cue, the city was flooded by the Tiber—proof of the Lord's displeasure with the Romans.

The flood was therefore an evocative image for Michelangelo, a potent reminder not of the power of nature but of the wrathful God

of the Old Testament that Savonarola's sermons had brought so vividly to life. These sermons would influence a number of other images on the ceiling and may even have been behind the switch in the fresco's subject matter from a New Testament theme—the Twelve Apostles—to a series of Old Testament stories, some of which featured in the friar's most scarifying harangues.[12] For the previous two centuries, Italian artists had concentrated mainly on New Testament subjects such as the Annunciation, the Nativity, the Assumption, and so forth—gentle, elegant scenes telling reassuringly optimistic stories of God's grace and humankind's salvation through Christ. Except for his own most famous New Testament subject, the *Pietà*, as well as his Madonna-and-Child reliefs and panels, Michelangelo had displayed little interest in such motifs. He was fascinated, instead, by tragic, violent narratives of crime and punishment such as those—complete with hangings, plagues, propitiations, and beheadings—that he was soon to fresco on the vault of the Sistine Chapel. And these turbulent visions of a vengeful God, doomed sinners, and prophets crying in the wilderness were undoubtedly part of Savonarola's legacy.[13]

Savonarola's story ended tragically, with all of the flames, wrath, and retribution of one of his sermons. He had earlier written a book, *Dialogo della verità profetica,* in which he claimed that God still sent prophets to walk the Earth as in the days of the Old Testament, and that he, Fra Girolamo, was just such an oracle. He believed his visions to be the products of angelic intervention, and his sermons and dialogues explained how his gloom-and-doom predictions had supposedly been fulfilled by recent historical events. These prophecies became his downfall since according to the Church's official line the Holy Spirit spoke to the pope alone, not to rabble-rousing friars from Ferrara. In 1497 Alexander VI therefore ordered Savonarola to stop preaching and prophesying, eventually excommunicating him when he failed to do so. When the friar continued stubbornly to preach even while under excommunication, he was tortured and then, in May 1498, hanged in the middle of the Piazza della Signoria. His corpse was, ironically, incinerated in a bonfire, and the ashes dumped into the Arno.

Michelangelo had been in Carrara at this time, quarrying marble for the *Pietà*. However, he would have learned of Savonarola's fate soon enough, not least from his older brother Lionardo, a Dominican priest who had visited him in Rome soon after the execution, and who had been defrocked because of his devotion to Savonarola. While the *Pietà*, with its dead Christ cradled in the arms of the Virgin, was a supreme example of the redemptive Christianity of the New Testament,[14] a decade later, as he started work in the Sistine Chapel, Michelangelo was able to give a freer rein to the more apocalyptic imagination shaped by Savonarola.

COMPETITION

AS MICHELANGELO AND his assistants commenced work on their fresco, the pope was busy with affairs of state. Since his return from Bologna in 1507, Julius had been hatching schemes for further conquests. He may have successfully retrieved Perugia and Bologna, but the Venetians still had their hands on territories that he considered the property of the Church. Hoping to resolve the situation peacefully, he had sent his great advocate, Egidio da Viterbo, to Venice to request the return of Faenza. However, not even Egidio's flawless eloquence could persuade the Venetian senators to hand back their ill-gotten gains. The Venetians had further trodden on the pope's toes by appointing their own bishops. Even worse, they had provided a safe haven for the leaders of the Bentivoglio clan from Bologna, flatly refusing to turn them over to the pope. Julius fumed at these insults. "I will never rest," he bellowed at the Venetian envoy, "until you are brought down to be the poor fishermen that you once were."[1]

The Venetians had made other enemies even more powerful than the pope. The republic's various landgrabs over the previous few years had also alienated the French, who, like Julius, wanted the return of their former fiefs, including cities such as Brescia and Cremona. Julius did not trust Louis XII, the king of France, whose territorial ambitions in Italy were clearly worrying to the Church. But if the Venetians remained intransigent, Julius made it clear, he would make an alliance with the French.

However, fierce politicking did not prevent the pope from attending to more personal matters, namely the decoration of his private apartments. Since his election, Julius had done his best to blot the hated Borgia name from history. He had struck Alexander VI's name from all documents in the Vatican, shrouded the portraits of the Borgias in black, and ordered the opening of the dead pope's tomb

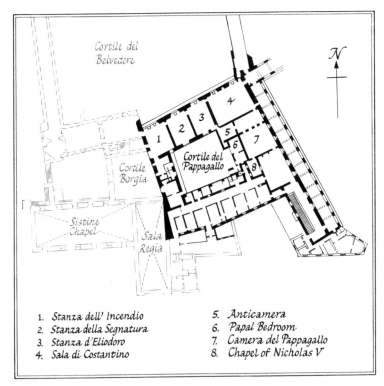

1. Stanza dell' Incendio
2. Stanza della Segnatura
3. Stanza d'Eliodoro
4. Sala di Costantino
5. Anticamera
6. Papal Bedroom
7. Camera del Pappagallo
8. Chapel of Nicholas V

A plan by Reginald Piggott of the apartments on the
third floor of the Vatican Palace.

and the shipping of his remains back to Spain. It would therefore have
come as no surprise when, in November 1507, he made it known that
he no longer intended to use as his official residence the set of apart-
ments on the second floor of the Vatican previously occupied by
Alexander. His Holiness could "no longer live there," Paride de' Grassi
reported, "in the presence of that wicked and criminal memory."[2]

These rooms, in the north wing of the palace, had been deco-
rated a dozen years earlier by Pinturicchio, who had covered the
walls and ceilings with stories from the Bible and the lives of the
saints, including St. Catherine, the model for whom was the blond-
haired Lucrezia Borgia. Since Pinturicchio had also portrayed both
Alexander and the Borgia coat of arms everywhere on the walls,
the decor of the apartments was offensive to Julius. Paride sug-
gested that the frescoes should be chipped from the walls, but the
pope protested that such desecration was not proper.[3] Instead he

planned to move upstairs, to the third floor of the palace, into a suite of intercommunicating rooms offering even more stunning views of Bramante's new Cortile del Belvedere. These apartments—which would include an audience hall and a library—were therefore in need of decoration.

When, in 1504, Piero Soderini had hired Michelangelo as Leonardo's sparring partner in the Hall of the Great Council, he was perhaps hoping that a little healthy competition might force Leonardo, a notorious procrastinator, to complete his work on time.[4] The pope may have resorted to a similar sort of tactic with Michelangelo in 1508. Whatever the case, no sooner had Michelangelo begun painting in the Sistine Chapel than he learned that work was commencing on another major project only a short distance away. Four years after his contest with Leonardo in Florence, Michelangelo was again plunged into open competition.

Michelangelo's new competitors made a formidable team. Determined, as always, to hire only the best craftsmen, the pope had assembled the most daunting group of frescoists seen in Rome since Pietro Perugino led the team that decorated the walls of the Sistine Chapel. Perugino was in fact a member of this new group, which included at least a half-dozen other highly experienced frescoists, such as Pinturicchio, whose authorship of the offending frescoes in the Borgia apartments did not deter Julius, and the 58-year-old Luca Signorelli, another veteran of the wall frescoes in the Sistine Chapel.

Michelangelo must have recognized that these men possessed expertise that no one on his team—least of all he himself—could hope to match. The competition was further sharpened by Michelangelo's hatred for Perugino. A few years earlier, in Florence, the pair had traded public insults, their feud eventually becoming so heated that they were summoned to appear before the Otto di Guardia, Florence's criminal magistracy.[5] Even more alarming to Michelangelo was the fact that this team of painters had been recruited for the pope by Donato Bramante, who was on close personal terms with them, having been responsible for bringing a number of them to Rome and launching their careers.[6]

The other painters on Bramante's team were less familiar to Michelangelo, but they too had solid reputations. They included Bartolomeo Suardi, who was called Bramantino (Little Bramante) in honor of his former master, and a thirty-one-year-old Lombard named Giovanni Antonio Bazzi, nicknamed Sodoma. Bramantino's skill was especially renowned. Forty-three years old, he could paint figures so realistic that it was said they lacked nothing but the powers of speech. The team also had an international flavor, with a Dutch artist named Johannes Ruysch and a Frenchman, Guillaume de Marçillat, best known as a designer of stained-glass windows. Another member was a promising young Venetian painter named Lorenzo Lotto, who had arrived in Rome a short while earlier.

This Vatican team must have undertaken their task with more enthusiasm and fewer trepidations than Michelangelo, since the total surface area to be frescoed in the four rooms was less than half that awaiting Michelangelo's brush in the Sistine Chapel. Furthermore, as the ceilings were less than thirty feet from the floor, the job was easier from a logistical point of view. Bramante no doubt designed their scaffolds and, in doing so, presumably enjoyed greater success than he had in the Sistine Chapel. More important, he also designed the mythological and religious scenes for the vaults, which were to be painted in dazzling colors.[7]

Bramante involved himself in this major project in one further and ultimately even more significant respect. Scarcely had work in the rooms begun than early in the new year yet another of the architect's protégés, the youngest member of the team, started worked on the Vatican frescoes. He was the new boy wonder of Italian painting, a prodigiously gifted twenty-five-year-old named Raffaello Santi.

Raffaello Santi—or "Raphael," as he signed his paintings—would have been known to Michelangelo from his growing reputation in

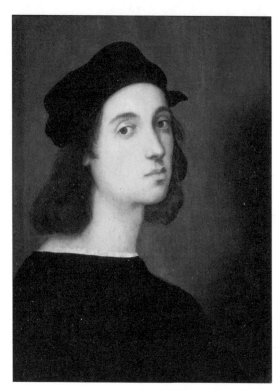

Self portrait by Raphael.

Florence. The most promising and ambitious member of the Vatican team, he came from Bramante's hometown of Urbino, a hilltop city seventy-five miles east of Florence. Unlike Bramante, who was the son of a farmer, he had enjoyed a privileged upbringing. His father, Giovanni Santi, had been court painter to the duke of Urbino, Federigo da Montefeltro, a wealthy and sophisticated patron of the arts. Giovanni died when Raphael was eleven, leaving him to serve his apprenticeship under Evangelista di Pian di Meleto, who had been Giovanni's assistant. Evangelista was a mediocre artist, but the boy's genius was not long in showing itself. He earned his first commission at seventeen, when he was hired to paint an altarpiece for the church of Sant'Agostino in Città di Castello, a small fortified town twenty-five miles from Urbino.[8]

Raphael's precocious talents soon came to the attention of a more acclaimed painter than Evangelista. In about 1500 Perugino was preparing for the sizable task of frescoing the Collegio del

Cambio, the guildhall of bankers and moneylenders in his home-town of Perugia. Always one for spotting gifted young assistants, Perugino had trained, among others, the young Pinturicchio, who aided him in the Sistine Chapel. Another of his helpers had been an apprentice from Assisi named Andrea Luigi, known because of his dazzling skills by the enviable nickname L'Ingegno (the Genius). After Andrea's promising career was brought to a tragic halt when he went blind, Perugino must have been thrilled with the discovery of another young prodigy from the hills of Umbria.✝

Perugino seems to have invited Raphael to Perugia to work with him in the Collegio del Cambio,9 after which the city's two feud-ing families, the Baglioni and the Oddi, were soon vying with each other to commission work from the talented young artist. Their savageries proved good for business. Madonna Maddalena, matri-arch of the Oddi clan, hired Raphael to paint an altarpiece for a family funeral chapel that housed the bones of some of the 130 men slaughtered by the Baglioni a decade earlier. No sooner had he finished this piece than the matriarch of the Baglioni clan asked for an "Entombment," which she intended to hang in the church of San Francesco in atonement for the sins of her son who, in the bloodbath known as the "Scarlet Wedding"—a ghastly carnage even by the odious standards of Perugia—had slain four members of his own family in their beds after a nuptial celebration.

But Raphael was in search of more exalted patrons than the warring clans of Perugia, and more renowned masters than Perugino. In 1504 he was assisting Pinturicchio with the frescoes for the Piccolomini Library in Siena when he learned that Leonardo and Michelangelo were frescoing the walls of the Palazzo della Signoria. He promptly abandoned Pinturicchio and headed north to Florence, hoping to study the works of the two older artists and

✝The precise details of Raphael's training and apprenticeship are a matter of speculation among art historians, in particular where, and from whom, he learned perspective construction. Since his ability to construct perspective schemes dra-matically surpasses Perugino's, critics have been led to suppose the presence of another teacher as well.

seek his fortune among Europe's most vibrant and discerning artistic community.

To make his mark in Florence, Raphael needed to come to the attention of Piero Soderini, the head of the republican government. He therefore decided to exploit his late father's connections with the Montefeltro family by asking Federigo's daughter, Giovanna Feltria, for a letter of recommendation. No commissions were forthcoming from Soderini, but over the next four years Raphael was much in demand in Florence, painting numerous works for a host of wealthy merchants. Most of these pictures were variations on the Madonna and Child theme, showing the pair with a goldfinch, a lamb, in a meadow, under a canopy, between a pair of saints, and so forth—a series of sweetly impassive Madonnas fondly observing shy, frolicsome Christ Childs. He likewise proved himself adroit at what had been his father's specialty, painting a series of amazingly lifelike portraits of prominent Florentines, among them Agnolo Doni, the wool merchant and collector of antiquities who, a year earlier, had commissioned the *Holy Family* from Michelangelo.

Despite all of this work, Raphael still dreamed of a major commission from Soderini, something along the lines of the awe-inspiring projects with which Leonardo and Michelangelo had been entrusted in the Hall of the Great Council. In the spring of 1508, therefore, he once again tried to pull some strings, asking his uncle to obtain from Giovanna Feltria's son, Francesco Maria, a letter to Soderini requesting that Raphael be allowed to fresco a wall in the Palazzo della Signoria. Though not explicit about the commission, Raphael may have hoped to complete one of the two abandoned frescoes in the Hall of the Great Council, perhaps even both.* If so, it was a bold request that revealed the mammoth scale of the young painter's aspirations. With a few small exceptions,

*He might also have wished to complete the frescoes in the Sala dei Gigli, begun by Perugino, Ghirlandaio, and Botticelli immediately after their work in the Sistine Chapel, but never finished.

almost all of his own works had been done on panel, in either tempera or oil. Like Michelangelo, he did not have a great deal of experience with fresco, only a stellar reputation in another medium. Though he had worked on frescoes with both Perugino and Pinturicchio, his only solo work had been done in about 1505, when he began decorating a wall of the Lady Chapel in the monastery of San Severo in Perugia. Work appears to have gone well, but after about a year of sporadic work he left the fresco incomplete. His reasons for doing so remain a mystery. However, decorating one wall of a chapel in a tiny church belonging to an obscure order of monks in the backwater of Perugia was not the distinguished sort of work he craved.

Raphael's new petition to Soderini produced no better result than Giovanna Feltria's four years earlier, perhaps due to Tuscan jingoism. Soderini, a Florentine patriot, would hardly have wished to let an artist from beyond the borders of Tuscany, no matter how talented, adorn the walls of the political headquarters of the Florentine republic.[10]

The lack of a large public commission in Florence ceased to matter so much, however, when the pope began taking an interest in the young artist. Raphael could have come to Julius's attention in a number of ways. Since Giovanna Feltria was married to Julius's brother, he may have learned of Raphael through either her or his nephew, Francesco Maria. However, it is equally possible that Bramante was the first one to mention the brilliant young painter from his hometown.[11] The architect was even said by Vasari to be Raphael's kinsman.

Whatever the case, in the autumn of 1508 Raphael was summoned to Rome, where Bramante quickly became his close ally and faithful supporter. Taking lodgings near St. Peter's, in the Piazza Scossa Cavalli (the Square of the Riderless Horses), a stone's throw from Michelangelo's workshop, Raphael prepared to start work on exactly the kind of prestigious commission that had eluded him in Florence.[12]

A Great Quandary

AFTER HEAVY AUTUMN rains, Rome was whipped in the new year by the *tramontana*, the frigid north wind that was reputed to bring fatigue and depression to Italy along with the cold. More unfavorable conditions for painting a fresco could hardly be imagined, but Michelangelo and his team pressed on, eager to finish *The Flood*. However, in January disaster struck when both a fungus and an efflorescence of salt appeared on the surface of the fresco, obscuring its figures so badly that they could barely be distinguished. "I am in a great quandary," Michelangelo wrote to his father after this efflorescence appeared. "My work does not seem to go ahead in a way to merit anything. This is due to the difficulty of the work and also because it is not my profession. In consequence, I lose my time fruitlessly."[1]

Michelangelo and his assistants had made the worst possible start. The salts crystallizing on the surface of the fresco at such an early stage of the project did not bode well, obviously, for the rest of the task. The damage was most likely the result of calcium nitrate, known as wall or lime saltpeter. Generally caused by damp, calcium nitrate was a scourge of the frescoist. The salts carried in any rainwater that managed to penetrate the vault would leach their way through the plaster, dissolving the crystals of calcium carbonate and causing the pigments to blister and flake. Occasionally, there were more macabre infiltrations than rainwater. The floods that regularly swamped Florence and Rome would soak the ground under churches, releasing the saltpeter produced by decomposing corpses, then carrying it to the painted surfaces of the walls, where it ate like a cancer into the frescoes.

Painters went to great lengths to prevent their frescoes from being attacked by damp and, therefore, by salts and nitrates. Giotto

was well aware of the danger when he painted the facade of the Camposanto in Pisa. Because the facade was turned to the sea, he knew it would face the full might of the sirocco, which blew sea salt onto the surface. He tried to overcome the problem by mixing pounded brick into both the *arriccio* and *intonaco,* but this measure proved fruitless and soon the *intonaco* began scaling off. Sometimes frescoists would try to waterproof their work by attaching reed mats to the walls, then covering them with the *arriccio.* Buffalmacco, a younger contemporary of Giotto, used these mats in his *Triumph of Death* on the Camposanto in order to protect it from the salt breezes—but this expedient only hastened the disintegration of the plaster. Buffalmacco was a chilling exemplum for the frescoist. A master whose skills were praised by Boccaccio and Ghiberti, he proved so unlucky in preserving his frescoes from the elements that not one of them now survives.

Michelangelo appears to have used a different method to safeguard his fresco against damp. He and his assistants made their *intonaco* not with sand but by mixing the lime with the volcanic ash known as pozzolana. Although common in Roman building work, pozzolana was probably a bit of an unknown quantity to Michelangelo's team of Florentines, given that Ghirlandaio, like most Tuscan frescoists, had made his plaster with sand instead of ash. But Michelangelo may have chosen pozzolana for its special properties. This blackish ash from Mount Vesuvius was the key to the large vaults and domes of the ancient Romans—and the reason that so many of them survived more or less intact for well over 1,000 years. By mixing volcanic ash into their mortars, Roman builders had created strong, swift-setting concretes that were almost impervious to water. While conventional plasters gained strength only when the lime reacted with carbon dioxide in the atmosphere, pozzolana added a further ingredient to the mix, a compound of silica or alumina. These acted directly on the calcium oxide independent of its contact with the atmosphere, resulting in a rapid bond that could even set underwater.

Pozzolana should, then, have made for a plaster ideally suited to

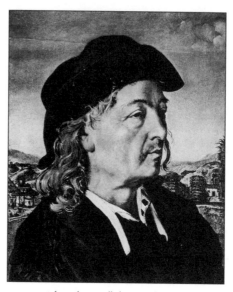

Giuliano da Sangallo by Piero di Cosimo.

the wet weather of Rome as the *tramontana* swept down from the Alps. But something had clearly gone awry.

The problem seemed to the frustrated Michelangelo a final proof of his inability to carry out the task. He even used the efflorescence as a convenient excuse to throw down his brushes and quit work. "Indeed I told Your Holiness that this is not my art," he informed the pope. "What I have done is spoiled. If you do not believe it, send someone to see."[2]

Julius duly dispatched the architect Giuliano da Sangallo to the Sistine Chapel. His concerns possibly extended beyond Michelangelo's fresco. He may have suspected a serious problem with the chapel's roof, perhaps even a recurrence of the flaw that damaged Piermatteo's fresco a few years earlier and threatened the stability of the entire chapel.

Sangallo was the man in charge of inserting the twelve iron rods that, in 1504, temporarily arrested the movement of the south wall of the chapel. He was therefore a natural choice to examine the vault in 1509. But the pope sent him for another reason as well, since Sangallo was one of the few people in Rome whom Michelangelo trusted. With the artist now threatening to quit work, Julius knew that Sangallo was probably the only person able to mollify him.

Damp may well have infiltrated the Sistine Chapel because of problems with its roof, since renovations were needed a few years later, in 1513, when 130 square feet of roofing were replaced.[3] But the problem, as Sangallo saw it, was simpler. Although born and trained in Florence, he had lived and worked for many years in Rome. Having carried out repairs on the Castel Sant'Angelo and built several churches as well as a huge palace for Julius, he knew far more than Michelangelo about Roman building materials. The lime for the *intonaco* in the Sistine Chapel had been made from travertine, a whitish limestone quarried near Tivoli, twenty miles east of Rome. As unfamiliar with travertine as they were with pozzolana, Michelangelo's crew of Florentines had used large amounts of water to slake the quicklime and, once the pozzolana was added, to make the mixture plastic enough for spreading. However, whereas pozzolana cured quickly, travertine dried much more slowly. Michelangelo and his assistants, in their ignorance, had been applying the plaster when it was still too wet. The salt efflorescence was not so much the result of foreign water infiltrating the vault, therefore, as it was of these copious quantities added by the assistants—an error that Sangallo taught the team to correct.

The other complication confronting Michelangelo—the appearance on the vault of mildew—raised a different issue. The mildew was probably concentrated in those places where the pigments were spread, after the plaster had dried, with the help of a fixative like glue or oil. Unlike a painter in tempera or oil, a frescoist would, of course, normally dilute his pigments with nothing but water. Binding agents were superfluous for the simple reason that the pigments, sealed fast in plaster, needed no further adhesives.

Sometimes, however, a frescoist would be tempted to paint *a secco* (in the dry), that is, to mix his pigments with a fixative and add them to the plaster after it had dried. The benefit of painting *a secco* was that it allowed for a wider range of colors, especially the brighter, mineral-based pigments such as vermilion, ultramarine, and verdigris. The frescoist's palette was somewhat restricted because a good many of these bright colors could not withstand the corrosive activity of the

lime-rich *intonaco*. For example, the blue pigment azurite, sometimes called "German blue," gradually turned green after coming into contact with the moisture in the plaster—a phenomenon that explains the number of green skies found in frescoes. Even more drastic was what happened to ceruse, or lead white, which would oxidize and turn black, transforming highlights into shadows, snow-white robes into black, pale skin into dark, and so forth—an inversion that made the fresco into a sort of negative of itself.

A frescoist wanting to use bright colors like azurite or verdigris therefore added them to the fresco only after the *intonaco* had dried. This method had a major drawback, however. Because the glues and gums used as fixatives were not as tenacious as the rock-hard *intonaco,* the *secco* touches were always the first to perish. Giorgio Vasari warned of the dangers of this technique, pointing out that "the colours become clouded by that retouching and in a short time turn black. Therefore let those who desire to work on the wall work boldly in fresco and not retouch *a secco,* because, besides being a very poor thing in itself, it renders the life of the pictures short."[4]

By Michelangelo's time, painting exclusively in *buon fresco*—that is, without any *secco* additions whatsoever—was imperative for any artist who wished to showcase his virtuoso talents and test the limits of his art. Patrons often demanded the more durable *buon fresco* for their commissions. Ghirlandaio's contract with Giovanni Tornabuoni, for example, decreed that the frescoes in Santa Maria Novella should be done entirely in *buon fresco,* a condition expertly fulfilled by the workshop.[5] However, even though Michelangelo was lucky enough to have on his team a number of painters trained by Ghirlandaio in this virtuoso technique, he and his assistants used a large number of *secco* touches when they frescoed *The Flood.*[6] And as anyone with wallpaper knows, molds and mildews tend to grow on binding agents exposed to damp—precisely the problem that beset the team of painters in the Sistine Chapel. These molds needed to be removed immediately; otherwise, like the salts, they would destroy the fresco. Sangallo duly showed Michelangelo how to deal with the fungus, after which the artist was ordered to con-

tinue his work.[7] Michelangelo was not to be released from his obligations in Rome quite so easily.

The episode of the salt efflorescence and the outbreak of mildew may have led Michelangelo to take a jaundiced view of his assistants. The story goes that, dissatisfied with their work, he dismissed the lot of them soon after starting the project, then heroically carried on by himself. The man largely responsible for this myth, his biographer and friend Giorgio Vasari, relates how one day Michelangelo locked the door of the chapel on his helpers as they arrived for work, refusing them entry. "And so, when the jest appeared to them to be going too far," Vasari wrote, "they resigned themselves to it and returned in shame to Florence."[8] Michelangelo then went on to paint the ceiling, as Condivi puts it, "without any help whatever, not even someone to grind his colors for him."[9]

This story is every bit as appealing—and every bit as farfetched—as the one that claims Michelangelo frescoed the vault while lying flat on his back. It is unlikely that the event described by Vasari ever actually happened, much less at such an early stage, when Michelangelo needed all the help and expertise he could get.[10] It is true that none of the Florentine assistants was present for the whole of the Sistine Chapel project. They had been hired by Granacci on the understanding, implicit in their lump-sum payments of twenty ducats each, that Michelangelo would release them from service when he no longer needed their help. And in time they would indeed be replaced by a team of lesser-known artists. But their departure from Rome, when it eventually came, was neither as dramatic nor as ignominious as Vasari made it, especially since most of them stayed on friendly terms with Michelangelo for years to come.

At this point, though, one of Michelangelo's assistants did leave Rome under a cloud, since Jacopo del Tedesco departed for Florence at the end of January, never to return. Michelangelo was not sorry to see him go. "He was in the wrong a thousand times over and I have every reason to complain about him," he seethed in a letter to Lodovico, warning his father not to listen to anything that Tedesco might say against him.[11] He was concerned that the disgruntled assistant would traduce his reputation in Florence, as Lapo and Lotti had done a few years earlier. Following their sacking in Bologna, the two goldsmiths had gone straight to Lodovico with their complaints, causing him to chastise his son. Michelangelo was keen to prevent Tedesco from tarnishing his name with a similar pack of lies. "Turn a deaf ear and leave it at that," he instructed his father.

One of Tedesco's faults was that he complained about the shabby accommodation in the workshop behind Santa Caterina. Even though he himself had grumbled about exactly the same situation in Bologna, Michelangelo had scant sympathy for Tedesco. The assistant's problem seems to have been that he was altogether too much like the perpetually malcontent Michelangelo.

Tedesco may well have had a point about his living conditions in Rome. Besides working side by side on the scaffold, the men were living together in the grim hospitality of the workshop near the Piazza Rusticucci, where conditions were almost as cramped as they had been in Michelangelo's quarters in Bologna. Tucked away in a narrow backstreet beneath the looming city wall, close by the swamplike moat of the Castel Sant'Angelo, and hemmed in by the teams of masons and carpenters at work on both St. Peter's and the Cortile del Belvedere, the studio cannot have provided the men with a pleasant or restful atmosphere. And their spirits would not have been helped by heavy rains that pelted Rome throughout the autumn and winter, threatening a real-life flood.

Though undoubtedly convivial at times, life in the workshop must have been frugal, industrious, and devoid of all but the simplest comforts. Michelangelo might well have believed the

Buonarroti to be descended from princes, but he himself did not live like a prince. Quite the opposite. "Ascanio," he once proudly boasted to his faithful apprentice, "however rich I may have been, I have always lived like a poor man."[12] He was indifferent, for example, about his food, taking it "more out of necessity than for pleasure,"[13] and often fortifying himself with nothing more than a piece of bread and some wine. Sometimes he would eat his humble dinner as he worked, chewing on a crust of bread as he sketched or painted.

Worse than Michelangelo's frugality was his personal hygiene, or lack thereof. "His nature was so rough and uncouth," wrote Paolo Giovio in his biography of the artist, "that his domestic habits were incredibly squalid, and deprived posterity of any pupils who might have succeeded him."[14] There is no reason to doubt that Michelangelo faithfully followed his father's advice. "Never wash yourself," Lodovico urged his son. "Allow yourself to be rubbed, but don't wash yourself."[15] Even Condivi was forced to admit that Michelangelo had some disgusting habits after witnessing how he "often slept in his clothes and in the boots which he has always worn . . . and he has sometimes gone so long without taking them off that then the skin came away like a snake's with the boots."[16] This sight was disconcerting even in an age when people changed their clothes and went to the public baths, at most, only once a week.

Perhaps even worse was Michelangelo's antisocial behavior. He was, of course, a man capable of friendship and camaraderie. The Florentine assistants had been brought to Rome for the very reason that they were long-standing friends and acquaintances whose company he enjoyed. But often Michelangelo did not want the society of others, since he was by nature a solitary and melancholic character. Condivi admits that Michelangelo won himself a reputation, as a young man, for being *bizzarro e fantastico* because he "withdrew from the company of men."[17] According to Vasari, this aloofness was not arrogance or misanthropy so much as a necessary prerequisite to creating great works of art, since artists, he claimed, should "shun society" in order to devote themselves to their studies.[18]

What was beneficial for Michelangelo's art was not, however, quite so good for his personal relations. One of his friends, Donato Giannotti, told the story of how he invited Michelangelo to dinner only to be rebuffed by the artist, who wished to be left to himself. Giannotti persevered with his invitation, arguing that Michelangelo should allow himself the pleasure of an evening's entertainment as an antidote to the cares and worries of the world. Still Michelangelo refused, musing gloomily that he had no desire to be cheered up since the world was a place of tears.[19] Another time, however, he accepted a friend's invitation to dinner because, as he put it, "my melancholy—or perhaps better, my madness—left me for a while."[20] He then discovered, much to his astonishment, that he actually enjoyed himself.

Fortunately for Michelangelo, by the time of Tedesco's departure he already had another assistant on hand, one who was as different from Tedesco as could be imagined. Sometime late in the autumn of 1508 yet another alumnus of the Ghirlandaio workshop had joined the team, a thirty-two-year-old named Jacopo Torni, known as Indaco (Indigo). A competent if unspectacular painter, Indaco was attractive to Michelangelo because, like Granacci and Bugiardini, he was a loquacious, happy-go-lucky character whom Michelangelo had known for the better part of two decades. Indaco was, in fact, one of Michelangelo's closest friends. "No one was more pleasing to him," Vasari writes, "or more suited to his humour, than this man."[21]

Michelangelo must have been delighted to exchange the one Jacopo for the other—the surly, griping Tedesco for the jovial and fun-loving Indaco. However, despite his affability, Indaco was actually a less than ideal choice for the Sistine Chapel. He had first come to Rome a decade earlier to work with Pinturicchio on the frescoes in the Borgia apartments that so offended Julius. Since then he had painted frescoes of his own in the church of Sant'Agostino, near the Piazza Navona. But lately his output had been shamefully slight. "Jacopo worked for many years in Rome," Vasari wrote, "or, to be more precise, he lived many years in Rome, working very little."[22]

Even by the standards of the work-shy Granacci, Indaco was a notorious shirker, never working "save when he could not help it."[23] All work and no play, Indaco declared, was no life for a Christian.

Though this philosophy of life may have lightened the mood in the studio or on the scaffold, especially at a time when the work was going so badly, it hardly seemed the most befitting doctrine for a man expected to help Michelangelo fresco 12,000 square feet of vault for an obstreperous and demanding patron such as Julius II.

THE FLAYING
OF MARSYAS

IF MICHELANGELO WAS slovenly and, at times, melancholy and antisocial, Raphael was, by contrast, the perfect gentleman. Contemporaries fell over themselves to praise his polite manner, his gentle disposition, his generosity toward others. Even the poet and playwright Pietro Aretino, a man known for his vicious character assassinations, could not find a bad word to say about him. Raphael, he wrote, lived "like a prince rather than a private person, bestowing his virtues and his money liberally on all those students of the arts who might have need of them."[1] A Vatican bureaucrat named Celio Calcagnini enthused that Raphael, despite his formidable talents, "is far removed from any kind of arrogance; indeed, his behaviour is friendly and courteous, nor does he reject any advice, or refuse to listen to an expression of opinion."[2]

Giorgio Vasari, who did not know him personally, also praised Raphael's flawless character. He observed (no doubt with an eye to Michelangelo) that until Raphael came along most artists showed "a certain element of savagery and even madness."[3] Vasari attributed Raphael's sweet, civilized nature to the fact that he was breast-fed by his mother, Magia Ciarli, instead of being sent to a wet nurse in the country. A wet nurse, Vasari believed, would have exposed him to "the less gentle and even boorish ways and habits in the houses of peasants or common people."[4] Suckled by his own mother, Raffaello Santi grew into such a saintly figure that it was said even the animals loved him—a legend that recalls another equally angelic character from the Umbrian hills, St. Francis of Assisi, likewise said to have charmed the birds and animals. Added to Raphael's appealing personality were his good looks: a long neck, oval face, large eyes, and

olive skin—handsome, delicate features that further made him the antithesis of the flat-nosed, jug-eared Michelangelo.[5]

While Michelangelo was sorting out the problems with *The Flood,* Raphael was establishing himself in the Vatican apartments. He was put to work not with either of his old mentors, Perugino or Pinturicchio, but in a room with Giovanni Antonio Bazzi. The two made an unlikely pair, since Bazzi was, if anything, even more *bizzarro e fantastico* than Michelangelo. He possessed ample fresco experience, having just spent five years on a large cycle on the life of St. Benedict in the monastery of Monte Oliveto, near Siena, and he was the favored artist of the wealthy Chigi family of bankers. However, he was more famous as a flamboyant eccentric than for his work with a paintbrush. Foremost among his numerous oddities was the zoo he kept in his house, which included badgers, squirrels, monkeys, bantam hens, and a raven that he taught to speak. He also sported garish clothing, such as brocaded doublets, necklaces, rich caps, "and other suchlike fripperies," sniffed Vasari, "fit only for clowns and charlatans."[6]

Bazzi's oddball antics had flabbergasted the monks of Monte Oliveto, who took to calling him Il Mattaccio (the Maniac). To the rest of the world he was known as Sodoma (Sodom). This nickname was given to him, Vasari claimed, because "he had about him boys and beardless youths, whom he loved more than was decent."[7] Why Bazzi alone should have earned this sobriquet is a bit of a mystery considering the sexual preferences of the average Renaissance painter. In Rome the punishment for sodomy was burning at the stake, so it is unclear how Sodoma could have survived, let alone flourished, had he indeed been the flagrant sodomite his name suggests. Whatever the case, far from objecting to this nickname, he reveled in it, "writing about it songs and verses in terza rima, and singing them to the lute with no little facility."[8]

The room assigned to Raphael and Sodoma was a few steps away from Julius's bedroom. Later in the sixteenth century, after seeing use as the seat of the papal tribunal known as the Signatura Graziae et Iustitiae, the room came to be called the Stanza della

Segnatura. Julius intended to use it, however, as his private library.[9] He was no bookworm, but even so he had managed to amass a respectable collection of 220 volumes. Known rather grandly as the Bibliotheca Iulia, these treasures were in the care of the learned humanist scholar Tommaso Inghirami, who also oversaw the much larger holdings of the Vatican Library.[10]

The style in which libraries were decorated had been standard since the Middle Ages. Raphael would have been familiar with the scheme from, among other examples, Federigo da Montefeltro's library in Urbino. Each of the four subjects into which the books were divided—theology, philosophy, justice, and medicine—were represented by an allegorical female figure on the wall or ceiling. The painter usually also added portraits of men and women who had won acclaim in these particular fields. The design for the Stanza della Segnatura faithfully followed this tradition, although poetry replaced medicine, no doubt because of Julius's preference for poets over doctors. Each wall was devoted to a scene illustrating one of the faculties, while above them, on the vault, four corresponding goddesses were to be framed inside the sort of geometric pattern of circles and squares that Julius had originally planned for the Sistine Chapel's ceiling.[11] The books themselves, meanwhile, would occupy rows of cases on the floor.

This particular design was settled before Raphael arrived in Rome, and Sodoma had already made a start on the vault by the time Raphael joined him. However, the exact division of labor during the early stages of the decoration in the Stanza della Segnatura is as ambiguous as the early stages of work in the Sistine Chapel. Vasari claimed in his biography of Sodoma that the eccentric artist's preoccupation with his zoo meant work on the vault did not proceed to the satisfaction of the pope, who then drafted Raphael. Whatever the case, Raphael started work on the rectangular panels in the corners of the Stanza della Segnatura, ultimately painting three out of four of them.[12] Each of these panels is a modest three and a half feet wide by four feet tall, an area that would take an experienced frescoist a single *giornata*.

The first of these panels shows the *Temptation in the Garden,* an

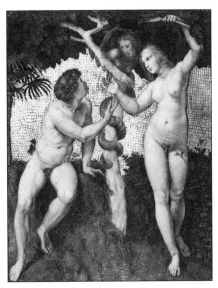

Raphael's The Temptation, *from the ceiling of the Stanza della Segnatura.*

episode with which Raphael would have been familiar from, among other places, Masolino's rendering of it in the Brancacci Chapel in Florence. In Raphael's depiction, Eve offers the tiny fruit to Adam while the serpent, wrapped around the trunk of the tree of knowledge, watches from behind a branch. In keeping with misogynistic medieval tradition, the serpent is a woman, complete with long hair and bare breasts—a sort of mermaid with coils instead of fins.

More interesting than the serpent, though, is the figure of Eve herself. The scene gave Raphael the opportunity to fresco a pair of nude figures, the standard by which all great artists were judged. Naked but for some strategically placed shrubbery, his Eve stands with her hips turned in one direction, her shoulders in the other, and her weight resting on her right foot, causing her left side to elongate and her right to contract. This asymmetrical pose, known as *contrapposto* (placed opposite), was revived from antiquity a century earlier by sculptors like Donatello who contrasted the hip and shoulder axes of their figures to create an illusion of bodily movement. Raphael could have seen Donatello's *St. Mark,* a famous early example, in its niche on the outside of Orsanmichele in Florence. However, his Eve was inspired not by Donatello but by the work of another artist whose influence, for the past four years, had loomed over him like a colossus.

Raphael's sketch of Leonardo's
Leda and the Swan.

When Raphael moved to Florence in 1504 to witness the fresco contest between Michelangelo and Leonardo, he had, like every other aspiring artist in Florence, made sketches of the two monumental cartoons when they were displayed together in Santa Maria Novella. But it was Leonardo rather than Michelangelo who seemed, at this point, to inspire him most, and he studied Leonardo's style even more closely than he had Perugino's a few years earlier. He was clearly influenced not just by *The Battle of Anghiari,* for very quickly motifs from Leonardo's other drawings and paintings appeared in his own. Leonardo's cartoon for *Virgin and Child with St. Anne,* first displayed in Florence in 1501, taught him to balance his composition and allow for a compact and ordered group by arranging his figures in a pyramid. Each of the numerous Madonna and Child combinations that Raphael painted during his time in Florence explores the permutations of this design so exhaustively that one art critic has labeled them "variations on a theme by Leonardo."[13]

Likewise, from the *Mona Lisa,* probably painted about 1504, Raphael took the pose for a number of his Florentine portraits.

Portraits usually featured their subjects in profile, possibly in imitation of the silhouettes on antique medals and coins. But Leonardo painted La Gioconda more or less face-on, with her hands folded and an aerial perspective of an eerie landscape in the background—a pose whose sheer iconic familiarity tends to blind modern viewers to its originality. Raphael duplicated this pose almost exactly when he painted a portrait of Maddalena Strozzi, the wife of Agnolo Doni, in 1506.

About the time of the *Mona Lisa* Leonardo executed another masterpiece in Florence, one that has long since been lost. *Leda and the Swan* was transported to France soon after completion, then burned 150 years later, supposedly on the orders of Madame de Maintenon, the second wife of Louis XIV. The redoubtable madame, who was reforming the morals of the court in Versailles by, among other unpopular measures, banning opera during Lent, objected to what she regarded as the indecency of Leonardo's work. Indecent or not, the painting (which is known through copies) was one of Leonardo's rare nudes: a naked, *contrapposto* Leda with her hands on the swan's straining neck.

Though wary of the younger generation of artists, Michelangelo in particular, Leonardo seems to have allowed Raphael access to a number of his drawings, possibly because of the young artist's association with his great friend Bramante.✝ At any rate, Raphael somehow saw, and made a sketch of, Leonardo's cartoon for *Leda and the Swan,* which he then used to generate his pose for Eve in the Stanza della Segnatura. Raphael's Eve is actually a mirror image, rather than a direct copy, of Leonardo's Leda, a common trick used by artists to disguise an otherwise familiar image.

✝No evidence suggests that Raphael and Leonardo ever actually met, either in Florence or elsewhere, though opportunities existed as early as 1502, when Leonardo toured Umbria as Cesare Borgia's military engineer.

The last of the four rectangular panels on the ceiling of the Stanza della Segnatura, *Apollo and Marsyas,* was painted, most art historians agree, by Sodoma rather than Raphael. A tale of artistic competition, it was an apt subject for Rome in the winter of 1508–9—and an apt subject, as it transpired, for Sodoma.

The story of the musical duel between Marsyas and Apollo is told by Herodotus and Ovid, among numerous others. It is one of a grotesque mismatch, of an underdog challenging an opponent with vastly superior powers. While Apollo was the god of, among other things, music, archery, prophecy, and medicine, Marsyas was a silenus, one of a race of ugly, satyrlike creatures that artists usually portrayed with donkey's ears.

According to myth, Marsyas took up the flute after finding the one invented by Athena, who hoped to imitate the keening wail of the Gorgons as they mourned the dead Medusa. The flute had captured the sad sound, but the vain goddess threw it away after catching sight of her unflattering reflection in the water as she puffed a melody. Marsyas soon became so confident and expert on her flute that he challenged Apollo, on the lyre, to a duel. This was a rash act given that Apollo once murdered his own grandson, Eurytus, for daring to challenge him to an archery contest. Apollo agreed to the competition, adding the grisly clause that the winner should be allowed to do whatever he pleased to the loser.

The outcome was all too predictable. With the Muses serving as judges, both Apollo and Marsyas played so beautifully that no winner could be declared until Apollo craftily turned his lyre upside down and continued to play, an act the silenus was unable to duplicate on his flute. The victorious Apollo then took his due, hanging Marsyas from a pine tree and viciously flaying him alive. As the woodland creatures wept at his cruel death, their tears became the River Marsyas, a tributary of the Meander, down which bobbed the flute until it was plucked from the water by a shepherd boy. The shepherd had the good sense to dedicate the instrument to Apollo, who was also the god of flocks and herds. Marsyas's skin, meanwhile, became a museum piece, having sup-

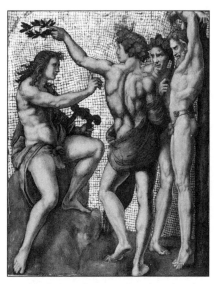

The Flaying of Marsyas *by Sodoma, from the ceiling of the Stanza della Segnatura.*

posedly been exhibited in ancient times at Celaenae, in present-day Turkey.

The myth was given various interpretations over the centuries. For Plato, in the *Republic,* the story showed how the dark, unruly passions aroused by the flute were vanquished by the calmer tones of the Apollonian lyre. Christian moralists were no more sympathetic to Marsyas, seeing in the contest a parable for how overweening human pride was quite rightly swatted down by an effortlessly superior being.

Sodoma's scene depicts the moment of Apollo's victory. The god receives the laurels and tut-tuts the defeated silenus with a wagging index finger. Marsyas is already bound to a pole, and one of Apollo's henchmen stands at the ready, holding a knife under the loser's nose, eagerly awaiting his cue.

The irony of his own situation as he painted the scene cannot have been lost on Sodoma, who had suddenly found himself playing the part of the underdog as he worked side by side with the immensely talented Raphael. For the painters in the Vatican were not only in competition with Michelangelo and his team in the Sistine Chapel; they were also, it transpired, competing against one another. As Leonardo and Michelangelo had discovered, patrons

often arranged contests among their teams of frescoists. To give another example, when Perugino and his team frescoed the walls of the Sistine Chapel in the 1480s, Pope Sixtus IV decided to award a prize to the artist whose work he deemed the best—giving it, ironically, to Cosimo Rosselli, usually considered the weakest of the lot.

The terms of the competition in the Vatican were somewhat harsher than those imposed by Sixtus. Like a number of the other artists, Sodoma had been paid fifty ducats as an advance on his work in the room.[14] Since this sum amounted to a payment for roughly six months' work, he must have been aware that his contract might not be renewed, and that the pope was pitting him against Raphael, as well as the other artists, to find among Bramante's recruits the frescoist most capable of doing justice to the rooms.

Sodoma, like Marsyas, was vanquished soon enough. *Apollo and Marsyas* was the last scene he would paint in the Vatican Palace, for sometime early in 1509 he was relieved of his duties, supplanted for the simple reason that Raphael had proved himself more proficient in both design and execution. While Sodoma resorted to numerous *secco* touches, the younger and less experienced artist showed himself skillfully in command of the *buon fresco* technique.[15]

Sodoma was not alone in his dismissal from the Vatican. Perugino, Pinturicchio, Bramantino, Johannes Ruysch—the rest of the team were likewise removed from the commission, their half-finished frescoes destined to be scraped from the walls to make room for the creations of Raphael. So impressed had the pope been with Raphael's work in the Stanza della Segnatura that from then on the young painter from Urbino would be in charge of decorating the apartments, bringing him into even sharper confrontation with Michelangelo.

True Colors

PIETRO PERUGINO MAY have been past his best when, like Sodoma and the rest of the team, he was unceremoniously relieved of his duties in the Vatican. Nonetheless, he had been the most prominent member of the team that frescoed the walls of the Sistine Chapel some thirty years earlier. While neither Ghirlandaio nor Botticelli really did justice to himself in the chapel, Perugino positively excelled, executing an undisputed masterpiece—and one of the finest frescoes of the fifteenth century—on the north wall of the chapel. *The Giving of the Keys to St. Peter* was therefore a scene against which Michelangelo knew his own work on the vault would inevitably be measured.

Found thirty feet directly beneath *The Flood, The Giving of the Keys to St. Peter* is one of the six scenes from the life of Christ that decorate the north wall of the Sistine Chapel. It illustrates the episode from Matthew 16:17–19 in which Christ confers unique priestly powers on St. Peter, making him the first pope. Perugino portrayed a blue-robed Christ handing the "keys to the kingdom of heaven"—a symbol of the papacy—to his kneeling disciple. The pair are surrounded by the other disciples in the middle of a huge, Renaissance-style piazza that features an octagonal temple and two triumphal arches in the background, all represented in flawless perspective. A subtle piece of papal propaganda, Perugino's fresco portrays Peter in the colors of the Rovere clan, blue and gold, thus emphasizing that Pope Sixtus IV, the patron of the work, was one of Peter's successors.

Such was the regard for Perugino's fresco that, soon after its completion, it assumed a mystical significance. The Sistine Chapel was—and still is—used for conclaves to elect a new pope, when rows of small wooden cubicles were constructed on the floor, turn-

ing the chapel into a kind of a dormitory. Inside these small cells
the cardinals could eat, sleep, and scheme. The cubicles were
assigned by lottery a few days in advance of the conclave, and cer-
tain of them were held to be luckier than others. Particularly aus-
picious was the cell beneath *The Giving of the Keys to St. Peter,* probably
because of its subject matter.[1] There may have been something to
the superstition, given that in the conclave beginning on the
thirty-first of October 1503, the cardinal who drew the cell
beneath Perugino's fresco was Giuliano della Rovere.

Michelangelo climbed past Perugino's masterpiece—and past
scenes by Ghirlandaio, Botticelli, and the rest of the team—each
time he ascended the ladder to his scaffold. And one thing that
must have struck him about these scenes was the brilliance of their
pigments. Plenty of gold and ultramarine had been used in the
frescoes, making for an array of splendid—even somewhat gaudy—
color. Sixtus IV had been so dazzled by Cosimo Rosselli's use of
these pigments, it was said, that he ordered the other artists to fol-
low his example in creating scintillating displays.

According to Vasari, Michelangelo was determined to show
that "those who had painted there before him [i.e., in the Sistine
Chapel] were destined to be vanquished by his labors."[2] Ordinarily,
he had contempt for those who used great splashes of color in their
paintings, condemning "those simpletons, of whom the world is
full, who look more at a green, a red or similar high colour than at
the figures which show spirit and movement."[3] Acutely aware,
however, that these same simpletons would compare his own work
to that of Perugino and his team, he seems to have made a com-
promise, using an abundance of ravishing color on the vault of the
chapel.

This dramatic use of pigment would be especially pronounced
in the case of the spandrels and lunettes, that is, the areas above
and around the chapel's windows, which are closest to the walls.
With *The Flood* finished sometime early in 1509, Michelangelo did
not yet backtrack toward the door, since he was evidently still leery
of working on the more conspicuous sections of the ceiling.

Instead, as would become his habit throughout the painting of the vault, after completing the central panel with its episode from Genesis he painted the scenes lateral to it.[4]

Michelangelo planned to illustrate the spandrels and lunettes with portraits of the ancestors of Christ, the biblical characters listed in the opening verses of the New Testament as the descendants of Abraham and forebears of Christ. Each pictorial field would be frescoed with several figures, both male and female, adult and child, making for a series of family groups whose identities are suggested by nameplates on the lunettes. These portraits were destined to appear just inches above the spaces between the windows where Perugino and his team had frescoed portraits of thirty-two popes—one of which even wears a robe with orange polka dots—in a full spectrum of gorgeous, vivid color. Michelangelo planned to dress the ancestors of Christ in the same sort of bright costumes. Eager not to let his own work be overshadowed by an older generation of artists, he needed to find top-quality pigments.

An artist was, of course, only as good as his paints. Some of the best and most famous pigments came from Venice, the first port of call for ships returning from the markets of the Orient with exotic materials like cinnabar and ultramarine. Painters would sometimes arrange with their patrons to travel to Venice in order to fetch the necessary colors. Pinturicchio's contract for the frescoes in the Piccolomini Library had set aside two hundred ducats for this purpose.[5] The cost of travel to Venice would be offset by the fact that pigments could usually be bought more cheaply there due to reduced transport and distribution costs.

Michelangelo, however, typically chose to get his pigments from Florence. Ever the perfectionist, he fretted about their quality. Sending his father money to buy an ounce of red lake, he stipulated

that the color "must be of the best obtainable in Florence. If there is none of the best quality to be got, then do not get any at all."[6] This kind of quality control was essential because many expensive pigments were adulterated with cheaper ones. Anyone buying vermilion, a pigment made from cinnabar, was advised to purchase it by the lump rather than as a powder, since powdered vermilion was often cut with minium, a cheaper alternative.

It was natural that Michelangelo should have looked to his hometown rather than Venice, where he had few if any contacts. There were some forty painters' workshops in Florence[7] and, to feed them with pigments, numerous monasteries and apothecaries. The most famous dealers of pigments were, of course, the Gesuati friars. But a visit to San Giusto alle Mura was not always necessary to find colors. Painters in Florence were members of the Arte dei Speziali e Medici (the Guild of Apothecaries and Doctors). The logic behind putting artists in this particular guild was that apothecaries sold the ingredients for numerous pigments and fixatives, since many of them doubled as medicines. Gum tragacanth, for instance, was prescribed by doctors for coughs, hoarseness, and weals on the eyelids, but it was also widely used by painters to suspend their pigments. And besides its use in red lake, the root of the madder plant was also promoted as a cure for sciatica. A comical overlap between pigments and medicines is found in an anecdote about the Paduan artist Dario Varatori, who was once painting a fresco while being under the care of his doctor. Taking his draft of medicine to work, Varatori sniffed the concoction, then promptly dipped his brush into the bottle and began slathering the solution onto the wall—apparently without harming either the fresco or his health.[8]

The manufacture of pigments was a tricky and highly specialized business. For example, one of the colors produced by the Gesuati friars—and used by Michelangelo for the sky and waters of *The Flood*—was *smaltino,* a pigment made from pulverizing glass tinted with cobalt. Making *smaltino* was messy and even dangerous, since cobalt was both corrosive and, because it contained arsenic, poison-

ous. (Such was its toxicity that one of its other uses was as an insecticide.) However, the Gesuati friars, whose stained glass was famous throughout Europe, were skilled in handling cobalt. They would roast the ore in a furnace (hence the name *smaltino,* or "smelt") and then add the resulting cobalt oxide to molten glass. Having colored the glass, the friars would crush it to make pigment. This powdered glass is visible if a work painted with *smaltino* is examined in cross section under a microscope. Even a fairly low magnification reveals both splinters of glass and tiny air bubbles.

Purchased by artists in an unrefined state, pigments such as *smaltino* needed to be specially prepared in the studio before they could be added to the *intonaco.* Condivi's declaration that Michelangelo ground his pigments himself is extremely dubious, since preparing pigments was a task that always called for several hands. In Michelangelo's case, it also called for the advice and expertise of his assistants. Like most of his helpers, he had learned these tricks of the trade at the feet of Ghirlandaio. But as almost twenty years had passed since he used many of the pigments needed for the Sistine ceiling, the experience of men like Granacci was essential.

The type of preparation varied for each pigment. Some were pulverized into fine powders, others left in coarser grains, still others heated, dissolved in vinegar, or repeatedly washed and sieved. Since the tone of the pigment depended, like the taste of coffee, on the grind, it was vital to find the right consistency. For example, if *smaltino* was coarsely ground, it produced a dark blue, while a finer grind yielded a much paler tone. Moreover, if left coarse-grained, the *smaltino* needed to be added while the plaster was still wet and therefore adhesive. For this reason, it was always the first color applied, though a second coat might be added a few hours later to darken it. Such tricks could spell the difference between the success or failure of a fresco. Not having used *smaltino* in his only recent encounter with a paintbrush, his *Holy Family,* Michelangelo must have leaned heavily on his assistants when the time came to prepare it.

Most of the other pigments used on the Sistine ceiling were somewhat simpler to prepare.[9] Many were concocted from clays

and other earths excavated in various parts of Italy. Tuscany was particularly rich in this regard. The variety of colors found in its soil was described by Cennino Cennini in *Il Libro dell' Arte,* a handbook for painters written in the 1390s. As a boy, Cennini was taken by his father to the bottom of a hill in the Val d'Elsa, near Siena, where, "scraping the steep with a spade," he later wrote, "I beheld seams of many kinds of colour: ochre, dark and light sinoper, blue and white. . . . In this place there was also a seam of black colour. And these colours showed up in this earth just the way a wrinkle shows in the face of a man or woman."[10]

Generations of pigment makers had learned where to find these clays and then how to turn them into pigments. From the hills around Siena came an iron-rich clay, *terra di Siena,* that produced a yellowish brown pigment. Heated in a furnace, the clay yielded burnt sienna, which was reddish brown. Raw umber, darker in tone, came from earth rich in manganese dioxide, while red ochre was manufactured from another variety of ruddy clay excavated among the Tuscan hills. *Bianco sangiovanni* (St. John's White) was a white pigment that came from Florence itself and was named for the city's patron saint. It was made from quicklime that had been slaked and then buried in a pit for several weeks until it turned into a thick paste that was then exposed to the sun to cake.

Other pigments came from farther afield. *Terra verde* was manufactured from a grayish green mineral (glauconite) quarried near Verona, one hundred miles to the north of Florence. A much more remote source provided ultramarine. As the name *azzurro oltramarino* indicates, ultramarine was a blue that came from "beyond the sea," that is, from Afghanistan, where lapis lazuli was quarried. The Gesuati friars made this expensive pigment by grinding the blue stone in a bronze mortar, mixing it with waxes, resins, and oils, then melting everything together in an earthenware pot. The pasty mixture would be wrapped in linen and kneaded like bread dough in a solution of warm lye. Once saturated with color, the lye was poured into a glazed bowl, after which more lye was added to the squelchy mass, saturated with blue, and emptied into a second

bowl—and so forth, until the mush no longer colored the lye. The lye was then drained from each of the bowls, leaving the blue residue behind.

This method produced several grades of ultramarine. The largest and bluest particles came from the first press, after which grades of diminishing quality were collected. It was likely a blue from this first press that Michelangelo wanted when he asked Fra Jacopo di Francesco for a "certain amount of fine quality azure." If so, the pigment would not have come cheaply. Ultramarine was almost as valuable as gold, costing as much as eight ducats per ounce—thirty times more than azurite, the next most expensive blue, and more than half the annual rent of a good-size studio in Florence.[11] Ultramarine was so valuable, in fact, that when Perugino frescoed the cloisters of San Giusto alle Mura, the prior insisted on being present whenever the pigment was used in case the artist should be tempted to pinch some. Perugino was an honest man, but the prior had good reason to safeguard his ultramarine, since unscrupulous artists would substitute azurite for ultramarine and pocket the difference in price, a fraud outlawed by the guilds in Florence, Siena, and Perugia.

Ultramarine was almost always added *a secco,* that is, with the aid of a fixative once the *intonaco* had dried. There were precedents, however, for using ultramarine in *buon fresco,* most notably that of Ghirlandaio in the Tornabuoni Chapel. Michelangelo may have chosen his Florentine assistants, among other reasons, because as pupils of Ghirlandaio they were trained in the *buon fresco* application of bright colors like ultramarine. Still, he seems not to have used a great deal of ultramarine on the vault.[12] This was no doubt partly for economic reasons, since he would later boast to Condivi that he spent no more than twenty or twenty-five ducats on pigments for the Sistine Chapel[13]—barely enough to buy three ounces of ultramarine, let alone any of the other colors. Nor did he use very much, if any, of the other mineral-based pigments—azurite, vermilion, malachite—that were traditionally added *a secco.* Following their problems with mildew on *The Flood,* he and his

assistants worked primarily in the more impregnable, but also more difficult, *buon fresco* style, albeit with occasional *secco* touches.[14] Remarkably, the Ancestors of Christ, the brightest figures on the vault, would be painted almost exclusively in *buon fresco*.

Though small in size, the spandrels projecting above the windows on either side of *The Flood* were not easy to paint, offering curved, triangular surfaces onto which Michelangelo had to project his figures.[15] Still, work seems to have progressed fairly swiftly. Whereas *The Flood* consumed the better part of two months, the first two spandrels took only eight days each to paint.[16] Michelangelo and his team transferred the cartoon for the first one, that on the north side, by means of a combination of *spolvero* and incision. Evidently growing more confident, for the one on the south side, whose nameplate reads IOSIAS IECHONIAS SALATHIEL,[17] Michelangelo used *spolvero* to transfer the designs of the faces but then abandoned his cartoon altogether and painted freehand on the plaster. This was a bold move, considering that mistakes made in painting *The Flood* had entailed removing the plaster and starting again. Yet it seems to have worked, since neither *pentimenti* nor *secco* touches were needed. A small scene that occupies an unobtrusive spot on the ceiling, this spandrel—which shows a trio of people slumped on the ground—nevertheless marks an important stage. After several months of work, Michelangelo finally seemed to be finding his feet.

With these two scenes completed, Michelangelo moved down a few steps on the scaffold to the level of the lunettes, always the last segments in these latitudinal bands to be painted. He found them much easier than the scenes on the vault fifteen or twenty feet above. Unlike these loftier panels, which forced him to bend over backward and raise his brush above his head, the lunettes offered a

flat, vertical surface. Painting the lunettes proved so simple, in fact, that he continued the unusual practice of dispensing with cartoons altogether and worked freehand on the plaster.

Not having to spend time preparing cartoons in the workshop and transferring them to the wall allowed Michelangelo to work much faster. The first lunette was dispatched in only three days: One *giornata* was spent on the square, gold-trimmed nameplate, a second on the figures to the left of the window, a third on those to the right. Given that the figures in this lunette are seven feet high, Michelangelo was working at a frantic pace, even by the rapid standards of fresco painting. And while the nameplates were executed by assistants using rulers and string, there is no doubt that all of the figures were painted by Michelangelo himself.

Eager to start work, Michelangelo sometimes began painting while the plaster was still too wet, abrading its surface with his paintbrush and tearing the fragile membrane on which the frescoist worked. Because the lime in the *intonaco* destroyed miniver brushes, which were made from the fur of squirrels or stoats, he almost always used brushes made from hogs' bristles. Sometimes he worked so frenetically that bristles from his brush were left in the plaster.

On the lunettes, Michelangelo first sketched the outlines of the ancestors onto the *intonaco* with a dark pigment on a narrow brush, making reference to small drawings executed earlier. Next, switching to a wider brush, he painted the backgrounds surrounding the ancestors with a purplish pink pigment known as *morellone*. This pigment, iron sesquioxide, was produced by combining vitriol with alum and then heating the mixture in an oven until it turned a light purple. It was a substance well known to alchemists, who called it *caput mortuum* (dead head), their name for the residue left at the bottom of the beaker.

Having completed the background, Michelangelo returned to the figures themselves, using color to shape them, starting with the shadows, moving on to the middle tones, then finishing with highlights. Frescoists were usually taught to charge their brushes with

pigment, then squeeze the bristles between the thumb and index finger to remove the excess water. But Michelangelo painted the lunettes with a wet brush, applying color in such thin, watery coats that in places he created a translucent effect akin to watercolor.

Bright yellows, pinks, plums, reds, oranges, and greens—Michelangelo charged his brush with the brightest colors in the frescoist's palette as he painted the spandrels and lunettes, using them in startling combinations that in places imitated the effect of shot silk. One of the spandrels beneath *The Flood,* for example, shows an orange-haired woman in a shimmering pink-and-orange dress sitting beside her elderly husband, who sports a robe of brilliant scarlet. The full tone of these dazzling colors has only recently been rediscovered. Layers of unsaturated fat from five hundred years' worth of candles and oil lamps, together with thick layers of glue and linseed-oil varnishes slathered across the fresco during multiple incompetent restorations, served to give the spandrels and lunettes such a somber and muddied appearance that in 1945 the greatest Michelangelo scholar of the twentieth century, the Hungarian-born Charles de Tolnay, christened them "the Sphere of Shadow and Death."[18] Only when more expert conservation work undertaken by the Vatican in the 1980s stripped these layers of grime from the surface of the fresco did Michelangelo's true colors reveal themselves.

It is no surprise, perhaps, that Michelangelo, a man obsessed with his own family tree, should have decided to paint that of Christ. However, the ancestors of Christ were not a common theme in Western art. Giotto had frescoed them in decorative strips on the vault of the Scrovegni Chapel in Padua, and they also appeared on the facades of a number of Gothic cathedrals in France. Still, these forebears of Christ had never won the same popularity as other fig-

ures from the Bible, such as the prophets or the apostles. Michelangelo chose to depict this uncommon subject, moreover, in a highly unconventional manner, one without literary or artistic precedents. Hitherto, the forefathers of the Messiah had been shown as regal characters with crowns and scepters, as befits an illustrious line that stretched from Abraham to Joseph and included kings of Israel and Judah such as David and Solomon. Giotto even added haloes to their heads. Michelangelo, on the other hand, planned to portray them as considerably humbler characters.

This idiosyncratic interpretation shows itself in one of the first ancestors that Michelangelo painted. Josiah, whose story is told in the second Book of the Kings, was one of the greatest heroes of the Old Testament. Among his various reforms, he sacked idolatrous priests, burned their idols, halted the ritual sacrifice of children, banned mediums and wizards, and knocked down the houses of a notorious cult of male prostitutes. After an eventful reign of thirty-one years, he died bravely on the battlefield from arrow wounds sustained in a skirmish with the Egyptians. "Before him there was no king like him," the Bible reports. "Nor did any like him arise after him" (2 Kings 23:25).

Michelangelo was renowned for designing and sculpting heroic male figures. However, there is not the faintest flicker, in his portrait of Josiah, of this awe-inspiring scourge of wizards, idolaters, and male prostitutes. The lunette shows what appears to be a domestic spat in which a mother with a squirming child angrily turns her back on a husband who gestures at her in helpless exasperation as he wrestles with a child on his own lap. The spandrel above the window, meanwhile, features a wife sitting on the ground with a baby in her arms and her husband sprawled beside her, eyes closed and head drooping. If their lethargic bodies contrast dramatically with the gusto of the biblical Josiah, they are also at odds with both the burly nudes a few feet above their heads and the vigorous aplomb of Michelangelo as he dashed about the scaffold, painting each of these torpid figures in only a day or two.

Michelangelo would portray the rest of the ancestors of Christ—a grand total of ninety-one figures running in a colorful frieze above the windows—in similar fashion. His preparatory drawings are full of characters whose heads droop, limbs flop, and bodies slouch in poses that could in no way be described as "Michelangelesque." Many of them perform humdrum routines, such as combing their hair, winding yarn, cutting cloth, falling asleep, tending children, or gazing into mirrors. These actions make the ancestors virtually unique in Michelangelo's oeuvre, since images of everyday life are few and far between in his work. And something else makes the ancestors noteworthy. Among these ninety-one passive, nondescript figures, Michelangelo would paint twenty-five women—something completely unheard of in previous depictions of the ancestors of Christ, except, of course, for Christ's most immediate female relative, the Virgin Mary.[*]

The inclusion of women in these mundane scenes serves to transform Michelangelo's illustrations of the ancestors into several dozen family groups. With their father-mother-child combinations, his figures are actually more akin to representations of the Holy Family than to earlier characterizations of the ancestors. Several years later, in fact, Titian would use some of the figures from the IOSIAS IECHONIAS SALATHIEL lunette as the model for his own version of the Holy Family, *The Rest on the Flight into Egypt*, painted about 1512.[19]

The Holy Family was a relatively new subject in art. Evolving from portraits of the Madonna and Child, it tended to accent the human and familial aspect of the Incarnation, featuring candid pictures of Joseph and Mary in homely poses with which viewers would easily identify. Raphael painted several renditions in Florence, including one for Domenico Canigiani in which a

[*]Apart from the Virgin Mary, of the forty ancestors of Christ listed in the Bible, only four women are mentioned: Tamar, Bathsheba, Rahab, and Ruth. Michelangelo does not, however, inscribe any of their names on the tablets.

benevolent-looking Joseph leans on his staff while the Virgin and St. Elizabeth repose under his watchful eye and their two children happily disport themselves on the grass. Michelangelo's own *Holy Family*, painted about 1504, shows Mary seated on the ground with a book in her lap as a gray-bearded Joseph passes the Christ Child into her hands.

Portraits of the Holy Family were often private commissions that served as domestic devotional pieces. Hung in the home or ancestral chapel, they were intended to shape and strengthen family identity by offering examples of loving bonds between husband and wife as well as parent and child.[20] Michelangelo's *Holy Family* was no exception. Painted for Agnolo Doni at the time of his marriage to Maddalena Strozzi, it offered the newlyweds an inspiring image of the perfect domestic unit to contemplate as they embarked on their future together.✝

Several years later, Michelangelo presented a very different vision of domestic life. The acrimonious and exhausted couples in the Sistine Chapel's spandrels and lunettes occupy a harsher and more infelicitous world than the avuncular Josephs and blissful Madonnas of the Holy Family genre. Far from offering virtuous examples of loving little units, Michelangelo's ancestors express a range of less desirable emotional states, including anger, boredom, and sheer inertia. Given that these slothful, bickering figures graphically illustrate a "wretched family life" (as one art historian calls it),[21] one is tempted to see a connection between them and Michelangelo's discontentment and frustration with his own rather unhappy family. He may have been close to his father and brothers, but the Buonarroti home was still a place of squabbles, worries, divisions, and incessant demands and complaints. With domestic irritations such as the lawsuit of his aunt and the aimless lives of his brothers forefront in his mind as

✝Similarly, Domenico Canigiani commissioned the *Holy Family* from Raphael on the occasion of his marriage in 1507 to Lucrezia Frescobaldi, after which the work hung in their wedding chamber.

he designed the spandrels and lunettes, Michelangelo seems to have incorporated into his fresco what a psychoanalyst has called his "confused and conflicted feelings about his own ancestry,"[22] thereby rendering the family of Christ as miserable and unruly as his own.

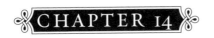

HE SHALL BUILD THE TEMPLE OF THE LORD

ON THE FOURTEENTH of May 1509 the Venetian army was defeated in battle by the French at Agnadello, in northern Italy. More than 15,000 soldiers were either captured or killed, including Venice's most senior commander, Bartolomeo d'Alviano. It was a shattering defeat for the republic, and its first on dry land since 452 C.E., when Attila the Hun came rampaging through Italy on his way to Rome. Now, it seemed, another enemy from across the Alps was poised to storm the peninsula.

Louis XII, leader of Europe's greatest superpower, had invaded Italy with an army of 40,000 men, bent on reclaiming what he regarded as French possessions. He did so with the blessing of the pope, who had excommunicated the Venetian republic three weeks earlier for refusing to surrender the Romagna. Julius had declared that the Venetians combined the cunning of the wolf with the ferocity of the lion, to which Venetian satirists retorted with accusations that he was a homosexual, a pedophile, and a drunkard.

Julius did not merely excommunicate Venice; in March 1509 he also made public his adherence to the League of Cambrai. Drawn up a few months previously, the league was supposedly an agreement between Louis XII and the Holy Roman Emperor Maximilian to launch a Crusade against the Turks, but it also included a secret clause calling for the two parties, along with Julius and the king of Spain, to join forces to make Venice give back its spoils. Learning the true aims of the league, the Venetians hastily offered to return Faenza and Rimini to the pope. But the overture came too late, since Louis XII's juggernaut was already rolling into Italy. In the weeks after the battle of Agnadello, papal forces under the command of

King Louis XII of France, engraving by Allais after Chasselat.

Julius's nephew, Francesco Maria, the new duke of Urbino, mopped up after the French, sweeping through the Romagna and reclaiming its cities and fortresses.

The crushing defeat of the Venetians was celebrated in Rome with a display of fireworks over the Castel Sant'Angelo. In the Sistine Chapel, a preacher with the imperial-sounding name of Marcus Antonius Magnus delivered an oration praising the great French victory and the welcome return of papal lands. The pope himself was in no mood for festivities, however. It was little more than a decade since French troops under Charles VIII had invaded Italy, spreading terror throughout the peninsula and forcing Pope Alexander to flee inside the Castel Sant'Angelo. In the spring of 1509, history appeared about to repeat itself.

The forty-seven-year-old Louis XII had come to the throne of France in 1498, when his cousin Charles VIII died after striking his head on a low timber beam in his château at Amboise. He was

a distinctly unimposing specimen, thin and frail, with a weak con-
stitution and a domineering wife. Still, with his royal blood, he fan-
cied himself more than a match for Julius. "The Rovere are a
peasant family," he once sniffed haughtily to a Florentine envoy.
"Nothing but the stick at his back will keep this pope in order."[1]

Despite the celebrations, then, Julius had good reason to be
troubled. Soon after Agnadello he claimed to be "counting the
hours until the king of France leaves Italy."[2]

The festivities in Rome after the Venetian defeat at Agnadello
must have brought to mind, for those who witnessed them, the
ones that had taken place when the pope returned from his tri-
umphant campaign against Perugia and Bologna. On that occasion
Julius and his cardinals had ridden in a splendid three-hour pro-
cession from the Porta del Popolo to St. Peter's. In front of the
half-demolished basilica a full-size replica of the Arch of
Constantine had been built, and coins tossed into the crowd were
inscribed "Ivlivs Caesar Pont II," a legend explicitly comparing the
victorious pope to his namesake.✝ One of the triumphal arches
erected along the Via del Corso even read "Veni, vidi, vici."

The pope did not see himself merely as the new Julius Caesar.
His return to Rome had been carefully timed to coincide with
Palm Sunday, the commemoration of the time enthusiastic crowds
tossed palm leaves into Christ's path as he entered Jerusalem on
the back of an ass. To make sure no one missed the point, Julius was
preceded through the streets by a horse-drawn chariot from which
ten youths dressed in angel costumes waved palm fronds at him.

✝Julius was not the only leader at the time to suffer from a Caesar complex:
Cesare Borgia had chosen for himself the motto *Aut Caesar, aut nihil* (Caesar or
nothing).

The reverse of the Julius Caesar coin bore the text for Palm Sunday: "Blessed is he who comes in the name of the Lord," the words shouted by the ecstatic crowds as Christ entered Jerusalem. Such a display of megalomania must have given even the pope's most devoted supporters pause for thought.

Christ's entry into Jerusalem on the back of an ass was foretold, like many of the Messiah's other activities, in the Old Testament. "Rejoice greatly, O daughter of Zion!" wrote the prophet Zechariah. "Shout aloud, O daughter of Jerusalem! Lo, your king comes to you, triumphant and victorious is he, humble and riding on an ass, on a colt, the foal of an ass" (Zechariah 9:9).

Zechariah's vision of Christ's arrival took place when the Jews returned to Jerusalem following their long exile in Babylon. King Nebuchadnezzar had laid waste to Jerusalem in 587 B.C.E., knocking down its walls, burning its palaces, pillaging the Temple of Solomon of everything including the candle snuffers, and carrying off the population into captivity. As the Jews returned to their ravaged city seventy years later, Zechariah received not only his vision of a Messiah entering the city on the back of a colt but also one of the temple's reconstruction: "Behold, the man whose name is the Branch: for he shall branch out in this place, and he shall build the temple of the Lord, and shall bear royal honor, and shall sit and rule upon his throne" (Zechariah 6:12).

Zechariah was the first of seven Old Testament prophets to be frescoed on the Sistine Chapel's vault. Thirteen feet in height, and wrapped in heavy crimson and green robes, he was given a yellow-ochre shirt with a brilliant blue collar and held in his hands a book with a *morellone* cover. As befits someone who foresaw the reconstruction of the despoiled temple—a building on whose dimensions the Sistine Chapel was built—he occupied a conspicuous location, directly above the entrance. Some six months into the fresco project, Michelangelo finally felt confident enough of his abilities to begin work above the door of the chapel.

Zechariah was also painted directly above the Rovere coat of arms placed in its prominent location over the door by Pope Sixtus IV.

Michelangelo's sketch of Zechariah.

The word *rovere* means "scrub oak," and the Rovere armorial bearings punningly featured an oak tree with intertwined branches sprouting twelve golden acorns. As Louis XII had been quick to point out, the Rovere were not actually a noble family. Sixtus IV took the coat of arms from a blue-blooded, but unrelated, family from Turin, also named Rovere. Henceforth, as one commentator has observed, "the shadowy claim of the Rovere popes to the *rovere* tree was only matched by the zeal with which they applied it in every possible situation."[3] The fresco on the Sistine's vault presented Julius with an opportunity to display his coat of arms. There are frequent allusions to it—and to the chapel's two great patrons—in the borders of some of the Genesis scenes which are decorated with fat garlands of oak leaves and acorns.

These green swags were not Michelangelo's sole homage to Julius. Little more than a year after his bronze statue of the pope was installed above the door of the church of San Petronio, Michelangelo

placed a portrait of his patron above the door of the Sistine Chapel as well. Zechariah not only sits a few inches above the Rovere coat of arms but also wears clothing featuring the Rovere colors, blue and gold. Furthermore, his tonsured head, aquiline nose, and strong, stern features all look suspiciously familiar. Michelangelo's Zechariah looks so much like the pope, in fact, that a black-chalk study of the prophet's head was thought until 1945 to be a preparatory sketch for a portrait of Julius.[4]

It was common for an artist to immortalize his patron in a fresco. Ghirlandaio portrayed Giovanni Tornabuoni and his wife in the Tornabuoni Chapel, and Pope Alexander and his children were prominently displayed, much to Julius's annoyance, in Pinturicchio's frescoes in the Borgia apartments. But if Zechariah was indeed intended as a portrait of Julius, Michelangelo may have included it only reluctantly. Relations between the artist and his patron had never really recovered from the events of 1506, for Michelangelo was still consumed with regret over the failure of the tomb project. The portrait almost seems to imply that someone besides Michelangelo did in fact have a hand in designing the program, for it hardly seems likely that he would have chosen to memorialize the man whom he regarded as his persecutor. At the very least it suggests that he took certain instructions or requests from either the pope or his advisers.

"Behold, the man whose name is the Branch," Zechariah had written, "for he shall branch out in this place, and he shall build the temple of the Lord." Zechariah's prophecy is generally said to have been fulfilled by Zorobabel, who completed the temple's recon-struction in 515 B.C.E. But another interpretation was possible dur-ing the reign of Julius II. Able to present himself unblushingly as both Caesar and Christ, the pope—with his coat of arms featuring sprouting branches—most certainly would have glimpsed himself in these words of Zechariah, especially since he was both repairing the Sistine Chapel and rebuilding St. Peter's.

This staggering conceit smacks of the pope's official propagan-dist, Egidio da Viterbo, whose specialty was spotting allusions to Julius in Old Testament prophecies. In December 1507 he had

preached a sermon in St. Peter's explicating the vision in which the prophet Isaiah, following the death of Uzziah, saw "the Lord sitting upon a throne, high and lifted up." Egidio believed the prophet had not properly expressed himself. "He meant to say," he informed the congregation, "'I saw Julius II, the Pope, both succeeding the dead Uzziah and seated on the throne of religious increase.'"[5] As Egidio made clear in his sermons, Julius was the messianic agent of the Lord, the man destined to fulfill scriptural prophecies and God's providential design. Not surprisingly, Egidio had been the man who had planned the symbolic Palm Sunday festivities the previous March.

Michelangelo entertained no such fantasies about the pope's glorious mission. Unsympathetic to his military aspirations, he once composed a poem lamenting the state of Rome under Julius. "They make a sword or helmet from a chalice," he wrote bitterly, "and sell the blood of Christ here by the load, / And cross and thorn become a shield, a blade."[6] The poem is signed "Michelangelo in Turkey," an ironic comparison between Rome under Julius and Istanbul under Christianity's greatest foe, the Ottoman sultan—and hardly the sentiments of a man who believed Julius to be the architect-in-chief of the New Jerusalem.

The portrait of the pope above the door of the Sistine Chapel was not the only image of Julius to be painted in the Vatican in 1509. After completing the vault of the Stanza della Segnatura with Sodoma, Raphael began his first wall fresco in the early months of 1509, helped by a small band of assistants whose identities history has failed to record.[7] This large fresco, whose surface covers some four hundred square feet, decorated the wall against which Julius's books on theology would be placed. The fresco was therefore, not surprisingly, given a religious theme. Known since the seventeenth

century as *The Dispute of the Sacrament,* or the *Disputà,* it actually portrays not so much a debate as an exaltation or celebration of the Eucharist, and of the Christian religion in general.

The area on which Raphael had to work was a semicircle of wall some twenty-five feet wide at the base. This flat wall was easier to paint than the curved expanses on which Michelangelo was working and also much easier to reach. Like all frescoists, Raphael started at the top of the painting and worked his way down as the scaffold was progressively dismantled, so that by the end he was working only a few feet off the ground. Art historians agree that most of the fresco is "autograph," that is, painted in Raphael's own hand. It is a curious fact that the affable and sociable Raphael should have begun his fresco with so little outside help, while in the Sistine Chapel a solitary and taciturn genius had found himself at the head of a boisterous group of collaborators.

Raphael would spend in excess of six months planning and then executing the *Disputà,* creating, according to one estimate, more than three hundred preparatory drawings in which, like Michelangelo, he worked out the individual poses and features of his characters.[8] There are sixty-six figures in all grouped around and above an altar, the largest just over four feet high. They form a huge cast of famous characters. Christ and the Virgin Mary are surrounded by a host of other biblical characters, such as Adam, Abraham, St. Peter, and St. Paul. Another group of animated figures includes many familiar faces from Church history: St. Augustine, Thomas Aquinas, various popes, Dante, and even, lurking in the background, Girolamo Savonarola. Two other figures are equally unmistakable, for Raphael painted portraits of both Donato Bramante and, in the guise of Gregory the Great, Pope Julius II.

Julius was never averse to having himself immortalized in art, but the portraits of the pope and Bramante were not slipped into the *Disputà* for reasons of vanity alone. As in Michelangelo's fresco, Julius was memorialized as a builder, or rebuilder, of the Lord's temple. On the left of the *Disputà,* far in the background, a church is under construction, sheathed in scaffolding and dotted with fig-

ures who roam the building site. Yet another architectural tableau occupies the opposite side of the fresco, where huge blocks of half-dressed marble—what appear to be the beginnings of some colossal building—loom behind the clutch of poets and popes, making the scene look as if it takes place amid the half-built piers of St. Peter's as they would have appeared in 1509.

The celebration of the Roman Church is therefore a celebration, Raphael implies, of both its architectural monuments and its two chief builders, the pope and his official architect. This idea, like the portrait of Zechariah, bears the stamp of Egidio da Viterbo, according to whom the construction of the new basilica—which Egidio wanted to rise "up to the very heavens"—was an important part of God's design and a sign that Julius was fulfilling the destiny for his pontificate.[9]

The portrait of Bramante may indicate that the architect was still closely involved in the decorations of the papal apartments. More likely, though, he had relinquished responsibility for the design of the wall frescoes to someone else. Raphael's friend and biographer Paolo Giovio, the bishop of Nocera, wrote that the design of the *Disputà* was, like those of the other frescoes in the papal apartments, the brainchild of Julius himself.[10] The pope probably outlined the general themes and characters, and he was no doubt the force behind the inclusion of Savonarola, since Julius had been sympathetic to his revolutionary aims so long as they were directed against Pope Alexander VI. Indeed, one of the reasons for Savonarola's execution had been his confession (albeit under torture) that he had plotted against Alexander with the help of the exiled Giuliano della Rovere.[11]

However, neither the pope nor Bramante, the latter of whom read no Latin, would have been responsible for the fresco's finer details, such as the Latin epigraphs. Indeed, the detailed historical scenes must have been invented in collaboration with an adviser, and the most logical candidate was a disciple of Egidio da Viterbo, Julius's librarian, the thirty-eight-year-old Tommaso "Fedro" Inghirami. One of the Vatican's more audacious personalities,

Fedro was not merely a librarian and a scholar but also an actor and orator who earned his nickname—and his reputation as Rome's greatest actor—by improvising in rhyming Latin couplets as stage-hands scrambled to replace a piece of scenery that had collapsed behind him during a production of Seneca's *Phaedra*. Fedro, at any rate, soon became friends with Raphael, who painted his portrait a few years later, showing a fat, moon-faced canon with a severe squint and a ring on his right thumb.[12]

The fresco was not created without a few false starts that slowed Raphael's progress. Surviving compositional sketches show how the young artist struggled to find a suitable design, plotting various arrangements and perspectival schemes only to abandon them a short time later. Like Michelangelo, he was clearly trying to find his feet in a difficult medium in which he had limited experience—and he was also, no doubt, a little abashed by both the magnitude and the prestige of the task that had unexpectedly befallen him. The *Disputà* required numerous *secco* touches, which indicate that, like Michelangelo, Raphael was much less confident in *buon fresco* than he would presently become.

As if executing the *Disputà* was not difficult and ambitious enough, Raphael also took several commissions on the side soon after arriving in Rome. Barely had work on the fresco started when he was engaged by the pope to execute a Madonna and Child—what would become the *Madonna di Loreto*—to hang in Santa Maria del Popolo. A short time later he also accepted from Paolo Giovio, a commission to paint the so-called *Alba Madonna*, which Giovio planned to send to the church of the Olivetani in Nocera dei Pagani. These works also help account for the fairly slow pace at which work proceeded in the Stanza della Segnatura.

Whatever minor setbacks Raphael might have suffered in design-ing and then executing the *Disputà*, the finished product spectacular-ly justified the pope's decision to hand the commission to him. In ranging his characters in lively, elegant postures across the twenty-five-foot-wide wall, he not only demonstrated flawless perspective and superb use of pictorial space but also proved his incontestable

superiority over the high-powered team of frescoists he had just displaced. And Raphael had not simply outstripped veteran artists such as Perugino and Sodoma. The adroit orchestration of the dozens of figures in the *Disputà* made Michelangelo's *Flood,* painted only a few months earlier, look ponderous and disorganized by comparison. Raphael, unlike Michelangelo, had made a thoroughly brilliant start.

CHAPTER 15

FAMILY BUSINESS

AS THE HOT Roman summer approached, Raphael's ascendancy
looked set to continue. The speed and self-assurance with which
Michelangelo had painted the ancestors of Christ on the first span-
drels and lunettes deserted him as he and his assistants returned to
a larger and more difficult scene, *The Drunkenness of Noah,* the east-
ernmost of the ceiling's nine episodes from the Book of Genesis.
Occupying a spot above the door of the chapel, this scene took
even longer to paint than *The Flood,* consuming a grand total of
thirty-one *giornate,* or some five or six weeks.

The pope was not, of course, a patient man. So anxious was he
to see the Cortile del Belvedere completed—a structure he wished
to see "spring up from the ground," according to Vasari, "without
needing to be built"[1]—that the beleaguered Bramante had taken to
carting building materials to the site in the dead of the night and
unloading them by torchlight. Julius was equally eager to have the
Sistine Chapel fresco completed, and Michelangelo's halting
progress inevitably proved a source of frustration to him. Michel-
angelo was constantly aggravated by the pope's impatient urgings
as he worked on the vault; on occasion he was even subjected to his
violent rages. Ascanio Condivi gives one example of these deterio-
rating relations. "Michelangelo was hampered," he writes, "by the
urgency of the pope, who asked him one day when he would finish
the chapel. And when Michelangelo answered, 'When I can,' the
pope, enraged, retorted, 'You want me to have you thrown off the
scaffolding.'"[2]

Another time, according to Vasari, the pope grew so incensed at
Michelangelo's slow progress and impudent replies that he
thrashed him with a stick. Michelangelo had wished to return to
Florence for a feast day, but Julius stubbornly refused him permis-

sion on the grounds that the artist had made too little headway on the project.

"Well, but when will you have this chapel finished?"

"As soon as I can, Holy Father," replied Michelangelo.

Julius then struck Michelangelo with a staff. "As soon as I can! As soon as I can! What do you mean? I will soon make you finish it."

The story concludes with an apologetic pope assuring Michelangelo that the blows were meant "as favours and marks of affection." He was also wise enough to give the artist five hundred ducats, "fearing lest he might commit one of his caprices."[3]

The gift of five hundred ducats may have been one of Vasari's embellishments, since Julius was niggardly with his gold. But the flailing stick at least rings true. Disobliging courtiers and servants often received similar marks of affection, and Julius also resorted to pushing and punching.[4] Nor was it wise to come close when His Holiness was in good spirits. News of a military victory or other such good tidings would cause him to clap his subordinates so violently on the shoulder that it was said one needed body armor to approach him.

Julius did not merely exasperate Michelangelo with demands to know when he might finish the fresco; he also wanted to see it for himself, a privilege the artist was not especially keen to grant. Michelangelo's obsessive secrecy differed sharply from the atmosphere of the Stanza della Segnatura, to which Julius had unlimited and convenient access. Raphael was painting his frescoes only two rooms from the pope's bedroom—a walk of less than twenty yards—and as one of the driving forces behind the fresco's subject matter, Julius probably spent a good deal of time in the room, inspecting Raphael's progress and making suggestions.

The pope could not count on the same kind of courtesy in the Sistine Chapel. According to Vasari, Julius eventually grew so exasperated with Michelangelo's secrecy that one night he bribed the assistants to sneak him into the chapel to see the work for himself. Michelangelo already suspected the pope of donning disguises so he could bluff his way onto the scaffold for a peek. So this time,

catching wind of a plot, he concealed himself on the scaffold and, as the intruder entered the chapel, repelled him by hurling planks at his head. Julius angrily fled the scene, bellowing curses and leaving Michelangelo to contemplate the possible repercussions of his outburst. Fearing for his life, he escaped through a window and bolted to Florence, where he lay low for a spell and waited for the pope's famous temper to cool.[5]

This story is probably an exaggeration if not an outright invention on Vasari's part. Still, no matter how dubious, it was nonetheless inspired by the undeniable fact that there was no love lost between the artist and his patron. The major problem seems to have been that Michelangelo and Julius were remarkably alike in temperament. "His impetuosity and his temper annoy those who live with him, but he inspires fear rather than hatred, for there is nothing in him that is small or meanly selfish."[6] Penned by a frazzled Venetian ambassador, this description of Julius might easily have been applied to Michelangelo. The adjective most often used to describe Julius was *terribile*. Julius himself, however, used the term to refer to Michelangelo—one of the few people in Rome who refused to cringe before him.

The scene on which Michelangelo and his team were laboring so falteringly, *The Drunkenness of Noah,* is found in Genesis 9:20–27. This episode describes how Noah planted a vineyard after the Flood and then proceeded to overindulge on the fruits of his labors. "He drank of the wine, and became drunk, and lay uncovered in his tent," the Bible records. As Noah lay slumped in this naked and insensible state, his son Ham happened to enter and, seeing his father's undignified posture, summoned his older brothers and mocked the old man. Shem and Japheth showed more respect for the inebriated patriarch, covering him with a garment

after walking backward into the tent with their eyes averted to protect his modesty. Waking at last from his stupor and realizing how his youngest child had sneered at him, Noah rather gracelessly cursed Ham's son, Canaan, who went on to become the father of not only the Egyptians but also the inhabitants of Sodom and Gomorrah.

This scene featuring an elderly father at the mercy of his three sons, one of whom pitilessly mocks him, bore odd analogies to Michelangelo's own family situation in the spring of 1509. "Most revered Father," Michelangelo wrote home to Lodovico at this time, "I learn from your last letter how things are going at home and how Giovansimone is behaving. I have not had, these ten years, worse news than on the evening I read your letter."[7]

Once again, domestic problems—in the form, predictably, of an unruly Giovansimone—intruded on Michelangelo's work. Almost a year had passed since Giovansimone visited Rome, fell ill, and, much to Michelangelo's relief, returned to the wool shop. Michelangelo still hoped to establish Buonarroto and Giovansimone in the wool business if, in the meantime, the pair could behave themselves and learn the secrets of the trade. "Now I see that they are doing the contrary," he wrote angrily in response to Lodovico's report on their behavior, "and particularly Giovansimone, whence I realise that it is useless to help him."

The exact nature of Giovansimone's transgression, to which Michelangelo's letter alludes with anger and revulsion, remains unclear. Certainly, it was more than his usual aimless loafing about the family home. He appears to have stolen either money or property from Lodovico and then struck him, or at least threatened to strike him, once the theft was discovered. Whatever the offense, Michelangelo was incandescent with rage when word reached him in Rome. "If, on the day I received your letter, I had been able to, I would have mounted my horse and by this time have settled everything," he assured his father. "But not being able to do this, I am writing him the letter I think he deserves."

And what a letter it was. "You are a brute," he railed at Giovan-

simone, "and as a brute I shall treat you." As with all of his family crises, he threatened to return to Florence and sort things out himself. "If I hear the least little thing about you, I will ride post to Florence and show you the error of your ways. . . . You are not in the position you think. If I do come home, I will give you cause to weep scalding tears and you will learn what grounds you have for your presumption."[8]

The letter concluded with a self-pitying diatribe of the sort that Giovansimone must have been accustomed to hearing from his older brother. "For twelve years now," Michelangelo wrote, "I have gone about all over Italy, leading a miserable life. I have borne every kind of humiliation, suffered every kind of hardship, worn myself to the bone with every kind of labour, risked my very life in a thousand dangers, solely to help my family. And now when I begin to raise it up a little, you alone must be the one to confound and destroy in one hour what I have accomplished during so many years and with such pains."

Giovansimone's delinquent behavior forced Michelangelo to reappraise his plans for his family. Far from establishing the young man in his own shop, Michelangelo vowed to his father that he planned to "leave that wretch to scratch his arse." He discussed taking the money for the wool shop and giving it instead to his youngest brother, Sigismondo, the soldier. He would then lease both the farm in Settignano and the three adjoining houses in Florence to tenants, using the money to support Lodovico and a servant in lodgings of his choice. "With what I will give you," he promised his father, "you can live like a gentleman." Meanwhile his brothers, turned out from both house and farm, would be left to fend for themselves. He even mentioned bringing Lodovico to Rome to live with him—but then hastily dismissed the idea. "It is not the season, for you would not long survive the summer here," he pointed out, alluding once again to the city's conveniently unhealthy climate.

To compound matters, Michelangelo fell ill in June, probably due to a combination of overwork and the noxious air of Rome. His illness eventually became so serious that reports soon reached Florence that the great artist had died. He was therefore required

to assure his father that rumors of his demise were greatly exaggerated. "It is a matter of little importance," he informed Lodovico, "because I am still alive."[9] However, he let his father know that all was not well with him. "I am living here ill-content and not too well, faced with an enormous task, without anyone to manage for me and without money."

Like *The Flood,* Michelangelo's second effort at a large-scale composition was not a great triumph. Though he would have seen Jacopo della Quercia's version of *The Drunkenness of Noah* on the porch of San Petronio, his depiction more closely resembled another one equally familiar to him: Lorenzo Ghiberti's bronze relief of the subject on the Porta del Paradiso in Florence. The fact that Michelangelo drew on Ghiberti's work indicates how he was still thinking largely in terms of sculpture rather than graphic composition, blocking out individual characters without regard to their position on the picture plane or their interplay with the other figures. As a result, the four characters in *The Drunkenness of Noah* lack the grace and suppleness of those in the *Dìsputà,* where Raphael animated his cast of dozens with a variety of lively poses and fluent gestures. Michelangelo's characters are stiff and solid—"petrified beings," as one commentator has called them.[10]

The unsurpassed master of composing animated group scenes was Leonardo da Vinci. His *Last Supper* displays his gift for evoking what he called the "passions of the soul" through telling movements, such as grimaces, frowns, shrugs, hand gestures, whispered confidences, all of which lend the figures their verisimilitude and the mural its unity and intense drama—qualities expertly captured by Raphael in the Stanza della Segnatura.

Whereas Ghiberti and Quercia both showed Noah's three sons dressed in flowing robes, Michelangelo depicted them—

somewhat surprisingly, given the import of the story—every bit
as naked as their father. This theme of nudity being shamed makes
The Drunkenness of Noah a strangely appropriate scene to place over
the door of the Sistine Chapel. Never before had so much naked
flesh been put on display in a fresco, much less on the vault of
such an important chapel. The nude was a controversial subject
in art even during the peak of Michelangelo's career, having made
a triumphant reappearance in European art only during the pre-
vious century. If for the ancient Greeks and Romans the nude
body had been a symbol of spiritual beauty, in the Christian tra-
dition it was almost exclusively confined to naked sinners suffer-
ing the torments of Hell. Giotto's nudes in *The Last Judgment* in the
Scrovegni Chapel in Padua, for instance, are a far cry from the
noble, idealized bodies found in Greek and Roman art. Painted
between 1305 and 1313, this fresco shows a host of nude figures
undergoing some of the most horrific tortures the medieval mind
could summon.

Not until Florentine artists such as Donatello reverted to classi-
cal aesthetic ideals in the first decades of the fifteenth century—a
time when antique art was being excavated and collected—did the
nude come back into favor. Even so, appreciation of the nude was
not unqualified. "Let us always observe decency and modesty," Leon
Battista Alberti pleaded in *De pictura,* his handbook for painters first
published in the 1430s. "The obscene parts of the body, and all those
that are not pleasing to look at, should be covered with clothing or
leaves or the hand."[11] Michelangelo paid scant heed to this injunc-
tion when sculpting his marble *David,* causing the members of the
Opera del Duomo, who commissioned the statue, to insist on the
addition of a garland of twenty-eight fig leaves to hide the genitals.✝

✝Five centuries later, Michelangelo's nudes were still a cause of controversy. In
1995, on the 3,000th anniversary of its establishment as the capital of the king-
dom of Israel, the city of Jerusalem refused the gift of a replica *David* from
Florence on the grounds of the statue's nudity. Eventually, the city fathers some-
what grudgingly accepted the replica, though only after its privates had been con-
cealed by a pair of underpants.

One of Michelangelo's drapery studies for the Erythraean sibyl.

By the time of Michelangelo's apprenticeship, drawing from nude models was among the workshop's most valued exercises. Would-be painters started their careers by sketching statues and frescoes, then graduated to human models, taking turns drawing one another's posed bodies, both nude and draped, and then working them into their paintings and sculptures. Leonardo, for example, advised painters to "pose men, dressed or nude, in such a way as you have determined in your work." Quite considerately, he also recommended using nude models only during the warm summer months.[12]

Michelangelo naturally employed nude models for the Sistine ceiling. Even robed figures were sketched from nude models, a practice encouraged by Alberti, who urged artists to "draw the naked body . . . and then cover it with clothes."[13] Only through this method, it was felt, could the artist convincingly portray the nuanced shapes and motions of the human figure. Michelangelo designed the robes themselves through a method learned in Ghirlandaio's workshop. A length of fabric was dipped in wet plaster and then arranged in folds over a support, either a workbench or a purpose-built model. As the plaster hardened, the folds would freeze in place, enabling the artist to use them as models for tum-

Michelangelo's study for a female figure.

bling draperies and robes.[14] Apprentices in Ghirlandaio's work-shop made sketches from these drapery models as part of their training, and their drawings were then compiled in a portfolio that provided ready-made patterns for Ghirlandaio's finished paint-ings.[15] Michelangelo might have used one of these model-books as a shortcut for some of the garments, but many others undoubtedly came from plaster models cast in his workshop.

One of the ancestors in the lunettes, a blond woman who raises one foot and peers contemplatively into a mirror held in her left hand, shows how Michelangelo proceeded. Though the young woman in the fresco is robed in green and orange, the model in the sketch is clearly naked. The merest glance at the sketch also reveals that this model was not a woman at all, rather an elderly man with a slight paunch and sagging buttocks. Unlike Raphael, who did not scruple to use women, Michelangelo's models were always male, no matter the sex of the character portrayed.

Even if Michelangelo heeded Leonardo's advice about warm weather, life for his models must have been uncomfortable at times. Some figures on the ceiling called for awkwardly contorted poses that even the supplest model could have held for only the shortest time. How these startling poses were arranged and held—and who exactly were the models for them—remains one of the mysteries of Michelangelo's working practice. He was rumored to have visited Rome's *stufe,* or bathhouses, to study the anatomy of nude men.[16] These were underground spas with steam rooms that originally catered to illnesses such as rheumatism and syphilis but soon became the haunts of prostitutes and their clients. Michelangelo may or may not have visited some of these establishments in search of models and inspiration. However, the old man who served as a model for the female ancestor in the lunette, as well as the bulky muscles of so many figures on the ceiling, suggests that he did not make exclusive use of young apprentices.

Another means of studying the human body was also available to the artist of Michelangelo's time: the dissection of corpses. One of the inspirations for the artistic interest in the minutiae of sinews and muscles was Alberti's doctrine that "it will help when painting living creatures first to sketch in the bones. . . . Then add the sinews and muscles, and finally clothe the bones and muscles with flesh and skin."[17] Knowledge of how flesh and skin clothed the bones and muscles required the artist to possess more than a passing acquaintance with how the body fitted together. Leonardo therefore claimed that anatomical study was an essential part of the artist's training. Unless a painter knew the structure of the body, he wrote, his nude figures would look like either "a sack full of nuts" or "a bundle of radishes."[18] The first artist to perform dissections seems to have been Antonio del Pollaiuolo, the Florentine sculptor, born about 1430, whose works show a keen interest in the nude. Another dedicated anatomist was Luca Signorelli, who was rumored to make nocturnal visits to burial grounds in his search for body parts.

Such macabre activities may have been partly responsible for a story about Michelangelo that once circulated through Rome. The

rumor spread that while preparing to carve a sculpture of the dying Christ he fatally stabbed his model in order to study the muscles of a dying man—a perverse devotion to art recalling the malicious gossip that Johannes Brahms strangled cats so he could transcribe their dying cries for use in his symphonies. After the model's death was discovered, Michelangelo supposedly fled to Palestrina, twenty miles southeast of Rome, and hid out in the village of Capranica until the fuss subsided. This anecdote is undoubtedly apocryphal,* yet it hints at how Michelangelo—the moody, aloof, obsessive perfectionist—was viewed by the people of Rome.

Michelangelo did study the muscles of dead bodies, of course, albeit not ones that had perished on the point of his dagger. As a young man in Florence, he had dissected corpses given to him by Niccolò Bichiellini, the prior of Santo Spirito, who put a room in the hospital at his disposal. Condivi applauded Michelangelo's gruesome studies, relating how the maestro once showed him the corpse of a Moor, "a most handsome young man," laid out on a table. Then, plucking up his scalpel like a doctor of medicine, Michelangelo proceeded to describe "many rare and recondite things, perhaps never before understood."[19]

This statement is not the hyperbole in which Condivi sometimes indulged, since Michelangelo was indeed an accomplished anatomist. Surface anatomy today possesses a nomenclature of roughly six hundred terms with which to refer to bones, tendons, and muscles. Yet, according to one estimate, Michelangelo's paintings and sculptures show at least eight hundred different anatomical structures.[20] For this reason he is sometimes accused of inventing or distorting anatomical forms. In fact, his works

*No real evidence exists for the story, partly because many of the documents that may have shed light on the subject—the records of the Congregation of San Girolamo della Carità, a confraternity that acted as a public notary in all criminal cases—have been damaged, destroyed, or stolen. There are local legends in Capranica that ascribe to Michelangelo both carved and painted work in the church of St. Mary Magadalene. Yet Michelangelo's handiwork in Capranica is not, of course, proof of murder.

accurately depict structures so recondite that medical anatomy, five hundred years later, has yet to name them. One of the few instances where he did alter an anatomical structure is the right hand of the *David,* where he correctly represented some fifteen bones and muscles but then elongated the border of one muscle—the *abductor digiti minimi*—to enlarge slightly the hand holding the stone that will slay Goliath.[21]

By the time of his work in the Sistine Chapel, Michelangelo had for the time being ceased dissecting corpses. He was forced to abandon the practice, Condivi reported, "because his long handling of dead bodies had so affected his stomach that he could neither eat nor drink."[22] Still, his nauseating labors in Santo Spirito were put to good use as he began displaying on the chapel's vault his unsurpassed knowledge of the contours and structures of the human body.

CHAPTER 16

LAOCOÖN

WHEN DOMENICO GHIRLANDAIO came to Rome to paint the walls of the Sistine Chapel in 1481, he strolled among the ancient ruins with his sketchbook in hand, looking for likely subjects. A superb draftsman, he soon made scores of detailed studies of columns, obelisks, aqueducts, and, of course, statues. Among these drawings was a sketch of one of Rome's best-known marbles, a statue known as the *Arrotino,* or "Knife Grinder." An ancient replica of a statue carved in Pergamon in the third century B.C.E., the *Arrotino* depicted a nude youth kneeling to sharpen his weapon. Back in Florence a few years later to paint the Tornabuoni Chapel, Ghirlandaio neatly turned the figure in this sketch into a character in his fresco: a nude man kneeling to remove his shoe in the scene showing the *Baptism of Christ.*

Some of Michelangelo's earliest sketches show how he too had roamed the streets with his sketchbook after arriving in Rome for the first time in 1496. There is in the Louvre a drawing that reproduces a statuette from a fountain in the Giardino Cesi, a pudgy child carrying a wineskin on his shoulder. Another statue drawn on one of these expeditions was a Mercury that stood on the Palatine Hill. Like Ghirlandaio, he made these drawings to develop a repertoire of classical poses for his paintings and statues. One of the marbles he sketched, a nude figure on the corner of an ancient Roman sarcophagus, even seems to have inspired the pose for his *David.*[1]

Nude models alone could not have provided Michelangelo with the hundreds of poses he needed for the Sistine Chapel. When the time came to make drawings for his fresco, it was only natural that he should have turned for inspiration to the antiquities of both Florence and Rome. Faced with such a huge task, he resorted to

One of Michelangelo's sketches of a figure on a Roman sarcophagus.

borrowing—or what art historians call "quoting"—from ancient statues and reliefs. One place where these quotations are particularly evident is in the nudes that flank five of the Genesis scenes—twenty strapping, six-foot-high figures for whom Michelangelo coined the name *ignudi* (from *nudo,* "naked").

One of the first designs for the ceiling—the geometric design featuring the Twelve Apostles—had called for angels supporting medallions. While the overall plan was quickly abandoned as a "poor thing," the concept of angels holding medallions was not. However, Michelangelo "paganized" these angels, removing their wings and turning them into athletic young nudes akin to the "slaves" he had been hoping to carve for Julius's tomb. Michelangelo found poses for some of these *ignudi* by copying Hellenistic reliefs in Rome and ancient engraved gems in the collection of Lorenzo de' Medici in Florence.[2] For two of them, he even reproduced, in an altered form,

The Laocoön, *engraving by an unknown artist.*

the most famous antique statue of the day, the *Laocoön*—a work he was uniquely placed to appreciate.[3]

Carved by a team of three sculptors on the island of Rhodes around 25 B.C.E., this marble group portrayed the Trojan priest Laocoön and his two young sons struggling with sea serpents sent by Apollo to strangle them after Laocoön—the man who uttered the famous phrase "Beware of Greeks bearing gifts"—tried to stop the Trojans from opening the hatch of the Wooden Horse. The sculpture was transported to Rome by the emperor Titus in 69 C.E., and afterward buried for centuries amid the city's rubble and ruins. In 1506, the group (minus Laocoön's right arm) was unearthed in a vineyard on the Esquiline Hill, which belonged to one Felice de' Freddi. Michelangelo was present at the excavation, having been summoned by Julius to the vineyard to help Giuliano da Sangallo confirm its identity.

Ecstatic at the find, Julius purchased the statue from Felice for the price of six hundred gold ducats per year for life, then moved it to join the *Apollo Belvedere* and various other marbles in the new sculpture garden designed by Bramante in the Vatican. In a city where the antique was fast becoming a religion, a mania for the statue was unleashed. Cheering crowds tossed flowers as it trundled through the streets to the chanting of the papal choir. Copies were made in wax, stucco, bronze, and amethyst. Andrea del Sarto sketched it, as did Parmagianino. Baccio Bandinelli carved a version for the king of France, Titian drew a *Monkey Laocoön,* and the scholar Jacopo Sadoleto wrote a poem in the statue's honor. Its image was even displayed on majolica plates sold in Rome as souvenirs.

Michelangelo was as taken with the ancient statue as everyone else. With its writhing male nudes, the *Laocoön* had a clear appeal to the man whose youthful *Battle of the Centaurs* anticipated its tortured, athletic figures. Soon after its excavation he made a study of it, sketching the three snake-entwined figures locked in the twisted pose aptly known as the *figura serpentinata.* At the time, Michelangelo was hard at work on Julius's tomb and so undoubtedly drew the statue with the plan of carving versions of it for the mausoleum. But with the tomb project shelved, the figures inspired by the *Laocoön* were transplanted to the ceiling of the Sistine Chapel, where they grapple, not with serpents, but with the fat garlands of Rovere oak leaves and acorns.

The two *ignudi* inspired by the *Laocoön* are found beneath *The Sacrifice of Noah,* the third and last of Michelangelo's scenes from the life of Noah. *The Sacrifice of Noah* shows the old patriarch and his extended family giving thanks with "burnt offerings" after the

waters of the deluge have retreated.✝ Michelangelo and his assistants took slightly more than a month to paint Noah's sons hard at work before the altar, carrying wood, stoking the fire, eviscerating a ram. A red-robed Noah watches as one of his daughters-in-law shields her face from the heat as she holds a torch to the altar. These figures, too, were inspired by ancient statues. Noah's daughter-in-law is a direct copy of the figure of Althea on a Roman sarcophagus now in the Villa Torlonia in Rome,[4] while the young man who stokes the fire comes from an ancient sacrificial relief which Michelangelo likewise sketched on one of his excursions.[5]

Despite their sculptural antecedents, the figures in *The Sacrifice of Noah* make for a considerably more effective scene than those in the previous Noah panels. Michelangelo managed to create a compact, action-packed tableau in which the figures are carefully developed in relation to one another. Their mirroring body language as they grapple with rams or hand each other sacrificial fowl balances the composition and provides a sense of interplay absent from *The Drunkenness of Noah.*

By the time this triptych of the life of Noah was completed, sometime in the early autumn of 1509, Michelangelo and his team had painted their way across a third of the chapel's ceiling.[6] Work was beginning to proceed more steadily, and after a full year on the scaffold, some 4,000 square feet of the vault had been frescoed in

✝Or, at least, most art historians now agree that the scene shows Noah's sacrifice, though both Condivi and Vasari claim the panel depicts the sacrifice of Cain and Abel described in Genesis 4:3–5. The confusion can be explained by the fact that Michelangelo painted his three scenes from the life of Noah in nonchronological order. As it portrays the earliest event, *The Flood* ought to have been the third scene from the door, occupying the space where *The Sacrifice* was eventually frescoed. But Michelangelo reversed the sequence of these two episodes so he could paint his panicked, drowning legions on a larger field, one that was ten feet by twenty feet rather than the more modest six-by-ten-foot space devoted to *The Sacrifice.* Noah therefore ends up giving thanks for his deliverance from the deluge before it actually occurs, causing both Condivi and Vasari to conclude that the sacrifice in question was that of Cain and Abel, who, of course, preceded Noah. Vasari correctly identified the scene in his 1550 edition of *Lives of the Painters, Sculptors, and Architects* but deferred to Condivi's judgment in the 1568 version.

glorious color, including three prophets, eight *ignudi,* a pair of span-drels, four lunettes, and two of the pendentives. The year consumed, in total, more than two hundred *giornate.* And all of this work had been done despite several drastic hitches in the winter and Michelangelo's illness during the summer.

Michelangelo was in no mood for celebrations, however. "I am living here in a state of great anxiety and of the greatest physical fatigue," he wrote to Buonarroto. "I have no friends of any sort and want none. I haven't even time to eat as much as I should. So you must not bother me with additional worries, for I could not bear another thing."7

Michelangelo was still distracted from his work by irksome family problems. Predictably, Lodovico had lost the legal dispute with his sister-in-law, Cassandra, and was obliged to repay her dowry. Equally predictable, he was distraught at having to part with the money. For the past year he had been living in what Michelangelo called a "state of fear."8 With the suit finally lost, the artist tried to raise his father's low spirits. "Do not alarm your-self or be in the least depressed about it," Michelangelo urged him, "because to lose one's possessions is not to lose one's life. I will do more than make up to you what you will lose."9 Michel-angelo and not Lodovico, it was clear, would be the one to reach into his pocket to repay the disgruntled widow. Fortuitously, how-ever, he had just received from the pope a second installment of five hundred ducats.

Buonarroto, usually the reliable one, was also the cause of the "additional worries." Not content with life in Lorenzo Strozzi's wool shop, he hoped to invest some money—Michelangelo's, of course—in a bakery. The switch from wool to wheat was inspired by his experience on the family farm, where surplus quantities of wheat were sometimes sold to friends at knockdown prices. Michelangelo, a bit stingily, disapproved of the practice. After a bountiful harvest in 1508, he scolded his father for giving the mother of a friend named Michele 150 *soldi* worth of wheat. Buonarroto therefore seems to have decided to make a more lucra-

tive use of the surplus. Flushed with enthusiasm for his new venture, he dispatched a courier to Rome with a loaf of bread for Michelangelo to sample. Michelangelo enjoyed the bread but pronounced the enterprise itself unappetizing. He pointedly ordered the would-be entrepreneur to keep his nose to the grindstone in the wool shop, writing, "I hope when I return home that you will be set up on your own, if you be man enough."[10]

Even Michelangelo's youngest brother, Sigismondo, the soldier, was a cause for concern that autumn. Enticed by the same shimmering prospects that lured Giovansimone to Rome a year earlier, he was planning his own visit. A houseguest was, of course, the last thing that Michelangelo needed, especially one, like Sigismondo, woefully unable to support himself. As the season for both plague and malaria had passed, Michelangelo could no longer preach his usual sermon about Rome's unhealthy air, so he resigned himself to his brother's visit. But he begged Buonarroto to warn the young man that he was not to expect any help. "Not because I do not love him as a brother," he emphasized, "but because I cannot help him in any way."[11] If Sigismondo did travel to Rome, the visit must have passed without event, for Michelangelo made no further mention of it.

The only good news from Florence was that Giovansimone, at least, was behaving himself. Michelangelo's enraged letter had produced startling effects in the young man. Hitherto Giovansimone had lazed about either in the house in Florence or on the farm in Settignano. Now, though, he began looking boldly and ambitiously to his future. But unlike Buonarroto, who saw his destiny in loaves of bread, Giovansimone dreamed of making his fortune from more exotic fare: He planned to invest in a ship that would sail from Lisbon to India and return laden with spices. He even talked about sailing to India—the sea route to which had been discovered by Vasco da Gama a decade earlier—if this first venture succeeded.

Such a voyage would have been extremely hazardous, and Michelangelo must have realized that he could easily lose his brother as well as his ducats if he agreed to fund this latest enterprise. Still, Giovansimone was ready to risk life and limb on the adventure,

Manuscript of Michelangelo's comic poem about the experience of painting the Sistine ceiling.

stirred to action, perhaps, by Michelangelo's claim that he had risked his life "in a thousand dangers, solely to help my family."

Michelangelo's complaint to Buonarroto that he was suffering "the greatest physical fatigues" indicates the incredible strain involved in painting the fresco. Around this time he sent to a friend named Giovanni da Pistoia a comic poem recounting his grotesque physical travails as he painted the vault, complete with a sketch that shows him reaching upward with his paintbrush. He was forced to work, he informed Giovanni, with his head tipped back, his body bent like a bow, his beard and paintbrush pointing to heaven, and his face splattered with paint. His posture on the scaffold, as he

toiled at the fresco, was almost as painfully twisted, it seems, as that of the half-strangled Laocoön, who likewise tips back his head, warps his back, and thrusts his arm skyward.

I've got myself a goiter from this strain,
As water gives the cats in Lombardy
Or maybe it is in some other country;
My belly's pushed by force beneath my chin.

My beard toward Heaven, I feel the back of my brain
Upon my neck, I grow the breast of a Harpy;
My brush, above my face continually,
Makes it a splendid floor by dripping down.

My loins have penetrated to my paunch,
My rump's a crupper, as a counterweight,
And pointless the unseeing steps I go.

In front of me my skin is being stretched
While it folds up behind and forms a knot,
And I am bending like a Syrian bow.

And judgment, hence, must grow,
Borne in mind, peculiar and untrue;
You cannot shoot well when the gun's askew.

Giovanni, come to the rescue
Of my dead painting now, and of my honor;
I'm not in a good place, and I'm no painter.[12]

Ingenious and efficient though the scaffold was, certain physical hardships were inescapable on a project of such magnitude, since pain and discomfort were the occupational hazard of a frescoist. Michelangelo once told Vasari that fresco was "not an art for old men."[13] Vasari himself claimed that when he frescoed five rooms in

the palace of the grand duke of Tuscany, he was forced to build a kind of brace to support his neck as he worked. "Even so," he complained, "this work has so ruined my sight and injured my head that I still feel the effects."[14] Jacopo da Pontormo suffered just as badly. His diary for 1555 describes how he was forced to stoop on his scaffold for long periods at a stretch as he frescoed the Chapel of the Princes in the church of San Lorenzo in Florence. The result, unsurprisingly, was terrible back pain that sometimes grew so intense he was unable to eat.[15]

One of Michelangelo's worst symptoms was a bizarre form of eyestrain. After spending so much time with his eyes turned upward, he found he could read letters or study drawings only if he held them at arm's length above his head.[16] This debilitating condition, which persisted for months on end, must have affected his ability to make sketches and cartoons. But Vasari claimed that Michelangelo courageously bore the rigors and pains of his job. "In fact," he declared, "becoming more and more kindled every day by his fervour in the work, and encouraged by the proficiency and improvement that he made, he felt no fatigue and cared nothing for discomfort."[17]

There is little evidence of this heroic disregard for physical distress in the wretched letter to Buonarroto. A grueling year of work on the scaffold, coupled with the worries about his family, seems to have left Michelangelo both physically and emotionally depleted. And other factors may have contributed to his downcast spirits, since he also felt that he lacked moral support. "I have no friends of any sort," he had grumbled in his letter. It seems unlikely that he would have deplored a lack of friends had Granacci, Indaco, and Bugiardini still been on the scene. Having served their purpose, most of the handpicked team of assistants had probably left the project by the summer or autumn of 1509, after spending no more than a year on the job. Michelangelo was therefore left to continue his task—two-thirds of which still remained—with a new group of assistants.

CHAPTER 17

THE GOLDEN AGE

MICHELANGELO WAS A superstitious man. When one of his friends, a lute player named Cardiere, told him of a strange vision, the artist did not scruple to question its reliability.[1] It was 1494, the year in which Charles VIII's army descended on Italy. In Cardiere's dream the ghost of Lorenzo the Magnificent appeared before him, dressed in rags, and ordered the lute player to warn Lorenzo's son Piero de' Medici, the new ruler of Florence, that unless he mended his ways he would be driven from power. Michelangelo urged the frightened Cardiere to relate the dream to the arrogant and incompetent Piero, but the lute player refused, fearing Piero's temper. A few days passed; then Cardiere came to Michelangelo a second time, more terrified than ever. The ghost of Lorenzo had again appeared to him, on this occasion striking him on the cheek for having failed to carry out his orders. Once more, Michelangelo begged the lute player to divulge the vision to Piero. But when Cardiere finally plucked up the courage to confront him, Piero scorned him, stating that his father's ghost would not sink so low as to appear to a lowly lute player. Convinced, however, that the prophecy was soon to be fulfilled, Michelangelo and Cardiere promptly fled for Bologna. Soon afterward, Piero de' Medici was indeed toppled from power.

Michelangelo was not alone in his belief in dreams and omens. At the time, there was at all levels of society an unquenchable fascination with prophetic knowledge—with everything from visions and astrology to "monstrous births" and the ranting of bearded hermits. Even as skeptical a thinker as Niccolò Machiavelli accepted the deeper meaning of prophetic utterances and other portents. "Nothing important ever happens in a city or in a region," he wrote, "that has not been foretold either by diviners or by revelations or by prodigies or by celestial signs."[2]

Anyone professing the power to read the future could be assured of a large audience in a city like Rome, and there was no shortage of prophets and other self-professed holy men wandering the streets and prophesying doom to anyone who would listen. In 1491 Rome had been visited by one of these latter-day oracles, a mysterious beggar who roamed the streets and squares, crying, "I say to you, O Romans, that many will weep in this year of 1491, and there will be tribulations, killings and blood upon you!"[3] One year later, Rodrigo Borgia was elected pope. Then another such prophet appeared in the city. His rather sunnier message—"Peace, peace"—brought him such a large following among the rabble, who called him Elijah, that the authorities threw him in prison.[4]

This credulous fascination with prophetic knowledge helps explain the presence of the five larger-than-life female figures—sibyls from Greek and Roman mythology—in Michelangelo's fresco. The sibyls were soothsayers, women who dwelled in sacred shrines and predicted the future in fits of inspired madness, often using obscure utterances such as riddles and acrostics. The Roman historian Livy reported that a collection of their writings was guarded by priests and consulted by the Roman Senate in times of need. The writings were used for this purpose as late as 400 C.E., but soon after that date, most of them were burned on the order of Stilicho, leader of the Vandals. From the ashes of these texts, however, reams of new ones arose, claiming to offer the wisdom of the sibyls. In Michelangelo's time, these prophetic writings enjoyed a wide circulation, including in a manuscript called the "Oracula sibyllina." This particular work was actually a confusing and fraudulent mishmash of Judaeo-Christian writings, but in 1509 few scholars thought to question its validity.

Figures from pagan mythology might seem like strange interlopers in a Christian chapel, but two of the church fathers, Lactantius and St. Augustine, had granted the sibyls a Christian respectability by declaring that their utterances actually foretold such things as the Virgin Birth, the Passion of Christ, and the Last Judgment. The sibyls had prepared the pagan world for the com-

ing of Christ, it was maintained, in the same way that the Old Testament prophets had prepared the Jews. The sibyls and their prophetic books were therefore alluring to scholars who aimed to reconcile pagan mythology with orthodox Christian teachings. They neatly bridged the gap between these two worlds, offering a compelling link between the sacred and the profane, between the Roman Church and the esoteric pagan culture that so enchanted artists and scholars alike.

Some theologians, such as Aquinas, had refused to grant the sibyls the same powers as the Old Testament prophets, but by the Middle Ages their place in Christian art was assured. Choir stalls carved in the cathedral of Ulm in the fifteenth century boldly displayed them alongside female saints and Old Testament heroines. In Italian art they became almost ubiquitous, appearing, among other places, on the facade of the duomo in Siena, on pulpits in Pistoia and Pisa, and on Ghiberti's bronze doors for the baptistery in Florence. They also made popular subjects for frescoes. After Ghirlandaio depicted four sibyls on the vault of the Sassetti Chapel in Santa Trìnita, Pinturicchio followed suit in the Borgia apartments, frescoing a dozen sibyls alongside a dozen Old Testament prophets. Soon afterward, Perugino included six of each in the Collegio del Cambio in Perugia.

The first sibyl that Michelangelo painted in the Sistine Chapel, Delphica, was famous for informing Oedipus that he was destined to kill his father and marry his mother. The most important oracle in Greece, the Delphic Sibyl dwelled on the slopes of Mount Parnassus, in a temple to Apollo that displayed on its facade the maxim "Know Thyself." From here she delivered pronouncements so enigmatic that priests were required to interpret them. One of her notoriously slippery prophecies had been addressed to Croesus, the king of Lydia, who was told that, by attacking the Persians, he would bring down a mighty empire; only after his dramatic defeat did Croesus realize that the empire in question was his own. Less ambiguous were her prophecies in the "Oracula sibyllina," where she supposedly foretold how Christ

would be betrayed into the hands of his enemies, mocked by soldiers, and given a crown of thorns.

Michelangelo and his assistants spent twelve *giornate* on the Delphic Sibyl in the autumn of 1509, taking roughly the same amount of time, in other words, as they had on Zechariah a short while earlier. Michelangelo depicted her as a young woman with parted lips, wide eyes, and a faint look of distress, as if she had just been startled by an intruder. Showing little of the divine madness for which the sibyls were renowned, she was in fact pieced together from a number of Michelangelo's Virgins. Her blue headdress, painted in *smaltino*, resembles those on the heads of the sculpted Virgins of both the *Pietà* and the *Bruges Madonna*, the latter being a Madonna and Child completed in 1501 and purchased by a family of Flemish cloth merchants who installed it in their family chapel in Bruges. Her head and posture, meanwhile, recall the Virgin in Michelangelo's *Pitti Tondo* (a marble relief finished about 1503), and her draped garment and muscular arm, bent at a ninety-degree angle, come from the *Holy Family* painted for Agnolo Doni.[5]

"Michelangelo has a most retentive memory," Condivi once claimed, "so that, although he has painted all the thousands of figures that are to be seen, he has never made two alike or in the same pose."[6] On the contrary, it was precisely because Michelangelo had a most retentive memory that he was able to generate, in a short space of time, so many hundreds of postures for the Sistine's ceiling.

Michelangelo would paint four more sibyls on the vault, including the ancient Romans' most important prophetess, Cumaea. According to the myth, Cumaea lived one hundred miles south of Rome in a grotto at Lake Avernus, near Naples. It was here, supposedly, that Aeneas, the hero of Virgil's *Aeneid*, watched her lapse into a frightening trance and heard her utter "words of mystery and dread."[7] And it was here, to a stinking cave beside this deep, sulphurous lake, that scholars of Michelangelo's day beat a trail as if to a religious shrine. The cave beside Lake Avernus was probably a Roman tunnel built by Agrippa as part of a harbor known as the Portus Julius. These learned pilgrims imagined themselves, howev-

er, in the very spot where Aeneas and his Trojan friends had conversed with the Cumaean Sibyl and then made their way into the Underworld.

Given the popularity of the sibyls in Italian art, Michelangelo did not necessarily require the urgings of an adviser such as Egidio da Viterbo to incorporate Cumaea and the other ancient prophetesses into the ceiling. The sibyls depicted in the Sistine Chapel are the first five from a list of ten given in the *Divine Institutions* of Lactantius, a coincidence suggesting that Michelangelo might simply have leafed through this volume to make his selection. Egidio may nonetheless have been responsible for the inclusion and prominence of the sibyls, since he had a strong interest in their prophecies, particularly those of the Cumaean Sibyl.[8] He himself had made an excursion to her grotto on Lake Avernus, boldly descending into the cave to report how the fetid subterranean air was conducive to trances and hallucinations of the sort witnessed by Aeneas.[9]

One of Cumaea's pronouncements Egidio found of special significance. In Virgil's *Eclogues* she prophesied the birth of a child who would bring peace to the world and return it to a golden age: "Justice returns to earth, the Golden Age / Returns, and its first-born comes down from heaven above."[10] It had obviously been a simple matter for theologians such as St. Augustine to give this prophecy a Christian spin by identifying the "first-born" child as Christ. The resourceful Egidio went a step farther, declaring in an oration in St. Peter's that the new golden age foreseen by Cumaea was actually the one inaugurated by—naturally—Julius II.[11]

Prophets in Italy were divided into those, such as Savonarola, who foresaw the approach of a deadly doom, and those like Egidio who took a more optimistic view of things. Egidio's reason for optimism was his faith in the steady unfolding of God's purpose through Julius II and King Manuel of Portugal. In 1507, for example, Manuel had written to the pope announcing the discovery of Madagascar and various Portuguese conquests in the Far East. This wonderful news prompted Julius to declare three days of feasting in Rome. In the

midst of these celebrations Egidio took to the pulpit and announced that these events on the other side of the world were proof— together with various other events closer to home, chief among them the rebuilding of St. Peter's—that Julius was fulfilling his divine destiny. "See how God calls you by so many voices," he rejoiced in a sermon addressed to the pope, "so many prophecies, so many deeds well done."[12] Surveying these accomplishments, he was in no doubt that the prophecies of both the Scriptures and the Cumaean Sibyl were being fulfilled, and that a golden age of a worldwide Christendom was about to dawn.[13]

Not everyone in Rome agreed with Egidio. The Cumaean Sibyl depicted on the Sistine ceiling certainly cut a strange figure for someone meant to be the prophetess of the golden age her- alded by the deeds of Julius. Michelangelo portrayed her as a grotesque behemoth with one of the most daunting physiques on the entire vault, complete with long arms, huge biceps, and fore- arms, and Atlas-like shoulders whose sheer bulk dwarfs her head. This rather derogatory portrait also shows her to be farsighted, for she has to hold her book almost at arm's length in order to read. Poor eyesight need not, of course, mean poor insight. Quite the reverse, in fact, since according to some versions of his myth, Tiresias received his prophetic powers as compensation for being blinded after watching Athena at her bath. The impaired eyesight of Cumaea might likewise be understood as a sign of her spiritual foresight.[14] Equally, Michelangelo may have been making a point about the unreliability of her spiritual as well as her physical vision. Whatever the case, his attitude toward this hideous crone and her prophecies seems to be summed up in the gesture of one of the two naked children by her side: He "makes the fig" at her, a rude gesture (described by Dante and still known to Italians) that involved sticking the thumb between the index and middle fin- gers—an Italian equivalent of giving someone the finger.[15]

This obscene gesture is one of a number of sly jokes, not visible from the floor in an age before photographs and telescopic aids to vision, that Michelangelo inserted into his fresco. Despite his surly

nature, the artist was renowned for his sarcastic wit. He once joked, for example, that a certain artist had executed a picture of an ox very well because "any painter can make a good portrait of himself."[16] The naked child making the fig behind the sibyl's back shows that, despite everything, Michelangelo had not lost his sense of humor. But, like his poem about crosses and thorns, it also indicates his skepticism regarding Egidio's exuberant proclamations about the pope and the golden age.

Michelangelo was not the only person in Rome to take a dim view of the pope's supposedly divine mission to reclaim papal territories. An even more skeptical attitude toward Julius was expressed by a distinguished visitor who had arrived in the city in the summer of 1509. Desiderius Erasmus, a forty-three-year-old priest from Rotterdam, was one of the greatest scholars in Europe. He had traveled to Italy three years earlier to serve as tutor to the sons of the court physician of Henry VII of England, who were completing their education abroad. Dividing his time between Venice and Bologna, in the latter city he happened to witness Julius's triumphant entrance. Now with a new student in his care, Alexander Stuart, the illegitimate son of King James IV of Scotland, he came to Rome as the guest of the pope's cousin, the enormously wealthy Cardinal Raffaello Riario. As well as educating Alexander in the classics, Erasmus hoped in the course of this visit to obtain from the pope a dispensation absolving him of the sin of his father, a priest who had clearly not kept his vow of celibacy.

Erasmus enjoyed the warmest of receptions in Rome. He was accommodated in Cardinal Riario's luxurious palace near the Campo dei Fiori and honored during a Mass in the Sistine Chapel with a place inside the sanctum sanctorum. He met both Egidio da Viterbo and the equally bookish and brilliant Fedro Inghirami. Like Egidio,

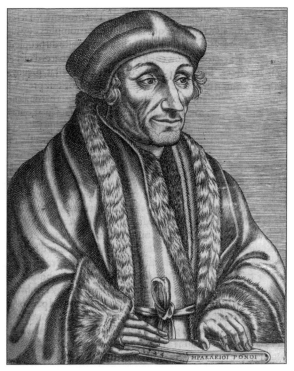

Desiderius Erasmus by Andre Thever.

Erasmus made a piligrimage to the grotto of the Cumaean Sibyl on Lake Avernus. He was also treated to a tour of Rome's ancient monuments and shown the treasures of its libraries—experiences that would linger fondly in his memory. He may even have been allowed a view of the fresco taking shape behind its screen of canvas in the Sistine Chapel. In the summer of 1509 the vault of the chapel was already numbered among the marvels of Rome, for a canon named Francesco Albertini, a onetime pupil of Domenico Ghirlandaio, had just finished his *Opusculum de mirabilis novae et veteris urbis Romae,* a guidebook listing the city's most notable monuments and frescoes. "Michaelis Archangeli," wrote Albertini, was hard at work on his fresco in the Sistine Chapel.[17]

Michelangelo jealously defended his scaffold against intruders, and the frescoes were certainly not open to public viewing. Still, it is not inconceivable that Erasmus was invited onto the scaffold to view the work. Although Erasmus was far more enthusiastic about

books than paintings, his path could easily have crossed Michelangelo's, especially if Egidio da Viterbo was indeed involved in the ceiling's design. They could even have known each other from Bologna, since Erasmus's visit there in 1507 overlapped almost exactly with Michelangelo's. However, no documentary or anecdotal evidence supports any meeting between them, and it is equally possible that these two great men passed like ships in the night.

Erasmus eventually succeeded in his mission, for Julius decreed that the great scholar was the son of a "bachelor and a widow," which was technically the truth but not, of course, the whole story. This dispensation removed from Erasmus the blemish of illegitimacy and made him eligible for ecclesiastical office in England. The offer of a benefice was not long in arriving. His invitation to return to London came from none other than the archbishop of Canterbury, who sent five pounds toward the expenses of his journey. He also received from his friend Lord Mountjoy an excited account of England's new king. Henry VII had died in April of 1509 and been succeeded by his eighteen-year-old son, a handsome young man renowned for both piety and learning. "The heavens laugh and the earth rejoices," Mountjoy wrote of the new reign of King Henry VIII, "all is milk and honey."[18]

Still, Erasmus departed for England only with the greatest reluctance. "Had I not torn myself from Rome," he later recalled, "I could never have resolved to leave. There one enjoys sweet liberty, rich libraries, the charming friendship of writers and scholars, and the sight of antique monuments. I was honoured by the society of eminent prelates, so that I cannot conceive of a greater pleasure than to return to the city."[19]

However, not quite everything about Rome had pleased Erasmus. When he arrived in London, in the autumn of 1509, a short period of convalescence was called for since the stress of the long journey and a rough crossing of the Channel had given him pains in the kidney. He retired to the Chelsea home of his good friend Thomas More, whose coronation poem for Henry VIII had

rejoiced—in words echoing Egidio's praise of Julius—that a new golden age was about to dawn. Forced to stay indoors, in the company of More's numerous children, Erasmus spent seven days composing *The Praise of Folly,* the treatise that would win him notoriety. This work suggests that Erasmus had taken a shrewder view of Rome than he later admitted in his letter extolling the "sweet liberty" of the city. A devastating satire on corrupt courtiers, filthy and ignorant monks, greedy cardinals, arrogant theologians, long-winded preachers, and even crackbrained prophets who claimed to have visions of the future, *The Praise of Folly* was aimed, at least in part, at the culture of Rome under Julius II and his cardinals.

Unlike Egidio, Erasmus did not believe that Julius was about to inaugurate a new golden age. One of the Cumaean Sibyl's other prophecies must have seemed more appropriate to him as he stood beside the sulphurous waters of Lake Avernus in the summer 1509. "I see war and all the horrors of war," she told Aeneas and his companions in *The Aeneid.* "I see Tiber streaming and foaming with blood."[20] To Erasmus, this prophecy of impending war and bloodshed seemed to be fulfilling itself under the bellicose Julius. Included among his numerous targets in *The Praise of Folly* were harsh words for popes who made war in the name of the Church. "Ablaze with Christian zeal," he wrote, no doubt remembering the conquest of Bologna, "they fight with fire and sword . . . at no small expense of Christian blood."[21] And, indeed, only a few short weeks after Erasmus landed in England and wrote these words, Christian blood was shed in the name of the pope.

Once again Julius was having troubles with Venice. Following their defeat at Agnadello, the Venetians had sent envoys to Rome to sue for peace. At the same time, however, they duplicitously appealed for help to the Ottoman sultan and started a fierce military campaign,

The frontispiece for the German edition of Erasmus's
Julius Excluded from Heaven.

capturing both Padua and Mantua. Their attentions then turned to Ferrara, which was ruled by Alfonso d'Este, the commander of the pope's troops and the husband of Lucrezia Borgia. Taking to their galleys, the proud symbol of their far-flung military power, the Venetians sailed up the Po in early December 1509.

Alfonso was ready for them. Though only twenty-three years old, the duke of Ferrara was one of the best military commanders in Europe, a clever tactician whose artillery possessed a worldwide reputation. Fascinated by large guns, he cast enormous cannons in special foundries and then deployed them to devastating effect. One of his most fearsome weapons was "the Lord's Devil," a legendary piece of artillery that in the words of Ferrara's court poet, Lodovico Ariosto, "spits fire and forces its way everywhere, by land, sea, and air."[22]

In 1507, after assuming command of the papal forces while barely out of his teens, Alfonso had repelled the Bentivogli from

Bologna with a tremendous cannonade. The Venetians were next to taste his lethal firepower. Posting cannons on both land and water, his gunners opened fire on the Venetian fleet, ripping it to shreds before the warships could either retaliate or escape. The swiftest and most emphatic artillery victory ever seen in Europe, it not only ended all Venetian hopes of a recovery but also served as a portent of the violent storms soon to rage across the peninsula.

Erasmus had been careful not to name names when he attacked warmongering popes in *The Praise of Folly*. A few years later, however, he published, anonymously, *Julius Excluded from Heaven*, a vitriolic work that portrayed Julius as a drunken, impious, pederastic braggart bent only on war, corruption, and personal glory. Showing a biting wit and a keen eye for historical events, the pamphlet featured Julius arriving at the gates of Heaven, clad in bloodstained armor and followed by his entourage, "a horrifying mob of ruffians, reeking of nothing but brothels, booze shops and gunpowder."[23] He was denied entry by St. Peter, who persuaded him to confess his numerous sins and then condemned his papacy as "the worsty tyranny in the world, the enemy of Christ, the church's bane."[24] Julius, however, was undaunted. He vowed, typically, to raise an even larger enemy and then take Heaven by force.

THE SCHOOL OF ATHENS

ST. PETER: *Did you distinguish yourself in theology?*
JULIUS: *Not at all. I had no time for it, being continually engaged in warfare.*

SUCH WAS ERASMUS'S disparaging view of the intellectual and religious achievements of Julius II.[1] While it is true that the pope was not a distinguished theologian like his uncle Sixtus, he was nonetheless an important patron of letters. Although Erasmus dismissed the scholarship produced during Julius's reign as the "fanciest rhetoric" whose sole aim was flattering his vanity,[2] others were more complimentary. In particular, the pope was praised by his supporters for having revived classical learning in Rome by fostering institutions such as the Vatican Library. On the Feast of the Circumcision in 1508, for instance, a poet and preacher named Giovanni Battista Casali delivered a sermon in the Sistine Chapel extolling his promotion of art and learning.[3] "You, now, Julius II, Supreme Pontiff," Casali enthused, "have founded a new Athens when you summon up that prostrated world of letters as if raising it from the dead, and you command that . . . Athens, her stadia, her theatres, her Athenaeum, be restored."[4]

This sermon was preached almost a year before Raphael's arrival in Rome. However, the young painter would take this idea of Julius's foundation of a new Athenaeum as the subject for his second wall fresco in the Stanza della Segnatura. By the start of 1510, after spending nearly a year on *The Dispute of the Sacrament,* he had moved across to the opposing wall and begun frescoing, beneath the muse of philosophy, the scene known since the seventeenth century (following its designation in a French guidebook) as *The School of Athens.*[5] Where the

Disputà featured a gallery of eminent theologians, Raphael's new fresco portrayed a host of Greek philosophers and their students on the wall above where the pope intended to place his volumes of philosophy.

The School of Athens shows more than fifty figures, including Plato, Aristotle, and Euclid, gathered in conversation and study beneath the coffered vault of a classical temple that looks suspiciously like the interior of St. Peter's as planned by Bramante. The architect was said by Vasari to have helped Raphael design the fresco's architectural features. Still in charge of the thousands of carpenters and masons who were in the process of building the new basilica, the great architect was not so busy, it seems, that he could not find the time to assist his young protégé.[6] Raphael in turn paid homage to Bramante by portraying him as Euclid, the bald-headed figure who bends over a slate and illustrates one of his theorems with a compass.

Besides Bramante, Raphael included a portrait of someone else who had, in a manner of speaking, assisted him with his fresco. His depiction of Plato—bald crown, gray-blond locks, a long, wavy beard—is usually understood to be a portrait of Leonardo. Giving Plato the features of an artist was a somewhat ironic gesture, as Raphael may have known, since in the *Republic* Plato had condemned the arts and banished painters from his ideal city. However, the equation of this multitalented artist with the greatest of all philosophers may have had something to do with the wide range of Leonardo's studies and accomplishments, which by 1509 had become legendary throughout Europe. It was also a tribute to a painter to whom Raphael still turned for inspiration, since the figures grouped around Pythagoras (seated in the fresco's left foreground) are modeled closely on the passionately animated figures crowding the Virgin Mary in Leonardo's unfinished *Adoration of the Magi,* an altarpiece begun thirty years earlier.[7]

The fresco's homage to Leonardo seemed to imply that this great sage, like Plato, was the teacher from whom all others must learn. One art historian has identified this sense of discipleship as a characteristic feature of Raphael's nature.[8] Consisting of a series

of teacher-student relationships in which philosophers like Euclid, Pythagoras, and Plato are surrounded by their respective acolytes, *The School of Athens* implies that learning to philosophize is a process not unlike the one through which an apprentice learns to paint by studying under a master.✝ Raphael modestly portrayed himself as a student of Ptolemy, the Alexandrian astronomer and geographer. However, on the strength of his work in the Stanza della Segnatura, he was soon to become a revered master himself, a teacher in demand by flocks of eager students. Vasari described, in a scene that could have come straight out of *The School of Athens,* how the young painter was always surrounded by dozens of pupils and assistants: "He was never seen to go to court without having with him, as he left his house, some fifty painters, all able and excellent, who kept him company in order to do him honour."9

The sociable and popular Raphael was therefore a simpatico member of the sort of company that he portrayed in *The School of Athens,* first as student, then as a revered master. This kind of sociable existence—and style of art—was, of course, alien to the solitary, self-absorbed Michelangelo. Far from portraying elegant groups engaged in polite and learned conversation, Michelangelo's crowd scenes, such as *The Battle of Cascina* or *The Flood,* were always violent, every-man-for-himself struggles for survival, full of straining limbs and wrenched torsos. Nor was Michelangelo ever surrounded by a team of students. On one occasion, legend has it, Raphael was leaving the Vatican in the company of his vast entourage when he encountered Michelangelo—who, typically, was alone—in the middle of the Piazza San Pietro. "You with your band, like a bravo," sneered Michelangelo. "And you alone, like the hangman," retorted Raphael.

Living and working in such close proximity, the two artists were destined occasionally to cross paths. However, Michelangelo seems

✝The only philosopher portrayed completely on his own in the initial version of *The School of Athens* was Diogenes, a notorious eccentric who lived in a barrel and treated Alexander the Great to insolent replies. Because of his shameless disregard for social conventions, Diogenes was known by the people of Athens as Kyon (Dog). Raphael shows him sprawled on the marble steps in a carefree state of undress.

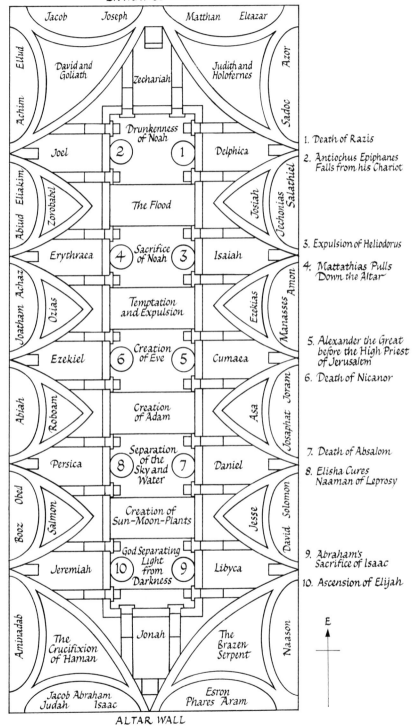

ENTRANCE WALL

Jacob Joseph Matthan Eleazar

Eliud

Achim David and Zechariah Judith and Azor
 Goliath Holofernes Sadoc

Abiud Eliakim

Zorobabel Joel Drunkenness Delphica Josiah Jechonias Salathiel
 of Noah
 ② ①

Erythraea The Flood

Joatham Achaz

Ozias Erythraea Sacrifice Isaiah Ezekias Manasses Amon
 ④ of Noah ③

Abiah Ezekiel Temptation Cumaea
 and Expulsion
 ⑥ Creation ⑤
 of Eve

Roboam Creation
 of Adam Asa Josaphat Joram

Obed Persica Separation Daniel David Solomon
Booz of the
Salmon ⑧ Sky and ⑦
 Water

 Creation of
 Sun–Moon–Plants Jesse

Aminadab Jeremiah God Separating Libyca
 Light
 ⑩ from ⑨
 Darkness

Naason The Jonah The
 Crucifixion Brazen
 of Haman Serpent

Jacob Abraham Esron
Judah Isaac Phares Aram

ALTAR WALL

1. Death of Razis

2. Antiochus Epiphanes
 Falls from his Chariot

3. Expulsion of Heliodorus

4. Mattathias Pulls
 Down the Altar

5. Alexander the Great
 before the High Priest
 of Jerusalem

6. Death of Nicanor

7. Death of Absalom

8. Elisha Cures
 Naaman of Leprosy

9. Abraham's
 Sacrifice of Isaac

10. Ascension of Elijah

E

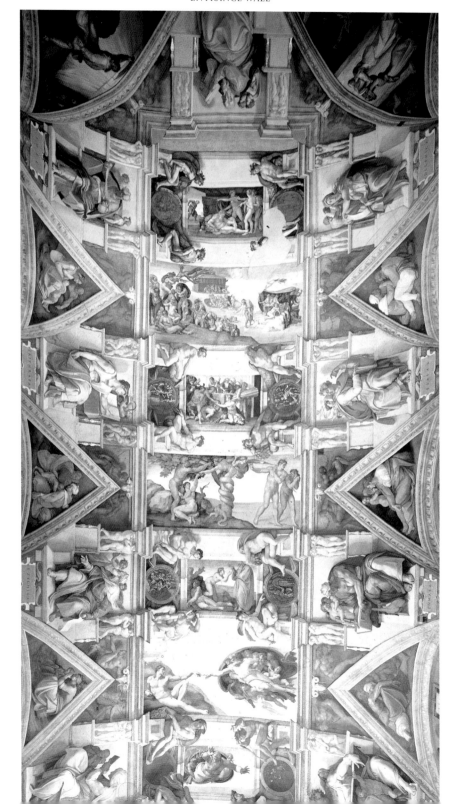

E

ALTAR WALL

The ceiling of the SISTINE CHAPEL

The Naason Lunette

The Josias Jechonias Salathiel *lunette and spandrel*

The Prophet Jonah

MICHELANGELO *by Bugiardini Giuliano*

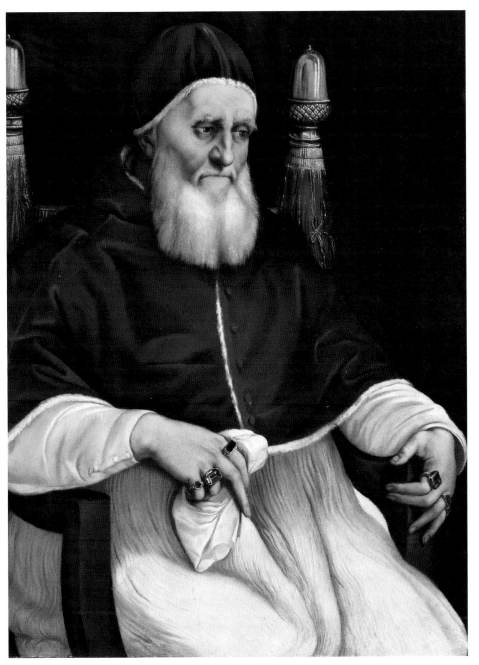

The portrait of Pope Julius II painted for Santa Maria del Popolo in 1511
(Raphael)

THE DISPUTE OF THE SACRAMENT *(Raphael)*

THE EXPULSION OF HELIODORUS *(Raphael)*

to have kept to one corner of the Vatican, Raphael to another. Such were Michelangelo's suspicions of Raphael, whom he regarded as an envious and malicious imitator, that the younger artist was one of the last people who would ever have been allowed onto the scaffold. "All the discords that arose between Pope Julius and me," he later wrote, "were owing to the envy of Bramante and Raphael," both of whom, he insisted, wished to "ruin me."[10] He even managed to convince himself that Raphael had plotted with Bramante to creep into the chapel for a sneak preview of the fresco. The young artist had supposedly played an ignominious role in the episode in which Michelangelo fled to Florence after hurling planks from the scaffold at the pope. Taking advantage of Michelangelo's absence, he was secretly admitted to the chapel by Bramante, after which he proceeded to study his rival's style and technique, hoping to give his own works the same majesty.[11] Though Raphael would naturally have been curious to see Michelangelo's work, talk of such a conspiracy should probably be dismissed. Nonetheless, it seems clear that the rude, suspicious Michelangelo was the one person in Rome on whom Raphael's famous charm was entirely lost.

Raphael was already becoming the leader of a team of talented assistants and apprentices by the time he worked on *The School of Athens*. Proof that he used at least a couple of helpers comes from a series of different-sized handprints found in the plaster during conservation work in the 1990s. These impressions date from the time of the fresco's execution, having been left in the wet *intonaco* by the painters as they supported themselves on the wall while balancing on the scaffold.[12]

The presence of these assistants notwithstanding, Raphael himself seems to have done most of the actual painting, which took

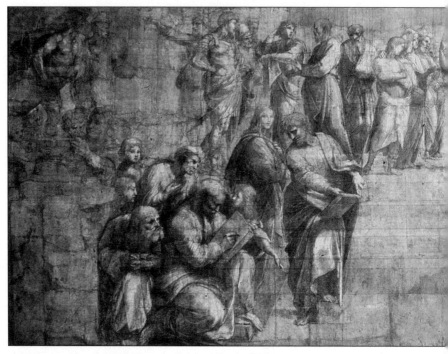

Raphael's cartoon for The School of Athens.

forty-nine *giornate,* or some two months of work. On the neck of the tunic worn by Euclid he even inscribed his signature, four letters—RVSM—that stand for "Raphael Vrbinus Sua Mano" (Raphael of Urbino, His Hand). This inscription leaves in little doubt whose hands were ultimately responsible for the work.

Raphael made scores of sketches and designs for *The School of Athens,* beginning with *pensieri* (first thoughts), tiny ink squiggles which he turned into much more detailed drawings in red or black chalk. One of his sketches, a silverpoint study of Diogenes, who sprawls on the steps of the temple, shows how extensively the poses were rehearsed on paper, with careful attention paid to every detail—arms, torso, even the toes. Unlike Michelangelo's fresco, more than fifty feet above the heads of its viewers, Raphael's would be subject to close scrutiny. Scholars and other visitors to the pope's library would be able to stand within a few

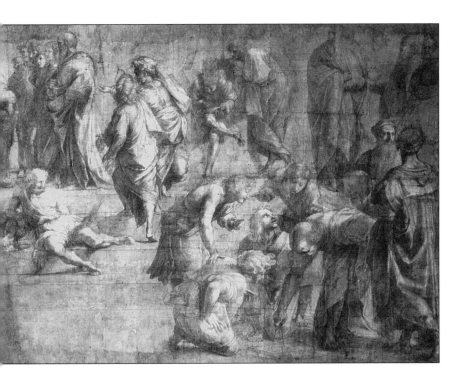

feet of the lower figures, hence Raphael's concern with every minute wrinkle and digit.

Having completed his numerous drawings of the faces and stances of his fifty-odd philosophers, Raphael used the technique known as *graticolare* (squaring) to enlarge the figures and transfer their designs onto the glued-together sheets of paper making up his cartoon. This enlargement was a fairly simple process that involved dividing the sketches into a grid of ruled squares which was then reproduced on the cartoon, enlarged by a factor of, say, three or four.

The enlargement squares can still be seen on Raphael's cartoon for *The School of Athens,* the only cartoon from either the Stanza della Segnatura or the Sistine Chapel to survive.[13] Nine feet high and over twenty-four feet wide, it was done in black chalk, with the ruled lines of the enlarging squares visible beneath the detailed drawings of Plato, Aristotle, and company. Intriguingly, none of the

architectural backdrop is included in the cartoon—evidence, per-
haps, that these details were indeed contrived by Bramante.[14]

The cartoon is intriguing for another reason. Although either
Raphael or his assistants meticulously perforated its outlines, the
cartoon itself was never actually applied to the wet plaster. It would
have been difficult, if not impossible, to transfer a cartoon of this
size to the wall. In such cases, artists usually cut their cartoons into
a number of smaller and more manageable pieces. But Raphael did
not choose this method. Instead, in a procedure entailing even
more work, its design was transferred by means of *spolvero* to small-
er pieces of paper that have been dubbed "auxiliary cartoons."[15]
These smaller cartoons were then fixed to the *intonaco,* while the
large "master cartoon" remained intact. This time-consuming
approach raises the question of why Raphael should have wished to
preserve his cartoon, and why it was never used for the purpose for
which it was seemingly created.

Until four or five years earlier, cartoons had been nothing more
than utilitarian drawings that almost never survived the projects for
which they were designed. Fixed to the damp *intonaco* and traced
with a stylus or pricked with hundreds of holes, they were by nature
ephemeral and disposable. All of this changed in 1504, when
Leonardo and Michelangelo exhibited their giant cartoons in
Florence. So popular and influential were these two drawings that
henceforth cartoons came to be celebrated as works of art in their
own right. Though the contest in the Hall of the Great Council
never reached a conclusion, it served to catapult cartoons, as one art
historian has observed, "to the forefront of artistic expression."[16]

In creating a showpiece cartoon for *The School of Athens,* Raphael
was both emulating his two artistic heroes and testing his own
powers of draftsmanship and design against theirs. No records
indicate that his cartoon was ever exhibited, but the ambitious
young Raphael always craved a wide audience for his work.
Michelangelo was assured of a steady stream of spectators for his
fresco in the Sistine Chapel, where, once unveiled, it would be
appreciated not only by the two hundred members of the Papal

Chapel but also by thousands of pilgrims from all over Europe. Raphael, on the other hand, could expect a more circumscribed group of admirers in the pope's private library, an area off-limits to all but the most eminent and erudite churchmen. His grand cartoon could therefore have been intended to make his work known outside the confines of the Vatican, and to invite comparisons to the works of both Michelangelo and Leonardo.

Raphael had good reason to wish to publicize *The School of Athens* far and wide, since it undoubtedly represented the zenith of his career to date. A masterpiece of pictorial composition in which the young artist skillfully integrated his large cast of uniquely expressive characters into a striking architectural space, it goes beyond artists' usual store of poses and gestures—blessing, prayer, adoration—to express more subtle feelings through the imaginative gestures, movements, and interactions of his figures.[*] The four young pupils surrounding Euclid, for example, were all given different poses and expressions to show their varying emotions: wonder, concentration, curiosity, comprehension. The overall result is a group of distinctive individuals whose graceful movements ebb and flow across the wall, drawing the spectator's eye from one figure to another, all expertly integrated within a brilliantly realized imaginary space. It reveals, in short, exactly the sort of drama and unity that had escaped Michelangelo in his first few Genesis scenes.

[*]Enthusiasm for Raphael's abilities to display ranges of emotion eventually reached such a peak that in 1809 two English engravers, George Cooke and T. L. Busby, published a book, *The Cartoons of Raphael d'Urbino,* in which they included an "Index of Passions" identifying specific figures with their precise emotional states.

FORBIDDEN FRUIT

THE ROMAN CARNIVAL that took place in February of 1510 was even more jubilant and unruly than usual. All of the familiar entertainments were on show. Bulls were released into the streets and slain by men on horseback armed with lances. Convicted criminals were executed in the Piazza del Popolo by a hangman dressed as a harlequin. South of the piazza, races along Via del Corso included a competition between prostitutes. An even more popular attraction was the "racing of the Jews," a contest in which Jews of all ages were forced to don bizarre costumes and then sprint down the street to insults from the crowd and sharp prods from the spears of the soldiers galloping behind. Cruelty and bad taste knew no bounds. There were even races between hunchbacks and cripples.

In addition to these regular delights, the carnival of 1510 offered yet another diverting spectacle. The ceremony officially lifting the excommunication of the Venetian republic took place on the steps of what remained of the old St. Peter's, in front of a huge crowd that swarmed into the piazza to watch. Five Venetian envoys, all noblemen clad in scarlet, the biblical color for sin, were forced to kneel on the steps before the pope and a dozen cardinals. Julius perched on his throne with a Bible in one hand and a golden wand in the other. The five envoys kissed his foot and then remained on their knees as the terms of absolution were read out. Finally, as the papal choir broke into the Miserere, the pope lightly struck the shoulder of each envoy with his wand, magically absolving them and the republic of St. Mark of their sins against the Church.

The conditions for Venice's absolution were severe. Besides giving up all claim to the towns in the Romagna, Venice lost all other possessions on the mainland as well as the exclusive right of naviga-

tion in the Adriatic. The pope also demanded that the Venetians stop taxing the clergy and return goods taken from religious associations. The republic had little choice in any of these matters following the defeat at Agnadello and the annihilation of its galleys by Alfonso d'Este.

In France, news of the reconciliation between the pope and Venice was received with rage and disbelief. Having longed for nothing less than the complete destruction of the Venetian republic, Louis XII protested that the pope, by making peace, had thrust a dagger into his heart. Julius was no happier with Louis. He had been eager to make peace with Venice precisely in order to curb the growing power of France. Louis was by now lord of both Milan and Verona, pro-French regimes ruled Florence and Ferrara, while in Genoa, the pope's hometown, the French had just raised an enormous fortress to keep the rebellious population in check. The complete ruin of Venice, Julius knew, would have rendered French domination of northern Italy complete, leaving Rome vulnerable to both the whims and assaults of the French monarch. Louis had already meddled in ecclesiastical affairs by insisting on appointing French bishops. This demand did not sit well with Julius. "These French," he bellowed to the Venetian ambassador, "are trying to reduce me to nothing but their king's chaplain. But I mean to be pope, as they shall find out to their discomfiture."[1]

Having reclaimed the papal territories and made peace with Venice, Julius turned his energies to achieving his next goal: ousting foreigners from Italy. *Fuori i barbari* (out with the barbarians) became his battle slogan. A "barbarian" was for Julius anyone who was not Italian, but especially anyone who was French. He tried to enlist the help of the English, the Spanish, and the Germans, but none of them relished the prospect of tangling with the French. Only the Swiss federation agreed to an alliance. In March 1510, therefore, Julius concluded a five-year treaty with the twelve cantons, who agreed to defend the Church and the Holy See against its enemies. They promised the pope the services, should he need them, of 6,000 soldiers.

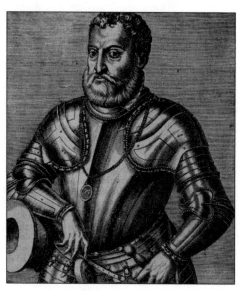

Alfonso d'Este, Duke of Ferrara, by Andre Thever.

Swiss soldiers were the best in Europe, but even 6,000 of their infantrymen was a modest force with which to face the 40,000 French troops encamped on Italian soil. Nonetheless, with this treaty in his pocket, an emboldened Julius began making plans to attack the French on all fronts—Genoa, Verona, Milan, Ferrara—with the help of both the Swiss and the Venetians. He appointed his twenty-year-old nephew, Francesco Maria della Rovere, the duke of Urbino, as captain general of the Church, making him the supreme commander of the papal forces. He then concerned himself with one battle in particular.

The duke of Ferrara, Alfonso d'Este, had once been the pope's good friend and ally. Barely two years earlier, Julius had presented Alfonso with a priceless ornament, the Golden Rose, which he awarded each year to the leader who had best served the interests of the Church. In Alfonso's case, the Golden Rose was a reward for helping the pope expel the Bentivogli from Bologna. More recently, Alfonso's ferocious display of firepower on the banks of the Po had been responsible, more than anything else, for bringing the Venetians, quite literally, to their knees.

Thereafter, however, Alfonso had not behaved so commendably. He was persisting with his attacks on the Venetians, even though

the peace treaty had been signed. Worse, he was doing so at the urgings of the French, with whom he had allied himself. Finally, adding insult to injury, he continued to work a salt marsh near Ferrara in defiance of the papal monopoly on salt, an impudence for which he was castigated in a sermon by Egidio da Viterbo. Julius therefore determined to bring the rebellious young duke to heel.

The people of Rome seemed to approve of Julius's saber rattling. On the twenty-fifth of April, the Feast of St. Mark, a battered statue known as the *Pasquino,* which occupied a pedestal near the Piazza Navona, was dressed by merrymakers in the garb of Hercules chopping off the head of the Hydra, a reference to the pope vanquishing his enemies. This ancient statue had recently been unearthed—so the story goes—in the garden of a schoolmaster named Pasquino. Featuring one man carrying another in his arms, the statue was probably meant to illustrate the episode in *The Iliad* where Menelaus hefts the body of the slain Patroclus. One of the most popular sights in Rome, the *Pasquino* was yet another ancient statue from which Michelangelo quoted as he frescoed the Sistine Chapel, since his tableau of the older, bearded man bear-hugging the limp corpse of his son in *The Flood*—one of the very first scenes painted—was clearly inspired by it.

Yet not everyone in Rome was prepared to celebrate the pope's new military campaign. That spring, Giovanni Battista Casali—the man who had praised Julius for creating a "new Athens"—delivered another oration in the Sistine Chapel. This time he was not so flattering to the pope, condemning kings and princes who made war against each other and shed Christian blood. The long-haired Casali was a wise and eloquent speaker whose sermon was aimed at the pope as much as Louis and Alfonso. No one, however, seems to have paid heed to him—certainly not Julius, who, in the bitter words of Michelangelo's poem, was busily beating chalices into helmets and swords.

The early months of 1510 were not a happy time for Michelangelo for reasons other than the pope's impending war. In April he learned of the death in Pisa of Lionardo, his older brother. Lionardo had reconciled himself with the Dominicans after the order defrocked him because of his support for Savonarola, and in the years before his death he lived in the convent of San Marco in Florence. After moving to the monastery of Santa Caterina in Pisa early in 1510, he died there of unknown causes, at the age of thirty-six.

Michelangelo seems not to have traveled home to Florence for the funeral, though it is unclear whether his absence was due to his heavy commitments in Rome or some breach with Lionardo, whom he almost never mentioned in his letters. Strangely, he was not nearly as close to his older brother as he was to the three younger ones, none of whom shared the same intellectual and religious interests.

Michelangelo had by this time moved on to the large field next to *The Sacrifice of Noah* and close to the center of the vault. Here he put the finishing touches to *The Temptation and Expulsion,* his latest Genesis scene. Frescoed more swiftly than its predecessors, the scene took only thirteen *giornate,* roughly one third as much time as the others. The feat was impressive considering how Indaco, Bugiardini, and the others had returned to Florence, leaving Michelangelo to carry out his complex preparations and routines with some new assistants. Giovanni Michi, who had joined the team in the summer of 1508, remained with Michelangelo during this time, as did the sculptor Pietro Urbano.[2] Among the new frescoists were Giovanni Trignoli and Bernardino Zacchetti, both of whom came, not from Florence, but from Reggio nell'Emilia, fifty miles northwest of Bologna. The pair were somewhat undistinguished as artists, but Michelangelo later became good friends with them.

Michelangelo's latest Genesis scene was split in two. The left half showed Adam and Eve reaching for the forbidden fruit in a rocky and barren Eden, the right their subsequent expulsion from the garden by an angel brandishing a sword above their heads. Michelangelo, like Raphael, painted the serpent with a female torso and head. With her fat coils knotted around the tree of

knowledge, she hands the piece of fruit to Eve, who reclines on the ground next to Adam, her left arm extended to receive it. The simplest of the Genesis scenes painted so far, it featured only six figures, all considerably larger than those in the previous panels. In contrast to the tiny figures in *The Flood,* the Adam of *The Temptation* stands almost ten feet tall.

The Bible makes it perfectly clear who was responsible for first tasting the fruit and therefore causing the Fall of Man. "So when the woman saw that the tree was good for food," the Book of Genesis reports, "and that it was a delight to the eyes, and that the tree was to be desired to make one wise, she took of its fruit and ate; and she also gave some to her husband, and he ate" (Genesis 3:6–7). Theology traditionally followed this passage and therefore blamed Eve for leading Adam astray. As the first one to transgress a covenant, she caused not only the expulsion from Paradise but also, as further punishment, her subordination to her husband. "Your desire shall be for your husband," she was told by the Lord, "and he shall rule over you" (Genesis 3:16).

This passage was used by the Church—as it had been by the ancient Hebrews—to justify the inferior position of women. However, Michelangelo departs from both the biblical account of the Temptation and previous depictions such as Raphael's. Whereas Raphael featured a curvaceous Eve holding a piece of fruit for Adam to sample, Michelangelo's Adam is far more aggressive, reaching into the branches to seize a piece of fruit for himself—a greedy initiative that almost seems to exonerate Eve, who adopts a far more languid, passive posture on the ground beneath him.

New theories about Eve were in the air in 1510. A year before Michelangelo painted his scene, a German theologian named Cornelius Agrippa von Nettesheim published *On the Nobility and Superiority of the Female Sex,* in which he argued that Adam, not Eve, had been forbidden from eating fruit from the tree of knowledge, "so it was man, not woman, who sinned in eating; man, not woman, who brought in death; and we have all sinned in Adam, not Eve."[3]

Agrippa concluded that on these grounds it was unjust to prevent women from holding public office or even preaching the Gospel—a liberal view that promptly got him expelled from France, where he had been teaching the cabala in Dôle, near Dijon.

Michelangelo's novel portrayal of the scene created no such stir. His motive was not so much an exculpation of Eve as an equal condemnation of Adam. The true nature of their sin seems to be pantomimed by the provocative tableau of the robust, straining male straddling the sprawled female—a pose made all the more suggestive by the proximity of Eve's face to Adam's genitalia. Michelangelo further stressed the sexual element of the story by portraying the tree of knowledge as a fig tree, since the fig was a well-known symbol of lust. These erotic implications are perfectly justifiable given that commentators through the ages have agreed that the Fall of Man—in which primordial innocence is doomed by the combination of a woman and a serpent—cries out for a sexual interpretation.[4] If carnal desire was believed to have brought sin and death into the world, nowhere is the fateful concupiscence in the Garden of Eden more graphically on show than in Michelangelo's *Temptation*. Testament to the scene's graphically sexual nature is the fact that, unlike most other parts of the fresco, it was not reproduced in an engraving for almost three centuries after its completion.[5]

Michelangelo's anxious, ascetic views on sex were neatly summed up in a piece of advice he once gave to Ascanio Condivi. "If you want to prolong your life," he informed his pupil, "practice it not at all, or the least that you can."[6] This abstemious philosophy was behind his depiction of the Virgin in the *Pietà,* which came in for criticism because it appeared to show a mother much too youthful to have an adult son. Michelangelo would have none of it. "Don't you know," he asked Condivi, "that women who are chaste remain much fresher than those who are not? How much more so a virgin who was never touched by even the slightest lascivious desire which might alter her body?"[7]

Lascivious desires have certainly left their mark on the body of the Eve portrayed in the right-hand side of Michelangelo's panel.

The woman that the angel evicts from Paradise has been transformed from the sensuously reclining, rosy-cheeked young woman of *The Temptation*—"one of the most beautiful female figures Michelangelo ever painted,"[8] according to one observer—into a hideously ugly old crone with tangled hair, wrinkled skin, and a hunched back. Cowering and covering her breasts, she flees Paradise with Adam, who throws out his arms to ward off a blow from the angel's sword.

Michelangelo's fears about the enervating effects of the sexual act may have been stoked by the scholar Marsilio Ficino, who wrote a treatise explaining how sex was the enemy of the scholar because it sapped the spirit, enfeebled the brain, and led to both indigestion and heart problems. An ordained priest and devout vegetarian, Ficino was famous for his abstinence and chastity. Yet he was also the lover—in the spirit if not the flesh—of a man named Giovanni Cavalcante, whom he bombarded with letters addressed to "my sweetest Giovanni."

Michelangelo's anxieties about sex are sometimes linked to his own perceived homosexuality. Any study of Michelangelo's sexual preferences is beset, however, by lost or suppressed evidence. Moreover, *homosexuality* is largely a modern, post-Freudian category of erotic experience which people in the Middle Ages and Renaissance clearly did not understand in terms equivalent to ours.[9] These different cultural practices and beliefs are exemplified by the Neoplatonic descriptions of love with which Michelangelo would have been familiar from the Garden of San Marco. For example, Ficino coined the term *platonic love* to describe the spiritual bond between men and boys expressed in Plato's *Symposium,* which celebrated such unions as the ultimate manifestation of a chaste, intellectual love. If love between men and women was merely physical, and resulted in feeble brains and indigestion, platonic love "seeks to return us," according to Ficino, "to the sublime heights of heaven."[10]

Another member of the Garden of San Marco, Pico della Mirandola, showed how ambiguously a Renaissance gentleman might conduct his love life. In 1486 the handsome young count,

then aged twenty-three, eloped from Arezzo with a woman named Margherita, the wife of a tax collector. In the ensuing scandal, which involved armed combat, several men were killed and Pico himself injured and then hauled before the magistrates to explain himself. He was forced to apologize to the tax collector, to whom Margherita was promptly returned. The bold young lover then moved to Florence and began exchanging passionate sonnets with the man who became his constant companion, the poet Girolamo Benivieni. This affair did nothing to dim Pico's admiration and support for Savonarola, the scourge of those who took "beardless youths" and nurtured "unspeakable vices." This was not simply a matter of hypocrisy. Despite his love for Benivieni, Pico clearly did not consider himself a sodomite—or at least not the sort of sodomite that Savonarola denounced. Pico and Benivieni were eventually buried side by side, like man and wife, in the church of San Marco, where Savonarola had been the prior.

The case for Michelangelo's homosexuality often rests on a similar sort of relationship with Tommaso de' Cavalieri, a young Roman nobleman for whom he developed a powerful infatuation after they met in about 1532. However, whether or not Michelangelo ever consummated his love for Cavalieri is an open question. Whether or not he ever consummated a love for anyone, male or female, is equally uncertain.[11] He seems to have been, throughout his life, almost utterly indifferent to women, at least as lovers. "Woman's too much unlike," he wrote in one of his sonnets, "no heart by rights / Ought to grow hot for her, if wise and male."[12]

One possible exception to this antipathy was Michelangelo's fourteen-month interlude in Bologna, when some biographers believe he may have taken time away from his work on the bronze statue of Julius to fall in love with a young woman. The evidence for a heterosexual love affair on this occasion is extremely slight: a sonnet inscribed on the back of the draft of a letter written to Buonarroto in December 1507. In the poem, one of the earliest surviving examples of his three-hundred-odd sonnets and madrigals, Michelangelo rather saucily imagined himself as a wreath of

flowers crowning a girl's brow, a dress binding her breast, and a sash embracing her waist.[13] Yet even if his work on the huge statue did leave him opportunities for an affair of the heart, such elaborate conceits make the poem more likely to have been a literary exercise than an ardent declaration of love for a flesh-and-blood Bolognese maiden.

Another biographer, hoping to overcome rumors that Michelangelo was impotent, a pedophile, or a homosexual, has speculated that the artist may once have contracted syphilis.[14] The evidence for a venereal disease—a mysterious letter from a friend who celebrates the fact that the artist has been "cured of a malady from which few men recover"[15]—is even more slender than that for a passionate heterosexual tryst in Bologna. The most damning evidence against this theory is simply that Michelangelo lived to the age of eighty-nine without any of the debilitating symptoms, such as blindness or paralysis, associated with the disease. On balance, it seems highly likely that he practiced the abstinence that he preached to Condivi.

This kind of self-denial was definitely not the prevailing philosophy in the workshop of Raphael. Popular not merely among his numerous male companions, the young artist was also a dedicated and successful ladies' man. "Raphael was a very amorous person," claimed Vasari, "delighting much in women, and ever ready to serve them."[16]

If Michelangelo abstained from the pleasures of the flesh available in Rome, Raphael would have found many opportunities for indulging his own apparently insatiable appetites. Since there were more than 3,000 priests in Rome, and since celibacy for priests generally meant little more than not taking a wife, there was naturally an abundance of prostitutes. Chroniclers of the day claimed

that Rome, a city of fewer than 50,000 people, was home to some 7,000 prostitutes.[17] The houses of the wealthier and more sophisticated, the so-called *cortigiane onesti* (honorable courtesans), were easy to find since their facades were decorated with gaudy frescoes. The courtesans themselves could be seen in the windows and loggias, where they lounged on velvet cushions or dyed their hair blond by sitting in the sun after drenching their tresses with lemon juice. The *cortigiane di candela* (courtesans of the candle) occupied less salubrious premises, plying their trade in either the bathhouses or a foul labyrinth of lanes near the Arch of Janus known as the Bordelletto. They generally ended their days living under the Ponte Sisto—the bridge built by Julius's uncle—or confined to a hospital, San Giacomo degli Incurabili, where victims of syphilis were treated with *lignum vitae* (wood of life), a medicine made from the wood of a Brazilian tree.

In 1510, Rome's most famous courtesan was a woman named Imperia, whose father had been a singer in the Sistine Chapel's choir, and whose house stood conveniently near Raphael's in the Piazza Scossa Cavalli. Her house was probably more opulent than the young painter's, for its walls were covered with gold-threaded tapestries, its cornices painted in ultramarine, and its bookcases filled with richly bound books in both Latin and Italian. Its floors were even carpeted—something of a novelty at the time. It also boasted another coveted feature, since legend claims that Raphael and his assistants took time away from their efforts in the Vatican apartments to paint a fresco of a naked Venus on the facade.

It was hardly surprising that Raphael and Imperia should have crossed paths, since artists and courtesans frequently mixed together. Not only did courtesans provide painters with nude models, but wealthy patrons sometimes paid for artists' portraits of their mistresses. A few years earlier, for example, Lodovico Sforza, the duke of Milan, had hired Leonardo da Vinci to portray his mistress, Cecilia Gallerani. Even the *Mona Lisa* might have been the portrait of a courtesan, since a visitor to Leonardo's study once claimed to have seen what he described as a portrait of Giuliano de' Medici's mistress.[18]

The *Mona Lisa* was never delivered to Giuliano, or whoever else the client might have been. Evidently fond of the piece, Leonardo kept it with him for many years, eventually taking it to France, where it was bought by King Francis I. Still, nothing suggests that Leonardo's interest in his enigmatic sitter was anything other than aesthetic. Not so, however, with Raphael and Imperia. Their relations became considerably more intimate, since the amorous young painter—perhaps predictably—eventually became one of her numerous lovers.[19]

THE BARBAROUS
MULTITUDES

"HERE I AM working as usual," Michelangelo wrote home to Buonarroto at the height of the summer in 1510. "I will have finished my painting by the end of next week, that is to say, the part I began, and when I have uncovered it, I think I shall receive payment and will try to get leave to come home for a month."[1]

It was a triumphant moment. After two years of unremitting work, the team had finally reached the middle of the vault.[2] Despite his concern for secrecy, Michelangelo planned to remove the canvas and scaffolding to show his work to the public before starting the second half. Julius had ordered this unveiling, but Michelangelo himself was no doubt eager to see what effect the fresco would produce from the floor. However, he was surprisingly downcast in his letter to Buonarroto. "I do not know what will ensue," he wrote. "I am not very well. I have no time to write more."[3]

Recent work had gone smoothly in comparison to some of the earlier efforts. In a relatively short space of time Michelangelo had completed two more lunettes and spandrels, the prophet Ezekiel, the Cumaean Sibyl, two more pairs of *ignudi*, and his fifth Genesis scene, *The Creation of Eve*. The three figures in *The Creation of Eve* had been painted in only four *giornate*, a swift pace that would have impressed even Domenico Ghirlandaio. Michelangelo was able to work so quickly in part because he had started transferring his cartoons onto the *intonaco* using a combination of *spolvero* and incision—the method used by Ghirlandaio and his assistants in the Tornabuoni Chapel. While the finer details on the cartoons, such as faces and hair, were always perforated and then pounced with charcoal, the larger outlines of bodies and clothing were

simply traced over with a sharp stylus. This technique showed Michelangelo's growing confidence in his abilities as well as, perhaps, his increasing desire to finish the task.

The Creation of Eve was painted directly above the marble screen that separated the clergy from the rest of the chapel. Openmouthed with astonishment, Eve staggers from behind the slumbering Adam to greet her Maker, who regards her almost sorrowfully as he offers a benediction that looks rather like the conjuring gesture of a magician. This was Michelangelo's first portrayal of God, and he represented him as a handsome old man with a white, wavy beard and a flowing lilac robe. The Garden of Eden in the background, like that in *The Temptation and Expulsion,* was represented as a place of the most dubious charms. Michelangelo had no use for landscape painting, deriding the depictions of natural scenery by Flemish painters as works of art suitable only for old ladies, young girls, monks, and nuns.[4] His Paradise was therefore nothing more than a barren patch of land distinguished by a dead tree and a few outcrops of rock.

After the dexterous and imaginative handling of the figures in *The Temptation and Expulsion,* those in *The Creation of Eve* come as something of a disappointment. Michelangelo's design borrows heavily from Jacopo della Quercia's version on the portal of San Petronio in Bologna and is therefore slightly stilted. No foreshortening was used, and the trio of figures have shrunk to a mere couple of feet in height, making them difficult to see clearly from the chapel's floor.

Michelangelo's talents were displayed to much better advantage in the adjacent figure of Ezekiel. Thus far the prophets and sibyls, together with the *ignudi,* had been the most successful parts of the fresco. If Michelangelo experienced difficulties composing scenes as eloquent and ordered as those of Raphael, his larger-than-life single figures allowed him to invoke his talent for muscular colossi. By the halfway point he had painted seven prophets and sibyls in all, a gallery of weighty characters who scrutinize books and scrolls or else, like Isaiah beneath *The Sacrifice of Noah,* stare contemplatively into the middle distance with a furrowed brow that recalls the thoughtful and worried expression of the *David.* The hand-

some, tousle-headed Isaiah resembles, in fact, a seated version of the famous statue, complete with an overlarge left hand.

Ezekiel made a fine addition to this cast of broad-shouldered giants. He was an appropriate subject for the Sistine Chapel, having exhorted the Jews to rebuild the Temple of Jerusalem after receiving a vision in which a surveyor armed with a line of flax and a measuring rod appeared to him and demonstrated the structure's proper dimensions, including the thickness of its walls and the depth of its threshold—dimensions faithfully repeated when the Sistine Chapel was constructed. Michelangelo painted him sitting on a throne with his body torqued violently to the right as if to confront someone. His head is in profile, his face a mask of concentration, eyebrows raised and jaw outthrust.

Besides Ezekiel and Cumaea, *The Creation of Eve* is flanked by four *ignudi* and two bronze-colored medallions threaded with yellow ribbons. The medallions, like the architectural decorations, were left almost entirely to Michelangelo's assistants, who painted ten of them in all. At least one was not only painted but also designed by an assistant, probably Bastiano da Sangallo, since it is similar in style to a number of drawings attributed to him.[5] Four feet in diameter, these medallions were painted entirely *a secco* and, after the first pair, without cartoons as guides. Michelangelo simply drew sketches, which the assistants then transferred onto the plaster in freehand. The bronze color was achieved using burnt sienna, to which gold leaf was afterward applied using a resin-and-oil fixative.

All ten of these scenes were inspired by woodcuts in the 1493 edition of the *Biblia vulgare istoriata,* Niccolò Malermi's Italian translation of the Bible. One of the first printed Bibles to be translated into Italian, it was published in 1490, eventually proving so popular that it had run to six editions by the time work started in the Sistine Chapel. Michelangelo must have owned a copy of this text and consulted it as he made his sketches for the medallions.

The popularity of the Malermi Bible meant that Michelangelo would have expected the pilgrims filing into the Sistine Chapel for

Mass to recognize the scenes on the medallions. But even the illiterate, who had never seen the Malermi Bible, would no doubt have been familiar with many of the scenes from depictions of them elsewhere—just as, of course, they would also have recognized *The Flood* and *The Drunkenness of Noah*. Few artists lost sight of the fact that their art was intended to illuminate stories for the uneducated. The statutes of the painters' guild in Siena stated outright that their task was "the expositions of sacred writ to the ignorant who know not how to read."[6] Frescoes therefore served much the same purpose as the *Biblia pauperum,* or "Poor Man's Bible," a picture book used by the illiterate. And since Masses could last for several hours, worshipers had plenty of time in which to contemplate the illustrations around them.

What, then, might a pilgrim from Florence or Urbino have made of the medallions on the ceiling of the Sistine Chapel? Michelangelo's choice of woodcuts from the Malermi Bible is intriguing. Five of the medallions were copied from the illustrations to the Books of Maccabees, the last of the fourteen books of the Bible known as the Apocrypha. The Apocrypha (derived from the Greek *apokrupto,* meaning "hidden") were works of doubtful authority nonetheless included in the Vulgate, the official Latin version of the Bible compiled and translated by St. Jerome. The Books of Maccabees tell the exploits of a family of heroes who "chased the barbarous multitudes, and recovered again the temple renowned all the world over."[7] The most illustrious member of the family was Judas Maccabaeus, the warrior-priest who stormed Jerusalem in 165 B.C.E. and reconsecrated the temple, an event still commemorated by Hanukkah, the Jewish feast of dedication.

Michelangelo's scenes from Maccabees showed the enemies of the Jewish people getting their just deserts. One of the medallions nearest the door, that above the prophet Joel, illustrated II Maccabees 9, where God sends the king of Syria, Antiochus Epiphanes, sprawling to the ground as he rides toward Jerusalem in his chariot, bent on conquering the Jews. Farther along the vault, the medal-

lion over the prophet Isaiah showed the episode from II Macca-
bees 3 in which Heliodorus, the king's chancellor, descends on Jeru-
salem with orders to despoil the temple, only to be stopped in his
tracks by the sight of a horse mounted by a "terrible rider." Helio-
dorus is not only trampled by the horse but also flogged by two
men armed with sticks—the action featured in the medallion.

Religious wars, would-be plunderers, a city under threat from
invaders, a warriorlike priest who wins victory for his people with
the help of the Lord—the Books of Maccabees would have pos-
sessed a special resonance for visitors to the Sistine Chapel during
the turbulent reign of Julius II. Art was meant to do more, of
course, than simply educate the masses about events in biblical his-
tory; it could also bear a compelling political import. It was no acci-
dent, for example, that the rulers of Florence had commissioned
The Battle of Cascina, an illustration of a victorious skirmish fought
against Pisa, at a time when they were themselves waging their own
war with the Pisans. The scenes from Maccabees on the vault of
the Sistine Chapel likewise suggest that Michelangelo—or, more
likely, an adviser—was anxious to bring home points about papal
authority.

One of the medallions painted in the spring or summer of
1510 was particularly emphatic. The Malermi Bible included at
II Maccabees 1 a woodcut of an event not actually described in the
Apocrypha, that of Alexander the Great kneeling before the high
priest of Jerusalem. Alexander had been on his way to plunder
Jerusalem when the high priest met him outside its walls and so
awed him that the great warrior spared the city. The medallion
itself displays the crowned Alexander kneeling before a robed fig-
ure wearing a papal miter. As such, it was similar to a stained-glass
window commissioned for the Vatican in 1507, which depicted
Louis XII on his knees before Julius. Both this window and the
bronze medallion were eloquent and uncompromising in their
insistence that kings and other temporal rulers must submit to the
will of religious leaders such as the pope.

Michelangelo was therefore glorifying the Rovere popes not

only by festooning the chapel with oak leaves and acorns but also by bolstering the conviction, through the images on these bronze medallions, that enemies of the Church should be brought sharply to heel. However, since he objected in private to the belligerence of the Warrior Pope, Michelangelo seems to have proved something of an unwilling propagandist for Julius's military campaigns. The illustrations from Maccabees may well have been familiar to pilgrims visiting the chapel, but deciphering the tiny disks from the floor would have been possible only for the most sharp eyed among them. Their small size, plus the fact that hundreds of larger and more striking figures overshadowed them, meant their political impact was inevitably blunted. It would take Raphael, working next door in the Vatican, to inflate scenes such as these to more grandiose proportions.

If Michelangelo's feelings about the pope's campaigns were decidedly mixed when he started the fresco, in the summer of 1510—as he prepared to unveil the first half—his support must soon have dwindled even further.

Intimidated by neither the fierce reputation of Alfonso d'Este nor the presence on Italian soil of an enormous French army, Julius readied himself for battle. He confidently informed the Venetian envoy that it was the "will of God" that he should "castigate the duke of Ferrara and free Italy from the hand of the French."[8] The thought of the French presence in Italy put him off his food, he claimed, and kept him from sleeping—which was indeed unusual, for Julius liked both his dinner and his bed. "Last night," he complained to the envoy, "I got up and paced the room, unable to rest."[9]

He might have believed his mission to be divine, but Julius recognized that he needed some earthly help to castigate Alfonso and

evict the French. With this in mind, he took advantage of his alliance with the Swiss federation to form a military elite, the Swiss Guards, granting them their own costume—black berets, ceremonial swords, and uniforms striped crimson and green. Julius had an almost religious faith in Swiss soldiers, the most feared infantrymen in Europe. During the previous century the Swiss had revolutionized the use of the pike—which was now eighteen feet long—and formed themselves into disciplined and relentlessly effective battalions. Wearing almost no armor for the sake of speed and mobility, they would bunch together in tight units and then force themselves en masse against the enemy—a tactic that had so far proved virtually invincible. Julius had hired several thousand Swiss for his crusade against Perugia and Bologna in 1506. Though they saw little action other than tooting their trumpets as the pope sailed on Lake Trasimeno, the success of the expedition seems to have led to his blind faith in their powers.

The campaign against Ferrara began in July of 1510, even though the Swiss troops had yet to arrive from across the Alps. The height of summer was far from an ideal time to start a war. The scorching heat made long marches unpleasant, since suits of body armor weighed more than fifty pounds and had little or no ventilation. Even worse, summer was the season for plague, malaria, and camp fevers, which traditionally claimed more soldiers than the enemy's guns. Ominously, Ferrara was surrounded by a malaria-breeding swamp. Fighting Alfonso d'Este on his own ground was therefore dangerous for reasons other than the duke's celebrated gunners.

The campaign went auspiciously at first as the papal troops, led by Francesco Maria, made incursions into Alfonso's lands to the east of Bologna. Alarmed by this turn of events, within weeks the duke offered to surrender all his lands in the Romagna so long as Julius made no attempt to take Ferrara itself. He even promised to pay the pope's expenses for the war. But Julius, scenting blood, was in no mood for negotiations, and Alfonso's ambassador was ordered to leave Rome on pain of being thrown into the Tiber.

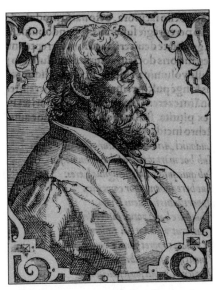

Lodovico Ariosto, engraving by an unknown artist.

This unlucky emissary was none other than Lodovico Ariosto, who had shuttled back and forth on the two-hundred-mile journey between Ferrara and Rome five times during the spring and summer. At the time, he was trying to write his masterpiece, *Orlando furioso,* a 300,000-word poem about knights and chivalry in the days of Charlemagne.✝ With curly dark hair, intense eyes, a thick beard, and a prominent nose, Ariosto looked the part of a poet. He had also distinguished himself as a soldier, but not wishing to cross swords with the pope, he hurried back to Ferrara.

Worse was still to come for Alfonso, for on the ninth of August he was excommunicated as a rebel against the Church. Little more than a week later, no doubt hoping to recapture the glory of his audacious campaign against Perugia and Bologna, the pope decided to go into battle himself. As in 1506, all but the most geriatric cardinals were conscripted into service and ordered to rally in Viterbo, sixty miles north of Rome. Julius meanwhile went first to Ostia—led, as usual, by the Blessed Sacrament—to inspect his war fleet.

✝*Orlando furioso* was first published in forty cantos in 1516; a second edition, also of forty cantos, followed in 1521; the definitive edition of forty-six cantos did not appear until 1532.

From there he sailed north to Civitavecchia on a Venetian galley before continuing the journey overland toward Bologna, which he reached three weeks later, on the twenty-second of September.

Far from worrying about the heat, the expedition was forced to contend with miserable weather. Paride de' Grassi lamented, "The rain perseveringly accompanied us."[10] He also complained that, as the caravan toiled along in the mud and rain, the people in the cities through which they passed—Ancona, Rimini, Forlì—"burst out laughing, instead of greeting the Pope as they ought to have done."[11] Nor did all of the cardinals obey orders, since a number of French prelates stayed loyal to Louis and took themselves instead to the enemy camp in Milan. But at least the splendid entry into Bologna, complete with the usual fanfare, echoed the victorious procession of 1506. Indeed, as Julius was greeted by the enthusiastic Bolognese, it seemed that the Warrior Pope was on the verge of repeating his earlier triumphs.

CHAPTER 21

BOLOGNA REDUX

THE POPE'S DECISION to lead his troops into battle came at a most inopportune moment as far as Michelangelo was concerned. Julius's departure from Rome meant that the first half of the vault could not be unveiled and, worse still, that a promised payment of 1,000 ducats—the sum Michelangelo expected to receive for completing the first half—was not forthcoming. It had been a year since the pope had paid Michelangelo, who was anxious to receive his wages. "The five hundred ducats I have earned in accordance with the agreement are due to me," he complained in a letter to Lodovico early in September, "and as much again which the pope has to give to me to put the rest of the work in hand. But he has gone away and left me no instructions, so that I find myself without any money and do not know what I ought to do."[1]

Michelangelo soon had other worries, for he learned that Buonarroto was seriously ill. He instructed his father to withdraw funds from his bank account in Florence so that his brother had enough money for doctors and medicine. Then as the days passed and Buonarroto's condition failed to improve, and as neither instructions nor money arrived from the pope, Michelangelo decided to take matters into his own hands. In the middle of September he left his assistants at work in the studio, climbed on a horse, and, for the first time in more than two years, took the road north to Florence.

Arriving at the house in Via Ghibellina, Michelangelo found Lodovico preparing to take up a six-month posting as *podestà*, or criminal magistrate, in San Casciano, a small town ten miles south of Florence. The post was not without prestige, since the *podestà* had the power of convicting criminals and passing sentence on them. Lodovico would also be responsible for the town's security, holding the keys to its gates and, if necessary, leading its militia

into battle. He therefore felt the need to make a good impression in San Casciano. Obviously, it would not do for a *podestà* to cook his own meals, sweep the floor, wash the pots and pans, bake his bread, and perform various other humiliating tasks of the sort that he was always complaining about in Florence. Inspired by Michelangelo's offer to pay for Buonarroto's care, he took himself off to the hospital of Santa Maria Nuova and withdrew 250 ducats from his son's account—more than enough to outfit himself in an appropriate style.*

This misappropriation of funds was a shock for Michelangelo, already short of money to finish the fresco. Worse still, the ducats could not be replaced, as Lodovico had spent almost all of them.

"I took it in the hope of being able to replace it before your return to Florence," Lodovico later wrote apologetically to his son. "I said to myself, seeing your last letter, 'Michelangelo won't return for six or eight months from now and in that time I shall have returned from San Casciano.' I will sell everything and will do everything to replace what I took."[2]

Buonarroto's condition soon improved, and Michelangelo therefore saw little reason to linger in Florence. He departed for Bologna, where he arrived on the twenty-second of September, the same day as the pope. The trip to Bologna—not a city that lingered fondly in Michelangelo's memory—turned out to be equally frustrating, for he found the pope in poor health and an even worse temper. The strenuous journey through the Apennines had taken its toll on Julius, and as soon as he arrived in the city he fell ill with a fever. This malady had been predicted by the court astrologers, though it was hardly a risky forecast since Julius was sixty-seven years old and already suffered from gout, syphilis, and the aftereffects of malaria.

*Santa Maria Nuova, founded in 1285, served as a deposit bank as well as a hospital. Its enormous revenues, earned from shrewd investments, made it a safer bet than the more traditional banks, which had a woeful habit of going bust. This financial security meant that many well-to-do Florentines—Leonardo da Vinci as well as Michelangelo—opened deposit accounts in the hospital in return for a 5 percent interest rate.

It was not malaria, however, that felled Julius in Bologna, but a tertian fever, the disease that had killed Pope Alexander VI. Besides his fever, the pope was suffering from hemorrhoids. His physicians no doubt provided him with little relief. Hemorrhoids were treated with celandine, also known as pilewort, a plant considered efficacious in curing piles for no other reason than because its roots looked like distended rectal veins. Such were the hopeful delusions of medical science. Julius's defiance of his physicians and a naturally strong constitution were probably the only things keeping him alive. An intractable patient, he ate foods forbidden to him and threatened to hang his servants if they dared tell the doctors.

Neither the pope's health nor his mood was improved by the disastrous news that his Swiss soldiers had neglected to turn up for the fight. After halfheartedly crossing the Alps, they had turned back unexpectedly soon after reaching the southern end of Lake Como. This defection was a terrible blow to Julius, leaving him vulnerable to a French attack, which now seemed inevitable. At Tours Louis XII had convoked various French bishops, prelates, and other influential men, all of whom assured him that he could in all good conscience make war against the pope. Thus emboldened, the French army, led by the viceroy of Milan, Maréchal Chaumont, advanced on Bologna, while behind it, clamoring for revenge, were the Bentivogli. The pope, delirious with fever, vowed that he would swallow poison rather than fall into the clutches of his enemies.

Fortunately for Julius, the French did not immediately begin their assault. The heavy rains that fell in September continued throughout October, forcing the French troops to pull back when their camp became a quagmire and the muddy roads prevented their provisions from arriving. They beat a retreat to Castelfranco d'Emilia, fifteen miles to the northwest of Bologna, plundering all the way.

The pope was overjoyed by this unexpected turn of events. Even his fever seemed to subside, and when he heard the people of Bologna chanting his name beneath his balcony he was able to totter to the window and shakily offer his blessing. The Bolognese

roared their allegiance, vowing to fight the enemies with him. "Now," he murmured as his aides carried him back to bed, "we have conquered the French."[3]

Michelangelo spent less than a week in Bologna, departing before the end of September. His long and hazardous trip was not without its rewards, however. He returned to Rome with the gift of a block of cheese from a friend in Florence, the sculptor Michelangelo Tanagli. Better still, a month after his visit, at the end of October, he received from the pope's coffers the five hundred ducats due to him for completing the first half of the ceiling. It was his third installment, bringing his total earnings to 1,500 ducats, or half of what he was expecting to be paid. Most of this payment he sent to Buonarroto for deposit in Santa Maria Nuova, thereby plugging the hole left by Lodovico.

But still he was unsatisfied. He felt he was owed another five hundred ducats according to the contract composed by Cardinal Alidosi, and he was determined to have this money before starting work on the second half of the vault. In the middle of December he therefore braved the bad roads and dire weather for a second time in order to plead his case before the pope. As well as demanding the additional five hundred ducats, he intended to present Julius with a document declaring his right to use the house and studio behind Santa Caterina rent free.[4]

Arriving in Bologna in the dead of winter, Michelangelo must have been as dumbfounded as everyone by the changed appearance of the pope. After his fever returned in the autumn, Julius had been taken to convalesce in the house of a friend, Giulio Malvezzi. It was here, at the start of November, that an odd phenomenon had been noted: His Holiness was growing a beard. The cardinals and ambassadors were wide-eyed with disbelief. A pope with a beard— no one had ever seen such a thing. The envoy from Mantua wrote

that the unshaven pontiff looked like a bear; another astounded spectator compared him to a hermit.[5] By the middle of November his white whiskers were an inch or two in length, and in December, when Michelangelo arrived, Julius was wearing a full beard.

Beards were not uncommon among courtiers and artists of the day. Baldassare Castiglione wore one, as did both Michelangelo and Leonardo. Even one of the doges of Venice, the aptly named Agostino Barbarigo, who died in 1501, had sported one. But Julius was going against papal tradition—and even against canon law—by growing his facial hair. In 1031 the Council of Limoges had concluded after much deliberation that St. Peter, the first pope, had shaved his chin, and his successors were therefore expected to follow his clean-shaven example. Priests were not allowed to wear beards for another reason. A mustache, it was reasoned, would interfere with drinking from the chalice, and drops of consecrated wine might stay on it—an undignified fate for the blood of Christ.

Though Erasmus later mischievously claimed in *Julius Excluded from Heaven* that the pope grew the long white beard "as a disguise,"[6] in order to evade capture by the French, he was in fact emulating his imperial namesake, Julius Caesar, who grew a beard in 54 B.C.E. after learning of a massacre of his forces by the Gauls, swearing not to shave until the deaths of his men had been avenged. Julius repeated the vow: A Bolognese chronicler wrote that the pope wore his beard "for revenge," refusing to shave it off until he could "thrash" Louis XII and drive him from Italy.[7]

Michelangelo therefore found Julius cultivating his whiskers in the house of Giulio Malvezzi as he slowly regained his strength. He was entertained in his sickroom by Donato Bramante, who read passages to him from Dante. Also present to raise the pope's spirits was Egidio da Viterbo, who was soon to deliver a sermon comparing Julius's new beard to that of the high priest Aaron, the brother of Moses.

The pope had been frustrated, throughout his illness, by the lack of progress in the push against Ferrara. Coming to grips with the situation, a council of war held in the papal bedchamber in

December concluded that the best way forward was to attack Mirandola, a fortified town twenty-five miles west of Ferrara. Mirandola, like Ferrara, was under French protection, mainly because the widow of the count of Mirandola, Francesca Pico, was the illegitimate daughter of Giangiacomo Trivulzio, an Italian commander in the French army. Both the doctors and the cardinals blanched when Julius announced his intention to lead the assault himself. The scenario did not look plausible, however, since his fever was as bad as ever and the weather unseasonably cold.

Though ill and preoccupied with these affairs, the pope consented to release another payment to Michelangelo. The artist then returned to Florence for Christmas, where he learned that the family home had been burglarized and Sigismondo's clothes stolen. Two weeks later, he was back in his workshop in Rome.

The pope's military expedition and the foul weather at the end of 1510 also inconvenienced a pair of German monks who had come to Rome on business. Following a long journey across the Alps, the two of them arrived at the convent of Santa Maria del Popolo, near Rome's north gate, sometime in December, only to discover that the general of their order, Egidio da Viterbo, was in Bologna with the pope.

Under Egidio's direction, the Order of the Augustinian Hermits was undergoing a reform intended to make the monks adopt a stricter discipline. Under these reforms, Augustinian monks would be forced to stay within their cloisters, wear identical habits, surrender all personal possessions, and shun contact with women. Egidio and other "Observants" were carrying forward these reforms in the face of opposition from "Conventuals" within the order who favored a more relaxed discipline and had no desire for such strict rules.

Martin Luther by Theodore De Bry.

One of the nests of dissent was the Augustinian monastery at Erfurt. In the autumn of 1510, two monks with Conventualist sympathies were therefore chosen to make the 1,300-mile round-trip to Rome to lodge an appeal with Egidio. The older of the monks, though fluent in Italian and an experienced traveler, was prevented by the rules of the order from making even a short journey on his own. He was therefore given as a *socius itinerarius,* or traveling companion, a twenty-seven-year-old monk from the Erfurt monastery named Martin Luther, the witty and spirited son of a miner. This was Luther's one and only trip to Rome. Arriving within sight of the Porta del Popolo in December 1510, he threw himself on the ground and shouted, "Blessed be thou, holy Rome!"[8] His enthusiasm would be short-lived.

During the four weeks it took to receive Egidio's reply to their appeal, Luther explored Rome armed with the *Mirabilia urbis romae,* the guidebook for pilgrims. Few pilgrims to Rome can have been as devout—or as energetic. He visited all seven of the pilgrimage churches, starting with San Paolo fuori le Mura and finishing in St. Peter's, or what there was of it. He descended into the catacombs beneath the streets to stare at the bones of forty-six popes and 80,000 Christian martyrs crammed into their nar-

row aisles. In the Lateran Palace he ascended the Scala Santa, the Holy Staircase miraculously transported from the home of Pontius Pilate. He crawled up the twenty-eight steps, saying a paternoster and then kissing each, hoping thereby to release from Purgatory the soul of his dead grandfather. He saw so many other opportunities to do good deeds for the souls of the dead that, as he later remarked, he began to regret that his parents were still alive.

Yet Luther grew steadily more disillusioned with the city. He could not help but notice that the priests were woefully ignorant. Many did not know the right way to hear a confession, while others performed Mass in "slapdash fashion," he wrote, "as if they were doing a juggling act."[9] Even worse, some of them were completely irreligious, professing not to believe in such basics as the immortality of the soul. The Italian priests actually dared to poke fun at the piety of German pilgrims, and their name for a fool was, scandalously, a "good Christian."

The city of Rome itself was, in Luther's view, a dump. Rubbish covered the banks of the Tiber, into which the *cloaca maxima,* an open sewer, drained the waste tipped from windows. Rubble seemed to be scattered everywhere, and the facades of many churches suffered the indignity of being draped with animal hides placed there by tanners. So unhealthy was the air that when Luther made the mistake of sleeping beside an open window, he suffered an attack of what he diagnosed, erroneously, as malaria. He cured himself of the affliction by eating pomegranates.

The Romans themselves were no better. Luther, who would later become renowned for his obscene wit and toilet humor, was disgusted at how people shamelessly relieved their bladders in the street. They urinated so indiscriminately that to deter the culprits it was necessary to hang on the exterior wall a religious icon such as a portrait of St. Sebastian or St. Anthony. He found ridiculous the Italian habit of making flamboyant hand gestures as they spoke. "I do not understand the Italians," he later wrote, "and they do not understand me."[10] Equally ludicrous, in his

opinion, was the Italian male's refusal to allow his wife out of doors unless she first donned a veil. Prostitutes seemed to be everywhere, as did the poor, many of whom were destitute monks. While this rabble occupied the ancient ruins—from which they might emerge to attack unwary pilgrims—the cardinals lived decadently in their palaces. Luther learned that syphilis and homosexuality were rife among the clergy, and that even the pope suffered from the French pox.

Luther had therefore seen quite enough of Holy Rome by the time he finally returned to Germany. Nor had the mission been a success, for Egidio, bent on pushing through his reforms, denied the request for an appeal. The two monks arrived in Nuremberg some ten weeks later, after passing through Florence and Milan—the latter swarming with French soldiers—and recrossing the Alps in the dead of winter. Still, even though Luther did not have fond memories of Rome to cherish on the long journey, he later insisted the trip had been a miracle. It allowed him to see for himself, he claimed, how Rome was the seat of the devil and the pope worse than the Ottoman sultan.

THE WORLD'S GAME

THE POPE'S CONDITION failed to improve in the period between Christmas and New Year. So ill was he on Christmas Day that Mass was celebrated in his chamber as he lay prone and feverish in bed. Soon afterward, on St. Stephen's Day, his persistent fever and more bad weather prevented him from making the short trip to Bologna's cathedral. He was therefore still in bed as the papal forces, led by his nephew Francesco Maria, waded through the snow toward Mirandola.

Francesco Maria was proving a grave disappointment to his uncle. One of the few members of the extensive Rovere clan whom Julius had chosen to promote, he had been named duke of Urbino following the death of Guidobaldo da Montefeltro, and afterward captain general of the Church. This latter post had once been held by Cesare Borgia, but thus far Francesco Maria had shown himself a tamer warrior than the bloodthirsty Cesare. Raphael had portrayed him in *The School of Athens,* placing him next to Pythagoras. Depicted as a coy, almost effeminate young man with flowing white robes and shoulder-length blond hair, he looked an unlikely soldier. Julius probably selected him for reasons of his unstinting loyalty rather than for any qualities he had displayed as a leader of men.

The pope knew he could count even less on another of his commanders, Francesco Gonzaga, the marquis of Mantua. Gonzaga was a commander of dubious aptitude in the best of times, having been known to use supposed attacks of syphilis (a disease from which he did indeed suffer) to absent himself from the battlefield. And now his loyalties were divided. His daughter was married to Francesco Maria, which placed him in the pope's camp, but he him-

self was married to Alfonso d'Este's sister Isabella, meaning he was about to attack his brother-in-law. Gonzaga was therefore considered so untrustworthy that, during the previous summer, his ten-year-old son Federico had been sent as a hostage to Rome to ensure his fidelity to the pope.

The days passed and still no assault was made on Mirandola. The pope grew ever more furious at the dawdling of his commanders. Finally, on the second of January, undeterred by either illness or foul weather, he rose like Lazarus and began preparations for the thirty-mile march over the frozen roads to Mirandola, including shipping his sickbed to the front. "Vederò si averò sì grossi li coglioni come ha il re di Franza!" he muttered. "Let's see if I've got balls as big as the king of France!"[1]

By January no painting had been done in the Sistine Chapel for more than four months. Work was still proceeding in the studio, since in September Michelangelo had received from Giovanni Michi a letter reporting that Giovanni Trignoli and Bernardino Zacchetti were busy making a drawing for the project. But Michelangelo was exasperated by the lost opportunity. The absence from Rome of the pope and his cardinals meant no Masses would have interrupted work in the chapel. The Papal Chapel convened for Mass some thirty times each year, occasions when Michelangelo and his men were prevented from mounting the scaffold. Not only did these ceremonies drag on for several hours, but the preparations overseen by Paride de' Grassi also took up a good deal of time.

"When the vault was nearly finished," Michelangelo bitterly recalled a decade later, "the pope returned to Bologna, whereupon I went there twice for money that was owed me, but effected noth-

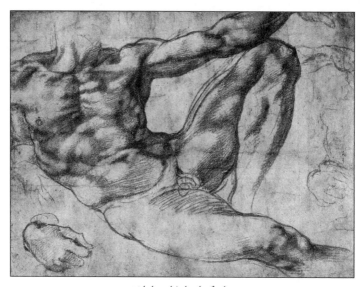

Michelangelo's sketch of Adam.

ing and wasted all that time until he returned to Rome."[2] Michelangelo exaggerated when he claimed that his two journeys "effected nothing," since several weeks after Christmas he received the requested five hundred ducats, almost half of which he sent home to Florence. However, it was true that painting could not begin on the second half of the vault until the pope returned to unveil the first.

The long hiatus at least gave Michelangelo and his men some respite from their strenuous physical labors on the scaffold. It also offered Michelangelo the opportunity to prepare more sketches and cartoons, a task at which he occupied himself during the early months of 1511. One of the drawings executed at this time, done in red chalk on a small piece of paper measuring only seven and a half by ten and a half inches, was a highly detailed sketch of a reclining male nude extending his left arm while bending his left knee—a pose now famous the world over. The only surviving sketch of Adam in the famous *Creation of Adam* scene,[3] it may have been inspired by the figure of Adam in Jacopo della Quercia's *Creation of Adam* on the Porta Magna of San Petronio, a work with which Michelangelo could have reacquainted himself during one of his

recent trips to Bologna. Quercia's scene depicted a nude Adam recumbent on a sloping patch of ground, reaching out to the heavily robed figure of God. However, the posture of Michelangelo's figure actually owes more to Lorenzo Ghiberti than to Quercia, since the Adam on the Porta del Paradiso in Florence—a figure with an extended left arm and retracted left foot—served as a kind of template for the Adam in Michelangelo's drawing.

Michelangelo's meticulous drawing gives the rather stiff figure from Ghiberti's bronze relief the languid, voluptuous beauty of one of his own *ignudi*. The image was undoubtedly drawn from life. After deciding to pose his own Adam like Ghiberti's bronze version, he would have arranged a nude model in the desired position, then carefully sketched the trunk, limbs, and muscles. He may even have used the same model for Adam as he did for many of the *ignudi*. As it was the middle of winter, Michelangelo was presumably unable to follow Leonardo's sensible advice about using nude models only in the warmer weather.

The refinement of detail in this sketch of Adam suggests it was probably the last one executed before the cartoon was made. Its small size meant, of course, that Adam's dimensions needed to be increased by a factor of seven or eight before being transferred to the ceiling. However, since neither this sketch nor any of the others done for the vault shows signs of having been squared, how exactly Michelangelo enlarged his preparatory drawings remains a mystery.[4] Possibly yet another drawing—one that *was* squared for enlargement—came between this red-chalk study and the cartoon for *The Creation of Adam*. Or perhaps Michelangelo executed two of these red-chalk studies, dividing the one into enlargement squares and retaining the other, as a memento, in a more pristine condition.

Whatever the case, the cartoon for *The Creation of Adam* must have been completed sometime during the early months of 1511. However, Michelangelo still faced a long wait before he would be allowed to apply it to the vault of the chapel.

"This is something to put in all the histories of the world," wrote Girolamo Lippomano, the amazed Venetian envoy, in a dispatch from Mirandola a few weeks after Julius rose from his deathbed. "That a pope should have come to a military camp, when he has just been ill, with so much snow and cold, in January. Historians will have something to write about!"[5]

It may have made history, but the expedition against Mirandola did not begin auspiciously. The cardinals and envoys, still stunned by the pope's plan, begged him to reconsider, but their pleas fell on deaf ears. "Julius was not restrained," the chronicler Francesco Guicciardini later wrote, "by the consideration of how unworthy it was for the majesty of so high a position, that the Roman pontiff should lead armies in person against Christian towns."[6] So, to the sound of trumpets bleating in the frigid air, Julius set off from Bologna on the sixth of January, bellowing such shocking profanities that Lippomano could not bring himself to commit them to paper. To everyone's amusement, he also started chanting "Mirandola, Mirandola!"

Alfonso d'Este was lying in wait. No sooner had the pope and his train passed San Felice, only a few miles from Mirandola, than Alfonso's troops ambushed them, moving their guns swiftly through the deep snow on sleds designed by an enterprising French master of artillery. Julius hastily fell back, taking refuge in the sturdy castle at San Felice. Alfonso's gunners were in such hot pursuit that, to avoid capture, he was forced to scramble from his litter and help raise the castle's drawbridge—"the deed of a wise man," noted a French chronicler, "for had he but waited long enough to say a paternoster, he would have been crunched."[7]

But Alfonso and his troops chose not to press their advantage, and once they retreated the pope again took to the road. Following a short journey, he halted at a farm a few hundred yards outside the walls of Mirandola, taking up residence in the house while his car-

dinals competed for the stables. After a brief respite, winter had returned with a vengeance. The rivers froze, more snow fell, and bitter winds howled across the plain—none of which gave Francesco Maria any more appetite for battle. He huddled in his flapping tent, playing cards with his troops and trying to hide from his uncle. But the pope was not to be ignored. Bareheaded and wearing nothing warmer than his papal robes, he rode about the camp on a horse, cursing at the troops as he ordered the proper placement of the artillery. "Apparently he has quite recovered," wrote Lippomano. "He has the strength of a giant."[8]

The siege of Mirandola commenced on the seventeenth of January. A day earlier a shot from a harquebus had narrowly missed the pope as he stood outside the farmhouse. He responded by moving even closer to the action, commandeering the kitchen of the convent of Santa Giustina, in the shadow of the walls, from where he could direct the gunners as they trained cannonballs at the fortifications. Some of these weapons—and possibly other equipment such as assault ladders and catapults—were designed by Donato Bramante. The architect had left his projects in Rome and, besides reading Dante to the pope, was busy inventing "ingenious things of the greatest importance" for the siege.[9]

On the first day of bombardment the pope cheated death a second time as a cannonball smashed into the kitchen and injured two of his servants. He thanked the Virgin Mary for deflecting the shot and kept the cannonball as a souvenir. As more fire rained down on Santa Giustina, the Venetians began to suspect Julius's own troops of secretly signaling his location to the gunners inside Mirandola, hoping he would be driven back by a fierce cannonade. But Julius declared that he would rather be shot in the head than retreat a single step. "He hates the French worse than ever," Lippomano observed.[10]

Mirandola did not hold out long under the furious assault, surrendering after only three days. The pope was exultant. Eager to set foot inside the conquered town, he had himself hauled over the fortifications in a basket when the huge mounds of earth piled

behind the gates by the defenders proved difficult to move. His soldiers, as their reward, were allowed to plunder, while Francesca Pico, the countess of Mirandola, was promptly sent into exile. Yet the pope was not satisfied with his latest conquest. "Ferrara!" he promptly started chanting. "Ferrara, Ferrara!"[11]

If it was any consolation to Michelangelo, work in the Stanza della Segnatura had also slowed somewhat during the pope's absence from Rome.[12] Raphael did not, however, chase after Julius as Michelangelo had done. Instead, showing his entrepreneurial flair, he took advantage of the situation to accept other commissions, including the design of some salvers for Agostino Chigi, the Sienese banker who was Sodoma's patron. The blue-eyed, red-haired Chigi, one of the wealthiest men in Italy, also had bigger plans in mind for Raphael. In about 1509 he had started building a palace for himself beside the Tiber. Designed by Baldessare Peruzzi, the Villa Farnesina would boast lush gardens, vaulted rooms, a stage for theatricals, and a loggia overlooking the river.[13] It would also feature some of the finest frescoes in Rome. To decorate its walls and ceilings, Chigi hired both Sodoma and a young Venetian, Sebastiano del Piombo, a former pupil of Giorgione. Determined to employ only the best artists, he also engaged Raphael, who, sometime in 1511, began making preparations to paint on a wall in the villa's spacious ground-floor salon a fresco showing *The Triumph of Galatea*, complete with tritons, cupids, and a beautiful sea nymph drawn across the waves by a pair of dolphins.✱

✱Scholarly opinion diverges widely as to when exactly Raphael painted *The Triumph of Galatea*. Theories range from as early as 1511 to as late as 1514. However, the commission seems to have come in 1511, when Julius was absent from Rome and the Stanza della Segnatura was nearing completion. Chigi appears to have taken advantage of Julius's departure to secure Raphael's services for himself.

Yet Raphael did not abandon his work in the Vatican. After finishing *The School of Athens* he had moved on to decorate the wall whose window overlooked the Belvedere—and the one against which the bookcases holding Julius's volumes of poetry would be placed—with a fresco now known as *Parnassus*. While the *Disputà* portrayed famous theologians and *The School of Athens* a distinguished cast of philosophers, the *Parnassus* fresco featured twenty-eight poets, both ancient and contemporary, gathered around Apollo on Mount Parnassus. Included among them were Homer, Ovid, Propertius, Sappho, Dante, Petrarch, and Boccaccio, all sporting wreaths of laurel and conversing together with the expressive hand gestures that so irritated Martin Luther.

Raphael included living as well as dead poets in his scene, their portraits, according to Vasari, painted from life. Among these luminaries was Lodovico Ariosto, the beleaguered envoy of Alfonso d'Este, whom Raphael sketched before the poet fled Rome in the summer of 1510 under threat of being thrown into the Tiber.[14] Ariosto returned the compliment in *Orlando furioso,* describing Raphael as the "boast of Urbino" and naming him as one of the greatest painters of the age.[15]

In contrast to the almost exclusively masculine companies featured in the *Disputà* and *The School of Athens,* Raphael's *Parnassus* included a number of women, including Sappho, the great female poet from Lesbos. Raphael, unlike Michelangelo, frequently used women as his models. According to a rumor in Rome, he once requested five of the city's most beautiful women to pose nude for him so he could select the best features of each—the nose from one, the eyes or hips from another—to create a portrait of the perfect woman (an anecdote that recalls one that Cicero told about the Greek painter Zeuxis). Nevertheless, it is said that when Raphael came to paint Sappho, he needed the features of only one Roman beauty, since the portrayal of the great female poet was said to have been inspired by his neighbor in the Piazza Scossa Cavalli, the famous courtesan Imperia. While Michelangelo was trudging the frozen roads of Italy in search of ducats from the pope, Raphael, it

therefore seems, was enjoying the comfort of Agostino Chigi's palace on the Tiber and the company of Rome's most beautiful woman.

The pope did not, following the conquest of Mirandola, press forward to Ferrara. He had hoped, as usual, to lead the expedition himself, but as French reinforcements were gathering along the Po, he feared capture should the attempt fail. On the seventh of February he therefore returned to Bologna on a sleigh drawn through the deep snow by an ox. Soon Bologna was no longer safe from the French, and only a week later he rode the sleigh fifty miles east to Ravenna, on the Adriatic coast. Here he lingered for the next seven weeks, making plans for the assault on Ferrara and spending his leisure hours watching from the shore as galleys rode up and down the coast on a stiff breeze. Though a small earthquake that shook Ravenna in March was interpreted by everyone else as an evil omen, it failed to dampen Julius's spirits. Nor were they doused by the heavy rains that caused ponds to overflow and rivers to burst their banks.

Without the pope on site to rally the troops, the campaign against Ferrara soon spluttered and ran out of steam. To take matters in hand, Julius returned to Bologna in the first week of April. Here he gave an audience to an envoy from the emperor Maximilian, who urged him to make peace with the French and war on Venice, rather than the other way around. But the embassy came to nothing, as did another attempt to mediate. Julius's daughter Felice tried to reconcile her father with Alfonso d'Este by proposing a marriage between her infant daughter and the duke's infant son. Julius did not respond favorably to the idea, sending Felice home to her husband with gruff orders to attend to her sewing.[16]

May arrived, bringing better weather. For a second time the French army closed in on Bologna, and for a second time Julius

slipped away to Ravenna. Francesco Maria and his troops tried to do the same, fleeing the enemy in such a shameful panic that their artillery was left behind in their camp, along with their baggage, all of which was captured by the French. Bologna, defenseless, fell soon afterward, and the Bentivogli were returned to power after almost five years in exile. Amazingly, the pope did not fly into one of his customary rages when the disastrous news was brought to him. He calmly informed his cardinals that the fault was his nephew's, and that Francesco Maria would pay with his life.

Francesco Maria had other ideas about who should pay for the defeat. He blamed Cardinal Alidosi, whom the pope had appointed legate of Bologna in 1508. Through his ruthless stewardship, Alidosi had succeeded in making himself every bit as unpopular in Bologna as he had in Rome, so alienating the populace that they longed for the return of the Bentivogli. When the city was recaptured, Alidosi fled through the gates in disguise, fearing the Bolognese even more than the French.

Both Cardinal Alidosi and Francesco Maria were summoned to Ravenna to account for themselves before the pope. They arrived on the twenty-eighth of May, five days after Julius. As luck would have it, the pair of them met by accident in Via San Vitale, Alidosi on horseback and Francesco Maria on foot. The cardinal smiled and saluted the young man. Francesco Maria's reply was not nearly so cordial. "Traitor, art thou here at last?" he demanded. "Receive thy reward!" Taking a dagger from his belt, he stabbed Alidosi, who fell from his horse and died of his wound an hour later. His last words were: "I reap the reward of my misdeeds."[17]

News of Alidosi's cold-blooded murder was greeted in many quarters with outright celebration. Paride de' Grassi even thanked God for the cardinal's death. "Bone Deus!" he wrote joyously in his diary. "How just are Thy judgements, and what thanks we owe Thee that Thou has rewarded the false traitor according to his deeds."[18] Only the pope mourned the loss of the man who had been his best friend, "lamenting and crying out to heaven and wailing in

misery."[19] Abandoning his dreams of conquest, he demanded to be taken back to Rome.

But even larger problems suddenly loomed. On the journey back to Rome the grieving pope discovered, plastered to the door of a church in Rimini, a document announcing that Louis XII and the Holy Roman emperor proposed to summon a General Council of the Church. Councils of this sort were a serious business. Attended by all cardinals, bishops, and other major prelates of the Church, they were grand assemblies at which new policies would be set and existing ones updated or reformed. Though quite rare, they often had far-reaching aims and consequences, occasionally even going so far as to dethrone the reigning pope. One of the more recent examples, the Council of Constance, convoked in 1414, had ended the Great Schism (the forty-year period when rival popes reigned in Rome and Avignon) by deposing the antipope John XXIII and electing Martin V. While Louis XII claimed that the purpose of his council was to reform abuses within the Church and make preparations for a crusade against the Turks, no one believed its purpose was anything other than to remove Julius and install a rival pope in his place. If the Council of Constance had ended the Great Schism, this new council, which was scheduled to meet on the first of September, threatened to reopen it.

After the loss of Bologna and the death of Cardinal Alidosi, none of the pope's advisers had dared tell him this latest news. The citation affixed to the door of the church therefore came as a complete surprise to him. Having just lost his temporal authority in Bologna, he was suddenly menaced with the loss of his spiritual powers as well.

It was a gloomy procession that, on the twenty-sixth of June, passed through the gates of Porta del Popolo and entered Rome. The pope halted at Santa Maria del Popolo, where he celebrated Mass and hung on a silver chain above the altar the cannonball that the Virgin had deflected at Mirandola. The procession then wound its way, in blazing sunshine, toward St. Peter's. "This was

the end of our toilsome and useless expedition," sighed Paride de' Grassi.[20] A full ten months had passed since the pope had departed on his crusade to rid himself of the French. As he rode along the Via del Corso in full pontificals, he was still wearing his white beard. It did not seem likely that he would shave anytime soon.

A New and
Wonderful Manner
of Painting

In July 1510, Michelangelo had written to Buonarroto that he expected to finish the first half of the Sistine's vault and then uncover it within the week. One year later, the unveiling was finally made possible, though Michelangelo still had to wait seven weeks after the pope's return from Ravenna for the ceremony to take place. The reason for the delay was that Julius had selected the Feast of the Assumption, which always fell on the fifteenth of August, as the day for the unveiling. This was a significant date for for him, since in 1483, as the archbishop of Avignon, he had consecrated the Sistine Chapel—complete with its decorations by Perugino and his team—on the Feast of the Assumption.

Julius had doubtless seen the frescoes at various earlier stages of the composition, having climbed onto the scaffold, as Condivi reported, to inspect Michelangelo's progress. But the dismantling of this massive wooden staging allowed him to see the work for the first time as it was intended to be seen, from the floor of the chapel. The removal of the planks from the lug holes in the masonry at the tops of the windows must have created a lot of dust, but the pope was undeterred. Anxious to view Michelangelo's handiwork, on the evening before the feast he rushed into the chapel "before the dust raised by the dismantling of the scaffold had settled."[1]

At nine o'clock in the morning on the fifteenth, a Mass like no other was celebrated in the Sistine Chapel.[2] The pope was robed for the ceremony, as usual, on the third floor of the Vatican, in the

Camera del Pappagallo, the "room of the parrot," so named because it was occupied by a caged parrot. (There was a good population of birds in the Vatican. If Julius climbed a staircase leading from his bedroom he came to an aviary—the *uccelliera*—on the fourth floor.) After the ritual of robing, he was carried in his ceremonial chair, the *sede gestatoria,* down two flights of stairs to the Sala Regia. Then, flanked by two rows of Swiss Guards, he and his cardinals entered the Sistine Chapel, preceded by the cross and censer. The pope and his cardinals momentarily knelt on the *rota porphyretica,* a stone disk in the floor, before rising and passing slowly through the eastern half of the chapel, past the marble choir screen, and into the sanctum sanctorum at the far end.

The chapel was crammed with pilgrims and other sightseers eager to view the ceiling for the first time. "The opinion and expectation which everyone had of Michelangelo," Condivi reported, "brought all of Rome to see this thing."[3] One member of the congregation was especially zealous. Raphael would have been assigned a comfortable seat from which to contemplate his rival's achievement, since two years earlier he had become a member of the Papal Chapel when he was appointed *scriptor brevium apostolicorum,* that is, a secretary in the papal bureacracy—an honorary position (for which he probably paid about 1,500 ducats) entitling him to a place close to the pope's throne in the sanctum sanctorum.

When he laid eyes on Michelangelo's fresco, Raphael was, like everyone else in Rome, absolutely amazed by the "new and wonderful manner of painting"[4] that now became the talk of Rome. In fact, so impressed was Raphael with the fresco that, according to Condivi, he decided to try and secure the commission to finish it. Once again he relied on help from Bramante, who, Condivi claimed, appealed to the pope on his behalf soon after the Feast of the Assumption: "This greatly disturbed Michelangelo, and before Pope Julius he gravely protested the wrong which Bramante was doing to him . . . unfolding to him all the persecutions he had received from Bramante."[5]

It seems surprising that Raphael should have wished to take

over Michelangelo's commission. He had completed the four wall frescoes of the Stanza della Segnatura soon after Julius returned to Rome, following some thirty months of work.✶ After *Parnassus,* he had turned his attention to the final wall in the room, that before which the pope's volumes on jurisprudence were destined to sit. Above the window he had painted female personifications of the cardinal virtues: prudence, temperance, and fortitude, the latter of whom, in a tribute to Julius (who certainly needed fortitude at this low point in his career), clutched an oak tree hung with acorns. Historical scenes were frescoed on either side of the window, the one on the right bearing the unwieldy name *Pope Gregory IX Approving the Decretals Handed to Him by St. Raymond of Penafort,* that on the left the equally cumbersome title *Tribonian Presenting the Pandects to the Emperor Justinian.* The former scene featured a portrait of Julius, complete with his white beard, in the role of Gregory IX. A bewhiskered Julius approving the decretals was deeply ironic given how this collection of papal decrees expressly forbade priests from wearing beards.

Julius was evidently pleased with the decoration of the Stanza della Segnatura and, immediately upon its completion, commissioned Raphael to fresco the adjoining room. Still, if Condivi is to be believed, Raphael seems not to have been especially honored by the new assignment.

Taking over the commission in the Sistine Chapel may indeed have held a certain appeal for Raphael. He would have recognized how the chapel, with its large congregations, was a better stage for displaying and publicizing talent than the more exclusive Stanza della Segnatura. Brilliant though they were, Raphael's frescoes do not seem to have attracted the same attention in the summer of 1511, or created the same sensation, as Michelangelo's, despite the

✶The room was finished sometime during the year 1511, according to inscriptions on the window recesses giving that year as the *terminus ad quem* and specifying completion in the eighth year of the pontificate of Julius II, that is, sometime before the first of November 1511.

fact that *The School of Athens* was, unarguably, a better tableau than any of Michelangelo's individual scenes from Genesis. The show-piece cartoon for *The School of Athens* had been intended to remedy exactly this situation—to capture a wider audience for his work than it could otherwise have expected in the pope's private apartments, where it remained inaccessible to most people in Rome. However, it seems that this work was never actually put on display.

Whatever his schemes and ambitions, Raphael did not succeed in securing the commission to paint the western half of the Sistine Chapel's vault. Instead, soon after Michelangelo's fresco was uncovered, he began work on the next room in the pope's apartments. First, however, he made a major alteration to *The School of Athens*—one that revealed the influence of Michelangelo's style, not to mention something of Raphael's opinion of the morose "hangman."

Even though he had finished *The School of Athens* more than a year earlier, Raphael returned to this work in the early autumn of 1511. Using a piece of red chalk, he sketched a single figure in freehand onto the painted plaster beneath Plato and Aristotle. He then counterproofed the image, placing an oiled piece of paper against the wall and taking the impression of the chalk. This paper with its chalk outline was subsequently turned into a cartoon and reapplied to the wall once the original *intonaco* had been chipped away and a fresh patch of plaster laid. Raphael then proceeded to paint, in a single *giornata*, the slumped, solitary philosopher known as the *pensieroso*, or "the thinker."[6]

This figure—the fresco's fifty-sixth—is generally thought to represent Heraclitus of Ephesus. Heraclitus was one of the few philosophers in *The School of Athens* to remain outside the teacher-student groups through which, in Raphael's view, knowledge was transmitted. No eager philosophical apprentices huddle around Heraclitus. A self-absorbed, downcast figure with black hair and a beard, he rests his head on his fist as he scribbles distractedly on a piece of paper, utterly oblivious to the philosophical debates raging about him. With leather boots and a shirt cinched at the waist, he is dressed in considerably more modern garb than his fellow

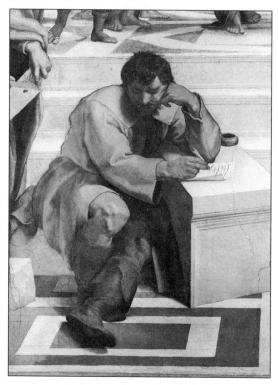

Raphael's pensieroso, "the thinker."

philosophers, all of whom are barefoot and wrapped in flowing robes. Most interesting of all, his nose is broad and flattened—a feature that has convinced a number of art historians that the model for him was none other than Michelangelo, whom Raphael added to the fresco as an act of homage after seeing the Sistine ceiling.[7]

If Michelangelo was in fact the model for Heraclitus, the compliment was double-edged. Heraclitus of Ephesus, known as both Heraclitus the Obscure and "the Weeping Philosopher," believed the world to be in a state of constant flux, a proposition summed up in his two most famous sayings: "You cannot step into the same river twice" and "The sun is new every day." But it is not this philosophy of universal change that seems to have inclined Raphael to lend him the features of Michelangelo; more likely it was Heraclitus's legendary sour temper and bitter scorn for all rivals. He heaped derision on predecessors such as Pythagoras, Xenophanes, and Hecataeus. He

even abused Homer, claiming the blind poet should have been horse-whipped. The citizens of Ephesus were no more popular with the cantankerous philosopher. Every last one of them, he wrote, ought to be hanged.

The appearance of Heraclitus in *The School of Athens* was therefore perhaps both a tip of the hat to an artist whom Raphael greatly admired and a joke at the expense of the surly, remote Michelangelo. Its addition also possibly carried the implication that the grandeur and majesty of Michelangelo's style on the Sistine ceiling—with its robust physiques, athletic posturings, and vibrant colors—had somewhat overshadowed Raphael's own work in the Stanza della Segnatura. Put another way, Michelangelo's individualistic and isolated figures from the Old Testament had eclipsed the elegant and congenial classical worlds of Parnassus and the "new Athens."

One way to understand the differing styles of the two artists is through a pair of aesthetic categories developed two and a half centuries later by the Irish statesman and writer Edmund Burke in his *Philosophical Enquiry into the Origin of Our Ideas of the Sublime and Beautiful,* published in 1756. For Burke, those things we call beautiful have the properties of smoothness, delicacy, softness of color, and elegance of movement. The sublime, on the other hand, comprehends the vast, the obscure, the powerful, the rugged, the difficult—attributes which produce in the spectator a kind of astonished wonder and even terror.[8] For the people of Rome in 1511, Raphael was beautiful but Michelangelo sublime.

Raphael recognized this difference more astutely than anyone. If his fresco in the Stanza della Segnatura represented the perfection and apotheosis of the best art of the past few decades—that of Perugino, Ghirlandaio, and Leonardo—he seems immediately to have realized how Michelangelo's work in the Sistine Chapel marked an entirely new direction. Especially in his prophets, sibyls, and *ignudi,* Michelangelo had brought the power, vitality, and sheer magnitude of works of sculpture such as the *David* into the realm of painting. The art of fresco would never be the same again.

Nevertheless, the contest was about to resume. As Raphael

moved himself and his assistants into the new room, Michelangelo
and his own team began preparing to assemble the scaffold over the
western half of the Sistine Chapel. After a year's delay, *The Creation
of Adam* was ready to be painted.

Or so it had seemed. But then, three days after the unveiling of
the fresco, the pope fell dangerously ill with a fever and severe
headaches. The diagnosis of his doctors was clear: malaria. Faced
with the prospect of his imminent death, Rome was plunged into
chaos.

THE FIRST AND SUPREME CREATOR

THE POPE HAD been hectically busy since his return from Ravenna in June. In the middle of July he fixed to the bronze doors of St. Peter's a bull summoning his own General Council of the Church. This council, to be held the following year in Rome, was intended to counter the one called by Louis XII and his band of schismatic cardinals. Julius had then embarked on a furious bout of politicking, dispatching briefs and emissaries to every corner of Europe, trying to drum up support for his own council and isolate the rebels. All the while, of course, he ate and drank as copiously as ever.

In order to relax from his labors, at the beginning of August the exhausted and careworn pope had taken a trip to Ostia Antica, the ancient Roman port on the mouth of the Tiber, for a day of pheasant hunting. The canons of the Church forbade clerics from hunting, but Julius paid no more heed to this law than he did to the one about beards. Shooting pheasants pleased him no end, and whenever he brought down a bird with his gun he showed the mangled creature "to all who [were] near him, laughing and talking much," according to the Mantuan envoy who joined the hunt.[1] Still, tramping through the mosquito-ridden marshes of Ostia in August, searching for birds to blast from the sky, was not such a wise idea. Soon after returning to Rome, he came down with a slight fever. He rallied a few days later, but very likely he was still unwell for the Feast of the Assumption. Then, within days of the fresco's unveiling, he fell seriously ill.

Everyone concerned recognized that the pope's illness was far more severe than the one suffered the previous year. "The pope is passing away," wrote Girolamo Lippomano, the Venetian envoy

who had witnessed Julius's miraculous recovery at the siege of Mirandola. "Cardinal Medici tells me he cannot last the night."[2] He did survive the night, but the following day, the twenty-fourth of August, his condition had become so hopeless that the sacraments of death were administered. Even Julius himself believed the end was nigh, and in what seemed a final act he removed the bans of excommunication from Bologna and Ferrara, and pardoned his nephew, the disgraced Francesco Maria. "I think I may close my Diary here," wrote Paride de' Grassi, "for the pope's life is coming to an end."[3] The cardinals asked Paride to make preparations for the pope's funeral, as well as for the conclave to elect his successor.

The pope's illness led to an unholy spectacle in the Vatican. As Julius lay on his bed, unable to move, his servants and other members of the papal household—almoners, beadles, a wine butler, bakers, and cooks—began clearing the palace of their own possessions. For good measure they also started looting much of what belonged to the pope. In the midst of this greedy commotion, the dying pope was sometimes left unattended in his chamber except for his young hostage, Federico Gonzaga, now eleven. Julius had become strongly attached to Federico since his return from Ravenna, and it seemed that the boy would be the only person not to desert him in his time of dying.

An unholy spectacle was likewise taking place on the streets outside the Vatican. "The city is in turmoil," Lippomano reported. "Everyone is armed."[4] Two families of feudal barons, the Colonna and Orsini, tried to take advantage of the pope's impending death to seize control of the city and establish a republic. Their representatives met on the Capitol with some of Rome's leading citizens, swearing an oath to put aside their differences and work for the good of the "Roman republic." The ringleader, Pompeo Colonna, addressed the mob, urging them to cast aside priestly rule—meaning the authority of the pope—and reclaim their ancient liberties. "Never," wrote the appalled Lippomano, "has there been such a clang of arms round the deathbed of any former pope."[5] So much

violence threatened that Rome's minister of police fled into the safety of the Castel Sant'Angelo.

As he prepared to assemble the scaffold over the western half of the chapel and begin painting *The Creation of Adam,* Michelangelo suddenly found himself faced with new uncertainties. He had already lost one ally and protector when Cardinal Alidosi was murdered in Ravenna. The death of the pope would present even more grave obstacles to his work. Not only, he knew, would a conclave in the Sistine Chapel delay his work on the fresco, but the election of a new pope might end the project altogether. Lippomano reported a consensus among the cardinals that victory was likely to come the way of the "French party," that is, to a cardinal sympathetic to Louis XII. Any such election could have spelled disaster for the fresco, since a pope friendly to the king of France would hardly have wished to see the Sistine Chapel become a monument to the two Rovere popes. Julius had declined to scrape Pinturicchio's propaganda for Alexander VI from the walls of the Borgia apartments, but the new pope might not be quite so restrained.

In the midst of so much chaos, the pope, incredibly, started showing signs of recovery. As usual, he had been a disobedient patient, ignoring his doctors' orders by demanding—on the rare occasions when he could eat—such forbidden fare as sardines, salted meat, olives, and, of course, wine. His doctors indulged him, assuming he would die no matter what he ate or drank. He also ordered fruit—plums, peaches, grapes, and strawberries. Unable to swallow, he chewed the flesh and sucked the juices before spitting out mouthful after mouthful.

His condition improved under this strange regimen, but his doctors still prescribed a blander diet, a thin broth which he refused to touch unless it was served to him by Federico Gonzaga. "At Rome

everybody is saying that if the pope recovers, it will be due to Signor Federico," the Mantuan envoy proudly informed the boy's mother, Isabella Gonzaga.[6] He also boasted to her that the pope had asked Raphael to portray Signor Federico in one of Raphael's frescoes.*

By the end of the month, barely a week after receiving last rites, the pope was well enough to listen to musicians in his room and play *tric-trac,* a board game similar to backgammon, with Federico. He also began planning how to chastise the republican rabble on the Capitol. Learning of this astonishing and unexpected improvement, the rebels melted swiftly away. Pompeo Colonna fled the city, and the remainder of the conspirators hastily denied any intention of subverting the authority of the pope. Peace was restored almost overnight. The mere thought of Julius, alive and well, was enough, it seemed, to quell the violence of even the unruliest Roman mob.

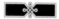

The pope's recovery must have been a relief to Michelangelo, who was thus permitted to continue his work. The scaffold was assembled over the second half of the vault during the month of September, and on the first of October he received his fifth installment, a payment of 400 ducats, which brought his total earnings to 2,400 ducats. With the scaffold rebuilt, the men resumed painting on the fourth of October, a full fourteen months after downing their brushes.

The Feast of the Assumption had not merely been the first chance for the people of Rome to see the new fresco in the Sistine Chapel. The removal of the scaffolding also gave Michelangelo his first real opportunity to appraise the fresco from the floor. If everyone else in Rome seemed impressed with the work, its author had some reservations about his approach, for he began painting the vault's second half in a conspicuously different manner.

*The identity of this fresco is a matter of debate. For a discussion, see p. 341, note 5.

Michelangelo's basic misgiving seems to have been the small size of many of his figures, especially those in cluttered scenes such as *The Flood,* which he now realized were difficult to see from the floor. He therefore decided to increase the size of the figures in the Genesis scenes. This new strategy was to hold for the prophets and sibyls as well, since those on the second half of the vault are, on average, some four feet taller than the ones painted earlier. The figures on the lunettes and spandrels likewise swelled in size and decreased in number: As they advanced toward the altar wall, the ancestors of Christ were destined to have fewer squirming babies.

The Creation of Adam was the first scene to benefit from this new approach. The entire panel took sixteen *giornate,* or two to three weeks of work. Since Michelangelo worked on the scene from left to right, the first figure painted was Adam himself. This most famous and easily recognizable of all the figures on the vault was executed in only four *giornate.* One day was spent on Adam's head and the surrounding sky, a second on his torso and arms, while his legs took a *giornata* each. At this rate, the figure took Michelangelo about the same amount of time as each of the *ignudi,* whom the nude, straining Adam so closely resembles.

The cartoon for the figure of Adam was transferred onto the plaster entirely by incision, a departure from Michelangelo's practice in the previous Genesis scenes, where *spolvero* was always reserved for the finer details of the face and hair. Michelangelo simply incised the outlines of Adam's head in the wet plaster and then deftly modeled the features with his brush, a technique perfected on the lunettes.

Forced to abandon his fresco for more than a year, Michelangelo approached his work with a new sense of urgency underscored by both Julius's precarious health and the political uncertainties raised by the pope's failed military campaign against the French. Further testament of the furious pace with which he resumed is found in one of the lunettes painted soon after *The Creation of Adam.* While the lunettes in the first half were all executed in three days, that inscribed ROBOAM ABIAS was completed in a

single *giornata*, making for a day's work of almost mind-boggling velocity.

The pose of Michelangelo's Adam is similar to that of the slumped, drunken Noah a few yards along the vault. But while the intoxicated Noah in Michelangelo's scene is an example of debased humankind, the newly created Adam is, in keeping with theological interpretation, a flawless physical specimen. Two and a half centuries earlier, St. Bonaventure, a Franciscan renowned for his purple prose, rhapsodized over the physical beauty that God gave the first man: "For his body is most glorious, subtle, agile and immortal, clothed with the glory of such brightness that verily it must be more radiant than the sun."[7] An admiring Vasari found all of these qualities brilliantly captured in Michelangelo's Adam, "a figure of such a kind in its beauty, in the attitude, and in the outlines, that it appears as if newly fashioned by the first and supreme Creator rather than by the brush and design of mortal man."[8]

There was no higher goal for an artist during the Renaissance than to make his figures seem alive. What separated Giotto from all painters before him, according to Boccaccio, was the fact that "whatever he depicted had the appearance, not of a reproduction, but of the thing itself," so that viewers of his paintings "mistake the picture for the real thing."[9] But Vasari's comments about Michelangelo's rendering of Adam involved something more than praise for a skillful painter who could make a two-dimensional image look truly alive. He drew a direct comparison between Michelangelo's creative work with his brush and God's divine fiat ("Let us make man in our own image") by suggesting that the artist's fresco appears to reenact, and not simply to portray, the Creation of Man. If Michelangelo's Adam is indistinguishable from the version created by God, it follows that Michelangelo is himself a kind of god. Higher praise is difficult to imagine, but then the opening premise of Vasari's biography is that Michelangelo was God's representative on Earth, sent down from Heaven to show humankind "the perfection of the art of design."[10]

Michelangelo's own figure of God was painted, like that of Adam,

in a total of four *giornate*. Though the outlines were transferred to the plaster mainly through incision, both the head and the left hand (though not the hand that reaches out to Adam) show signs of pouncing. The Almighty's airborne pose as he flutters toward Adam is a complex one, but the pigments used by Michelangelo were basic: *morellone* for the gown, *bianco sangiovanni* and a few touches of ivory black—a pigment made from charred pieces of ivory—for the hair and beard.

Michelangelo's conception of God had changed since he painted *The Creation of Eve* over a year earlier. There, wrapped in heavy robes, God stood firmly on the ground and conjured Eve from Adam's side with a gesture of his supine hand. Here, dressed in a much skimpier costume, he soars through the air surrounded by a billowing cape that enfolds ten tumbling cherubs and a wide-eyed young woman identified by a number of art historians as the as-yet-uncreated Eve.[11] And his simple summons to Eve is replaced, of course, by the fingertip touch that has become a shorthand for the entire fresco.

The sheer iconic status of this image of God, five centuries later, tends to blind modern viewers to its novelty. In the 1520s Paolo Giovio noted among the figures in the fresco "one of an old man, in the middle of the ceiling, who is represented in the act of flying through the air."[12] The Lord God in full length, complete with bare toes and kneecaps, was a rare and unaccustomed sight, even to the bishop of Nocera. While the Second Commandment's prohibition against images of "anything that is in heaven above" (Exodus 20:4) led the Byzantine emperors in the eighth and ninth centuries to order the destruction of all religious art, depictions of God were never officially banned in Europe. However, Creation scenes in early Christian art usually ventured to show nothing more of the Creator than a giant hand emerging from the heavens✝—a synecdoche that Michelangelo's straining digits almost seem to reprise.

✝Such as in the Old Testament scenes in the sixth-century mosaics in San Vitale, Ravenna.

God steadily acquired more bodily attributes through the Middle Ages, though most often he was portrayed as a young man.✝ The now-familiar image of an old man with a beard and long robes did not actually start to develop until the fourteenth century. There is, of course, no biblical authority whatsoever for this grandfatherly image; it was inspired instead by the many antique statues and reliefs of Jupiter and Zeus that could be seen in Rome. But the portrayal was still enough of a rarity early in the sixteenth century that no less an authority than Bishop Giovio—a cultivated historian who later opened a museum of famous men in his villa near Lake Como— failed to identify the "old man" flying through the air.

Nor is there any scriptural authority for God creating Adam with a touch of his finger. The Bible clearly described how Adam was fashioned: "The Lord God formed man of dust from the ground, and breathed into his nostrils the breath of life, and man became a living being" (Genesis 2:7). Early versions of the scene, such as a thirteenth-century mosaic in San Marco in Venice, stayed faithful to this account by showing God in the act of modeling the body of Adam from clay, thereby depicting him as a kind of divine sculptor. Others, concentrating on the "breath of life," showed a ray passing between God's lips and Adam's nose. However, artists soon came up with their own ways of illustrating the encounter. On the Porta del Paradiso, Ghiberti's cast-bronze God simply clasped Adam's hand as if helping him to his feet, a motif also used by Paolo Uccello in his *Creation of Adam* in the Chiostro Verde of Santa Maria Novella, painted in the 1420s. Meanwhile, in Bologna, Jacopo della Quercia's God gathered his voluminous robes with one hand and offered the naked Adam a benediction with the other.

✝An example is the God the Father in the carvings on the *Genesis* pilaster of the cathedral in Orvieto, done (probably by the architect Lorenzo Maitani) in the early decades of the fourteenth century. A very early example is the youthful-looking God the Father in the fifth-century Old Testament mosaics in Santa Maria Maggiore, Rome.

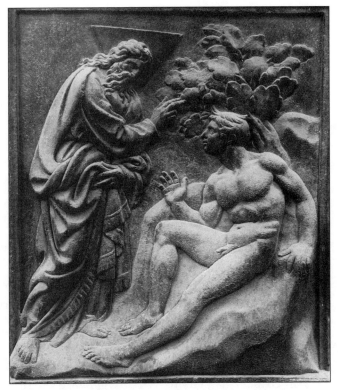

The Creation of Adam *by Jacopo della Quercia at*
San Petronio in Bologna.

All of these illustrations showed God upright on the ground, and
none featured the index finger as a point of contact.✝ Thus, while
many of the images in the fresco were recycled from various statues
and reliefs that Michelangelo had come across in his travels and
studies, there was really no precedent for his conception of the
finger-to-finger transmission of the spark of life from God to Adam.

This unique image did not always enjoy its iconic status. Condivi
interpreted the famous gesture not as an infusion of life so much
as—bizarrely—an admonishing wag of an autocrat's finger. "God is
seen with arm and hand outstretched," he wrote, "as if to impart to
Adam the precepts as to what he must and must not do."[13] The sim-
ple touch really only became a keynote in the second half of the

✝Another depiction with which Michelangelo was no doubt familiar—the *Genesis*
pilaster on the cathedral in Orvieto—does show God pointing his index finger,
albeit while standing erect over a prostrate and unresponsive Adam.

twentieth century. A turning point seems to have come in 1951, when the publisher Albert Skira, in its three-volume, color-plated "Painting-Color-History" series, introduced Michelangelo to its numerous readers in Europe and America by cropping the bodies of Adam and God and featuring only their outstretched hands.[14] The image, since then, has almost become a cliché.

It is a fine irony, then, that an important component of Michelangelo's signature piece—Adam's left hand—was restored in the 1560s and is therefore not actually his own work. The name Domenico Carnevale does not loom large in encyclopedias or art galleries, yet he is the one who painted the index finger that featured so prominently and influentially in the Albert Skira color plate. By the 1560s, the structural flaws that had destroyed parts of Piermatteo d'Amelia's fresco reasserted themselves, and cracks once more appeared in the vault. In 1565, the year after Michelangelo's death, Pope Pius IV ordered that repairs be made, and over the next four years the chapel's foundations were strengthened and the south wall buttressed. With the structure finally stabilized, Carnevale, a painter from Modena, was allotted the task of plastering over the cracks and repainting the missing bits of fresco. As well as taking his trowel and brush to a substantial section of *The Sacrifice of Noah,* Carnevale touched up *The Creation of Adam,* since one of the cracks had traveled longitudinally down the vault and amputated the tips of Adam's index and middle fingers.

The fact that the job of repainting the fingertips fell to an unspectacular artist such as Carnevale is yet another indication of how *The Creation of Adam* was not always regarded as the centerpiece of the fresco, as a masterpiece within a masterpiece. Even Vasari, despite his praise for Adam, did not consider this reclining nude to represent Michelangelo's finest moment on the vault. Nor did Condivi. Instead, each biographer would single out a different figure—two masterstrokes of design and execution that Michelangelo had yet to paint.

THE EXPULSION OF HELIODORUS

THE CREATION OF ADAM was probably finished by the beginning of November 1511, by which time events outside the Sistine Chapel had once again begun menacing the project. On the fifth of October, the day after work resumed in the chapel, the convalescing pope had announced the formation of the Holy League. This was an alliance by which Julius and the Venetians aimed to enlist the help of both Henry VIII of England and the Holy Roman emperor to drive the French from Italy "with the mightiest armies."[1] The pope wanted, most of all, the return of Bologna, and he aimed to reclaim it by all means possible. Besides hiring the services of 10,000 Spanish soldiers under the command of the viceroy of Naples, Ramón Cardona, he was counting on his Swiss soldiers, who had let him down so badly the year before, to march back across the Alps and attack the French at Milan. Yet again, it seemed, a long military campaign beckoned— one that, like the failed expedition of 1510–11, was guaranteed to draw the pope's resources and attentions away from the frescoes in the Sistine Chapel.

The pope's enemies were also organizing themselves. At the beginning of November, the schismatic cardinals and archbishops— the vast majority of them French—finally arrived in Pisa, after a two-month delay, to begin their council. The pope had taken action by excommunicating four of them and threatening two others with similar punishment if they persisted in their course of action, which he claimed was unlawful given the fact that only a pope could summon a council. He also placed an interdict on Florence as punishment for Piero Soderini's having allowed this rebel council to convene in Florentine territory. Since this interdict suspended most

ecclesiastical functions and privileges for the republic and its people, and since these privileges included both christenings and the sacraments of death, Julius was in effect damning to Hell the souls of all Florentines who died while the interdict was in place.

As winter descended, the battle lines were drawn. The Spaniards marched north from Naples, the Swiss south through the icy passes of the Alps. Henry VIII meanwhile prepared his ships for an assault on the coast of Normandy. Julius had managed to persuade him to join the Holy League by sending to England a ship laden with Parmesan cheese and Greek wine, two of his own favorites. When the ship arrived on the Thames, Londoners swarmed to see the rare and wonderful sight of a pontifical banner fluttering on the mast, while Henry—who shared Julius's love of food—gratefully accepted the gifts and then signed up for the Holy League before November was out.

However, for a second time the Swiss soldiers proved a disappointment. After crossing the Alps and reaching the gates of Milan, these fabled warriors in whom the pope placed so much faith were bribed by Louis to turn around and go home to Switzerland—which they did at the end of December, making lame complaints about the bad weather and the frightful state of the Italian roads.

More ominous tidings soon reached Rome. On the thirtieth of December, in a show of defiance against the pope, Michelangelo's bronze statue of Julius on San Petronio was destroyed by an angry mob, supporters of the Bentivogli, who slung a rope around its neck and pulled it from its pedestal above the porch. At some 10,000 pounds, the giant statue made a deep crater in the ground and broke into a number of pieces. The bronze was given to Alfonso d'Este, who proceeded to melt the statue's body in one of his foundries and then cast it as a massive cannon. He christened this mighty weapon "La Giulia"—an insolent play on the pope's name.*

*The statue's head remained at Ferrara for some time, though it finally disappeared. No doubt it, too, was melted down for artillery.

Still, the pope and the other members of the Holy League remained undaunted by these events. Their attacks on French positions finally came a month later, in the last days of January, with the pope, for once, staying away from the field of battle. The Venetians besieged the walled town of Brescia, fifty miles east of Milan, while Cardona and his troops surrounded Bologna. When Brescia fell in a matter of days, Milan, the seat of French power in Italy, suddenly looked vulnerable. Receiving word in the Vatican, the pope wept tears of joy.[2]

While Michelangelo avoided as much as possible giving a full-scale glorification of Julius's reign on the vault of the Sistine Chapel, Raphael was about to prove a more willing propagandist. Their contrasting attitudes toward the pope's politics are exemplified by their treatment of the story of Heliodorus's expulsion from the Temple of Jerusalem. Whereas Michelangelo had hidden his portrayal in a medallion that was virtually invisible from the floor, Raphael devoted an entire fresco to it. His *Expulsion of Heliodorus* was so impressive, in fact, that it eventually gave its name to the room adjoining the Stanza della Segnatura, which became known as the Stanza d'Eliodoro.

Raphael began *The Expulsion of Heliodorus* on the room's lone bare wall, a semicircular space fifteen feet wide at the base. The first of his frescoes to be painted since the unveiling of the Sistine Chapel, it displayed the sort of robust, athletic posturing that gave Michelangelo's work its "grandeur and majesty." Ascanio Condivi later claimed that Raphael, "however anxious he might have been to compete with Michelangelo, often had occasion to say that he thanked God that he was born in Michelangelo's time, as he copied from him a style which was quite different from the one he had learned from his father . . . or from his master Perugino."[3] With its

tumult of bodies, *The Expulsion of Heliodorus* is the first work, togeth-
er with the portrait of Heraclitus, in which Raphael revealed his
absorption of Michelangelo's style. However, as in his earlier
works, the success of the fresco actually depended on an exquisite
ordering of pictorial space within a grand and carefully contrived
architectural scheme.✝

Raphael made the backdrop of *The Expulsion of Heliodorus* similar
to that of *The School of Athens.* The interior of the temple, where the
action occurs, is a classical structure with pillars and arches,
Corinthian capitals, and a dome supported on large marble piers.
These deliberate anachronisms lent the setting the same imperial
flavor as one of Donato Bramante's architectural creations and, in
doing so, imaginatively transformed pre-Christian Jerusalem into
the Rome of Julius II—a parallel that certain other touches drove
home even more forcibly.

In the center of the scene, beneath the golden dome, Raphael
portrayed Onias, the high priest of Jerusalem, in the act of prayer.
In the right foreground, Heliodorus and his terrified would-be
plunderers sprawl beneath the hoofs of a rearing white horse rid-
den by what looks like a Roman centurion. Floating through the air
toward them are two muscular youths, who brandish their sticks as
they prepare to give Heliodorus a vicious beating.

As a political allegory, the scene is virtually transparent. The
defeated Heliodorus spilling his loot on the floor of the temple has
usually been understood as a frank reference to the expulsion of the
French from Italy—an event which, as Raphael worked on the fres-
co, was little more than wishful thinking on the part of the pope.
The fate of Heliodorus was probably also a warning to Louis XII's
allies and other despoilers of the Church such as the Bentivogli,
Alfonso d'Este, the schismatic French cardinals, and even Pompeo

✝As with *The School of Athens,* Raphael made and preserved intact a large-scale car-
toon for *The Expulsion of Heliodorus,* which was possibly intended to disseminate his
design more widely. Later given away as a gift, this cartoon still existed in the time
of Vasari, who claims it was in the possession of a man from Cesena named
Francesco Masini. It has since disappeared.

Colonna and his republican cohorts on the Capitol—all of whom had, in Julius's opinion, tried to claim for themselves what rightfully belonged to the Holy See.

To make the allusion to contemporary events completely clear, not only did Raphael dress the white-bearded Onias, the spiritual leader of Jerusalem, in a tiara and blue-and-gold robes; he also included yet another portrait of Julius in the left foreground, where an audience of a dozen people watches the dramatic fate of Heliodorus unfold. Wearing a red cope, the bearded figure borne on the shoulders of his attendants is an unmistakable rendering of Julius. Fixing his attention on the kneeling figure of Onias, he looks grimly resolute, every inch *il papa terribile*. It was probably no accident, given this forceful object lesson in the authority of the Church and its supreme ruler, that the fresco was later defaced by the troops of the duke of Bourbon, who sacked the city in the summer of 1527.

The pope's was not the only portrait included. Raphael continued his practice of painting the likenesses of various friends and acquaintances into his frescoes, and *The Expulsion of Heliodorus* contains at least two other contemporary references, one more intimate than the other. Such was the pope's regard for Federico Gonzaga, the young hostage who had sat by his sickbed, that he wished to have the boy immortalized in a fresco: the agent for the duke of Mantua reported to Isabella Gonzaga, the boy's mother, how "His Holiness has said that he wishes Raphael to portray Signor Federico in a room which he is having painted in the palace."[4] No clear identification of Federico Gonzaga has ever been made in one of Raphael's frescoes,[5] but the most likely candidate would seem to be one of the children in *The Expulsion of Heliodorus,* which was painted soon after the request was made.

While conscientiously carrying out the behest of the pope, Raphael also secreted references to his own personal life in the painting. The woman extending her right arm on the left-hand side of the scene is said to be Margherita Luti, whom a sentimental tradition celebrates as the great love of Raphael's life. A baker's daughter who

lived near Agostino Chigi's villa in Trastavere, this young woman became the subject of a number of Raphael's works, most famously the one known as *La Fornarina,* an oil portrait of a bare-breasted woman painted about 1518.[6] Raphael's fabled sexual appetites were occasionally indulged at the expense of his work, and his dalliance with the beautiful Margherita was said to have been responsible, at one point, for his truancy from the Villa Farnesina, where he was supposed to be frescoing the Loggia of Psyche for Agostino Chigi. A dedicated womanizer himself, Chigi hit on the simple solution of moving Margherita into the villa. The fresco—a steamily erotic pro- duction—was duly brought to completion. If Raphael was involved with Margherita Luti as early as the autumn of 1511, their amours did not seem adversely to affect work on *The Expulsion of Heliodorus,* which was completed, albeit with the help of assistants, at some point in the early months of 1512, after three or four months of work.

Busy as ever, Raphael was also painting yet another portrait of Julius during this time, one displaying him quite differently from the determined figure of authority overseeing the rout of Heliodorus. Done for the church of Santa Maria del Popolo, this three-and-a-half-foot-high oil painting presented the pope as if in a private audience with the viewer. Looking weary and careworn, the sixty-eight-year-old Julius is seated on his throne, his air of *ter- ribilità* almost utterly evaporated. Eyes downcast, he clutches the armrest of his throne with one hand, a handkerchief with the other. Apart from his white beard, there is little of the indomitable per- sonality who led from the front at Mirandola and subdued the city through the sheer force of his will. Instead he looks the part of the man who, over the previous few months, has lost not only his friend Francesco Alidosi and his territories in the Romagna but very near- ly his life as well. Nonetheless, however weakened Julius may have appeared, Vasari claimed this portrait was so true to life that when the people of Rome saw it hanging in Santa Maria del Popolo, they were overcome by trembling as if the pope were there in person.[7]

THE MONSTER
OF RAVENNA

A STRANGE AND alarming creature was born in Ravenna in the spring of 1512. Supposedly the offspring of a nun and a monk, the gruesomely deformed child was the latest and most grotesque in a series of monstrous births, both human and animal, that had been plaguing the city. The people of Ravenna knew these creatures to be unfavorable omens, and the appearance of this most recent prodigy—the so-called monster of Ravenna—so disturbed the governor of Ravenna, Marco Coccapani, that he immediately sent a description to the pope, together with a warning that such an unnatural birth meant evil times ahead.[1]

Both Coccapani and the pope had good reason to be disposed to such portents, since Ravenna housed the magazines that supplied the armies of the Holy League. That, and its position in the north of Italy, made it highly vulnerable to attack from the French. During the winter the Holy League's victories against the French had evaporated almost as quickly as they were won, mainly because of a series of stunning maneuvers by a young French general, Gaston de Foix, the nephew of Louis XII. Soon renowned as the "Lightning Bolt of Italy," Gaston succeeded in marching his troops down the peninsula with unparalleled speed, liberating and reclaiming French territories along the way. At the beginning of February he had swept south from Milan, bent on relieving Bologna. The city was under siege from Ramón Cardona, whose troops were bombarding the walls with long-range artillery, hoping to terrorize the populace into surrender. Instead of approaching Bologna through Modena, where the pope's troops lay in wait for him, Gaston arrived from the opposite direction, via the Adriatic

coast, leading his troops through the deep snow on a forced march of astonishing speed. On the night of the fourth of February, under the cover of a blizzard, he had slipped into Bologna unseen by the besiegers. The following day, dispirited by the sight of Gaston's reinforcements on the walls, Cardona's men had broken camp and ended their siege.

If the pope was furious when he learned of the aborted siege, he was even more so when he received further news of Gaston's feats a fortnight later. Taking advantage of Cardona's retreat, the young commander had left Bologna to lead his men on another lightning-fast cross-country march, this time north to Brescia, which he recaptured from the Venetians. These swift and unexpected victories won him, according to one chronicler, "an unusual reputation all over the world."[2] But Gaston was not finished yet. On orders from Louis XII, he turned around his army of 25,000 men and began marching on Rome. If the Council of Pisa was failing in its mission to depose the pope, Gaston de Foix, it seemed, would not.

Although Julius appears not to have been overly perturbed by news of the monster of Ravenna, at the beginning of March he left his quarters in the Vatican and, for safety's sake, took up residence in the Castel Sant'Angelo, traditionally the last refuge of besieged popes. Gaston de Foix was still some distance away, but Julius had other enemies closer to hand. The Roman barons, inspired by the proximity of the French, armed themselves for an assault against the Vatican. There was even a plot afoot to kidnap Julius and hold him hostage.

Soon after moving into the Castel Sant'Angelo, in a surprising gesture, the pope shaved off his beard. His vow to oust the French from Italy was far from being fulfilled, but he was determined to open the Lateran Council at Easter, and shearing himself of his beard seems to have been an indication that he planned to reform both himself and the papacy. Not everyone was impressed. Cardinal Bibbiena cattily remarked in a letter to Giovanni de' Medici that His Holiness looked better with whiskers.

The pope was not so cowed by his enemies that he did not make the occasional sortie from the Castel Sant'Angelo. On the Feast of the Annunciation, in one of his first public appearances since shaving his beard, he left his refuge to inspect Michelangelo's progress in the Sistine Chapel.[3] This inspection was probably the first time that Julius laid eyes on the newly finished *Creation of Adam,* though what he made of the scene unfortunately went unrecorded, for the Mantuan envoy who reported the visit seems to have been more taken by the pope's beardless chin than by Michelangelo's frescoes.

After almost four years, the pope was as anxious as Michelangelo for the project to be completed. However, work on the fresco appears to have slowed somewhat during the early months of 1512. At the beginning of January, Michelangelo had written to Buonarroto that he had almost finished the entire fresco and would return to Florence "in about three months or thereabouts."[4] This prediction was wildly optimistic. The first half of the ceiling had taken him and his large workshop of experienced frescoists almost two years to paint, and so it seems incredible that he could have believed himself capable of completing the second half in seven months. His statement showed either extreme confidence in his own abilities or else a desperate desire to be done with the project. Not surprisingly, three months later, as Easter loomed, he was forced to revise this timetable. "I reckon I shall have finished here within two months," he told his father, "and then I will come home."[5] But two months later he would still, of course, be hard at work on the fresco, with no clear end in sight.

After finishing *The Creation of Adam* and the figures on either side, including those in the spandrels and lunettes, he had moved along the vault to paint his seventh episode from Genesis, another Creation scene showing a steeply foreshortened God floating through the heavens with his arms outspread. There is confusion over exactly which day of Creation the scene portrays. Having

decided, after viewing the fresco from the floor, that less was more, Michelangelo reduced the scene to a bare minimum of form and color, representing nothing except God and several cherubs swirling through a two-toned grayish space. This extreme lack of detail renders identification highly speculative. Possibilities include *The Separation of the Land and Water, The Separation of the Earth and Sky,* and *The Creation of the Fishes.** Despite its minimalism, the scene consumed twenty-six *giornate,* or over a month's work, compared to the sixteen *giornate* in which *The Creation of Adam* had been completed a short time earlier.

One reason for Michelangelo's relative slowness of execution may have been the pose of God, whose foreshortened body marks a change of approach for Michelangelo. He was painted in *di sotto in sù,* the virtuoso technique of illusion in which, as Bramante pointed out, Michelangelo had no experience when he was first commissioned to fresco the chapel. Later to become a staple of the frescoist's art, *di sotto in sù* involved arranging the perspective of the figures or objects on a vault to give the viewer the impression of real-life figures rising overhead in a convincing three-dimensional space. Michelangelo had foreshortened several figures, such as Goliath and Holofernes, in the pendentives at the corners of the chapel's entrance wall. For the most part, however, the numerous other figures on the Sistine's vault were, despite their adventurous poses, parallel to the picture plane, not at right angles to it. They were painted as if on a flat, upright wall, that is, and not on a vault soaring over the head of the viewer.

Michelangelo's decision to experiment with this technique of foreshortening was no doubt another repercussion from the uncovering of the first half of the fresco. Earlier he had created an illusion of space rising vertically overhead by showing a banner of blue sky at the east end of the chapel—a modest trompe l'oeil effect that

*Condivi and Vasari disagree over the subject. Condivi identified it as the fifth day of Creation, showing the Creation of the Fishes, while Vasari stated that it showed the Separation of Land and Water on the third day.

serves to lend the architectural ensemble a weightless and almost dreamlike aspect. For his new scene, he realized, something more spectacular was required.

In this latest Creation scene, then, God seems to tumble toward the viewer at a forty-five-degree angle to the vault's surface. The visual effect from the floor is of the Almighty turned almost completely upside down against the gray heavens, his head and hands thrust toward the viewer, his legs trailing away. Vasari, for one, applauded the technique, noting how God "turns constantly and faces in every direction"[6] as one walks about the chapel.

Michelangelo's breathtaking use of foreshortening in this scene raises an interesting question. He once claimed that an artist should have "compasses in his eyes,"[7] by which he meant the painter must be able to arrange the perspective of his paintings by instinct alone, without resorting to mechanical aids. The best example of someone with compasses in his eyes was Domenico Ghirlandaio, whose sketches of Rome's ancient amphitheaters and aqueducts, done without measuring instruments of any kind, were found to be so accurate that artists who came afterward were astounded by them. Not everyone was blessed with this uncanny talent, and it is possible that, despite his idealism, even Michelangelo used an artificial device to help him foreshorten figures on the vault such as this particular God. Certainly other artists had either designed or used perspective devices. In the 1430s Leon Battista Alberti invented what he called a "veil" to assist painters in their work. It consisted of a net with intersecting threads that was stretched over a frame to create a grid of regular squares. The artist studied his subject through this grid, whose lines were reproduced, as a guide, on a piece of paper onto which he proceeded to copy the image seen through the web of squares.[8]

Leonardo designed (and probably used) similar aids to drawing, as did the German painter and engraver Albrecht Dürer, who found them useful in creating steep foreshortenings of the human form. Such a device would have helped Michelangelo create the marvelous effect of the Almighty flying toward the spectator. And, if he did

indeed resort to such a device, it must have seen a good deal of use as he worked on the designs for the last few scenes in the fresco, where his mastery of foreshortening was about to increase dramatically.

Michelangelo does not seem to have been unduly troubled, at this point, by the turbulent political situation in Rome; or, at least, he made light of these circumstances in his letters to Florence, attempting to reassure his father. "As to affairs in Rome," he wrote to Lodovico, in a masterpiece of understatement, "there has been some apprehension, and still is, but not much. Things are expected to settle down—may they do so by the grace of God."[9]

However, far from settling down, the situation soon became even more precarious. As Gaston de Foix and his army marched relentlessly southward, they paused at the beginning of April to lay siege to Ravenna with the help of Alfonso d'Este. As Ravenna housed the Holy League's arsenals, it had to be defended at all costs. Ramón Cardona and his Spanish lances therefore advanced on the French army, engaging it in battle two miles from Ravenna's gates.

Battles in Italy, according to Niccolò Machiavelli, "were commenced without fear, continued without danger, and concluded without loss."[10] He claimed, for example, that the Battle of Anghiari—the subject of Leonardo's ill-fated fresco in Florence—had witnessed a single fatality, a soldier who fell from his horse and was trampled to death.[11] Similarly, one of Federigo da Montefeltro's expeditions on behalf of Pope Pius II resulted in nothing more than the capture of 20,000 chickens. But Machiavelli's ideas about the bloodlessness of Italian warfare were belied by the battle fought outside Ravenna on Easter Sunday, the eleventh of April 1512.

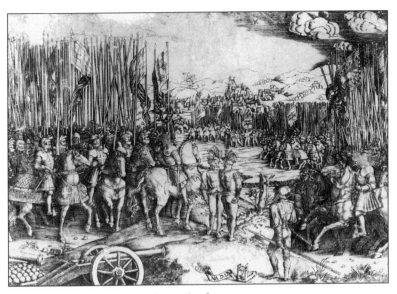

The Battle of Ravenna
by the Maestro della Trappola, 1530.

Sunday was a day when, traditionally, armies neither fought nor moved camp, and Easter Sunday was naturally even more sacred. However, circumstances had forced Gaston de Foix to strike. He and Alfonso d'Este had been besieging Ravenna for several days, and by Good Friday Alfonso's artillery—which now included "La Giulia," the cannon made from Michelangelo's melted-down statue—had breached the town's southern wall. The following day, the army commanded by Ramón Cardona arrived to defend the city, advancing along the River Ronco and then entrenching itself a mile from the French position. Cardona hoped to take a leaf out of Gaston's book and slip inside the besieged city without the French firing a shot. But Gaston had other plans. His supplies were running low, and he could ill afford to let the papal troops inside the walls to prolong the siege. As Easter Sunday dawned, he ordered Alfonso d'Este and his gunners to turn their attention from the battered walls of Ravenna to the camp of the opposing army. What followed was, in the words of one author, the "most violent cannonade between armies in the field that the world had yet seen."[12]

Cannonades by field artillery were usually restricted to short

bombardments that inflicted a minimum of damage before the hand-to-hand fighting commenced. Not so at Ravenna, where the one led by Alfonso d'Este lasted for three hours. Casualties, as a result, were unprecedented. As both armies moved foward, the duke led his gunners at lightning speed across the plain, outflanking the Spaniards and moving to the rear of their encampment—an encircling maneuver without precedent in the battles of the day. From this position his artillery proceeded to tear apart the Spanish cavalry and rear guard. "It was horrible to see how every shot made a lane through the serried ranks of the men at arms," wrote the Florentine envoy to Spain, "sending helmets and heads and scattered limbs flying through the air."[13]

Faced with such a deadly barrage and heavy casualties, Cardona's men finally panicked, plunging forward to engage the French in the open field. When the hand-to-hand fighting started, Alfonso left his guns and, collecting a troop of cavalry, took his attack to the Spanish infantry. Seeing that all was lost, the Spaniards broke off the fight and made for the bank of the Ronco. About 2,000 or 3,000 men, including Cardona, succeeded in reaching it, from where they beat a hasty retreat in the direction of Forlì. Many more were not so lucky, and by the time fighting ceased at four in the afternoon, 12,000 soldiers lay dead in the field, 9,000 of them Spaniards in the pay of the pope, making Ravenna one of the costliest battles in Italian history.

Lodovico Ariosto visited the scene the following day. He later described, in *Orlando furioso,* how the ground was dyed red and the ditches "brimming with human gore."[14] Ravenna marked an emphatic end to the romantic world of swords and chivalry depicted in his saga of intrepid knights, brave deeds, and fair maidens. So appalled was Ariosto by the devastation of modern warfare—a devastation wrought, ironically, by the guns of his patron—that in his poem he made Orlando, his knightly hero, curse the world's first cannon as a devilish invention and throw it into the depths of the ocean. But even an idealist like Ariosto recognized that history was running an unstoppable course. This "infernal contraption" lay

Frontispiece to a 1524 edition of Ariosto's Orlando furioso.

under one hundred fathoms of water for many years, he wrote, until it was brought to the surface with the help of black magic. The poet bitterly predicted that many more valiant men were therefore doomed to perish in a war "which has brought tears to all the world, but most of all to Italy."[15] Despite the heroics of Alfonso d'Este, there had been, in his view, no real victors at Ravenna.

MANY STRANGE FORMS

FOR THE POPE and his allies in the Holy League, the defeat at Ravenna was a catastrophe of stupendous proportions. When news reached Rome a few days later, panic set in. It seemed certain that the French would march on Rome, as Louis had ordered, and place a new pope on the throne. The city would be looted, it was feared, and the bishops put to the sword. Gaston de Foix himself had told his soldiers on the eve of battle that they could look forward to sacking the "wicked court" of Rome, where he promised them "so many stately ornaments, so much silver, so much gold, so many precious stones, so many rich prisoners."[1]

Even Julius, normally the most courageous of men, quailed at this sort of rhetoric. Some of his bishops fell at his feet, begging him to make peace with Louis; others urged him to flee. Galleys at Ostia were hastily made ready to transport him to a safe haven— a course of action advised, among others, by Don Jerónimo da Vich, the Spanish ambassador, who blamed the pope's sinful ways for the catastrophe at Ravenna, which he claimed was a punishment from God.

In the end, the pope elected to remain in Rome. He informed both Vich and the Venetian ambassador that he intended to spend a further 100,000 ducats on men and arms to drive the French from Italy. Fears of an imminent invasion were allayed slightly when it was learned, a day or two later, that Gaston de Foix was among the legions of dead at Ravenna—cut down on the field of battle by Spanish men-at-arms. With the brilliant young general out of the way, there was still a chance, Julius knew, to rescue the situation.

Michelangelo was no doubt as terror-stricken as everyone else in Rome. He must have feared not only for his life but also, once again, for the fate of his fresco. If his bronze statue of Julius had been unceremoniously ripped from the porch of San Petronio, broken to pieces and melted down only a few months earlier, why should his fresco in the Sistine Chapel escape similar treatment should forces hostile to the pope capture the city? After all, when his troops invaded Milan in 1499, Louis XII had allowed his archers to use Leonardo's twenty-five-foot-high model for his equestrian statue—a clay sculpture celebrated by poets and chroniclers with the grandest hyperbole—for target practice.

Oddly enough, Michelangelo seems not to have been unduly concerned about the destruction of his bronze statue, possibly because of his uneasy relationship with Julius and unpleasant memories of the onerous task in Bologna. Or, at least, no record of his anger or disappointment has survived.[*] However, he could hardly have been indifferent to the potential devastation of a fresco cycle on which he had spent almost four years of his life. Furthermore, Gaston de Foix's promises about looting gold and seizing prisoners meant that nothing and no one—no work of art and no inhabitant of Rome—would be safe should the French army reach the Vatican.

Michelangelo may have been as tempted as the pope to take to his heels in the aftermath of Ravenna. He had bolted, after all, as the army of Charles VIII approached in 1494, and in later years he would abscond while directing Florence's fortifications during a siege—on both occasions revealing a timorousness that has become a source of both embarrassment and speculation to scholars.[2] Yet in 1512 he seems to have stood his ground, and it comes as a surprise to find that, in these tumultuous times, he painted into the fresco some of his most whimsical figures.

Not all of the 343 human forms on the vault are as noble as the

[*]For example, Michelangelo makes no mention of the statue in letters written to Lodovico and Buonarroto in the week after its destruction.

Michelangelo's Booz

ignudi or the resplendent Adam. A good many of the figures, particularly those on the margins of the fresco, are rude-looking and downright plain. Among the most notably ugly are the children holding up the nameplates beneath the prophets and sibyls. One art critic found these little creatures unspeakably repulsive. "They are not only morose, stunted, grimacing," he wrote, "but often hideous in the full meaning of the word."[3] Another critic singled out the child beneath the prophet Daniel as especially vile, calling him "a dwarfish, brutal gamin dressed in rags."[4]

This grotesque little brute was painted early in 1512, a short time after the floating, foreshortened God, and around the time, coincidentally, that the real-life "monster" was born in Ravenna. Soon afterward, Michelangelo frescoed an equally ill-favored creature in one of the lunettes, the ancestor of Christ usually identified as Boaz (or Booz, as Michelangelo called him, following the spelling in the Vulgate). A wealthy landowner and the great-grandfather of King David, Boaz married the widowed Ruth after she came to glean barley in his fields outside Bethlehem. The Bible tells little of Boaz's personality beyond the fact that he was gentle and generous, yet for some reason Michelangelo caricatured him as an eccentric old man in a lime-green tunic and pink hose who snarls angrily at his walk-

ing stick—a fool's stick that features his own grotesque likeness snarling back.[5]

Michelangelo was following a long tradition by inserting these undignified figures into the nooks and crannies of his fresco. The Gothic art of the preceding centuries was distinguished by its irreverent marginalia. Humorous, bizarre, and sometimes impious images of monks, apes, and half-human monsters regularly featured in the books and on the buildings of the Middle Ages. Scribes and illustrators doodled comical pictures of hybrid beasts in the margins of devotional manuscripts, while woodcarvers decorated misericords and other pieces of ecclesiastical furniture with equally fantastic images that scarcely seemed in keeping with the dignity of a church. Bernard of Clairvaux, the high-minded Cistercian preacher who died in 1153, condemned the practice, but his objections did little to tame the freakish fancies of medieval artists in the centuries that followed.

The humorous and subversive images scattered across the Sistine ceiling indicate how Michelangelo did not train as an artist merely by sketching Masaccio's frescoes or studying ancient Roman statues in the Garden of San Marco. Although obsessed with the ideal proportions of the human body, he was equally fascinated with bodies that violated these proportions. According to Condivi, one of Michelangelo's first works was a copy of Martin Schongauer's *The Temptation of St. Anthony*. Engraved probably in the 1480s, this work showed the saint tormented by a clutch of demons—grotesque-looking monsters with scaled bodies, spikes, wings, horns, batlike ears, and snouts with long suckers attached. Given a print of the work by Granacci, the young Michelangelo was determined to improve on Schongauer's demons, making expeditions to Florence's fish market to study the shape and color of the fishes' fins, the color of their eyes, and so forth. The result was a painting with "many strange forms and monstrosities of demons"[6]—and a work that was a far cry from the perfectly proportioned nudes sculpted for the *David* and the *Pietà*.

When he came to paint the Sistine Chapel, Michelangelo dedi-

cated the spaces immediately above the spandrels and pendentives to a series of grotesque nudes that would not have been out of place in the comically gruesome visions of either Schongauer or the Dutch artist Hieronymus Bosch, whose *Garden of Earthly Delights* was painted only a few years earlier. Smaller in size than the *ignudi,* these two dozen bronze-colored nudes kick, squirm, and scream in confined areas adorned with rams' skulls, an ancient Roman symbol of death. While the *ignudi* are angelic figures, these bronze nudes look sinister and demonic; two of them even feature pointed ears.

It is possible that Michelangelo's interest in such ugliness stemmed from his own lack of physical charm. Though he became famous as the high priest of idealized masculine beauty, he was, as he ruefully acknowledged, a thoroughly unprepossessing physical specimen. "I see myself so ugly," he wrote in one poem.[7] "My face has the shape that causes fright," he lamented in another, a series of terza-rima stanzas in which he compared himself to a scarecrow and recounted how he coughed, snored, spit, pissed, farted, and lost his teeth.[8] Even Condivi felt obliged to admit that his master presented an odd sight with his flattened nose, square forehead, thin lips, scanty eyebrows, and temples "that project somewhat beyond his ears."[9]

Michelangelo's self-portraits—of which he made any number in both marble and paint—often emphasize this homely appearance. The pendentive in the southeast corner of the Sistine Chapel, completed in 1509, featured the episode from the Apocrypha in which Judith, the Jewish heroine, decapitates Holofernes, the commander of Nebuchadnezzar's troops. Michelangelo portrayed Holofernes lolling naked on his bed as Judith and her accomplice carted off their grisly trophy—a bearded, scowling, flat-nosed, disembodied head that served as Michelangelo's less-than-heroic image of himself.

The Italian Renaissance swarmed with handsome, strapping characters renowned for their amazing feats of physical strength, men who might have come straight from the pages of *Orlando furioso.* Cesare Borgia, for example, was said to have been the strongest

and most physically attractive man in all of Italy. Tall, blue-eyed, and muscular, he could bend silver coins double between his fingers, straighten horseshoes with a flick of his wrist, and lop off a bull's head with a single stroke of his ax. Leonardo, his onetime military architect, was likewise endowed with both superb looks and amazing brawn. "By his physical force he could restrain any burst of rage," Vasari claimed, "and with his right hand he twisted the iron ring of a doorbell, or a horseshoe, as if it were lead."[10]

Michelangelo belonged to a different tradition. With his misbegotten countenance and misshapen body, he resembled gloriously ugly Florentine artists such as Cimabue and Giotto, about the latter of whom Boccaccio marveled, in *The Decameron,* how Nature frequently planted genius "in men of monstrously ugly appearance."[11] While Raphael's self-portraits inspired later generations to enthuse over his serene beauty and the harmonious proportions of his skull, there was always, as Holofernes demonstrates, a touch of the grotesque in Michelangelo's images of himself. With his misshapen features, the artist had more in common, he knew, with the scrawny Boaz or the sinister Holofernes than with the freshly created Adam or the magnificent *ignudi* striking their herculean poses overhead.

CHAPTER 28

THE ARMOR OF FAITH AND THE SWORD OF LIGHT

CONTRARY TO ALL expectation, following its spectacular success on Easter Sunday the army of Louis XII did not immediately sweep south to depose the pope and pillage Rome. Instead, completely deflated by the death of Gaston de Foix, the French troops sat idle in their camp outside Ravenna. "So weakened and dispirited were they by the victory which they had won with such expenditure of blood," wrote one chronicler, "that they seemed more like the conquered than the conquerors."[1] Meanwhile both Henry VIII and King Ferdinand of Spain declared to the pope their intention to continue their fight against the French. There was even hope that the Swiss would return to do battle. The mood in Rome swiftly improved. Less than a fortnight after the disaster, on the Feast of St. Mark, the people of Rome, in a show of defiance, dressed the *Pasquino* in a breastplate and helmet, the costume of Mars.

It was equally urgent that the pope battle the French on a religious front, for the schismatic cardinals were still intent on holding their council. They had moved to Milan after a belligerent mob loyal to the pope had driven them from Pisa. On the twenty-first of April, emboldened by events at Ravenna, the rebellious prelates passed a resolution ordering Julius to be stripped of his spiritual and temporal powers. The pope busied himself with his response. His own ecumenical council, first proposed for Easter, had been postponed by the battle, but the preparations (overseen by Paride de' Grassi) continued unabated, and arrangements were

finally completed on the second of May. That evening, under heavy guard, the pope was carried three miles in a procession from the Vatican to the ancient basilica of San Giovanni in Laterano, "the mother and head of all the churches of the city and the world," as it was known.

The Lateran Palace, next door to the basilica, had been the official residence of the popes until 1377, when Gregory XI forsook it for the Vatican, believing the latter's position near both the Tiber and the Castel Sant'Angelo would offer better protection from outlaws and invaders. The Lateran had since fallen into decay, but Julius deemed it a more practical seat for the council than the sprawling building sites of St. Peter's and the Vatican. Outlaws and invaders were still a problem, however, and the surrounding neighborhood needed to be fortified with a strong detachment of soldiers before Julius and his cardinals could set foot in the palace.

The Lateran Council, as it was called, opened the following day, on the Feast of the Invention of the Holy Cross. Sixteen cardinals and seventy bishops were in attendance—numbers easily dwarfing those of Louis XII's rival council in Milan. The entertainment value was no doubt higher as well. Determined to win the propaganda battle against the French, Julius trundled out his best orators. Fedro Inghirami was chosen to serve as secretary for the council because his booming voice—one whose musical qualities had greatly impressed Erasmus—could make the proclamations audible at the back of the basilica. Better still, the opening address was delivered by the only man in Italy whose oratorical skills could surpass Fedro's: Egidio da Viterbo.

Egidio gave, by all accounts, a scintillating performance. Taking to the pulpit during the Mass of the Holy Ghost, he announced to the assembly that the defeat at Ravenna had been an act of divine providence—and one forecast, moreover, by creatures such as the monster of Ravenna. "At what other time," he asked his audience, "have there appeared with so much frequency and such horrible aspect monsters, portents, prodigies, signs of celestial menaces and

terror on earth?" All of these dreadful omens pointed, he said, to the Lord's displeasure that the Church of Rome had entrusted its battles to foreign armies. It was time, therefore, for the Church to fight its own wars—and to trust in the "armour of faith" and the "sword of light."[2]

At the end of Egidio's oration, more than one cardinal was seen dabbing at his eyes with a handkerchief. The pope, meanwhile, was so delighted with the proceedings that he promised to make the hardworking Paride de' Grassi a bishop.

Over the next fortnight the council sat for a number of sessions. The proceedings of the schismatic council were quickly declared null and void, after which other business was discussed, such as the necessity of undertaking a Crusade against the Turks. Then the pope adjourned the assembly until November, due to the heat of the approaching summer. Julius was in fine form. The council had gone well, and the military threat had begun to wane ever more. For the third time in eighteen months, an army of Swiss soldiers had crossed the Alps and finally reached Verona. Remembering all too well how they had been bribed by the king of France a few months earlier, Julius presented them with gifts—caps of honor and ornamental swords. Thus rewarded, the Swiss seemed to be ready, at last, to take on the French.

Raphael, like Michelangelo, had remained in Rome during the threat of a French invasion, continuing work on his frescoes in the Vatican. By the early months of 1512, he had been joined by several new assistants. A fifteen-year-old apprentice named Giovanni Francesco Penni, a Florentine known because of his humble duties in the workshop as Il Fattore (the Messenger), had started work soon after Raphael moved into the Stanza d'Eliodoro.[3] Several other assistants had also been engaged,

including another Florentine, Baldino Baldini, a former appren-
tice of Ghirlandaio.[4] Raphael had no shortage of assistants clam-
oring to work with him. According to Vasari, there were in Rome
"very many young men who were working at painting and seek-
ing in mutual rivalry to surpass one another in draughtsmanship,
in order to win the favour of Raphael and gain a name among
men."[5]

Although his name also attracted aspiring young artists,
Michelangelo was not interested in acquiring disciples. Late in his
life he declared that he had never run a workshop[6]—a statement
whose snobbery echoes Lodovico's reservations about apprentic-
ing his son with Domenico Ghirlandaio. Michelangelo was inter-
ested in finding assistants for particular tasks, merely using them
as hired help rather than nurturing their talents, as Raphael did
with his students. Although he sometimes gave his drawings to
apprentices for them to study, for the most part Michelangelo
demonstrated little interest in teaching. As Condivi wrote, he was
interested in instilling his art only in "noble people . . . and not in
plebeians."[7]

The subject of Raphael's new fresco was a miracle that took
place near Orvieto in 1263, when a priest traveling from Bohemia
to Rome halted in Bolsena, sixty miles short of his destination, to
perform Mass in the church of Santa Cristina. The priest had been
haunted by doubts about the doctrine of transubstantiation, the
literal transformation of bread and wine into the body and blood
of Christ. However, while celebrating Mass in Santa Cristina he
was amazed to see a cross of blood appear on the consecrated Host.
Each time he wiped at the stain with the corporal—the cloth on
which the chalice was placed—a new cross appeared on the Host.
His doubts were put soundly to rest, and the corporal, with its
bloody crucifixes, was placed in a silver tabernacle above the high
altar in the cathedral of Orvieto.[8]

The miracle at Bolsena had a special meaning for Julius. When
he had launched his military expedition against Perugia and
Bologna in 1506, he had taken time to halt his troops in Orvieto to

celebrate Mass in its cathedral. After the ceremony, he had exposed for adoration the blood-encrusted corporal from Bolsena. When, barely a week later, he marched triumphantly into Perugia, and then into Bologna two months after that, he began to look back on his visit to Orvieto as a fateful one, as a kind of pilgrimage for which God had rewarded him with the capture of the two rebellious cities.[9]

Raphael may have witnessed the pope's victorious march into Perugia, since in 1506 he was painting his small fresco, the *Trinity and Saints,* on the wall of the church of San Severo in Perugia. Moreover, given the pope's faith in this miracle, it was fitting that he should have requested an illustration of it from Raphael at a moment of acute crisis in the Church. Raphael portrayed some thirty worshipers in Santa Cristina at the dramatic moment when the Host stained the corporal with its crosses of blood. Altar boys holding candles kneel behind the priest, while women sprawl on the chapel's floor, cradling children on their laps. Featured prominently at the center of the scene, kneeling before the altar, is the bareheaded Julius, still wearing a beard—the fourth time that Raphael depicted him in the Vatican frescoes.

The contemporary relevance of the scene was made all the more apparent by the inclusion of five Swiss soldiers (one of whom is yet another of Raphael's self-portraits) in the lower right of the fresco. These soldiers were not so out of place in a religious setting as they might seem. Julius had created the Swiss Guards as the official papal escort in 1510, granting them a distinctive costume—striped uniforms, berets, and ceremonial swords—that was said to have been designed by Michelangelo. They were present during Mass to protect the pope and, occasionally, to enforce discipline among unruly worshipers. But the appearance of the uniformed figures in *The Mass of Bolsena* has an additional significance. Interestingly, they were absent from Raphael's original plan for the fresco. A preliminary sketch featured Julius, the priest, and the awed congregation (albeit in dif-

ferent poses) but no sign of the Swiss mercenaries. This sketch was probably done during the early months of 1512, when the arrival of the Swiss was a distant hope. A few months later, however, after twice being disappointed, the pope was finally rewarded for his faith and patience.

After reaching Verona in the third week of May, the 18,000-strong contingent of Swiss soldiers continued to march south, arriving at Valleggio on the second of June and then joining forces with the Venetians a few days later. At almost exactly the same time, the French suffered a devastating blow when the emperor Maximilian, under pressure from the pope, recalled to Germany 9,000 soldiers who had fought under Gaston de Foix at Ravenna. Louis was thereby deprived, at a stroke, of almost half his army. Moreover, it would prove impossible for him to dispatch reinforcements from France, since Henry VIII had landed his ships along France's north coast and the Spanish were forcing their way over the Pyrenees.

Faced with such massive opposition, the French had little option but to retreat from Italy. "The soldiers of Louis XII," wrote one exultant observer, "have vanished like mist before the sun."[10] It was one of the most breathtaking reversals in military history—something straight from the pages of Maccabees, as if the tale of Heliodorus had indeed been reenacted on an Italian stage. Julius must have been especially delighted by the fall of Bologna, which was reclaimed from the Bentivogli in the name of the Church.

"We have won, Paride," he cried to his Master of Ceremonies as word reached him of the French retreat, "we have won!"

"May God give your Holiness joy of it," replied Paride.[11]

The celebrations in Rome were even more jubilant than those

Swiss guards in Raphael's The Mass of Bolsena.

during the pope's victorious return from Bologna five years earlier. "Never was any emperor or victorious general so honoured on his entry into Rome," wrote Lippomano, the Venetian envoy, "as the pope has been today."[12] He was cheered through the streets as he returned to the Vatican from the church of San Pietro in Vincoli, where he had given thanks to God for the liberation of Italy. Poets sang his praises in verse. One of them, Marco Girolamo Vida, a friend of Ariosto's, even started an epic poem entitled the *Juliad,* in which he planned to document the pope's heroic military exploits.

Meanwhile cannons thundered on the parapets of the Castel Sant'Angelo, while at night fireworks lit the darkness and a procession featuring 3,000 torches wound its way through the streets. Alms were distributed to the city's convents, and such were his good spirits that Julius even announced an amnesty for outlaws and criminals.

At the end of June, a number of Swiss mercenaries, the heroes of the hour, arrived in Rome. One week later, on the sixth of July, the pope issued a bull giving the Swiss the title "Protectors of the

Liberty of the Church," and silk banners commemorating the victory were sent as gifts to every township in Switzerland. These were not, of course, the only honors granted to them by the grateful pope, for soon afterward Raphael altered his design of *The Mass of Bolsena,* giving the reluctant warriors pride of place.

IL PENSIEROSO

TWO WEEKS AFTER the Swiss soldiers arrived in Rome, Michelangelo entertained a famous guest on his scaffold in the Sistine Chapel. Alfonso d'Este had traveled to Rome to negotiate peace with the pope. The abrupt disappearance of the French from Italy had deprived him of his allies, leaving him at the mercy of the Holy League. Not even the prodigious might of his artillery could save him from the armies that the pope was capable of mustering against him. Forced to seek forgiveness from his erstwhile friend, he reached Rome on the fourth of July, accompanied by his ambassador, Lodovico Ariosto.

All Rome was abuzz at Alfonso's arrival. Julius had once claimed it was the will of God that he should castigate the duke of Ferrara, and the hour of castigation had clearly now arrived. Alfonso's absolution was expected to be a spectacle as grand—and as humiliating—as the treatment of the Venetians a few years earlier. Rumors spread that the duke would appear on his knees on the steps of St. Peter's, wearing a hair shirt, with a rope around his neck. The prospect of witnessing the humbling of one of the greatest soldiers of the age meant that on the appointed day, the ninth of July, the piazza in front of the basilica was crammed with onlookers. To their disappointment, the ceremony was conducted behind the closed doors of the Vatican Palace, and featured neither a hair shirt nor a rope. Instead, while waiting to face *il papa terribile,* Alfonso was entertained by violinists and treated to bowls of fruit and goblets of wine. Julius then duly absolved him of his crimes against the Holy See, embracing him warmly as the ceremony concluded.

Alfonso seems to have made the most of his visit to Rome. According to the Mantuan envoy, after a lunch in the Vatican a few

days later he asked the pope if he might see Michelangelo's frescoes in the Sistine Chapel.[1] A visit was arranged forthwith by Alfonso's nephew, Federico Gonzaga, who was entering his third year as a hostage in Rome. Julius could deny Federico nothing, except of course his liberty, and so one afternoon Alfonso and several other gentlemen ascended the ladder and clambered onto the platform where Michelangelo and his team were at work.

Alfonso was astounded by what he saw. Nine months had passed since work in the Sistine Chapel had resumed, and Michelangelo, working with incredible speed and facility, was finally approaching the west end of the vault. Only a few tantalizingly small fields of white plaster separated him from the altar wall and therefore the end of his labors, while on the other side of his scaffold stretched more than one hundred feet of vault, its every inch teeming with glorious images.

The last two Genesis scenes, *The Creation of the Sun, Moon, and Plants* and *God Separating Light from Darkness,* had been finished a short time before Alfonso's visit. The first of these panels shows events from the third and fourth days of Creation. The left-hand side features a rear view of an airborne God creating the plants—a few fronds of green—with a wave of his hand. On the right-hand side, he floats through the heavens in a pose reminiscent of *The Creation of Adam,* pointing at the sun with his right hand and at the moon with his left. Painted a century before Galileo's telescope first gave hints about its craterous topography, Michelangelo's moon is simply a bland arc of gray some four feet in diameter. Its perfect outline, like that of the sun, was incised onto the *intonaco* using a compass. Michelangelo used the same method he had employed for the medallions, pounding a nail into the plaster, attaching a cord to it, then tracing 360 degrees around the fixed point.

God Separating Light from Darkness, illustrating the first day of Creation, is the sparest of all the Genesis scenes, involving nothing more than the single figure of God spinning through a cloudy vortex. He strikes a *contrapposto* pose as he divides light and darkness, turning his hips one way and his shoulders the other as he extends

his hands over his head and wrestles with the elements. Deftly foreshortened, as in the previous two Creation scenes, this figure marks Michelangelo's most accomplished attempt at *di sotto in sù* so far—and, indeed, one of the finest examples seen anywhere in Italy. If he used a perspective device such as Alberti's "veil," he must have erected it at the feet of a recumbent model, who then twisted his body to the right and extended his arms above his tipped-back head, offering the artist a view through the grid of his sharply foreshortened form.

This last Genesis scene was remarkable for another reason: Covering sixty square feet of plaster, it was completed, incredibly, in a single day. Michelangelo created a cartoon for the corkscrewing figure of God but then ignored its incised outlines once he went to work with his brush, executing part of the figure in freehand on the wet plaster. The fact that this scene was painted directly above the pope's throne—and therefore in a highly conspicuous location—reveals Michelangelo's dauntless self-belief in his labors at this late point. While his first Genesis scene, *The Flood,* "hidden" in a relatively unobtrusive spot, took more than six troublesome weeks to paint, he was now able to dash off his final scene from Genesis in a single, seemingly effortless *giornata.*

Despite working so frantically on his fresco, Michelangelo seems not to have objected to the sudden appearance on his scaffold of the duke of Ferrara, the man who six months earlier had melted down his bronze statue and turned it into a cannon. Perhaps he was won over by the duke's quick wit and deep appreciation of art, for Alfonso was, together with his wife, Lucrezia, a bountiful and discriminating patron. He had recently hired Antonio Lombardo to carve marble reliefs in one room of his palace in Ferrara, while Giovanni Bellini, the great Venetian artist, was painting a masterpiece, *The Feast of the Gods,* for another. Alfonso even dabbled in the arts himself. When not casting enormous cannons to wreak havoc on his enemies, he made the tin-glazed earthenware known as majolica.

Alfonso relished his visit to the chapel so thoroughly that he stayed on the scaffold to talk to Michelangelo long after the other

visitors climbed down. He "could not not satiate himself with look-
ing at these figures," reported the envoy, "and made many compli-
ments."[2] So impressed was Alfonso by the fresco that he tried to
commission a project for himself. It is unclear whether Michel-
angelo accepted the offer immediately. Given his vexation with the
fresco and his eagerness to sculpt the papal tomb, he can hardly
have savored the prospect of still more work with his paintbrushes.
Still, the fiery-tempered Alfonso was, like the pope, not a man to
disappoint. In the end, Michelangelo did execute a painting for
him, albeit eighteen years later, when he painted *Leda and the Swan* to
adorn the palace in Ferrara.

Alfonso did not show a similar interest in Raphael on that day,
which must have pleased Michelangelo. "After the Lord Duke came
down," the envoy recorded, "they wanted to take him to see the
room of the pope and those that Raphael is painting, but he did not
want to go." Why Alfonso should have refused to view Raphael's
frescoes remains a mystery. Perhaps the prospect of seeing the pro-
Julius propaganda in the Stanza d'Eliodoro did not appeal to the
defeated rebel. Whatever the reason, it seems natural that Alfonso,
the fierce man of war, should have preferred the *terribilità* of
Michelangelo to the order and grace of Raphael.

Alfonso's bedeviled ambassador, Lodovico Ariosto, was among the
company who climbed the ladder onto Michelangelo's scaffold. In
Orlando furioso, first printed four years later, he called Michelangelo
"Michel più che mortal Angel divino" (Michael, more than human,
angel divine),[3] in recollection of this visit to the Sistine Chapel.
The sightseeing tour must have come as a welcome diversion for
Ariosto, who was busily negotiating details of the uneasy peace
between the duke and the pope. Julius had absolved Alfonso from
ecclesiastical censure, but he still did not trust him wholehearted-

ly. Believing the Papal States would not truly be safe from the French so long as Alfonso ruled Ferrara, he had ordered the duke to yield the city and accept another dukedom instead, such as Rimini or Urbino. Alfonso was appalled at the idea. His family had been the lords of Ferrara for many centuries, and he did not intend to surrender his birthright in return for what he considered a lesser dukedom.

Having just won such a remarkable victory, Julius was in no mood to compromise. Two years earlier, Ariosto had been threatened with a swim in the Tiber had he refused to quit Rome. Following Julius's demand, relations between the pope and Alfonso deteriorated so swiftly that suddenly neither the duke nor his ambassador felt safe. Alfonso believed, with good reason, that Julius planned to imprison him and take control of Ferrara himself. Therefore, after dark on the nineteenth of July, just days after climbing Michelangelo's scaffold, he and Ariosto forced their way through the Porta San Giovanni and fled Rome. They remained on the run for several months, hiding in the woods from the pope's spies and sharing experiences not unlike those of the roving heroes in *Orlando furioso*.

To the surprise of no one, Ferrara was once more declared a rebel against the Church, and the Ferrarese expected the same treatment that had been meted out to Perugia and Bologna a few years earlier. But first the pope turned his attention to another wayward state that had stubbornly supported the king of France and refused to join the Holy League. In August, the pope and the other signatories to the Holy League dispatched Ramón Cardona and 5,000 Spanish soldiers—men who badly wanted revenge for their defeat at Ravenna—on yet another campaign. The viceroy's men left Bologna and began marching south through the Apennines in the heat of summer. Florence was about to be punished for its sins against the Church.

At home in Via Ghibellina in Florence, Michelangelo's brother Buonarroto had more personal concerns on his mind. A few days after Alfonso's flight from Rome, he had received a letter from his older brother suggesting that he would have to wait even longer before he became proprietor of his own wool shop. Michelangelo had recently invested much of the money earned from the Sistine Chapel in a farm, the purchase of which was arranged by Lodovico, newly returned to Florence from his posting in San Casciano. Named La Loggia, this property was located a few miles north of Florence in San Stefano in Pane, near Michelangelo's childhood home in Settignano. Michelangelo had no intention of retiring to La Loggia to chop wood and cultivate his vines, even though a large house in the country had been the aspiration of every self-respecting Italian since Cicero and his illustrious peers had built themselves luxurious, vine-draped villas in which to escape from the cares of state and the heat of Rome. La Loggia was merely an investment, a means for Michelangelo to earn a higher return on his money than the 5 percent offered at Santa Maria Nuova. Yet he was also aware that, by becoming a landowner, he was helping restore the House of Buonarroti to something of what he imagined was its former glory.

Buonarroto had not been pleased by his brother's investment. Now thirty-five and desperate to become his own master, he had written to Michelangelo in July, stating his worries that the purchase of La Loggia meant his older brother was about to renege on the promise he had been making for the past five years. Michelangelo's response was emphatic: He rebuked Buonarroto for his lack of faith and ordered him to be patient. "I work harder than anyone who has ever lived," he wrote furiously. "I am not well and worn out with this stupendous labour, and yet I am patient to achieve the desired end. So you, too, can very well be patient for two months, being ten thousand times better off than I am."[4]

A suffering figure struggling heroically and patiently with endless cares, labors and illnesses—Buonarroto was by now all too familiar with the image that Michelangelo projected back to

Florence whenever his family made demands upon him. But at least the end of the "stupendous labour" was now in sight, since Michelangelo gave Buonarroto yet another revised forecast as to when he might finish the fresco, reporting that he anticipated roughly two more months of work. A month later he was still hoping he might finish by the end of September, though he had missed so many deadlines that he became reluctant to prophesy. "The truth is," he explained to Buonarroto, "it is so great a labour I cannot estimate the time within a fortnight. Let it suffice that I shall be home before All Saints in any case, if I do not die in the meantime. I am being quick as I can, because I long to be home."[5]

Michelangelo's gloomy and irritable mood as he neared the end of his labors was expressed in a figure on the north side of the chapel. Completed a short time after *God Separating Light from Darkness,* the prophet Jeremiah was portrayed slumping motionless on his throne in a pose that anticipated—and no doubt influenced—Auguste Rodin's famous sculpture *The Thinker.* An old man with a long beard and unkempt gray hair, Jeremiah stares at the ground, striking an attitude of morose reflection as he props his chin on his massive right hand. He sits directly across the chapel from the Libyan Sibyl, the last of the giant prophetesses painted on the vault. The body language of these two seers is sharply contrasting, for the sibyl adopts a dramatic and daring pose that required Michelangelo's model to sit in a chair, twist his torso sharply to the right, and raise his arms to the level of his head while bending his left leg and splaying his toes—an uncomfortable position that must have caused him agonies.

Jeremiah's idle pose, on the other hand, would not have taxed the sitter in the least. This is just as well, since it is generally believed that Jeremiah is another of Michelangelo's self-portraits. Jeremiah is not one of his unflinchingly ugly images of himself, such as the grimacing, beheaded Holofernes at the other end of the chapel. But his likeness as the prophet Jeremiah depicts a different—and, in some ways, equally unflattering—aspect of his character.

"My grief is beyond healing," the notoriously glum Jeremiah

exclaims at one point in the Bible, "my heart is sick within me" (Jeremiah 8:18). In a later chapter he laments: "Cursed be the day on which I was born! The day when my mother bore me, let it not be blessed!" (Jeremiah 20:14). This pessimism can be explained by the fact that Jeremiah lived in the dark days after the Babylonians invaded Jerusalem, sacked the temple, and carried the Jews into captivity. The sad fate of Jerusalem is deplored in another of his books: "How lonely sits the city that was full of people! How like a widow she has become, she that was great among the nations!" (Lamentations 1:1).

Jeremiah had been given a memorable interpretation more than a decade earlier when Savonarola compared himself to the prophet, claiming to have foretold the invasion of Florence just as Jeremiah had predicted the fall of Jerusalem to Nebuchadnezzar. In his final sermon before his execution, Savonarola further identified himself with Jeremiah, saying that since the prophet had continued to speak despite his afflictions, he, Fra Girolamo, would not be silenced either. "Thou has made me a man of strife and a man of contention to the whole earth," he declared a few weeks before his death, echoing the prophet's words.[6]

Michelangelo, too, saw himself as a man of strife. Given his reputation for moroseness, his comparison of himself with the most doleful of the Hebrew prophets was as appropriate as Raphael's depiction of him as the ornery and unpleasant Heraclitus. In fact, the Jeremiah on the Sistine vaults so closely resembles Raphael's *pensieroso* in *The School of Athens*—the slouching body, the crossed feet, the heavy head supported by a hand—that it raises the question whether Michelangelo saw his rival's work in the Stanza della Segnatura before painting Jeremiah. No evidence exists one way or another, though by the summer of 1512 Michelangelo had surely learned of Raphael's addition to his fresco.

Michelangelo may have been sharing Raphael's joke by portraying himself as the lugubrious author of Lamentations. Yet this characterization still bears a good deal of truth. "I get my happiness from my dejection," he wrote in one of his poems, many of which

are filled with somber meditations on age, death, and decay.[7] "Whatever's born must come to death," he declared in another, going on to describe how everyone's eyes will soon turn into "black and frightful" sockets.[8] In a poem composed in his midfifties, he even wrote longingly of suicide, observing that self-slaughter would be "right for him who lives a bondsman, / Wretched, unhappy . . ."[9]

If Michelangelo was wretched and unhappy by nature, his work in the Sistine Chapel made him all the more miserable, as the numerous complaints in his letters reveal. Not only was he made wretched by his seemingly never-ending labors on the scaffold, but he was constantly troubled by events outside the chapel. Like Jeremiah, he was doomed to live in dangerous and troublesome times. And in his last few months of work on the fresco, yet another cause for worry suddenly loomed.

"I long to be home," Michelangelo had written to Buonarroto toward the end of August. But within days his hometown would be awash with what one chronicler called "a terrible wave of terror."[10]

IN EVIL PLIGHT

IN THE SUMMER of 1512 Florence was battered by some of the most violent thunderstorms in decades. In one of the fiercest, a bolt of lightning struck the Porta al Prato, on the northwest edge of the city, knocking from the gate-tower a coat of arms decorated with golden lilies. Everyone in Florence knew that lightning strikes were portents of things to come. In 1492 the death of Lorenzo de' Medici had been foretold when a bolt of lightning hit the dome of the cathedral, sending tons of marble crashing down in the direction of the Villa Careggi, where Lorenzo lay in bed with a fever. "I am a dead man," Il Magnifico was said to have exclaimed when told of the cascading marble. True enough, he died three days later, on Passion Sunday.

The bolt of lightning that damaged the Porta al Prato was equally unambiguous. As the golden lilies on the shield were the insignia of the king of France, it was obvious to everyone that the Florentines were to be punished for supporting Louis XII against the pope. And the fact that the lightning struck the Porta al Prato, of all gates, suggested that this terrible vengeance would come by way of Prato, a walled town a dozen miles northwest of Florence.

This prophecy was fulfilled soon enough, since in the third week of August the 5,000-strong army of Ramón Cardona descended on Prato, which it aimed to conquer before marching on Florence. The pope and his allies in the Holy League were determined to crush the republic headed by Piero Soderini and restore the city to the sons of Lorenzo de' Medici, who had been in exile since 1494. The subjugation of Florence was expected to be a simpler matter than chasing the Bentivogli from Bologna or taking Ferrara from Alfonso d'Este. The Florentines, with their untested commanders and small, inexperienced army, were no match for the

well-drilled, battle-hardened Spaniards under Cardona. Panic swept the streets of Florence as the viceroy and his troops moved south through the valleys of the Apennines.

Amid these scenes of panic, hasty preparations were made for a defense of Florence. The official in charge of the republic's militia, Niccolò Machiavelli, conscripted foot soldiers from among the peasants and farmers in the surrounding countryside. Armed with long pikes, 2,000 of these ragtag soldiers filed under the blasted gate-tower and marched away to fortify Prato. Situated on a plain beneath the Apennines, Prato was notable for its greenish marble, which had been used to clad the exterior of the cathedral in Florence. It was also known for its most famous relic, the girdle of the Virgin, which Mary herself had given to St. Thomas, and which was preserved in a special chapel in Prato's cathedral. In the coming days, however, the town's name was to become synonymous with something else—an event that would make it more notorious even than Ravenna.

The Spaniards appeared before the walls of Prato at the end of August, hard on the heels of Machiavelli's militiamen. Despite their numbers, Cardona's men were not, at first sight, an especially imposing force, possessing a woefully inadequate artillery that consisted of only two cannons, both of them the small-caliber guns known as falconets. They were also poorly provisioned and, after eight months on the road, thoroughly exhausted. To cap it all, following their frantic retreat from Ravenna, some of the Spaniards had been assaulted in the countryside by the bandits who made the roads of Italy such a menace.

The siege did not begin promisingly for Cardona's men. As they started bombarding the walls, one of their guns promptly split in two, leaving them with a single cannon. Hungry and dispirited, they immediately offered a truce to the Florentines, claiming it was not their wish to attack the republic, only to persuade its government to join the Holy League. Suddenly encouraged, the Florentines refused to accept it, leaving the Spaniards to reload their lone cannon and pepper the walls with shot. To everyone's surprise, after a day's

bombardment the falconet managed to open a small breach in one of the gates. The Spaniards poured through the hole unresisted while Machiavelli's inexperienced soldiers threw down their weapons and ran for their lives.

What followed was, in Machiavelli's rueful description, "a miserable scene of distress."[1] Trapped in the cobbled streets of Prato, neither the conscripts nor the people of Prato were shown any mercy by the Spanish pikemen. For the next few hours there was, in the words of another commentator, nothing but "cries, flight, violence, sack, blood and killing."[2] By the end of the day, more than 2,000 people— Florentines and Pratesi alike—lay dead inside the walls. The Spaniards, meanwhile, who had lost barely a single fighter, were only a two-day march at most from the gates of Florence.

"I think you should all see about withdrawing to some place where you would be safe, abandoning your possessions and everything else, since a man's life is of far more value than his possessions."[3] So wrote a frantic Michelangelo to his father on the fifth of September, less than a week after the sack of Prato. The bloody massacre of civilians as well as soldiers had been the worst atrocity perpetrated on Italian soil since the dark days a decade earlier when Cesare Borgia bestrode the peninsula. Florence received word of the slaughter with shock and terror. Learning the news in Rome a few days later, Michelangelo was in no doubt as to what course of action his family should take to escape the "evil plight," as he called it, that had befallen his hometown. He urged Lodovico to withdraw money from the account in Santa Maria Nuova and flee with the family to Siena. "Act as in case of plague," he begged his father, "be the first to flee."[4]

The situation in Florence was already resolving itself by the time Michelangelo wrote this letter. Initially, Piero Soderini had been

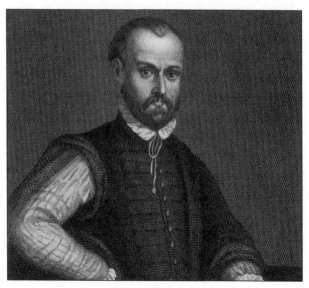

Niccolò Machiavelli, engraving by Hinchcliff after Brunzoni.

confident that he could bribe the Spaniards to spare Florence, there-by keeping the Medici at bay. Cardona had gladly accepted money, levying an indemnity of 150,000 ducats against the citizens of Florence, but still insisted that Soderini and his republican govern-ment must be replaced by the Medici. Made bold by the approach of the Spaniards, a band of young Florentines, supporters of the Medici, then stormed the Palazzo della Signoria and seized control of the government. A day later, the first of September, Soderini fled into exile in Siena. In a bloodless coup, Giuliano de' Medici, the son of Lorenzo, took control of the city. Machiavelli later remembered that a thunderbolt had struck the Palazzo della Signoria shortly before Soderini took to his heels—yet another example of how, in his opin-ion, nothing important ever happened without a celestial sign.

Machiavelli was optimistic about the return of the Medici. "This city remains very quiet," he wrote a week or two later, "and hopes not to live less honoured with the Medici's aid than she lived in times gone by, when the Magnificent Lorenzo their father, of happy memory, was ruling."[5] Sadly for him, he was deprived forth-with of his government post and then, suspected of anti-Medici plotting, imprisoned and tortured by the *strappado* (the ripper), a brutal technique that involved dropping the victim from a plat-

form and suspending him in midair from a rope binding his arms
together behind his back. The punishment usually resulted in dis-
located shoulders and agonized confessions. Tortured by the same
device, Savonarola had confessed to all sorts of crimes, including
having conspired with Giuliano della Rovere to overthrow Pope
Alexander VI. Machiavelli made no such forced confessions, how-
ever. Banished from Florence on his release from prison a few
months later, he retired, at the age of forty-three, to his small farm
near San Casciano, where Lodovico Buonarroti had recently been
podestà. There his days were spent snaring thrushes with his bare
hands and his nights playing *tric-trac* with the locals in a tavern. He
also began composing *The Prince,* his cynical work on statecraft in
which he bitterly declared all men to be "ungrateful, fickle, liars
and deceivers."[6]

Michelangelo proved much more cautious about the return of
the Medici. It is ironic that when Lorenzo's son, Piero de' Medici,
was expelled by the people of Florence in 1494, Michelangelo had
bolted to Bologna because of his close association with the dynasty,
only to be equally fearful of repercussions for himself and his fam-
ily when the Medici were returned to power almost two decades
later. "Don't get yourselves involved in any way, either by word or
deed," he urged his father, while to Buonarroto he offered similar
guidance: "Do not make friends or intimates of anyone, save God,
and do not speak good or evil of anyone, because no one knows
what the outcome will be. Attend only to your own affairs."[7]

Machiavelli's treatment at the hands of the new lords of Florence
suggests that Michelangelo had sound reason for encouraging such
caution. He was profoundly distressed, therefore, when he learned
from Buonarroto how it was reported in Florence that he had spo-
ken out against the Medici. "I have never said anything against
them," he protested to his father, though he did admit to having
condemned the atrocity at Prato, which everyone now blamed on
the Medici.[8] But the stones would have condemned the sack of
Prato, he claimed, if only they possessed the powers of speech.

Poised to return to Florence in a matter of weeks, Michelangelo

therefore suddenly found himself in fear that reprisals awaited him there. He urged his brother to carry out some detective work and get to the bottom of the malicious rumors. "I wish Buonarroto could see about learning discreetly where that person has heard that I spoke badly of the Medici," he told Lodovico, "to see if I can discover where it comes from . . . so I can be on guard against it." Despite his high reputation—or perhaps because of it—Michelangelo believed he had enemies in Florence who wished to blacken his name with the Medici.

Michelangelo had financial concerns as well at this time. He tried, as usual, to extract further payments from the pope, even though he had received virtually all of the money—a total, so far, of 2,900 ducats[9]—owing to him under the terms of the contract written by Cardinal Alidosi. He also attempted to retrieve money that his father had, for the second time in two years, misappropriated from his bank account. Prompted by his son's order to finance an escape to Siena with funds from Santa Maria Nuova, Lodovico withdrew, and spent, forty ducats despite the fact that the getaway never became necessary. Michelangelo expected restitution and forbade his father to take any more money. Still, he was soon forced to pay yet another of his father's unexpected expenses. Lodovico had found himself with a bill for sixty ducats as his share of the indemnity the people of Florence were required to pay the Holy League in order to preserve their liberties. He could afford only half, forcing Michelangelo to reach into his pocket for the remaining thirty ducats.

Michelangelo's frustrations at this point—with his father, with the dangerous political situation in Florence, with his own unceasing efforts on the fresco—showed themselves in a remarkably self-pitying letter written to Lodovico in October 1512, a month after

the sack of Prato. "I lead a miserable existence," he complained to his father in a lament worthy of Jeremiah. "I live wearied by stupendous labours and beset by a thousand anxieties. And thus have I lived for some fifteen years now and never an hour's happiness have I had. And all this I have done in order to help you, though you have never either recognised or believed it. God forgive us all."[10]

During this time of heightened anxieties and mounting frustrations, Michelangelo nonetheless managed to paint some of his most striking and accomplished scenes. For much of the summer and early autumn, he and his men worked on at the extreme west end of the chapel, frescoing the two pendentives in the corners as well as the narrow space of wall between them. The first of these areas to be painted, that on the left as one faces the altar, illustrated *The Crucifixion of Haman*. It was a virtuoso performance that shows Michelangelo at the summit of his powers.

The Book of Esther in the Old Testament provides the complex, operatic plot behind this episode. Haman was chief minister, or vizier, of King Ahasuerus of Persia, who reigned over an empire stretching from India to Ethiopia. Ahasuerus kept a populous harem that required the services of no fewer than seven eunuchs, but his favorite mistress was Esther, a beautiful young woman who, unbeknownst to him, was Jewish. Esther was also the cousin of one of the king's servants, Mordecai, who had urged her to keep her faith a secret. Mordecai had once saved Ahasuerus's life by foiling a plot by two eunuchs to have him murdered, but more recently he had fallen out of favor with Haman, the vizier, by refusing to bow before him as the other servants did. The arrogant and vengeful Haman therefore ordered the extermination of the Jews from Persia, issuing in the name of the king a proclamation "to destroy, to slay, and to annihilate all Jews, young and old, women and children . . . and to plunder their goods" (Esther 3:13). Not stopping at these measures, he began construction of a seventy-five-foot-high gallows on which he planned to deal with the insolent Mordecai personally.

Like the bronze medallions, the four pendentives in the corners

of the Sistine Chapel depict the timely rescue of the Jewish people from the machinations of their enemies. *The Crucifixion of Haman* is a perfect example. The act of genocide ordered by Haman was abruptly halted when Esther courageously intervened, announcing to King Ahasuerus that she herself was Jewish and, as such, in danger of falling victim to Haman's bloody purge. The king immediately revoked the decree and hanged Haman on the gallows built for Mordecai, who was then promoted to chief minister as a belated thanks for saving the royal life.

Michelangelo depicted Haman nailed to a tree instead of hanging from a gallows, as artists had more usually portrayed him. This great enemy of the Hebrew people thus strikes a pose more usually associated with the crucified Christ. There was a scriptural warrant for this depiction, however, since the Vulgate recounts how Haman prepared a cross, rather than a gallows, that stood fifty cubits high. But since Michelangelo read little Latin, he must have followed either the reference in Dante's *Purgatorio*—where Haman is also described as having been crucified[11]—or else the instructions of a more erudite scholar. Theologians were swift to spot a parallel with Christ in this episode, noting how both crucifixions were followed by salvation.[12] This image of salvation through the Cross therefore made an appropriate image for the chapel's altar wall.

Painted over twenty-four working days, *The Crucifixion of Haman* is striking for the brio of its composition, especially the naked Haman sprawled on the tree. An awed Vasari found this figure the most impressive of all of those on the vault, describing it as "certainly the most beautiful and most difficult."[13] He may well have been right, especially regarding its difficulty, since the scene required numerous preliminary sketches in which the artist repeatedly rehearsed Haman's exacting stance. The figure would have presented a challenge to Michelangelo's model, who was forced to pose with both arms outstretched, his head thrown back, his hips twisted, his left leg retracted, and his weight thrown onto his right foot—a pose that rivals that of the Libyan Sibyl for its strenuous gymnastics. The pose must have been held for considerable periods

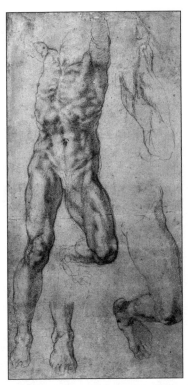

Michelangelo's sketches for The Crucifixion of Haman.

of time, since more drawings survive for *The Crucifixion of Haman* than for any other scene on the ceiling.

Once Michelangelo had settled his design for *The Crucifixion of Haman,* he did not transfer it to the plaster in freehand, as he had done only a few feet away with his upward-spiraling Creator in *God Separating Light from Darkness.* Instead, Haman's outlines were incised in great detail from a cartoon. The figure then took four *giornate* to paint, a fairly slow pace for Michelangelo at this late stage, especially in view of how several recent figures—including the most recent God—had been completed in a single day. Numerous nail holes can still be found in the area of Haman's arms and head, testifying to the problems involved in fixing the cartoon to a concave surface and then transferring its design to the damp plaster.

After completing this difficult scene, Michelangelo was left with only a few square yards of vault still to paint. The two lunettes on the altar wall remained, as did both the second pendentive and

the triangular stretch of vault directly across from where Zechariah was perched on his throne above the entrance. Michelangelo would feature Jonah, the last of his prophets, in this latter space. On the pendentive, meanwhile, he painted *The Brazen Serpent*—a scene that proved even more difficult than *The Crucifixion of Haman.*

It is interesting to note that when he was on the brink of finally completing his task, Michelangelo abruptly abandoned the minimalistic approach adopted for the second half of the vault and created, in *The Brazen Serpent,* a visually complex tableau featuring more than twenty struggling bodies. The drawn-out labors on this pendentive—which consumed an incredible thirty *giornate,* or about six weeks' work—were one of the reasons why Michelangelo failed to finish the fresco and make it back to Florence by the end of September, as he had been hoping. Only the first two Genesis panels, frescoed more than three years earlier, had required more time. Michelangelo may have been desperate to finish the fresco, but his artistic ambitions remained gloriously uncompromised.

The Brazen Serpent depicts the event from the Book of Numbers in which the Israelites, wandering in the wilderness, complained about their hunger and thirst, only to have a much worse cause for complaint when God, irritated by their griping, sent among them fiery serpents with poisonous fangs. After the surviving Israelites pleaded with Moses to rid them of this horrible scourge, God ordered him to construct a serpent of bronze and erect it as a standard. Moses duly fashioned this brazen serpent and raised it on a pole, so that "if a serpent bit any man, he would look at the bronze serpent and live" (Numbers 21:9). Like Haman spread-eagled on his tree, the brazen serpent was an image of the Crucifixion and, as such, a reminder of the salvation offered by Christ. Christ himself even drew this comparison in the Gospel According to St. John. "And as Moses lifted up the serpent in the wilderness," he told Nicodemus, "so must the Son of man be lifted up, that whoever believes in him may have eternal life" (John 3:14–15).

Michelangelo attacked the pendentive with gusto. The scene no doubt appealed to him because of the obvious similarities between

the doomed Israelites and the snake-entwined figures in the *Laocoön*.
Earlier depictions did not actually show the serpents constricting
themselves around the bodies of their victims, concentrating instead
on Moses raising his brazen image aloft.[14] Michelangelo, however,
chose to omit Moses altogether and emphasise instead the fate of the
doomed Israelites. The scene was therefore devoted largely to one of
his favorite motifs—a muscle-wrenching, spine-twisting battle, in
this case one in which a densely packed swarm of half-naked figures
writhe in the coils of the poisonous serpents.

Besides Laocoön and his sons, the contorted figures on the
right-hand side of the pendentive recall both the soldiers in *The
Battle of Cascina* and the half-human figures in *The Battle of the Centaurs,*
from the latter of which Michelangelo even borrowed a pose for one
of the Israelites.[15] With its host of doomed figures, the scene is also
reminiscent of *The Flood*. Nevertheless, Michelangelo's handling of
The Brazen Serpent—painted on a more confined and concave surface
than *The Flood*—demonstrates how vastly more daring and success-
ful his technique had become following four years on the scaffold.
Several of the twisted bodies are masterfully foreshortened, while
the overall composition is unified by both the undulating bodies
that Michelangelo neatly fitted between the sharp angles of the
pendentive and the brilliant oranges and greens that give the scene
such a striking visual presence on the vault.

As well as appealing to Michelangelo's artistic sense, the story of
the brazen serpent also endorsed his religious convictions. Done
around the time of the massacre at Prato, it reflected his belief,
shaped largely by Savonarola, that humankind's evil ways bring about
a doom and suffering that can be relieved only when we beg God for
forgiveness. Just as the waywardness of the Israelites brought down
the plague of serpents, so the sins of the Florentines had resulted, he
informed his father, in the descent of Ramón Cardona and his
Spanish soldiers, sent as a scourge by a wrathful deity: "We must be
resigned and commend ourselves to God and recognise the error of
our ways," he wrote to Lodovico in the aftermath of the bloody sack,
"through which alone these adversities come upon us."[16] This argu-

ment is a repetition of Savonarola's claim that Florence would be punished for its sins by the army of Charles VIII. As Michelangelo painted the pendentive, the words of Savonarola may well have echoed in his head: "O Florence, O Florence, O Florence, for your sins, for your brutality, your avarice, your lust, your ambition, there will befall you many trials and tribulations!"

Michelangelo's own adversities—those suffered on the scaffold, at least—were all but over by the time he wrote this letter to his father. After completing *The Brazen Serpent,* he proceeded to paint the spaces beneath, including the final pair of lunettes, one of which featured Abraham and Isaac in the same lackadaisical poses as the other ancestors of Christ.[17] A few days later, toward the end of October, he sent another letter to Florence. "I have finished the chapel I have been painting," he wrote, matter-of-factly. Typically, he did not rejoice in his accomplishment. "Other things," he lamented to Lodovico, "have not turned out for me as I had hoped."[18]

CHAPTER 31

FINAL TOUCHES

ON THE THIRTY-FIRST of October in 1512, the Eve of All Saints, the pope hosted a banquet in the Vatican for the ambassador of Parma. When the dinner was finished, the company retired to the palace's theater to watch two comedies and listen to a poetry recitation. As was his custom in the late afternoon, Julius then retired to his rooms for a short nap. But the entertainments were not over yet, and at sunset he and his entourage, which included seventeen cardinals, proceeded to the Sistine Chapel to observe vespers. An enthralling sight awaited them as they filed into the chapel from the Sala Regia. Michelangelo and his assistants had spent the previous few days dismantling and then removing the enormous scaffold. Some four years and four weeks after Michelangelo had begun his fresco, the time had come for him to exhibit it in its entirety.

Due to the larger figures in the second half of the vault as well as Michelangelo's more adroit and creative handling of his material, the fresco uncovered for the Eve of All Saints was much more breathtaking than the work-in-progress shown to the public some fifteen months earlier. One of the first figures seen by the pope and his cardinals as they made their way into the chapel for vespers was, in the opinion of Condivi, the most awe-inspiring of all of the vault's hundreds of figures. In the direct line of sight of worshipers entering at the opposite end of the chapel, Jonah occupied the narrow space between *The Crucifixion of Haman* and *The Brazen Serpent*. "A stupendous work," was Condivi's estimation, "and one which proclaims the magnitude of this man's knowledge, in his handling of lines, in foreshortening, and in perspective."[1]

Painted on a concave surface, Jonah leans backward with his legs apart, his torso twisted to the right, and his head tipped up and

turned to his left—a scene of struggle more akin to the body language of the *ignudi* than that of his fellow prophets. What most impressed Condivi was how Michelangelo created a trompe l'oeil through an incredible feat of foreshortening. He depicted the prophet in the act of leaning backward even though the painted surface curves *toward* the viewer, so that "the torso which is foreshortened backward is in the part nearest the eye, and the legs which project forward are in the part which is farthest."[2] Bramante had once stated that Michelangelo would be unable to paint overhead surfaces because he understood nothing of foreshortening, and Jonah seems to serve as his triumphant reply.

Jonah was the prophet ordered by the Lord to go to Nineveh and denounce its people for their wickedness. He refused this invidious mission, however, and instead boarded a boat going in the opposite direction, only to be caught in a violent tempest unleashed by the displeased Jehovah. Learning the reason for the storm, the frightened sailors tossed their passenger overboard, at which point the waters calmed and the reluctant prophet was swallowed by a "great fish" in whose belly he then spent three days and three nights before being disgorged onto dry land. Duly chastened, he went to Nineveh and prophesied its destruction, only to be disappointed when the Lord took pity on its inhabitants when they repented their evil ways.

Theologians regarded Jonah as a precursor of Christ and the resurrection, hence his position above the altar of the Sistine Chapel. Even Christ drew a direct comparison between himself and the prophet: "For as Jonah was three days and three nights in the belly of the whale," he told the Pharisees, "so will the Son of man be three days and three nights in the heart of the earth" (Matthew 12:40). However, the prophet's pose in Michelangelo's fresco has led scholars to puzzle over what moment in the biblical narrative Michelangelo was intending to portray. Some maintain that the fresco shows Jonah's anger at the Lord for not destroying Nineveh, others the moment of his regurgitation.[3] Whatever the episode in question, it is perhaps no accident that, in leaning back-

ward and gazing overhead, Jonah appears to stare in wordless stupefaction at the painted vault. Leon Battista Alberti had urged artists to include within their paintings a "spectator" to guide the attention and emotions of the work's viewers, either beckoning them to look at the scene or challenging them "with ferocious expression and forbidding glance."[4] Michelangelo seems to have taken Alberti's advice, since Jonah both directs the gazes of worshipers entering the chapel from the Sala Regia and pantomimes their reared-back stances and awestruck faces as they gaze at the magnificent fresco above their heads.

The pope was delighted with the unveiled fresco, surveying it "with immense satisfaction."[5] Everyone visiting the Sistine Chapel in the days after the fresco's completion was equally dazzled with Michelangelo's work. "When the work was thrown open," wrote Vasari, "the whole world could be heard running up to see it, and, indeed, it was such as to make everyone astonished and dumb."[6] The final pairs of *ignudi* were a particular tour de force, outstripping even magnificent ancient works such as the *Laocoön* for power and grace. They revealed a stunning virtuosity that pushed the limits of both human anatomy and artistic form. Never before, in either marble or paint, had the expressive possibilities of the human form been detailed with such astonishing invention and aplomb. None of Raphael's individual figures, no matter how expertly integrated into his graceful ensembles, came close to the brute visual force of Michelangelo's naked titans.

One of the two *ignudi* situated above Jeremiah—the very last *ignudo* to be painted, in fact—shows just how far behind Michelangelo had left his competition. Bent forward at the waist, his trunk tipped slightly to the left, and his right arm reaching back for a garland of oak leaves, he strikes a pose whose originality and complexity go beyond anything created even in classical antiquity. If the male nude was the genre in which, by 1512, all artists were forced to test themselves, Michelangelo's final few *ignudi* set an almost impossible standard.

Much as Julius admired the new fresco, in his opinion the work

was not quite finished: It lacked what he called *l'ultima mano* (the final touch). Accustomed to the ostentatious style of Pinturicchio, and wanting the vault to match the walls, where the garments had been trimmed with gold and the skies flecked with ultramarine, both of which needed to be added *a secco,* Julius asked Michelangelo to retouch the fresco "to give it a richer appearance."[7] Michelangelo did not relish the thought of reassembling the scaffold for the sake of a few *secco* touches, especially since he had avoided making such additions as much as possible in order to enhance both the durability of the fresco and, perhaps, his own reputation as a practitioner of the more prestigious style of *buon fresco.* He therefore informed the pope that the additions were unnecessary.

"It really ought to be retouched with gold," insisted the pope.

"I do not see that men wear gold," replied Michelangelo.

"It will look poor," protested His Holiness.

"Those who are depicted there," joked the artist, "they were poor too."[8]

Julius eventually relented, and the extra touches of gold and ultramarine were never added. This, however, was not the end of their disagreements, since Michelangelo believed he had not yet been properly compensated for his work. Despite having received, by the time of the unveiling, payments totaling 3,000 ducats, he claimed to be in a desperate financial situation. Had things become any worse, he later wrote, no option would have been left to him but to "go with God."[9]

The reason for Michelangelo's melodramatic lament about his poverty is difficult to fathom. His expenses as he painted the vault were not exceedingly high despite the great size of the project. In total, 85 ducats had gone to Piero Rosselli, 3 to the rope maker, 25 on pigments, another 25 on rent, and approximately 1,500 (at most) for his team of assistants. Probably another 100 ducats had been spent on assorted other expenses, including brushes, paper, flour, sand, pozzolana, and lime. He must therefore have cleared more than 1,000 ducats, meaning that he had earned, over the course of four years, an annual salary of around 300 ducats, or triple the

wages of the average craftsmen in Florence or Rome. The Sistine Chapel might not have made him wealthy by the standards of, say, a cardinal or a banker, but neither did it leave him in the poorhouse, as he implied. His purchase of La Loggia, for which he had paid about 1,400 ducats,[10] indicates that he was not short of cash as the project neared completion. Acquiring the farm may well have depleted his liquid assets, but this was hardly the fault of the pope.

The source of Michelangelo's complaint seems to have been that he felt he was owed a payment above and beyond the 3,000 ducats promised in his contract—a sort of a bonus for a job well done. He implied in one of his letters home that this bonus had been agreed in advance, and he was therefore irked when he did not receive it immediately after completing the vault. He was satisfied in due course, however, since a generous payment of 2,000 ducats was eventually disbursed to him. This payment, he later claimed, "saved my life."[11] However, he would discover to his extreme displeasure, years later, that this largesse had not been for the fresco at all; it was paid, instead, as an advance on work he was about to undertake on the long-delayed tomb. No bonus was ever paid for the fresco, leaving Michelangelo feeling, not for the first time, cheated by the pope.[12]

But for the moment, at least, Michelangelo was contented. And, with the vault completed, he was finally able to set down his brushes and, for the first time in years, prepare to take up his hammer and chisel.

More than six years after it was quarried, the marble for the pope's tomb still sat in the Piazza San Pietro, ignored by everyone except the thieves who had stolen several blocks. The tomb had never been far from Michelangelo's thoughts as he worked on his fresco, and he would have passed the pile of marble—a painful and vivid

reminder of how his ambitions had been sacrificed—whenever he made his way from the Piazza Rusticucci to the Sistine Chapel.

Having finished his fresco, Michelangelo was determined to resume work on the project for which Julius had brought him to Rome in the first place, and within a few days of uncovering his work he began making new sketches for the tomb. He also started preparing a wooden model from these sketches and arranging the lease on a large house owned by the Rovere family in Macello de' Corvi (Raven's Lane), across the Tiber near Trajan's Column. This was a more commodious property than the small studio behind Santa Caterina, complete with a garden for vegetables and chickens, a well, a wine cellar, and two cottages in which he could ensconce his assistants. Two assistants arrived from Florence soon afterward, though, as usual, Michelangelo suffered agonies with them. One of them, Silvio Falcone, fell ill soon after arriving in Rome, requiring Michelangelo to nurse him. A second—a "dunghill of a boy"[13]— harassed Michelangelo so incessantly that he was forced to evict him from the premises and make arrangements for his prompt return to Florence.

The task of carving the pope's tomb soon became acute. Julius celebrated his sixty-ninth birthday a few weeks after the fresco was unveiled. He also entered the tenth year of his tumultuous reign. He had cheated death many times, having survived danger-ous bouts of illness and several assassination attempts, eluded ambushes and kidnappings, dodged cannonballs on the field out-side Mirandola, and defied unfavorable prophecies and portents. These adversities inevitably took their toll, and, soon after the dawn of the new year 1513, the pope began to ail. By the middle of January he had lost all appetite—an alarming symptom in a gour-mand like Julius. Convinced, however, of the restorative proper-ties of wine, he insisted on tasting eight varieties to see which would do him the most good. Eager to continue working, he had his bed moved next door into the Camera del Pappagallo, where he received ambassadors and other visitors while lying on his back in the company of his caged parrot.

Still unable to eat or sleep, by the middle of February the pope had nevertheless improved enough to sit up in bed and drink a glass of malmsey with Paride de' Grassi, who was pleased to find him "looking quite well and cheerful."[14] It briefly seemed as if Julius was preparing to cheat death yet again. However, on the following day he was given a drink containing powdered gold—a quack remedy for all ailments—and overnight his condition swiftly deteriorated. The next morning, the twenty-first of February, the people of Rome learned that *il papa terribile* was dead.

"I have lived forty years in this city," an incredulous Paride de' Grassi wrote in his journal a few days later, "but never have I seen such a vast throng at the funeral of any former pope."[15] Julius's funeral, which took place during carnival time, caused an unprecedented and almost hysterical outburst of emotion among the people of Rome. The crowds pushed aside the Swiss Guards and insisted on kissing the feet of the dead pontiff as he lay in state in St. Peter's. Even Julius's enemies, it was said, burst into tears, declaring that he had delivered both Italy and the Church from "the yoke of the French barbarians."[16]

The funeral oration in St. Peter's was delivered by Fedro Inghirami. "Bone Deus!" he exclaimed in his sonorous voice. "Good God! What talent was his, what prudence, what experience at the ruling and administration of empire. What strength could match that of his lofty, unbreakable spirit?"[17] Afterward, Julius was laid to rest in the choir of the half-built basilica, beside the grave of Sixtus IV, in a temporary tomb from which he would be moved when Michelangelo's memorial was completed.

Plans for this memorial were finally going ahead. Two days before his death, in one of his very last acts, Julius had issued a bull confirming that he wished Michelangelo to carve the tomb and

setting aside 10,000 ducats for the purpose. He also made special plans for the structure. Whereas the monument had originally been destined for San Pietro in Vincoli, and afterward the rebuilt St. Peter's, on his deathbed Julius decided he wanted his body to repose beneath what was, of all his many achievements, the finest testament to his reign. Once completed, the magnificent tomb was to be installed, he insisted, inside the Sistine Chapel. Julius wished to be entombed beneath not just one, but two, of Michelangelo's masterpieces.[18]

Michelangelo's reaction to Julius's death is not recorded. Once an intimate of the pope, from whom he had expected great things, he became estranged following their disagreement over the tomb in 1506, an episode that he was never to forget and one to which, many years later, he still made bitter references. However, he must have recognized how Julius, whatever his shortcomings, had been the greatest of patrons, a man whose plans and visions were as impossibly grandiose as his own, whose energies and ambitions were as unflagging, and whose *terribilità* was manifest, like his own, in every inch of the painted vault.

Shortly after Julius was buried in St. Peter's, the thirty-seven-year-old Giovanni de' Medici, the son of Lorenzo the Magnificent, was elected Pope Leo X in a conclave that took place beneath Michelangelo's new fresco.[*] A childhood friend of Michelangelo, Leo was a cultivated, genial, and generous man, both reverent toward the memory of Julius II and, initially at least, favorably disposed toward Michelangelo, whom he promised to keep working as a sculptor on grand projects for years to come. He gave evidence of this intention immediately after his election by issuing a new contract for Michelangelo to carve Julius's memorial. Forty life-size marble figures were still planned for the tomb, and Michelangelo's

[*]During the conclave Cardinal de' Medici did not occupy the lucky cell beneath Perugino's *Giving of the Keys to St. Peter*. Instead, debilitated by a suppurating anal fistula, he was assigned by Paride de' Grassi a cell at the front of the chapel, convenient to the sacristy, where he could receive the necessary medical attention.

remuneration was increased to a hefty 16,500 ducats. The hundred tons of Carrara marble was promptly carted from the Piazza San Pietro to the studio in Macello de' Corvi. A full seven years after fleeing Rome on horseback, Michelangelo finally returned to what he called his "true profession."

EPILOGUE:
THE LANGUAGE OF
THE GODS

MICHELANGELO WOULD LIVE another fifty-one years after completing the Sistine ceiling, creating many more masterpieces in both paint and marble during the course of his long career. In 1536 he even returned to the Sistine Chapel to paint another fresco, *The Last Judgment*, on its altar wall. And, in a strange twist, toward the end of his life he served as the master of the works for St. Peter's. Donato Bramante died in 1514, at the age of seventy, but the construction of the new basilica dragged on for more than a century after Julius first pushed its foundation stone into place, thereby giving rise to the contemporary Italian expression *la fabbrica di San Pietro* (the building of St. Peter's), used to describe a never-ending process. Raphael succeeded Bramante as architect-in-chief, making a number of changes to his mentor's original design. Michelangelo inherited the enormous project more than three decades later, in 1547, having proved himself, among his other accomplishments, the most inventive and influential architect of the century. Accepting the commission from Pope Paul IV only with the greatest reluctance—he claimed that architecture was not his "true profession"—he proceeded to design for the basilica the majestic dome that dominates not only the Vatican but the skyline of Rome itself.*

Raphael would not have nearly so long a career. He did not even

*Michelangelo's design for the dome of St. Peter's was revised after his death by Giacomo della Porta, under whom it was completed, in collaboration with Domenico Fontana, in 1590.

live to see the decoration of the Vatican apartments completed. At the time of Julius's death, he had been starting work on his third fresco in the Stanza d'Eliodoro, *The Repulse of Attila.* One more fresco, *The Liberation of St. Peter,* then remained to be executed. Once it was completed, in 1514, Leo immediately commissioned him to paint the next room in the papal apartments, that now known as the Stanza dell'Incendio. Named after one of its frescoes, *Fire in the Borgo,* this room was finished, with the help of a large number of assistants, in 1517.

Raphael took on numerous other projects, including designs for tapestries, portraits of courtiers and cardinals, and of course more frescoes. Besides working on St. Peter's, he also served as an architect in the Vatican, completing and then decorating the loggias begun years earlier by Bramante. He designed a mortuary chapel for Agostino Chigi and started a villa outside Rome for the new pope's brother, Giuliano de' Medici. Abandoning his more humble lodgings in the Piazza Scossa Cavalli, he eventually moved into a palace of his own, the Palazzo Caprini, a grand lodging that had been designed by Bramante.

Raphael also kept busy with love affairs. Despite his dalliance with Margherita Luti, the baker's daughter, he became engaged, in 1514, to a young woman named Maria, the niece of Bernardo Dovizi da Bibbiena, a powerful cardinal who was the subject of one of his many portraits. Vows were never exchanged, however, since Raphael kept postponing the wedding. According to Vasari, his reasons for procrastinating were twofold. He was hoping to be made a cardinal—an office for which marriage would obviously disqualify him—and he was eager, Vasari claimed, "to divert himself beyond measure with the pleasures of love."[1] The incessant postponement of her nuptials supposedly caused Maria to die of a broken heart. Soon afterward, on Good Friday in 1520, Raphael himself died following a night of debauchery in which, Vasari maintained, he "indulged in more than his usual excess."[2] Like Shakespeare, he died on his birthday—in his case, his thirty-seventh.

Raphael's untimely death left the papal court, according to one observer, "in the utmost and most universal grief. Here, people are talking about nothing but the death of this exceptional man, who has completed his first life at the young age of thirty-seven. His second life—that of his fame, which is subject neither to time nor death—will endure for all eternity."[3] To the people of Rome, the heavens seemed to give a sign of their own grief at the painter's death, for cracks suddenly appeared in the walls of the Vatican, causing Leo and his entourage to flee the crumbling palace. These cracks were probably less celestial mourning, however, than a result of Raphael's recent structural modifications to the Vatican.

Raphael's body was exposed to public view on a catafalque beneath his latest painting, *The Transfiguration,* after which he and his frustrated bride-to-be, Maria da Bibbiena, were finally brought together in death and buried side by side in the Pantheon. As for Margherita, the baker's daughter, she is said to have entered a convent after Raphael left her the means to live a decent life. However, she may well have carried a secret with her into the cloisters. Recent X-ray analysis of *La Fornarina,* Raphael's 1518 portrait of her, has revealed a square-cut ruby ring on the third finger of her left hand, suggesting another reason why Raphael was anxious to postpone his wedding day: He was already married to Margherita. Then, as now, the fourth finger of the left hand was recommended for the wedding ring because it was believed a special vein, the *vena amoris,* passed directly from that finger to the heart.* This ring remained unseen for almost five centuries, having been painted over, probably by one of Raphael's assistants, in order to avoid a scandal after his death.

At the time of Raphael's premature death, the scaffolding was being constructed for the fourth and final room to be frescoed in the papal suite, the Sala di Costantino. If his frescoes in the Vatican

*In the *Sposalizio,* however, Raphael portrays Joseph preparing to slip the ring onto the fourth finger of the Virgin's right hand—an action repeated from Perugino's *Marriage of the Virgin,* where Mary likewise offers her right hand to Joseph.

apartments had been overshadowed by Michelangelo's work in the Sistine Chapel, Raphael at least won a posthumous victory over his great rival. A short while after Raphael's burial, Michelangelo's friend Sebastiano del Piombo applied to Pope Leo to have Michelangelo (who was not enthusiastic about the plan) fresco the Sala di Costantino, only to have the appeal rejected on the grounds that Raphael's students—who included the talented young Giulio Romano—possessed their master's cartoons and would fresco the walls according to these designs. The Sala di Costantino was duly finished by these assistants in 1524.

Julius's tomb engaged Michelangelo interminably, causing him, if anything, even more anguish than his fresco in the Sistine Chapel. He carved it, off and on, for more than thirty years before finally completing it in 1545. It was not installed in the Sistine Chapel, as Julius had wished, but instead in the transept of San Pietro in Vincoli, the church across from the Colosseum. Nor was it the grandiose monument envisioned by the pope, since both its dimensions and the number of statues had been greatly reduced at the behest of Julius's heirs. The ten-foot-high figure of *il papa terribile* wearing a tiara—the statue intended to crown the tomb—was never even started. In fact, much of the work was eventually done by other sculptors hired by Michelangelo, such as Raffaello da Montelupo. What is more, Julius's body was never exhumed, as planned, so it could repose within the massive sepulchre. Instead, his remains were left in their temporary grave in St. Peter's, beside those of Sixtus IV.

Michelangelo finally made good on his promise to Buonarroto and, in 1514, loaned his three younger brothers 1,000 ducats for a wool shop in Florence, which they ran with modest success for about a dozen years. Buonarroto, the only brother to marry and

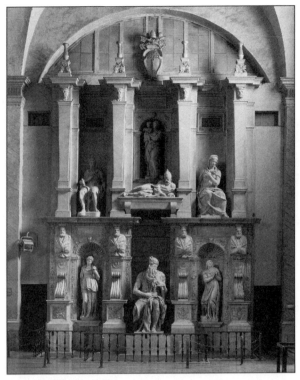

Michelangelo's tomb for Julius II in the church of San Pietro, Vincoli, Rome.

have children, died from the plague in 1528, at the age of fifty-one, much mourned by his older brother. Giovansimone died twenty years later, never having fulfilled his youthful dreams of voyaging to far-flung lands and making his fortune from the trade in exotic goods. On his deathbed he expressed contrition for his sins—an act which reassured Michelangelo that he would find his salvation in Heaven. Sigismondo, the soldier, died in 1555, at the family farm in Settignano. The death of Lodovico in 1531, at the age of eighty-seven, prompted Michelangelo to write one of his longest poems, a lament about his "great sorrow" and "weeping woe" for a man who had so frequently antagonized and infuriated him.[4]

Michelangelo himself died in Rome in 1564, a few weeks shy of his eighty-ninth birthday. His body was returned to Florence for burial in the church of Santa Croce, beneath a tomb sculpted by Giorgio Vasari. Poems and other tributes from the people of Florence were immediately pinned to the monument. Most praised

him as the greatest artist who had ever lived, supreme above all rivals in the fields of sculpture, painting, and architecture.[5] This opinion was given official sanction during a state funeral in which the consul of the Florentine Academy, a poet and historian named Benedetto Varchi, delivered an oration proposing that Raphael of Urbino would have been the greatest artist the world had ever known—if Michelangelo had not existed. More than five decades after the two men first started work on their frescoes in the Vatican, their rivalry was still green in everyone's memory.

None of Michelangelo's other works ever won him quite the same renown as his fresco in the Sistine Chapel, a building now virtually synonymous with his name. Almost immediately it became, like the cartoon for *The Battle of Cascina,* an academy for artists. It generated intense interest, in particular, among a new generation of Tuscan painters such as Rosso Fiorentino and Jacopo da Pontormo, exponents of the movement later known as mannerism. Both Rosso and Pontormo made artistic pilgrimages south to Rome during the pontificate of Leo X and then filled their works with the same luminous colors and sensual vigor that they saw on the vault of the Sistine Chapel.

Artists from farther afield also took note of Michelangelo's work. Titian began imitating some of the figures in the fresco before it was even finished. In the autumn of 1511 the Venetian painter, then twenty-six, painted in the Scuola del Santo in Padua a small fresco in which he copied the reclining figure of Eve from *The Temptation.*[6] Titian is not known to have visited Rome by this point; therefore he must have seen some of the sketches of Michelangelo's figures that had been done by other artists as soon as the first half of the vault was unveiled, and which were then passed from hand to hand. A market soon developed for these

sorts of sketches, which were used like model-books. Sometime after the full version was uncovered, an obscure artist named Leonardo Cungi executed a set of drawings of the entire fresco. This particular collection was purchased by one of Raphael's assistants, Perino del Vaga, who then used some of the motifs in his own ceiling decorations, including a chapel in San Marcello al Corso in Rome, where he frescoed a *Creation of Eve*.

In the 1520s, Marcantonio Raimondi, the preeminent engraver in Italy, made prints of a number of the scenes. Many other sets of prints appeared in the decades that followed, with engravers as far away as the Netherlands reproducing Michelangelo's figures, one set of which was bought at auction, in the following century in Amsterdam, by a famous painter and enthusiastic collector named Rembrandt van Rijn. Such engravings, as well as artistic excursions to the Sistine Chapel itself, served to inscribe Michelangelo's work on the European imagination, ensuring that no artistic education could be complete without a thorough knowledge of his work. When Sir Joshua Reynolds exhorted his students at the Royal Academy in London to copy from Michelangelo's fresco—which he called "the language of the Gods,"[7] and which he himself had copied during his visit to Rome in 1750—his injunction must almost have seemed redundant. Artists had long been using the Sistine Chapel as a storehouse of ideas, and they continued to do so long after Reynolds—so much so that the French impressionist painter Camille Pissarro later observed that artists treated the works of Michelangelo as a "portfolio" through which they could "rummage."[8] Indeed, from Peter Paul Rubens, who made chalk studies of the *ignudi* and *The Brazen Serpent* in 1602, and whose "Sturm und Drang" style, developed when he returned to Antwerp, featured heroically straining nudes; to William Blake, whose first graphic work of art was a pen-and-wash copy of an Adamo Ghisi engraving of the Sistine fresco; to the great Mexican muralist Diego Rivera, who spent seventeen months sketching and studying frescoes in Italy in the early 1920s, and whose first public mural, *Creation,* painted in the Escuela Nacional Preparatoria in Mexico

City in 1922, features a nude Adam seated on the ground with his left knee retracted—almost every painter of note, for more than four centuries, would "rummage" through Michelangelo's seemingly inexhaustible portfolio, reproducing gestures and poses whose contours and configurations are now as familiar as the shape of Italy on a map.

Still, not everyone who saw Michelangelo's fresco was entirely impressed. For Pope Hadrian VI, a puritannical scholar from Utrecht who succeeded Leo X in January of 1522, it seemed yet another example of the kind of Roman decadence that Martin Luther was using to whip up enmity against the Church. Unhappy about celebrating Mass beneath images that were, in his opinion, more appropriate to a bathhouse than a Christian chapel, Hadrian threatened to bring the fresco crashing to the floor. Fortunately, he died after a reign of only eighteen months.

Michelangelo's fresco has weathered the centuries remarkably well, serving as an admirable illustration of Vasari's confident assertion that fresco "resists anything that would injure it." It has survived, more or less intact, such depredations as a leaking roof, buckling walls, and, in 1797, an explosion in the Castel Sant'Angelo that shook the chapel so violently that large chunks of plaster fell from the vault, including a patch on which the *ignudo* above the Delphic Sibyl was painted.* It has also endured centuries of insidious assault by numerous pollutants: clouds of incense and candle smoke from thousands of Masses; smoke from the ballot papers ceremo-

*The unstable walls were the result of an old problem: the poor foundations on which the chapel was originally built. The entrance wall was the worst affected. In 1522, as Pope Hadrian entered the chapel, the door lintel collapsed, barely missing Hadrian and killing a Swiss Guard.

nially incinerated by the cardinals at the end of each papal con-
clave;✝ corrosive emissions from Rome's oil-fired central heating
and its one million automobiles; and even the breath of the 17,000
daily visitors, who release more than four hundred kilos of water
into the air of the chapel, setting off a damaging cycle of evapora-
tion and condensation.

The fresco has not come through entirely unscathed, of course.
The candle smoke and incense, as well as the braziers used to heat
the chapel in winter, darkened the fresco with layers of soot and
grime even during Michelangelo's lifetime, leading to various
attempts to restore its original brilliance. Following Domenico
Carnevale's repairs and retouchings in the 1560s, other interven-
tions were made in the centuries that followed. In 1625, a
Florentine artist named Simone Laghi used linen rags and slices of
stale bread to remove as much as he could of the accumulated
grime. He was followed in the next century by Annibale Mazzuoli,
who cleaned the surface with sponges dipped in Greek wine, which
the Italians used as a solvent. Mazzuoli and his son then retouched
certain passages *a secco,* like Carnevale, and slathered a protective
varnish across the surface.⁹

Restoration procedures eventually resorted to more precise
techniques. In 1922, recognizing the importance of preserving its
priceless art collection, the Vatican founded its Laboratory for the
Restoration of Pictures. Six decades later, this institution took on
its greatest challenge. Prompted by concerns that the glues and
varnishes from previous restorations were starting to flake and, in
so doing, pulling away flecks of Michelangelo's paint, the most

✝This ceremony involves stuffing the ballots into an old stove connected to the
chimney of the Sistine Chapel, then pulling either the "black" or the "white" han-
dle on the stove. Chemicals released by these handles ensure that the smoke issu-
ing from the chimney is either black or white, indicating that the conclave has
either succeeded (white) or failed (black) to elect the new pope. In August 1978,
during the conclave that elected John Paul I, the chapel itself was filled with a nox-
ious black smoke after someone neglected to sweep the chimney. The 111 cardinals
were nearly suffocated, and a further layer of grime was added to the fresco.

thorough intervention in the fresco's history commenced in June 1980. Funded by a Japanese television network, NTV, the Vatican's chief restorer, Gianluigi Colalucci, launched a multimillion-dollar operation that would involve dozens of experts and take twice as long as Michelangelo had needed to paint the fresco in the first place.

Colalucci's approach, overseen by an international examining committee, was a combination of high-tech wizardry—including a computer that digitized images from the vault and stored them in a giant database—and old-fashioned elbow grease. Spectrum technology determined the chemical compositions of Michelangelo's paints, isolating them from those of subsequent restorers like Carnevale. The restorers' *secco* additions were then removed, along with the grime and other extraneous substances, using AB57, a special cleaning solvent made from, among other things, sodium bicarbonate. The restorers applied this solvent on compresses of Japanese paper, leaving them in place for three minutes before cleansing the surface with distilled water. Cracks in the plaster were filled with *stucco romano,* a mixture of lime and marble dust, while any corroded patches received injections of a solidifying substance called Vinnapas.

With these steps completed, the fresco was retouched in a few places with watercolor paints. Standing on a special aluminium scaffold whose design mimicked Michelangelo's, the Vatican's restorers added these watercolors in parallel, vertical strokes, allowing future generations to tell where the work of Michelangelo ends and that of this latest restoration begins. Finally, to protect the colors from the pollutants that caused the damage in the first place, parts of the fresco were coated with an acrylic resin known as Paraloid B72.

Further measures were also taken to safeguard the fresco. To keep the chapel's microclimate under control, the windows were hermetically sealed and banks of low-heat lights installed, together with a state-of-the-art air-conditioning system that filters the air and maintains a constant temperature of twenty-five degrees Celsius (seventy-seven degrees Fahrenheit). An antidust carpet

was laid on the stairs leading down from the Vatican apartments (where Raphael's frescoes have also been restored using a similar array of techniques). The entire operation, documented with 15,000 photographs and twenty-five miles of 16mm film, was finished in December 1989.[10]

Such a comprehensive restoration of one of the great landmarks of Western civilization did not proceed without criticism, especially since the removal of five centuries of scum revealed such unexpectedly brilliant colors that the Vatican's restorers were accused by their detractors of having created a "Benetton Michelangelo."[11] Fought with a shrill animus on the front pages of newspapers and journals during the mid- to late 1980s, the controversy drew into the fray personalities such as Andy Warhol and Christo, the Bulgarian-born artist famous for wrapping up buildings and stretches of coastline in colorful fabric. Criticism ultimately hinged on whether or not Michelangelo himself had applied many of the glue-based pigments and varnishes that Colalucci's solvent had stripped away along with the film of soot. Opponents of the restoration claimed Michelangelo had made significant and extensive *secco* additions to the fresco, deepening its shadows and unifying the entire composition with darker tones. The restorers argued, on the other hand, that Michelangelo painted almost entirely in *buon fresco,* and that these darker tones were the accident of both airborne pollutants and the obscuring varnishes of incompetent restorations.

A number of inconsistencies in the Vatican's account of the cleaning were seized on by the critics, foremost among whom was the renowned American art historian James Beck of Columbia University. The Vatican first reported, for instance, that the application of Paraloid B72 was "thorough, complete and overall," only to retract this statement a few years later when critics argued that the resin might eventually turn opaque, asserting instead that no protective coating of any sort was applied to the fresco other than in a few places on the lunettes.[12] Similarly vacillating accounts have been offered regarding Michelangelo's possible use of ultramarine, a pigment that, if present, was almost certainly removed by the solvent.[13]

Despite anxieties about its methods, the restoration brought to light an extraordinary amount of new information regarding Michelangelo's technique, influences, and collaborations. Although disagreement persists as to how extensively Michelangelo retouched the painting *a secco,* it seems clear that, after a faltering start, he increasingly used *buon fresco,* the method he had learned in the workshop of one of Florence's greatest practitioners, Domenico Ghirlandaio. The full extent of the role played by Michelangelo's helpers also became clearer. The idea of Michelangelo at the head of a team of assistants dashes the cherished notion of the artist toiling alone on his scaffold, on his back, like Charlton Heston in the 1965 film adaptation of Irving Stone's novel *The Agony and the Ecstasy.* This image was exposed as nothing more than an appealing fallacy that, together with the camouflaging layers of soot and glaze, vanished beneath the tissue-paper poultices of AB57.[14] Michelangelo himself was largely responsible for this myth, as were Vasari, Condivi, and, much later, the German poet Goethe, who wrote, following a trip to Rome in the 1780s, that without visiting the Sistine Chapel we cannot understand what one man is capable of achieving.[15] We now know that the fresco in the Sistine Chapel was not the work of a single individual. But for the millions of visitors who negotiate the labyrinth of the Vatican's galleries and corridors to enter the chapel and seat themselves on its rows of wooden benches, staring upward in unwitting imitation of the prophet Jonah, the vision that rises above their heads is no less spectacular.

NOTES

1. THE SUMMONS

1. Ascanio Condivi, *The Life of Michelangelo,* trans. Alice Sedgwick Wohl, ed. Hellmut Wohl, 2d ed. (University Park: Pennsylvania State University Press, 1999), p. 6. All further references will be to this edition.

2. Quoted in Charles de Tolnay, *Michelangelo,* vol. 1, *The Youth of Michelangelo* (Princeton: Princeton University Press, 1943), p. 91.

3. For Michelangelo's summons to Rome, see Michael Hirst, "Michelangelo in 1505," *Burlington Magazine,* November, 1991, pp. 760–65.

4. For the rivalry between Sangallo and Bramante, see Arnaldo Bruschi, *Bramante* (London: Thames and Hudson, 1977), p. 178.

5. Michelangelo Buonarroti, *The Letters of Michelangelo,* ed. E. H. Ramsden, (London: Peter Owen, 1963), vol. 1, pp. 14–15.

6. Condivi, *The Life of Michelangelo,* p. 35.

7. Ibid.

8. *The Letters of Michelangelo,* vol. 1, p. 15.

9. Quoted in Ludwig Pastor, *The History of the Popes from the Close of the Middle Ages,* ed. Frederick Ignatius. Antrobus et al. (London: Kegan Paul, Trench, Trübner, 1898), vol. 6, pp. 213–14.

10. Quoted in Christine Shaw, *Julius II: The Warrior Pope* (Oxford: Blackwell, 1993), p. 304.

2. THE CONSPIRACY

1. See Bruschi, *Bramante,* pp. 177–79.

2. Condivi, *The Life of Michelangelo,* p. 4.

3. Ibid., p. 39.

4. *The Letters of Michelangelo,* vol. 1, p. 15.

5. This charge is made in Condivi's *Life of Michelangelo,* p. 30.

6. Benvenuto Cellini, *The Autobiography of Benvenuto Cellini,* trans. George Bull (London: Penguin, 1956), p. 31.

7. See Roberto Salvini and Ettore Camesasca, *La Cappella Sistina in Vaticano* (Milan: Rizzoli, 1965), pp. 15–23. The foreman in charge of the actual construction was Giovannino de' Dolci. For a comparison between the Temple of Solomon in Jerusalem and the Sistine Chapel, see Eugenio Battisti, "Il significato simbolico della Cappella Sistina," *Commentari* 8 (1957): 96–104; and Battisti's *Rinascimento e Barocca* (Florence: Einaudi, 1960), pp. 87–95.

8. See Karl Lehmann, "The Dome of Heaven," *Art Bulletin* 27 (1945): 1–27.

9. This letter is reproduced in *Il Carteggio di Michelangelo*, ed. Paola Barocchi and Renzo Ristori (Florence: Sansoni Editore, 1965), vol. 1, p. 16.

10. The idea of commissioning Michelangelo to paint the fresco may even have come from Sangallo himself. See Giorgio Vasari, *Lives of the Painters, Sculptors and Architects*, trans. Gaston du C. de Vere (London: Everyman's Library, 1996), vol. 1, p. 706.

11. *Il Carteggio di Michelangelo*, vol. 1, p. 16.

12. Ibid.

13. Recently it has been discovered that Michelangelo was associated with Ghirlandaio's workshop as early as June 1487, when, at the age of twelve, he collected a debt of three florins for the master. See Jean K. Cadogan, "Michelangelo in the Workshop of Domenico Ghirlandaio," *Burlington Magazine*, January 1993, pp. 30–31.

14. Condivi, *The Life of Michelangelo*, p. 10.

15. Two other early paintings sometimes attributed to Michelangelo are, in the opinion of some art historians, of debatable authenticity: *The Entombment* (in the National Gallery, London) and the so-called *Manchester Madonna*.

16. Leonardo da Vinci, *Treatise on Painting*, trans. A. Philip McMahon (Princeton: Princeton University Press, 1956), vol. 1, pp. 36–37.

17. Giorgio Vasari, *Vasari on Technique*, trans. Louisa S. Maclehose, ed. G. Baldwin Brown (New York: Dover, 1960), p. 216.

18. *Il Carteggio di Michelangelo*, ed. Paola Barocchi and Renzo Ristori (Florence: Sansoni Editore, 1965), vol. 1, p. 16.

19. Ibid.

3. THE WARRIOR POPE

1. For an eyewitness account of debauchery at the Borgia court, see *At the Court of the Borgias, Being an Account of the Reign of Pope Alexander VI Written by His Master of Ceremonies, Johann Burchard*, ed. and trans. Geoffrey Parker (London: Folio Society, 1963), p. 194.

2. Cellini, *The Autobiography of Benvenuto Cellini*, p. 54.

3. *The Letters of Michelangelo*, vol. 1, p. 15.

4. Quoted in Pastor, *History of the Popes*, vol. 6, pp. 508–9.

5. Quoted in ibid., p. 509.

4. PENANCE

1. For details of the relationship between the two men, see James Beck, "Cardinal Alidosi, Michelangelo, and the Sistine Ceiling," *Artibus et Historiae* 22 (1990): 63–77; and Hirst, "Michelangelo in 1505," pp. 760–66.

2. Quoted in Pastor, *History of the Popes*, vol. 6, p. 510.

3. Condivi, *The Life of Michelangelo*, p. 38.

4. Ibid.

5. Ibid.

6. *The Letters of Michelangelo*, vol. 1, p. 148.

7. Ibid., p. 38.

8. Ibid., p. 19.

9. Ibid., p. 20.

10. Ibid., p. 21.

11. Ibid., p. 36.

12. Ibid. p. 40.

13. Ibid.

14. See de Tolnay, *Michelangelo*, vol. 1, p. 39.

5. PAINTING IN THE WET

1. *I Ricordi di Michelangelo*, ed. Paola Barocchi and Lucilla Bardeschi Ciulich (Florence: Sansoni Editore, 1970), p. 1.

2. Beck, "Cardinal Alidosi, Michelangelo, and the Sistine Ceiling," p. 66.

3. *The Letters of Michelangelo*, vol. 1, p. 41.

4. Vasari, *Vasari on Technique*, p. 222.

5. Giovanni Paolo Lomazzo, *Scritti sulle arti*, ed. Roberto Paolo Ciardi (Florence: Marchi and Bertolli, 1973), vol. 1, p. 303.

6. Vasari, *Lives of the Painters, Sculptors, and Architects*, vol. 1, p. 57. Vasari is unreliable in his comments on Cavallini. Anxious to root fresco painting in Tuscany, he conveniently ignores the influence of Cavallini, making him, erroneously, a pupil of Giotto.

7. Vasari, *Lives of the Painters, Sculptors, and Architects*, vol. 1, p. 114.

8. Ibid., p. 915.

9. Quoted in William E. Wallace, "Michelangelo's Assistants in the Sistine Chapel," *Gazette des Beaux-Arts* 11 (December 1987): 204.

10. Vasari, *Lives of the Painters, Sculptors, and Architects*, vol. 2, p. 665.

11. See Frederick Hartt, "The Evidence for the Scaffolding of the Sistine Ceiling," *Art History* 5 (September 1982): 273–86; and Fabrizio Mancinelli, "Michelangelo at Work: The Painting of the Lunettes," in *The Sistine Chapel: Michelangelo Rediscovered*, ed. and trans. Paul Holberton (London: Muller, Blond, and White, 1986), pp. 220–34. For an alternative view of what the scaffold may have looked like, see Creighton E. Gilbert, "On the Absolute Dates of the Parts of the Sistine Ceiling," *Art History* 3 (June 1980): 162–63; and Gilbert's *Michelangelo on and off the Sistine Ceiling* (New York: George Braziller, 1994), pp. 13–16.

12. Condivi, *The Life of Michelangelo*, p. 101.

13. Quoted in de Tolnay, *Michelangelo*, vol. 2, p. 219.

6. THE DESIGN

1. *I Ricordi di Michelangelo*, p. 1.

2. For an argument in favor of Alidosi's active participation in the decorative scheme, see Beck, "Cardinal Alidosi, Michelangelo, and the Sistine Ceiling,"

pp. 67 and 74. Beck notes how a few years later, in 1510, the cardinal would try to hire Michelangelo to paint another fresco, one for whose complex blueprint he himself was the designer. This fact suggests that he may have had some experience composing decorative schemes for the Sistine Chapel frescoes.

3. For the contract, see Gaetano Milanesi, "Documenti inediti dell'arte toscana dal XII al XVI secolo," *Il Buonarroti* 2 (1887): pp. 334–38.

4. Bernard Berenson, *Italian Painters of the Renaissance* (London: Phaidon, 1968), vol. 2, p. 31.

5. Quoted in Lione Pascoli, *Vite de' pittori, scultori ed architetti moderni* (1730), facsimile edition (Rome: Reale Istituto d'Archaeologia e Storia dell'Arte, 1933), p. 84. For the gradual liberation of the artist from the constraints of the patron, see Vincent Cronin, *The Florentine Renaissance* (London: Collins, 1967), pp. 165–89; and Francis Haskell, *Patrons and Painters: A Study of the Relations Between Italian Art and Society in the Age of the Baroque*, revised ed. (New Haven: Yale University Press, 1980), pp. 8–10.

6. This point was made by Vasari and is supported by Sven Sandström in *Levels of Unreality: Studies in Structure and Construction in Italian Mural Painting During the Renaissance* (Stockholm: Almquist and Wiksell, 1963), p. 173.

7. *The Letters of Michelangelo*, vol. 1, p. 148.

8. Ibid.

9. For the career of Andreas Trapezuntius and the intellectual climate of Sixtus IV's Rome, see Egmont Lee, *Sixtus IV and Men of Letters* (Rome: Edizioni di Storia e Letteratura, 1978).

10. For a summary of the thought and career of Egidio da Viterbo—one which does not entertain ideas of his participation in the design of the Sistine Chapel frescoes—see John W. O'Malley, *Giles of Viterbo on Church and Reform: A Study in Renaissance Thought* (Leiden: E. J. Brill, 1968). For an argument in favor of his participation, see Esther Gordon Dotson, "An Augustinian Interpretation of Michelangelo's Sistine Ceiling," *Art Bulletin* 61 (1979): 223–56, 405–29. Dotson claims that Egidio was "the formulator of the programme," which she claims is based on St. Augustine's *City of God*. She notes, however, that there is no documented link between Michelangelo and Egidio. Another possible adviser has been offered by Frederick Hartt, who claims that the pope's cousin, Marco Vigerio della Rovere, was involved in design of the project. See Hartt's *History of Italian Renaissance Art: Painting, Sculpture, Architecture* (London: Thames and Hudson, 1987), p. 497.

11. *The Life of Michelangelo*, p. 15.

12. Charles de Tolnay is in no doubt that Michelangelo reaped the full benefit of life in the Garden of San Marco: "This inspiring group served as a sort of spiritual fount to Michelangelo. To them he owes his concept of aesthetics, which is based on the adoration of earthly beauty as the reflection of the divine idea; his ethics, which rests upon the recognition of the dignity of mankind as the crown of creation; his religious concept, which considers paganism and Christianity as merely externally different manifestations of

the university truth" (*Michelangelo*, vol. 1, p. 18). For a study of Neoplatonic symbolism in Michelangelo's work, see Erwin Panofsky, "The Neoplatonic Movement and Michelangelo," in *Studies in Iconography: Humanistic Themes in the Art of the Renaissance* (New York: Oxford University Press, 1939), pp. 171–230.

13. Charles de Tolnay argues that Michelangelo's biblical histories, as a genre, "have their origins in relief representations of the early Renaissance . . . but it is the first time that such large historical 'reliefs' appear on a ceiling. Until that time they had been placed on walls and doors" (*Michelangelo*, vol. 2, pp. 18–19). Another influence could have been Paolo Uccello's (now badly damaged) frescoes in the Chiostro Verde in Santa Maria Novella, which likewise depict a number of the same scenes as those in the Sistine Chapel: *The Creation of Adam, The Creation of Eve, The Temptation of Eve, The Flood, The Sacrifice,* and *The Drunkenness of Noah*. Michelangelo would have been familiar with these images through his work with Ghirlandaio in Santa Maria Novella.

7. THE ASSISTANTS

1. See Ezio Buzzegoli, "Michelangelo as a Colourist, Revealed in the Conservation of the Doni *Tondo*," *Apollo* (December 1987): 405–8.

2. *The Letters of Michelangelo*, vol. 1, p. 45.

3. *I Ricordi di Michelangelo*, p. 1. Preserved in the Buonarroti Archive in the Biblioteca Laurenziana-Medici in Florence, this document has been dated by Michael Hirst to April 1508. See "Michelangelo in 1505," p. 762.

4. For Urbano's participation in the Sistine Chapel project, see Wallace, "Michelangelo's Assistants in the Sistine Chapel," p. 208.

5. Vasari, *Lives of the Painters, Sculptors, and Architects,* vol. 2, p. 51.

6. Ibid., p. 54.

7. Ibid., p. 51.

8. Quoted in de Tolnay, *Michelangelo*, vol. 1, p. 31.

9. Vasari, *Lives of the Painters, Sculptors, and Architects,* vol. 2, p. 310.

10. Quoted in Charles Seymour, ed., *Michelangelo: The Sistine Chapel Ceiling* (New York: W. W. Norton, 1972), p. 105.

8. THE HOUSE OF BUONARROTI

1. See Condivi, *The Life of Michelangelo*, p. 5.

2. *Il Carteggio di Michelangelo*, vol. 2, p. 245.

3. Condivi, *The Life of Michelangelo*, p. 9.

4. *The Letters of Michelangelo*, vol. 1, pp. 45–46.

5. Ibid., p. 13.

6. See, for example, ibid., p. 39.

7. For dowries in Florence, see Christiane Klapische-Zuber, *Women, Family, and Ritual in Renaissance Italy,* trans. Lydia Cochrane (Chicago: University of Chicago Press, 1985), pp. 121–22.

8. Only II percent of women widowed in their thirties remarried, and so it is safe to assume that after the age of forty they had virtually no chance of remarrying. See ibid., p. 120.

9. See Wallace, "Michelangelo's Assistants in the Sistine Chapel," pp. 204–5.

10. *The Letters of Michelangelo,* vol. I, p. 46.

11. Fabrizio Mancinelli has speculated that Michi was a sculptor ("Michelangelo at Work: The Painting of the Lunettes," p. 253), only to retract the statement a few years later: "In truth there is nothing that indicates one way or another what his profession was" ("The Problem of Michelangelo's Assistants," in *The Sistine Chapel: A Glorious Restoration,* ed. Pierluigi de Vecchi and Diana Murphy, [New York: Harry N. Abrams, 1999], p. 266, n. 30). However, Michelangelo reports in a letter that Michi was at work in San Lorenzo (*The Letters of Michelangelo,* vol. I, p. 46), where decorations were being done in the north transept, a fact which seems to indicate that he was a frescoist.

12. When he offered his services to Michelangelo, Giovanni Michi also mentioned that someone else wished to come to Rome and work in the Sistine Chapel: a painter from Florence named Raffaellino del Garbo. However, no evidence suggests that Michelangelo ever accepted his offer. De Tolnay argues that it seems unlikely that Raffaellino did any work on the Sistine Ceiling since his paintings show a "pronounced Filippinesque style"—i.e., that of his master, Filippino Lippi—that is undetectable on any part of the ceiling. See *Michelangelo,* vol. 2, p. 115. However, Wallace points out that Michi's letter dates from the very beginning of the project, "at a time when Michelangelo and Granacci were actively seeking assistants," and so Raffaellino's presence should not automatically be discounted ("Michelangelo's Assistants in the Sistine Chapel," p. 216). Neither Vasari nor Condivi makes any reference to Raffaellino's participation, which might indicate that he was not involved. Yet neither of these biographers refers to Giovanni Michi either, someone who definitely did work with Michelangelo; nor do they mention other of Michelangelo's assistants whose work is clearly documented.

13. Quoted in de Tolnay, *Michelangelo,* vol. 2, p. 9.

9. THE FOUNTAINS OF THE GREAT DEEP

1. On this working practice, see Michael Hirst, *Michelangelo and His Drawings* (New Haven: Yale University Press, 1988), pp. 35–36, and Catherine Whistler, *Drawings by Michelangelo and Raphael* (Oxford: Ashmolean Museum, 1990), p. 34.

2. See *Scritti d'arte del cinquecento,* ed. Paola Barocchi (Milan and Naples: Ricciardi, 1971), vol. I, p. 10.

3. Genesis 8:10. All quotations from the Bible, unless otherwise indicated, are from the revised standard edition (London: William Collins, 1946).

4. For details, see de Tolnay, *Michelangelo,* vol. I, p. 218, and vol. 2, p. 29. He claims that some of the figures in the background of the fresco "are modified repetitions of figures of the bathing soldiers in [Michelangelo's] own *Battle of Cascina*" (vol. 2, p. 29).

5. See Mancinelli, "The Problem of Michelangelo's Assistants," pp. 52–53.

6. Carmen C. Bambach, *Drawing and Painting in the Italian Renaissance Workshop: Theory and Practice, 1300–1600* (Cambridge: Cambridge University Press, 1999), p. 366.

7. *The Letters of Michelangelo*, vol. 2, p. 182.

8. Quoted in Lene Østermark-Johansen, *Sweetness and Strength: The Reception of Michelangelo in Late Victorian England* (Aldershot, Hants.: Ashgate, 1998), p. 194.

9. Condivi, *The Life of Michelangelo*, p. 105.

10. Quoted in Roberto Ridolfi, *The Life and Times of Girolamo Savonarola*, trans. Cecil Grayson (London: Routledge and Kegan Paul, 1959), p. 80.

11. Quoted in Edgar Wind, "Sante Pagnini and Michelangelo: A Study of the Succession of Savonarola," *Gazette des Beaux-Arts* 26 (1944): 212–13.

12. For Savonarola's almost exclusive use of the Old Testament, see Donald Weinstein, *Savonarola and Florence: Prophecy and Patriotism in the Renaissance* (Princeton: Princeton University Press, 1970), p. 182.

13. For discussions of Savonarola's influence on Michelangelo's art, see Julian Klaczko, *Rome and the Renaissance: The Pontificate of Julius II*, trans. John Dennie (London: G. P. Putnam's Sons, 1903), p. 283; Charles de Tolnay, *The Art and Thought of Michelangelo* (New York: Pantheon, 1964); Ronald M. Steinberg, *Fra Girolamo Savonarola, Florentine Art, and Renaissance Historiography* (Athens, Ohio: Ohio University Press, 1977), pp. 39–42; and Cronin, *The Florentine Renaissance*, p. 296. Cronin, for example, argues that Savonarola's writings and sermons produced among a number of Florentine painters, including Botticelli and Signorelli, a "retrograde" art that regarded Christianity in terms of vengeance, terror, and punishment. De Tolnay likewise finds in Michelangelo's art a "profound echo" of Savonarola's words (pp. 62–63). Steinberg, however, is somewhat more cautious in attributing influences, claiming that direct links between Michelangelo's iconography and Savonarola's sermons are difficult to prove. This difficulty is partly due to Michelangelo's silence on the subject as well as our lack of knowledge about his theological mentors. For the possible influence of Savonarola through his successor at San Marco, Sante Pagnini, see Wind, "Sante Pagnini and Michelangelo," pp. 211–46.

14. Antonio Paolucci has argued that even the Vatican *Pietà*, with its "chaste beauty," was influenced by Savonarola's teachings. See Paolucci's *Michelangelo: The Pietàs* (Milan: Skira, 1997), pp. 16–17.

10. COMPETITION

1. Quoted in Pastor, *History of the Popes*, vol. 6, p. 308.

2. Quoted in Klaczko, *Rome and the Renaissance*, p. 151.

3. Quoted in ibid., p. 151.

4. This point is made in Michael Levey, *Florence: A Portrait* (London: Pimlico, 1996), pp. 265–56.

5. For this story, see Vasari, *Lives of the Painters, Sculptors, and Architects*, vol. 1, p. 593. André Chastel has pointed out that the Perugino anecdote "is not confirmed by any police document or judicial record. But there is little reason to doubt

it." See Chastel, *A Chronicle of Italian Renaissance Painting,* trans. Linda Murray and Peter Murray (Ithaca: Cornell University Press, 1984), p. 137.

6. For Bramante's role in fostering the various artists on the Vatican team, see Bruschi, *Bramante,* p. 178.

7. For Bramante's participation in the decoration, see ibid., p. 166.

8. For Raphael's early career in Città di Castello, see Tom Henry, "Raphael's Altar-piece Patrons in Città di Castello," *Burlington Magazine,* May 2002, pp. 268–78.

9. Raphael's participation in the Collegio del Cambio campaign is a matter of debate among art historians. For the arguments in favor, see Adolfo Venturi, *Storia dell'arte italiana* (Milan: Ulrico Hoepli, 1913), vol. 7, pp. 546–49. For reservations, see Alessandro Marabottini et al., eds., *Raffaello giovane e Città di Castello* (Rome: Oberon, 1983), p. 39.

10. For another instance of Tuscan jingoism, the case of the Baptistery Doors competition a century earlier, see Levey, *Florence: A Portrait,* p. 120.

11. According to Arnaldo Bruschi, Bramante was "instrumental in bringing Raphael to Rome" (*Bramante,* p. 178).

12. The precise date of Raphael's arrival in Rome is unknown. His presence is not definitively recorded before January 1509, though he may have been there as early as the previous September, when he wrote to the artist Francesco Francia referring to a commission about which he was "seriously and constantly worried"—a work that some art historians interpret as the Vatican apartments. He is not, however, listed in the original set of accounts recording the activities of Sodoma, Perugino, and the other artists, and so he was probably a late addition to the team. For an argument in favor of Raphael having visited Rome earlier than 1508, see John Shearman, "Raphael, Rome, and the Codex Excurialensis," *Master Drawings* (summer 1977): 107–46. Shearman speculates that Raphael may have visited Rome as early as 1503 and then again in 1506 or 1507.

11. A GREAT QUANDARY

1. *The Letters of Michelangelo,* vol. 1, p. 48.

2. Condivi, *The Life of Michelangelo,* p. 57.

3. John Shearman, "The Chapel of Sixtus IV," in *The Sistine Chapel: Michelangelo Rediscovered,* ed. Paul Holberton (London: Muller, Blond, and White, 1986), p. 33. The roof leaked stubbornly for the next four centuries, until it was completely rebuilt in 1903 and then restored in 1978.

4. *Vasari on Technique,* p. 222.

5. See Steffi Roettgen, *Italian Frescoes,* vol. 2, *The Flowering of the Renaissance, 1470–1510,* trans. Russell Stockman (New York: Abbeville Press, 1997), p. 168. Likewise, when Filippino Lippi painted his frescoes in the Strozzi Chapel in Santa Maria Novella (1487–1502), he was also under contract (with Filippo Strozzi) to paint only in *buon fresco.* Eve Borsook argues that by 1500 *buon fresco* was taken up as "an academic point of honour. . . . For Vasari and many oth-

ers, fresco painting was the test of an artist's virtuosity in speed and power of improvisation." See Borsook's *The Mural Painters of Tuscany* (Oxford: Clarendon Press, 1980), p. xxv.

6. Mancinelli, "The Problem of Michelangelo's Assistants," p. 52.

7. Vasari, *Lives of the Painters, Sculptors and Architects*, vol. 2, p. 667.

8. Ibid., p. 666.

9. Condivi, *The Life of Michelangelo*, p. 58.

10. For a sensible corrective to Vasari, see Wallace, "Michelangelo's Assistants in the Sistine Chapel," pp. 203–16.

11. *The Letters of Michelangelo*, vol. 1, p. 48.

12. Condivi, *The Life of Michelangelo*, p. 106.

13. Ibid.

14. Barocchi, *Scritti d'arte del cinquecento*, vol. 1, p. 10.

15. Quoted in de Tolnay, *Michelangelo*, vol. 1, p. 5.

16. Condivi, *The Life of Michelangelo*, p. 106.

17. Ibid., p. 102.

18. Vasari, *Lives of the Painters, Sculptors, and Architects*, vol. 2, p. 736.

19. Donato Giannotti, *Dialogi di Donato Giannotti*, ed. Deoclecio Redig de Campos (Florence: G. C. Sansoni, 1939), p. 66.

20. *Il Carteggio di Michelangelo*, vol. 3, p. 156.

21. Vasari, *Lives of the Painters, Sculptors, and Architects*, vol. 1, p. 607.

22. Ibid.

23. Ibid.

12. THE FLAYING OF MARSYAS

1. Quoted in Vincenzo Golzio, *Raffaello nei documenti, nelle testimonianze de contemporanei, e nella letteratura del suo secolo* (Vatican City: Panetto and Petrelli, 1936), p. 1.

2. Quoted in ibid., p. 281.

3. Vasari, *Lives of the Painters, Sculptors, and Architects*, vol. 1, p. 710.

4. Ibid., p. 711. Vasari's comments on Raphael's upbringing must be taken with a grain of salt, given the fact that he misses the actual date of Magia Ciarli's death by a decade.

5. Raphael's serene physical beauty sparked much discussion in later centuries. German physiologists scrutinized the handsome face in his self-portraits for clues to his personality and genius. One of them, Karl Gustav Carus, rhapsodized about the "sensual, arterial and pneumatic qualities of his temperament" reflected in the harmonious proportions of his skull. See Oskar Fischel, *Raphael*, trans. Bernard Rackham (London: Kegan Paul, 1948), p. 340. This harmoniously proportioned skull, or at least one purporting to be Raphael's, did the rounds of European museums for several decades until, in

1833, in order to expose the fraud, the painter's tomb in the Pantheon was opened and the remains—which included a skull—exhumed. The skeleton was examined by the professor of clinical surgery at the University of Rome, who concluded that the painter possessed a large larynx. Raphael therefore had a manly baritone to go with his sundry other charms.

6. Vasari, *Lives of the Painters, Sculptors, and Architects*, vol. 2, p. 422.

7. Ibid., p. 418.

8. Ibid.

9. No conclusive and incontrovertible documentary evidence links the Bibliotheca Iulia with the Stanza della Segnatura. Their identification—accepted by most (though not all) scholars—is based largely on the room's decorative design, which seems to be that of a library. For a clinching argument, see John Shearman, "The Vatican Stanze: Functions and Decoration," in *Proceedings of the British Academy* (London: Oxford University Press, 1973), pp. 379–81. Shearman argues convincingly that during Julius's reign the Signatura was located next door, in the room now known as the Stanza dell'Incendio (p. 377).

10. For the contents of Julius's library, see Léon Dorez, "La bibliothèque privée du Pape Jules II," *Revue des Bibliothèques* 6 (1896): 97–124.

11. For a study of the relationship of the personifications to the scenes on the walls below, see Ernst Gombrich, "Raphael's Stanza della Segnatura and the Nature of Its Symbolism," in *Symbolic Images: Studies in the Art of the Renaissance* (London: Phaidon, 1972), pp. 85–101.

12. Recent conservation in the Stanza della Segnatura has failed to discover whether Raphael and Sodoma worked simultaneously on the vaults, or whether Sodoma worked on the vaults while Raphael started on the walls and then intervened on the vault only when Sodoma completed his own sections. On this problem, see Roberto Bartalini, "Sodoma, the Chigi, and the Vatican Stanze," *Burlington Magazine*, September 2001, pp. 552–53.

13. Kenneth Clark, *Leonardo da Vinci* (London: Penguin, 1961), p. 34.

14. For Sodoma's payment, see G. I. Hoogewerff, "Documenti, in parte inediti, che riguardano Raffaello ed altri artisti contemporanei," in *Atti della Pontificia Accademia Roma di Archeologia, Rediconti* 21 (1945–46): 250–60.

15. On this difference in style, see Bartalini, "Sodoma, the Chigi, and the Vatican Stanze," p. 549.

13. TRUE COLORS

1. See D. S. Chambers, "Papal Conclaves and Prophetic Mystery in the Sistine Chapel," *Journal of the Warburg and Courtauld Institutes* 41 (1978): 322–26.

2. Vasari, *Lives of the Painters, Sculptors, and Architects*, vol. 2, p. 666.

3. Quoted in Robert J. Clements, ed., *Michelangelo: A Self-Portrait* (New York: New York University Press, 1968), p. 34.

4. On Michelangelo's practice of working in these latitudinal bands, from the central panels to the lunettes, see Mancinelli, "Michelangelo at Work," p. 241. There has been disagreement among scholars over whether Michelangelo

painted the lunettes concurrently with the rest of the vault or as part of a later campaign. In 1945 Charles de Tolnay argued that they were not painted until 1511–12, by which time he claims the remainder of the fresco was complete (*Michelangelo*, vol. 2, p. 105). The view has more recently been adopted by Creighton Gilbert ("On the Absolute Dates of the Parts of the Sistine Ceiling," p. 178). Other art historians, such as Fabrizio Mancinelli, disagree, arguing that the lunettes were not part of a distinct, later campaign but rather were painted at the same time as the rest of the vault: see Mancinelli, "The Technique of Michelangelo as a Painter: A Note on the Cleaning of the First Lunettes in the Sistine Chapel," *Apollo* (May 1983): pp. 362–63. Mancinelli's thesis in this article that "the painting of the lunettes should be related to the progress of the work on the ceiling of the whole" and that "these two phases were closely linked and not distinct" (p. 363) marks a revision of his earlier view—expressed in *The Sistine Chapel* (London: Constable, 1978), p. 14—that the lunettes were executed in a later campaign carried out in 1512. Mancinelli's revised view is a confirmation of Johannes Wilde's early intimation that "the lunettes and vaulted triangles [the spandrels] are not later than the central parts of the ceiling corresponding to them." See "The Decoration of the Sistine Chapel," *Proceedings of the British Academy* 54 (1958): 78, note 2. Wilde's chronology has also been accepted by Sidney Freedberg in *Painting of the High Renaissance in Rome and Florence* (Cambridge, Mass.: Harvard University Press, 1972), p. 626; and in *Painting in Italy, 1500–1600* (London: Penguin, 1971), p. 468; by Michael Hirst, "Il Modo delle attitudini: Michelangelo's Oxford Sketchbook for the Ceiling," in *The Sistine Chapel: Michelangelo Rediscovered*, pp. 208–17; and by Paul Joannides, "On the Chronology of the Sistine Chapel Ceiling," *Art History* (September 1981): 250–52.

5. John Gage, *Colour and Culture: Practice and Meaning from Antiquity to Abstraction* (London: Thames and Hudson, 1993), p. 131.

6. Robert W. Carden, ed., *Michelangelo: A Record of His Life as Told in His Own Letters and Papers* (London: Constable, 1913), pp. 57–58.

7. Evelyn Welch, *Art in Renaissance Italy* (Oxford: Oxford University Press, 1997), p. 84.

8. Mary Merrifield, *The Art of Fresco Painting* (London, 1846; reprint, London: Alec Tiranti, 1966), p. 110.

9. For Michelangelo's pigments, see Mancinelli, "Michelangelo at Work," p. 242, and "Michelangelo's Frescoes in the Sistine Chapel," in *The Art of the Conservator*, ed. Andrew Oddy (London: British Museum Press, 1992), p. 98.

10. Cennino Cennini, *Il Libro dell' arte: The Craftsman's Handbook*, trans. Daniel V. Thompson (New Haven: Yale University Press, 1933), p. 27.

11. A successful painter such as Pietro Perugino, for example, paid twelve gold florins per year for a studio in Florence: A. Victor Coonin, "New Documents Concerning Perugino's Workshop in Florence," *Burlington Magazine*, February 1999, p. 100.

12. For Ghirlandaio's use of ultramarine in *buon fresco*, see Roettgen, *Italian Frescoes*, vol. 2, p. 164. The possible use of ultramarine on the vaults of the Sistine

Chapel has been a matter of some debate since the controversial restoration of Michelangelo's frescoes between 1980 and 1989. The matter is clouded by a number of conflicting statements about ultramarine made by the director of operations for the restoration, Fabrizio Mancinelli, who was the Vatican's curator of Byzantine, medieval, and modern art until his death in 1994. At stake is whether the restorers, in their zeal to clean the fresco, removed *secco* touches (including passages of ultramarine) that Michelangelo added, or whether these *secco* touches—many of which had darkened the colors—were the work of previous restorers. Mancinelli vacillated wildly over whether or not Michelangelo used ultramarine and, if so, whether or not he added it *a secco*. In 1983 he claimed that some blues (which he did not name) were indeed added as *secco* touches. In 1986 he revised this view, declaring that Michelangelo made no *secco* touches to the fresco, but rather added ultramarine in *buon fresco*—a view reiterated the following year at a symposium in London. In 1991, two years after the restoration was completed, he changed his mind yet again, deciding that the blues on the ceiling were not ultramarine, but rather *smaltino*. In 1992, however, Mancinelli made yet another U-turn, proposing that ultramarine was used after all. It seems virtually impossible, on the basis of these contrary statements, to determine whether Michelangelo in fact used ultramarine on the Sistine's vaults. The bulk of evidence does, however, suggest that it was used in a number of places, for example, on Zechariah's collar, where it was added *a secco*.

For Mancinelli's various statements, see (in order of publication) "Michelangelo at Work," pp. 218–59; "The Technique of Michelangelo as a Painter," pp. 362–67; "Michelangelo's Frescoes in the Sistine Chapel," pp. 89–107. For a critique of the Sistine Chapel restoration, see James Beck and Michael Daley, *Art Restoration: The Culture, the Business, and the Scandal* (London: John Murray, 1993).

13. Condivi, *The Life of Michelangelo*, p. 58.

14. See Gianluigi Colalucci, "The Technique of the Sistine Ceiling Frescoes," in de Vecchi and Murphy, *The Sistine Chapel: A Glorious Restoration*, p. 34. Colalucci claims that Michelangelo's *secco* interventions consisted of a few additions of "a limited and imperceptible scale" (ibid.).

15. For a full discussion of the painting of the lunettes, see Mancinelli, "Michelangelo at Work," pp. 242–59.

16. For the number of *giornate,* as well as for information on *spolvero* and incision, see Bambach, *Drawing and Painting in the Italian Renaissance Workshop*, appendix 2: "Cartoon Transfer Techniques in Michelangelo's Sistine Ceiling," pp. 365–67.

17. It is difficult to know how exactly to refer to the characters on the spandrels and lunettes. Art historians sometimes identify the figures in the spandrel with the first name on the nameplate on the lunette below. However, difficulties with this procedure arise due to the fact that some of the nameplates provide only two names, others only one. It is now widely agreed that no one-to-one connection exists between the names on the tablets and the individual figures in the spandrels and lunettes. One looks in vain, for example, for King David on the lunette bearing his name. Lisa Pon therefore states that "it is impossible to give a specific identity to each individual figure. It is only

when they are seen collectively and in conunction with the series of names that the figures can represent the genealogy of Christ." See Pon, "A Note on the Ancestors of Christ in the Sistine Chapel," *Journal of the Warburg and Courtauld Institutes* 61 (1998): 257.

18. De Tolnay, *Michelangelo,* vol. 2, p. 77.

19. Paul Joannides, *Titian to 1518: The Assumption of Genius* (New Haven: Yale University Press, 2001), p. 161. This painting, in Longleat House in Wiltshire, England, was stolen in 1995 and recovered in London in the summer of 2002.

20. See Allison Lee Palmer, "The Maternal Madonna in Quattrocento Florence: Social Ideals in the Family of the Patriarch," *Source: Notes in the History of Art* (spring 2002): 7–14. Palmer argues that these images "played an active role in modelling behaviour within the family" (p. 7).

21. De Tolnay, *Michelangelo,* vol. 2, p. 77.

22. Robert S. Liebert, *Michelangelo: A Psychoanalytic Study of His Life and Images* (New Haven: Yale University Press, 1983), p. 28.

14. HE SHALL BUILD THE TEMPLE OF THE LORD

1. Quoted in Pastor, *History of the Popes,* vol. 6, p. 285.

2. Quoted in Shaw, *Julius II,* p. 246.

3. Frederick Hartt, "*Lignum Vitae in Medio Paradisi:* The Stanza d'Eliodoro and the Sistine Ceiling," *Art Bulletin* 32 (1950): 130.

4. The drawing, now in the Uffizi, was correctly identified by Charles de Tolnay. See *Michelangelo,* vol. 2, p. 55. Michelangelo added a beard to Zechariah, since Julius did not sprout whiskers on his chin until 1510.

5. See John W. O'Malley, "Fulfilment of the Christian Golden Age Under Pope Julius II: Text of a Discourse of Giles of Viterbo, 1507," *Traditio* (1969): 265–338. p. 320. The biblical text comes from Isaiah 6:1. For Egidio's prophetic view of history, see Marjorie Reeves, "Cardinal Egidio of Viterbo: A Prophetic Interpretation of History," in *Prophetic Rome in the High Renaissance Period,* ed. Marjorie Reeves (Oxford: Clarendon Press, 1992), pp. 91–119.

6. Michelangelo Buonarroti, *Complete Poems and Selected Letters of Michelangelo,* trans. Creighton E. Gilbert (Princeton: Princeton University Press, 1980), p. 8. Some editors date the poem to Michelangelo's first arrival in Rome in 1496. However, Christopher Ryan claims that "the pontificate of Julius II, with its direct involvement in military matters, would seem to fit better the subject matter of the poem." See *Michelangelo: The Poems* (London: J. M. Dent, 1996), p. 262. Ryan therefore dates the poem to 1512, but the bitter references elsewhere in the poem to the aborted tomb project—a phrase that Ryan translates as "here work has been taken from me"—and the militarized papacy make 1506 or 1508 seem more likely. In any case, the poem seems to be an indictment of Julius II, not Alexander VI.

7. Fabrizio Mancinelli states that Raphael painted the Stanza della Segnatura "almost single-handedly." See *The Dictionary of Art,* ed. Jane Turner (London: Macmillan, 1996), vol. 26, p. 817. Still, he almost certainly must have had a

number of assistants and apprentices, however modest in number. John Shearman states, for example, that for the first year or two of his work on the Stanza della Segnatura Raphael probably did not need help for anything but the humblest tasks; see "Raffaello e la bottega," in *Raffaello in Vaticano,* ed. Giorgio Muratore (Milan: Electa, 1984), p. 259. It is highly unlikely that any of the stalwarts of his later workshop—Giulio Romano, Giovanni da Udine, Francesco Penni, Perino del Vaga, Pelligrino da Modena—were with him at this early point. In 1509 Giulio Romano, for example, was only ten years old.

8. John Shearman, "The Organization of Raphael's Workshop," in *The Art Institute of Chicago Centennial Lectures* (Chicago: Contemporary Books, 1983), p. 44.

9. Quoted in John W. O'Malley, "Giles of Viterbo: A Reformer's Thought on Renaissance Rome," in *Rome and the Renaissance: Studies in Culture and Religion* (London: Variorum Reprints, 1981), p. 9.

10. *Raphaelis Urbinatis Vita,* in Golzio, *Raffaello nei documenti,* p. 192. It has also been argued that Egidio da Viterbo was the man behind the *Disputà.* See Heinrich Pfeiffer, *Zur Ikonographie von Raffaels Disputa: Egidio da Viterbo und die christliche-platonische Konzeption der Stanza della Segnatura* (Rome: Pontificia Universitas Gregoriana, 1975).

11. For the relations between Savonarola and Giuliano della Rovere, see Wind, "Sante Pagnini and Michelangelo," pp. 212–14.

12. For an argument in favor of Inghirami's participation in the decoration of the Stanza della Segnatura, see Ingrid D. Rowland, "The Intellectual Background of *The School of Athens:* Tracking Divine Wisdom in the Rome of Julius II," in *Raphael's "School of Athens,"* ed. Marcia B. Hall (Cambridge: Cambridge University Press, 1997), pp. 131–70.

15. FAMILY BUSINESS

1. Vasari, *Lives of the Painters, Sculptors, and Architects,* vol. 1, p. 663.

2. Condivi, *The Life of Michelangelo,* p. 58.

3. Vasari, *Lives of the Painters, Sculptors, and Architects,* vol. 2, p. 675.

4. See Shaw, *Julius II,* p. 171.

5. See Vasari, *Lives of the Painters, Sculptors, and Architects,* vol. 2, pp. 662–63.

6. Quoted in Pastor, *History of the Popes,* vol. 6, p. 214.

7. *The Letters of Michelangelo,* vol. 1, p. 50.

8. Ibid., p. 52.

9. Ibid., p. 49.

10. De Tolnay, *Michelangelo,* vol. 2, p. 25.

11. Leon Battista Alberti, *On Painting,* trans. Cecil Grayson, ed. Martin Kemp (London: Penguin, 1991), p. 76. Alberti translated this work from Latin into Italian in 1436.

12. Vinci, *Treatise on Painting,* vol. 1, pp. 106–7, 67.

13. Alberti, *On Painting,* p. 72.

14. Invented by Leonardo's master, Andrea del Verrocchio, this technique was later used by Ghirlandaio. See Jean K. Cadogan, "Reconsidering Some Aspects of Ghirlandaio's Drawings," *Art Bulletin* 65 (1983): 282–83.

15. See Frances Ames-Lewis, "Drapery 'Pattern'-Drawings in Ghirlandaio's Workshop and Ghirlandaio's Early Apprenticeship," *Art Bulletin* 63 (1981): 49–61.

16. Lynne Lawner, *Lives of the Courtesans: Portraits of the Renaissance* (New York: Rizzoli, 1986), pp. 8–9.

17. Alberti, *On Painting*, p. 72.

18. Vinci, *Treatise on Painting*, vol. 1, p. 129.

19. Condivi, *The Life of Michelangelo*, p. 99.

20. James Elkins, "Michelangelo and the Human Form: His Knowledge and Use of Anatomy," *Art History* 7 (June 1984): 177.

21. Ibid., p. 177. Other apparent anatomical anomalies in the *David*, such as its disproportionately large head and protuberant eyebrows, may be explained by the fact that the statue was originally intended to stand high on one of the cathedral's buttresses.

22. Condivi, *The Life of Michelangelo*, p. 97.

16. Laocoön

1. For this argument, see de Tolnay, *Michelangelo*, vol. 1, p. 71. This sketch is also in the Louvre. De Tolnay points out that Michelangelo "stored up in his memory a repertory of classical poses and figures which served him in an infinite number of combinations and transformations."

2. For a list of these classical quotations among the *ignudi*, see ibid., vol. 2, pp. 65–66.

3. For the similarities between these *ignudi* and the figures in the *Laocoön*, see ibid., p. 65. The statue is now thought to be a late-Hellenistic copy of the original.

4. Ernst Gombrich, "A Classical Quotation in Michelangelo's Sacrifice of Noah," *Journal of the Warburg Institute* (1937): 69.

5. For this reference, see Ernst Steinmann, *Die Sixtinische Kapelle* (Munich: Verlagsanstalt F. Bruckmann, 1905), vol. 2, pp. 313–15.

6. Lutz Heusinger writes that by this time, the autumn of 1509, Michelangelo had completed "the first three big frescoes with all the adjoining parts." See Fabrizio Mancinelli and Lutz Heusinger, *The Sistine Chapel* (London: Constable, 1978), p. 14. For the total number of *giornate* that this work entailed, see Bambach, *Drawing and Painting in the Italian Renaissance Workshop*, appendix 2, pp. 366–67.

7. *The Letters of Michelangelo*, vol. 1, p. 54.

8. Ibid., p. 48.

9. Ibid., p. 53.

10. Ibid., p. 54.

11. Ibid.

12. *Complete Poems and Selected Letters of Michelangelo*, pp. 5–6.

13. Quoted in Bambach, *Drawing and Painting in the Italian Renaissance Workshop*, p. 2.

14. Vasari, *Lives of the Painters, Sculptors, and Architects*, vol. 2, p. 669.

15. Merrifield, *The Art of Fresco Painting*, pp. 112–13.

16. Condivi, *The Life of Michelangelo*, p. 58.

17. Vasari, *Lives of the Painters, Sculptors, and Architects*, vol. 2, p. 669.

17. THE GOLDEN AGE

1. For the story of Cardiere, see Condivi, *The Life of Michelangelo*, pp. 17–18.

2. *Discourses on the First Decade of Titus Livius*, in Niccolò Machiavelli, *The Chief Works and Others*, trans. Allan Gilbert (Durham, N.C.: Duke University Press, 1965), vol. 1, p. 311.

3. Ottavia Niccoli, "High and Low Prophetic Culture in Rome at the Beginning of the Sixteenth Century," in Reeves, *Prophetic Rome in the High Renaissance Period*, p. 206.

4. Ibid., p. 207.

5. For these comparisons, see de Tolnay, *Michelangelo*, vol. 2, p. 57.

6. Condivi, *The Life of Michelangelo*, p. 107.

7. Virgil, *The Aeneid*, trans. W. F. Jackson Knight (London: Penguin, 1956), p. 146.

8. For Egidio's understanding of the sibyls, see O'Malley, *Giles of Viterbo on Church and Reform*, p. 55.

9. See Edgar Wind, "Michelangelo's Prophets and Sibyls," *Proceedings of the British Academy* 51 (1965): 83, n. 2.

10. Virgil, *The Eclogues and the Georgics*, trans. C. Day Lewis (Oxford: Oxford University Press, 1963), Eclogue 4, lines 6–7.

11. See O'Malley, "Fulfilment of the Christian Golden Age Under Pope Julius II," pp. 265–338.

12. Quoted in O'Malley, *Rome and the Renaissance*, p. 337.

13. On the idea of the golden age in the Renaissance, see Ernst Gombrich, "Renaissance and Golden Age," *Journal of the Warburg and Courtauld Institutes* 24 (1961): 306–9; O'Malley, *Giles of Viterbo on Church and Reform*, pp. 17, 50, 103–4; and Harry Levin, *The Myth of the Golden Age in the Renaissance* (Bloomington: Indiana University Press, 1969).

14. Paul Barolsky has argued this line, claiming that the failing eyesight of sibyls such as Cumaea and Persica reveals how "Michelangelo has slyly brought out the imperfection of the Seers' physical vision in order to magnify, antithetically, the grandeur of their spiritual vision." See Barolsky's "Looking Closely at Michelangelo's Seers," *Source: Notes in the History of Art* (summer 1997): 31.

15. For the relevant passage in Dante, see *The Divine Comedy*, vol. 1, *Inferno*, trans. John D. Sinclair (London: Bodley Head, 1948), canto 25, line 2.

16. Vasari, *Lives of the Painters, Sculptors, and Architects*, vol. 2, p. 743.

17. Francesco Albertini, *Opusculum de mirabilis novae et veteris urbis Romae,* in *Five Early Guides to Rome and Florence,* ed. Peter Murray (Farnborough, Hants.: Gregg International Publishers, 1972).

18. Desiderius Erasmus, *Opus Epistolarum des. Erasmi Roterdami,* ed. P. S. Allen (Oxford: Oxford University Press, 1910), vol. 1, p. 450.

19. Quoted in Albert Hyma, *The Life of Desiderius Erasmus* (Assen, The Netherlands: Van Gorcum, 1972), p. 68.

20. Virgil, *The Aeneid,* p. 149.

21. Desiderius Erasmus, *The Praise of Folly and Other Writings,* ed. and trans. Robert M. Adams (New York: W. W. Norton, 1989), p. 71.

22. Lodovico Ariosto, *Orlando furioso,* trans. Guido Waldman (Oxford: Oxford University Press, 1983), canto 25, line 15.

23. Erasmus, *The Praise of Folly and Other Writings,* p. 144.

24. Ibid., p. 168.

18. THE SCHOOL OF ATHENS

1. Erasmus, *The Praise of Folly and Other Writings,* p. 146.

2. Ibid., p. 172.

3. The text of Casali's sermon is printed in John W. O'Malley, "The Vatican Library and the School of Athens: A Text of Battista Casali, 1508," *Journal of Medieval and Renaissance Studies* (1977): 279–87.

4. Ibid., p. 287.

5. The dating of the four wall frescoes in the Stanza della Segnatura, and their order of painting, are subjects of much debate and little consensus. Most critics believe that *The Dispute of the Sacrament* was painted first and *The School of Athens* second (or possibly third). However, Matthias Winner has argued that *The School of Athens* was actually the first of the four frescoes to be painted; see "Il giudizio di Vasari sulle prime tre Stanze di Raffaello in Vaticano," in *Raffaello in Vaticano,* ed. Georgio Muratore, pp. 179–93. This thesis was repeated by Bram Kempers in "Staatssymbolick in Rafaels Stanza della Segnatura," *Incontri: Rivista di Studi Italo-Nederlandesi* (1986–87): 3–48. However, another scholar asserts that *The School of Athens* was the last to be painted: Cecil Gould, "The Chronology of Raphael's Stanze: A Revision," *Gazette des Beaux-Arts* (November 1991): 171–82.

6. As it is completely undocumented, Bramante's involvement in designing *The School of Athens* is a matter of debate. The foremost Bramante scholar of the twentieth century, Arnaldo Bruschi, finds the collaboration "not unlikely" (*Bramante,* p. 196). However, another scholar, Ralph Lieberman, is more skeptical. He claims Vasari's suggestion of a collaboration should be questioned on a number of counts, since the attribution of the design to Bramante "seems to be based more on vague analogy between church and painting than on any real knowledge that Bramante helped Raphael with the fresco" ("The Architectural Background," in Hall, *Raphael's "School of Athens,"* p. 71). Lieberman claims, first of all, that the architectural design in the painting may have been

based as much on the Basilica of Maxentius as on Bramante's plans for St Peter's. Second, the design in the painting is unbuildable, a fact that would seem to militate against the participation of Bramante, an experienced architect. It does not seem likely, Lieberman writes, "that at this stage of his life, had he drawn the architecture of the fresco after pondering church crossings for several years, he would have designed so unconvincing and irrational a passage as the one we now see" (ibid., p. 73). Various attempts have been made to reconstruct the building portrayed in *The School of Athens*. See, for an example, Emma Mandelli, "La realtà della architettura 'picta' negli affreschi delle Stanze Vaticane," in Gianfranco Spagnesi, Mario Fondelli, and Emma Mandelli, *Raffaello, l'architettura "picta": Percezione e realtà* (Rome: Monografica Editrice, 1984), pp. 155–79.

7. This borrowing has been noted by Gombrich in "Raphael's Stanza della Segnatura and the Nature of Its Symbolism," pp. 98–99.

8. A. P. Oppé, *Raphael*, ed. Charles Mitchell (London: Elek Books, 1970), p. 80.

9. Vasari, *Lives of the Painters, Sculptors, and Architects*, vol. 1, p. 747.

10. *The Letters of Michelangelo*, vol. 2, p. 31.

11. Vasari, *Lives of the Painters, Sculptors, and Architects*, vol. 1, p. 723.

12. For these findings, see Arnold Nesselrath, *Raphael's "School of Athens"* (Vatican City: Edizioni Musei Vaticani, 1996), p. 24.

13. This cartoon is now in the Biblioteca Ambrosiana in Milan. For Raphael's cartoon for *The School of Athens* and his working technique in the Stanza della Segnatura, see Eve Borsook, "Technical Innovation and the Development of Raphael's Style in Rome," *Canadian Art Review* 12 (1985): 127–36.

14. A cartoon, now lost, was also prepared for the top half of the fresco, showing the architectural features. See Nesselrath, *Raphael's "School of Athens,"* pp. 15–16.

15. See Oskar Fischel, "Raphael's Auxiliary Cartoons," *Burlington Magazine*, October 1937, pp. 167–8; and Borsook, "Technical Innovation and the Development of Raphael's Style in Rome," pp. 130–31.

16. Bambach, *Drawing and Painting in the Italian Renaissance Workshop*, p. 249.

19. FORBIDDEN FRUIT

1. Pastor, *History of the Popes*, vol. 6, p. 326.

2. Wallace, "Michelangelo's Assistants in the Sistine Chapel," p. 208.

3. Cornelius Agrippa von Nettesheim, *De nobilitate et praecellentia foeminei sexus*, quoted in Gilbert, "The Proportion of Women," in *Michelangelo on and off the Sistine Ceiling*, p. 96.

4. Much recent work has been done on Edenic sexuality. See, for example, Phyllis Trible, *God and the Rhetoric of Sexuality* (London: SCM, 1992); John A. Phillips, *Eve: The History of an Idea* (San Francisco: Harper and Row, 1984); Jean Delumeau, *The History of Paradise: The Garden of Eden in Myth and Tradition* (New York: Continuum, 1995); and Leo Steinberg, "Eve's Idle Hand," *Art Journal* (winter 1975–76): 130–35. It did not take modern scholars, however, to come up with sexual interpretations of the Fall. These were accepted even

before the time of Christ. The Qumrun community's *Serek ha-'Edâh* (*Rule of the Congregation*) translated the Hebrew "knowledge of good and evil" as "sexual maturity." The Qumrun sect of Jews lived in the Judaean Desert, along the northwest shore of the Dead Sea, between 150 B.C.E. and 70 C.E. Later, writers such as Philo Judaeus and Clement of Alexandria identified the serpent with sexual desire and evil thoughts. More recently, scholars have shown that the serpent was a phallic symbol in the fertility cults flourishing in Canaan at the time when the oldest version of the Fall in the Pentateuch (known as the Yahwist tradition) was composed in the ninth or tenth century B.C.E.

5. Steinberg, "Eve's Idle Hand," p. 135.

6. Condivi, *The Life of Michelangelo*, p. 146, n. 128. This advice is given in a marginal note in Condivi's manuscript.

7. Ibid., p. 24.

8. See Maria Piatto's caption for the scene on p. 91 of de Vecchi and Murphy, *The Sistine Chapel: A Glorious Restoration*.

9. See Michel Foucault, *The Uses of Pleasure: A History of Sexuality*, trans. Robert Hurley (London: Penguin, 1987), vol. 2; and Michael Rocke, *Forbidden Friendships: Homosexuality and Male Culture in Renaissance Florence* (Oxford: Oxford University Press, 1996), especially pp. 11–13.

10. Marsilio Ficino, *The Letters of Marsilio Ficino*, ed. and trans. by members of the Language Department of the School of Economic Science, London (London: Shepheard-Walwyn, 1975–99), vol. 4, p. 35.

11. James Beck speculates that Michelangelo's "sexual experiences, whether heter- or homosexual, were minimal—and possibly non-existent." *The Three Worlds of Michelangelo* (New York: W. W. Norton, 1999), p. 143.

12. *Complete Poems and Selected Letters of Michelangelo*, p. 145.

13. Ibid., pp. 4–5.

14. See Giovanni Papini, *Vita di Michelangelo nella vita del suo tempo* (Milan: Garzanti, 1949), p. 498.

15. *The Letters of Michelangelo*, vol. 1, p. xlviii.

16. Vasari, *Lives of the Painters, Sculptors, and Architects*, vol. 1, p. 737.

17. Lawner, *Lives of the Courtesans*, p. 5.

18. Ibid., pp. 111–14. A century later, an inventory at Fontainebleau also described the *Mona Lisa* as the portrait of a courtesan (ibid., p. 114).

19. For relations between Raphael and Imperia, see Georgina Masson, *Courtesans of the Italian Renaissance* (London: Secker and Warburg, 1975), p. 37.

20. THE BARBAROUS MULTITUDES

1. *The Letters of Michelangelo*, vol. 1, p. 54.

2. Not all critics agree on Michelangelo's actual progress by this point. Most notably, Creighton Gilbert has argued that Michelangelo completed *the whole of the vault* (except for the lunettes) by the summer of 1510 (see "On the Absolute Dates of the Parts of the Sistine Ceiling," p. 174). Gilbert's thesis is

predicated on the assumption that the lunettes formed a separate, later campaign. (On this topic, see note 4 in chapter 13.) His argument is criticized by Paul Joannides, who finds this incredibly rapid timescale "difficult to credit" ("On the Chronology of the Sistine Chapel Ceiling," pp. 250–52).

3. *The Letters of Michelangelo,* vol. 1, pp. 54–55.

4. See Kenneth Clark, *Landscape into Art* (London: John Murray, 1949), p. 26.

5. De Tolnay, *Michelangelo,* vol. 2, pp. 72 and 76. This particular medallion, *The Death of Absalom,* was painted late in the campaign, meaning that, if de Tolnay is correct, Bastiano was present for virtually the whole of the project.

6. Quoted in Welch, *Art in Renaissance Italy,* p. 137.

7. 2 Maccabees 2:22, in *The Apocrypha,* revised ed. (Cambridge: Cambridge University Press, 1895).

8. Marino Sanuto, *I diarii di Marino Sanuto* (Venice: F. Visentini, 1901), vol. 10, col. 369.

9. Ibid.

10. Quoted in Pastor, *History of the Popes,* vol. 6, p. 333.

11. Ibid.

21. BOLOGNA REDUX

1. *The Letters of Michelangelo,* vol. 1, p. 55.

2. Quoted in Linda Murray, *Michelangelo: His Life, Work, and Times* (London: Thames and Hudson, 1984), p. 63.

3. Quoted in Pastor, *History of the Popes,* vol. 6, p. 338.

4. This document is published in Hirst, "Michelangelo in 1505," appendix B, p. 766.

5. For an account of Julius's beard and its implications, see Mark J. Zucker, "Raphael and the Beard of Pope Julius II," *Art Bulletin* 59 (1977): 524–33.

6. Erasmus, *Julius Excluded from Heaven,* in *The Praise of Folly and Other Writings,* p. 148.

7. Quoted in Pastor, *History of the Popes,* vol. 6, p. 339 n.

8. Quoted in Heinrich Boehmer, *Martin Luther* (London: Thames and Hudson, 1957), p. 61.

9. Quoted in ibid., p. 67.

10. Quoted in ibid., p. 75.

22. THE WORLD'S GAME

1. Quoted in Shaw, *Julius II,* p. 269.

2. *The Letters of Michelangelo,* vol. 1, p. 148.

3. The British Museum now holds a chalk drawing that for many years was considered a study for Adam's head. However, it has since been identified as one of Michelangelo's drawings for Sebastiano del Piombo's *Raising of Lazarus.* See Ludwig Goldscheider, *Michelangelo: Drawings* (London: Phaidon, 1951), p. 34.

4. On this problem, see Michael Hirst, "Observations on Drawings for the Sistine Ceiling," in de Vecchi and Murphy, *The Sistine Chapel: A Glorious Restoration,* pp. 8–9.

5. Quoted in Shaw, *Julius II,* p. 270.

6. Francesco Guicciardini, *The History of Italy,* ed. and trans. Sidney Alexander (London: Collier-Macmillan, 1969), p. 212. Guicciardini's disapproving account was written in the 1530s.

7. Quoted in Klaczko, *Rome and the Renaissance,* p. 229.

8. Quoted in Pastor, *History of the Popes,* vol. 6, p. 341.

9. Vasari, *Lives of the Painters, Sculptors, and Architects,* p. 664. Bramante may have been familiar with Leonardo's numerous plans for weapons such as steam-powered cannons, exploding cannonballs, machine guns, and rapid-fire crossbows.

10. Quoted in Pastor, *History of the Popes,* vol. 6, p. 341.

11. Shaw, *Julius II,* p. 271.

12. Cecil Gould points out that it is reasonable to suppose "that work in the Stanza della Segnatura would have been at a standstill during the ten months of the pope's absence" ("The Chronology of Raphael's Stanze," p. 176). Work need not have come to a "standstill," but it almost certainly must have slowed, if only because of Raphael's work on other commissions.

13. The name Farnesina dates from only 1580, when the villa was acquired by Alessandro Farnese, the "Great Cardinal." The architectural design of the Villa Farnesina is sometimes attributed to Raphael himself. See, for example, Oppé, *Raphael,* p. 61. Few other scholars accept this attribution, especially since work on the villa may have begun as early as 1506, before Raphael had based himself in Rome.

14. For the identification of Ariosto in the fresco, see Gould, "The Chronology of Raphael's Stanze," pp. 174–75.

15. Ariosto, *Orlando furioso,* canto 33, line 2.

16. Shaw, *Julius II,* pp. 182–83.

17. Quoted in Pastor, *History of the Popes,* vol. 6, p. 350.

18. Quoted in Klaczko, *Rome and the Renaissance,* p. 242.

19. Guicciardini, *The History of Italy,* p. 227.

20. Quoted in Pastor, *History of the Popes,* vol. 6, p. 362.

23. A NEW AND WONDERFUL MANNER OF PAINTING

1. Condivi, *The Life of Michelangelo,* p. 57. In his diary entry for the fifteenth of August 1511, Paride de' Grassi speaks of the pope having gone to see the unveiled fresco for the first time on the previous evening.

2. The hour of the Mass is speculative, but Masses for holy days and feasts were customarily held at nine in the morning. See *The New Catholic Encyclopedia* (New York: McGraw-Hill, 1967), vol. 9, p. 419.

3. Condivi, *The Life of Michelangelo,* p. 57.

4. Ibid.

5. Ibid.

6. For Raphael's technique in adding the *pensieroso,* see Nesselrath, *Raphael's "School of Athens,"* p. 20. The *pensieroso* is known to be a later addition because it does not appear in Raphael's cartoon for *The School of Athens* (now in the Biblioteca Ambrosiana in Milan), and because examination of the plaster has proved that it was painted on *intonaco* added to the wall at a later date. The exact timing of this addition is speculative, but it seems most likely that Raphael painted it as he finished work in the Stanza della Segnatura, that is, sometime in the summer or autumn of 1511 (ibid., p. 21).

7. This intriguing theory was first suggested by Deoclecio Redig de Campos in *Michelangelo Buonarroti nel IV centenario del "Giudizio universale" (1541–1941)* (Florence: G. C. Sansoni, 1942), pp. 205–19, and repeated in his *Raffaello nelle Stanze* (Milan: Aldo Martello, 1965). Roger Jones and Nicolas Penny find the argument "implausible" without, however, offering strong counterarguments; see their *Raphael* (New Haven: Yale University Press, 1983), p. 78. Ingrid D. Rowland, on the other hand, states that Heraclitus "presents a simultaneous portrait of Michelangelo's face and Michelangelo's artistic style" ("The Intellectual Background," in Hall, *Raphael's "School of Athens,"* p. 157); and Frederick Hartt claims that his features "are clearly those of Michelangelo" (*History of Italian Renaissance Art,* p. 509).

8. Edmund Burke, *A Philosophical Enquiry into the Origin of Our Ideas of the Sublime and Beautiful,* ed. James T. Boulton (Notre Dame, Ind.: University of Notre Dame Press, 1986), esp. pp. 57–125.

24. THE FIRST AND SUPREME CREATOR

1. Quoted in Klaczko, *Rome and the Renaissance,* p. 246.

2. Quoted in Pastor, *History of the Popes,* vol. 6, p. 369.

3. Quoted in ibid.

4. Quoted in ibid.

5. Quoted in ibid., p. 371.

6. Quoted in Klaczko, *Rome and the Renaissance,* p. 253.

7. St. Bonaventure, *Lignum vitae,* quoted in Hartt, *"Lignum Vitae in Medio Paradisi,"* p. 191.

8. Vasari, *Lives of the Painters, Sculptors, and Architects,* vol. 2, p. 670.

9. Giovanni Boccaccio, *The Decameron,* trans. G. H. McWilliam, 2nd ed. (London: Penguin, 1995), p. 457.

10. Vasari, *Lives of the Painters, Sculptors, and Architects,* vol. 2, p. 642.

11. For a history of the debate over this young woman's identity, see Leo Steinberg's "Who's Who in Michelangelo's *Creation of Adam:* A Chronology of the Picture's Reluctant Self-Revelation," *Art Bulletin* (1992): 552–66. Other candidates are the Virgin Mary and Wisdom (*Sapientia*). Steinberg also iden-

tifies what he thinks is Lucifer and a devilish companion likewise enfolded in the Almighty's capacious cloak.

12. In Barocchi, *Scritti d'arte del Cinquecento,* vol. 1, p. 10.

13. Condivi, *The Life of Michelangelo,* p. 42.

14. Lionello Venturi and Rosabianca Skira-Venturi, *Italian Painting: The Renaissance,* trans. Stuart Gilbert (New York: Albert Skira, 1951), p. 59. For the significance of this publication in relation to Michelangelo, see Steinberg, "Who's Who in Michelangelo's *Creation of Adam,*" pp. 556–57.

25. THE EXPULSION OF HELIODORUS

1. Guicciardini, *The History of Italy,* p. 237.

2. Pastor, *History of the Popes,* vol. 6, p. 397.

3. Condivi, *The Life of Michelangelo,* p. 94.

4. Document reproduced in facsimile in the exhibition catalog, *Raffaello, Elementi di un Mito: le fonti, la letteratura artistica, la pittura di genere storico* (Florence: Centro Di, 1984), p. 47.

5. Vasari, who is often unreliable and confused in his discussion of Raphael's Vatican frescoes, identifies Federico in *The School of Athens.* (Even more dubiously, he identifies as Giulio Romano, then a boy of twelve, one of the bearded men carrying the pope's litter in *The Expulsion of Heliodorus.*) Cecil Gould has likewise proposed *The School of Athens* as the fresco in question, albeit seeing Federico's features in a different figure ("The Chronology of Raphael's Stanze," pp. 176–78). Gould's argument depends on the assumption that this fresco—which he argues was the last of the four in the Stanza della Segnatura to be finished—was not painted until after the summer of 1511.

6. Identification of the sitter for *La Fornarina* with Margherita Luti is by no means certain. The sitter was first identified as Raphael's mistress a century after the fact, in 1618, when she was referred to as a prostitute. She has also been identified as Imperia, as Beatrice of Ferrara (another courtesan) and as Albina (yet another courtesan). See Carlo Cecchelli, "La 'Psyche' della Farnesina," *Roma* (1923): 9–21; Emilio Ravaglia, "Il volto romano di Beatrice ferrarese," *Roma* (1923): 53–61; and Francesco Filippini, "Raffaello e Bologna," *Cronache d'Arte* (1925): 222–26. For a sensible discussion of the painting and its myths, see Lawner, *Lives of the Courtesans,* pp. 120–23. For a skeptical view of the myth of La Fornarina, see Oppé, *Raphael,* p. 69.

7. Vasari, *Lives of the Painters, Sculptors, and Architects,* vol. 1, p. 722. The painting is now in the National Gallery, London, with sixteenth-century copies in the Uffizi and the Palazzo Pitti in Florence.

26. THE MONSTER OF RAVENNA

1. Niccoli, "High and Low Prophetic Culture in Rome at the Beginning of the Sixteenth Century," pp. 217–18.

2. Guicciardini, *The History of Italy,* p. 250.

3. The inspection is reported by Isabella d'Este's envoy to Rome, Grossino. See Alessandro Luzio, "Isabella d'Este di fronte a Giulio II," *Archivio Storico Lombardo*, 4th series (1912): 70.

4. *The Letters of Michelangelo*, vol. 1, p. 64.

5. Ibid., p. 67.

6. Vasari, *Lives of the Painters, Sculptors, and Architects*, vol. 2, p. 670.

7. Quoted in Martin Kemp, *The Science of Art: Optical Themes in Western Art from Brunelleschi to Seurat* (New Haven: Yale University Press, 1990), p. 41.

8. See Alberti, *On Painting*, pp. 65–67. For perspective machines in the Renaissance, see Kemp, *The Science of Art*, pp. 167–88.

9. *The Letters of Michelangelo*, vol. 1, p. 64.

10. Quoted in Michael Mallett, *Mercenaries and Their Masters: Warfare in Renaissance Italy* (London: Bodley Head, 1974), p. 196.

11. Mallett claims that in fact the losses on both sides amounted to about nine hundred (ibid., p. 197).

12. F. L. Taylor, *The Art of War in Italy, 1494–1529* (Cambridge: Cambridge University Press, 1920), p. 188.

13. Quoted in Pastor, *History of the Popes*, vol. 6, p. 400.

14. Ariosto, *Orlando furioso*, canto 33, line 40.

15. Ibid., canto 11, line 28.

27. MANY STRANGE FORMS

1. Guicciardini, *The History of Italy*, p. 244.

2. Kenneth Clark notes that psychologists have occupied themselves with the question "why this man of immense moral courage, who was utterly indifferent to physical hardship, should have suffered from these recurrences of irrational fear," though he speculates that the sculptor probably had good reasons for escaping and may even have felt an obligation to preserve his genius ("The Young Michelangelo," in *The Penguin Book of the Renaissance*, ed. J. H. Plumb [London: Penguin, 1991], p. 102).

3. Klaczko, *Rome and the Renaissance*, p. 354.

4. De Tolnay, *Michelangelo*, vol. 2, p. 68. De Tolnay argues, in his Neoplatonist reading of the ceiling, that in such figures Michelangelo represents, in contrast to the angelic *ignudi*, "the lowest degree of human nature, the *natura corporale*" (p. 67).

5. For one of the few studies that pay heed to what he calls the "playful elements" of the Sistine ceiling—as well as to the underrated role of humor in Michelangelo's work more generally—see Paul Barolsky, *Infinite Jest: Wit and Humor in Italian Renaissance Art* (Columbia: University of Missouri Press, 1978).

6. Condivi, *The Life of Michelangelo*, p. 9.

7. *Complete Poems and Selected Letters of Michelangelo*, p. 142. For Michelangelo's vision of his own ugliness, see Paul Barolsky, *Michelangelo's Nose: A Myth and Its Maker* (University Park: Pennsylvania State University Press, 1990).

8. *Complete Poems and Selected Letters of Michelangelo*, pp. 149–51.

9. Condivi, *The Life of Michelangelo*, p. 108.

10. Vasari, *Lives of the Painters, Sculptors, and Architects*, vol. 1, p. 639.

11. Boccaccio, *The Decameron*, p. 457.

28. THE ARMOR OF FAITH AND THE SWORD OF LIGHT

1. Guicciardini, *The History of Italy*, pp. 251–52. In *Orlando furioso*, Ariosto likewise described the despair that overcame the French army following its bloody victory: "The victory afforded us encouragement, but little rejoicing—for the sight of the leader of the expedition, the Captain of the French, Gaston of Foix, lying dead dampened our spirits. And the storm which overwhelmed him carried off so many illustrious princes who had crossed the cold Alps in defence of their realms and of their allies" (canto 14, line 6).

2. Quoted in Pastor, *History of the Popes*, vol. 6, pp. 407–8.

3. For Penni's presence in Raphael's workshop at this point, see Shearman, "The Organization of Raphael's Workshop," pp. 41 and 49.

4. See Tom Henry, "Cesare da Sesto and Baldino Baldini in the Vatican Apartments of Julius II," *Burlington Magazine*, January 2000, pp. 29–35.

5. Vasari, *Lives of the Painters, Sculptors, and Architects*, vol. 1, p. 819.

6. On Michelangelo's antipathy to running a workshop, see George Bull, *Michelangelo: A Biography* (London: Viking, 1995), p. 16.

7. Condivi, *The Life of Michelangelo*, p. 107.

8. The corporal is still preserved in Orvieto. A different explanation of the miracle at Bolsena holds that the blood on the altar cloth was the result of the priest accidentally spilling wine from the chalice after consecration. He folded the cloth to hide his carelessness, but the stain spread through the folds, leaving an impression of the Host. See Pastor, *History of the Popes*, vol. 6, p. 595 n.

9. On this topic, see Klaczko, *Rome and the Renaissance*, p. 11, and Hartt, "*Lignum Vitae in Medio Paradisi*," p. 120. The altar cloth and its shrine probably had a further significance for Julius, because in 1477 his uncle, Sixtus IV, had granted indulgences to promote both the adoration of the relic and the construction of the cathedral.

10. Quoted in Pastor, *History of the Popes*, vol. 6, p. 416.

11. Quoted in ibid.

12. Quoted in ibid., p. 417.

29. IL PENSIEROSO

1. Grossino to Isabella d'Este, quoted in de Tolnay, *Michelangelo*, vol. 2, p. 243.

2. Quoted in ibid., p. 243.

3. Ariosto, *Orlando furioso*, canto 33, line 2.

4. *The Letters of Michelangelo,* vol. 1, p. 70.

5. Ibid., p. 71.

6. For Savonarola's identification of himself with Jeremiah, see Ridolfi, *The Life and Times of Girolamo Savonarola,* p. 283, and Weinstein, *Savonarola and Florence,* p. 285.

7. *Complete Poems and Selected Letters of Michelangelo,* p. 150.

8. Ibid., pp. 12–13.

9. Ibid., p. 31.

10. Guicciardini, *The History of Italy,* p. 257.

30. IN EVIL PLIGHT

1. Machiavelli, *The Chief Works and Others,* vol. 2, p. 893.

2. Guicciardini, *The History of Italy,* p. 262.

3. *The Letters of Michelangelo,* vol. 1, p. 71.

4. Ibid.

5. *The Chief Works and Others,* vol. 2, p. 894.

6. Niccolò Machiavelli, *The Prince,* trans. George Bull (London: Penguin, 1999), p. 54.

7. *The Letters of Michelangelo,* vol. 1, pp. 71 and 74.

8. Ibid., p. 81.

9. Ibid., appendix 9, p. 245.

10. Ibid., p. 75.

11. *The Divine Comedy,* vol. 2, *Purgatorio,* canto 17, line 26.

12. For an example of one such interpretation, see Hartt, "*Lignum Vitae in Medio Paradisi,*" p. 198.

13. Vasari, *Lives of the Painters, Sculptors, and Architects,* vol. 2, p. 674.

14. De Tolnay, *Michelangelo,* vol. 2, p. 182.

15. Ibid., p. 97.

16. *The Letters of Michelangelo,* vol. 1, p. 74.

17. These two lunettes were destroyed decades later by Michelangelo when he painted *The Last Judgment* on the altar wall. The subjects of these two lunettes are known through engravings.

18. *The Letters of Michelangelo,* vol. 1, p. 75.

31. FINAL TOUCHES

1. *The Life of Michelangelo,* p. 48.

2. Ibid.

3. See de Tolnay, *Michelangelo,* vol. 2, p. 151.

4. Alberti, *On Painting,* pp. 77–78.

5. Condivi, *The Life of Michelangelo,* p. 58.

6. Vasari, *Lives of the Painters, Sculptors, and Architects,* vol. 2, p. 675.

7. Condivi, *The Life of Michelangelo,* p. 58. Vasari tells a slightly different version of this anecdote in which it is Michelangelo, and not the pope, who first plans to retouch the painting *a secco* (*Lives of the Painters, Sculptors, and Architects,* vol. 2, p. 668).

8. Condivi, *The Life of Michelangelo,* p. 58.

9. *The Letters of Michelangelo,* vol. 1, p. 149.

10. Ibid., p. 62.

11. Ibid., p. 149.

12. For the story of these 2,000 ducats, see ibid., pp. 243–44.

13. Ibid., p. 85.

14. Quoted in Pastor, *History of the Popes,* vol. 6, p. 434.

15. Quoted in ibid., p. 437.

16. Quoted in ibid.

17. Tommaso Inghirami, *Thomae Phaedri Inghirami Volterrani orationes,* ed. Pier Luigi Galletti (Rome, 1777), p. 96.

18. Ibid., pp. 534–35.

Epilogue: The Language of the Gods

1. Vasari, *Lives of the Painters, Sculptors, and Architects,* vol. 1, p. 745.

2. Ibid. The truth of Vasari's statement is open to question. He reports that Raphael's doctors, mistakenly diagnosing sunstroke, bled him, an operation that frequently caused the death of patients.

3. Pandolfo Pico della Mirandola to Isabella Gonzaga, quoted in J. A. Crowe and G. B. Cavalcaselle, *Raphael: His Life and Works* (London: John Murray, 1885), vol. 2, pp. 500–501.

4. *Complete Poems and Selected Letters of Michelangelo,* p. 61.

5. For Michelangelo's death and funeral, see Rudolf and Margot Wittkower, eds., *The Divine Michelangelo: The Florentine Academy's Homage on His Death in 1564* (London: Phaidon Press, 1964).

6. On this borrowing, see Johannes Wilde, *Venetian Painting from Bellini to Titian* (Oxford: Oxford University Press, 1974), p. 123; and Creighton Gilbert, "Titian and the Reversed Cartoons of Michelangelo," in *Michelangelo on and off the Sistine Ceiling,* pp. 151–90.

7. Sir Joshua Reynolds, *Discourses on Art,* ed. Robert R. Wark (San Marino, Calif.: Huntington Library, 1959), p. 278.

8. Camille Pissarro, *Letters to His Son Lucien,* ed. John Rewald, 4th ed. (London: Routledge and Kegan Paul, 1980), p. 323.

9. For these restorations, see Gianluigi Colalucci, "Michelangelo's Colours Rediscovered," in Paul Holberton, *The Sistine Chapel: Michelangelo Rediscovered,* pp. 262–64. For a skeptical view of Colalucci's interpretation of these restorations, see Beck and Daley, *Art Restoration,* pp. 73–78.

10. For reports on this project of restoration, see Colalucci, "Michelangelo's Colours Rediscovered," pp. 260–65; Carlo Petrangeli, "Introduction: An Account of the Restoration," in de Vecchi and Murphy, *The Sistine Chapel: A Glorious Restoration*, pp. 6–7. For a history of the restoration, together with its financial motives and cultural implications, see Waldemar Januszczak, *Sayonara Michelangelo: The Sistine Chapel Restored and Repackaged* (Reading, Mass.: Addison-Wesley, 1990).

11. The case against the restoration is made most comprehensively in Beck and Daley, *Art Restoration*, pp. 63–122. For responses to objections raised by the critics, see Kathleen Weil-Garris Brandt, "Twenty-five Questions About Michelangelo's Sistine Ceiling," *Apollo* (December 1987): 392–400; and David Ekserdjian, "The Sistine Ceiling and the Critics," *Apollo* (December 1987): pp. 401–4.

12. See Beck and Daley, *Art Restoration*, pp. 119–120.

13. On this matter, see chapter 13, note 12 on pp. 329–30.

14. On the "new Michelangelo" exposed by the cleaning project, see Januszczak, *Sayonara Michelangelo*, especially pp. 179–89.

15. Johann Wolfgang von Goethe, *Italian Journey*, trans. W. H. Auden and Elizabeth Mayer (London: Penguin, 1970), p. 376.

BIBLIOGRAPHY

Ackerman, James S., "The Planning of Renaissance Rome." In *Rome in the Renaissance: The City and the Myth,* ed. P. A. Ramsey, pp. 3–17. Binghamton, N.Y.: Center for Medieval and Early Renaissance Studies, SUNY-Binghamton, 1982.

Alberti, Leon Battista. *On Painting.* Trans. Cecil Grayson. Ed. Martin Kemp. London: Penguin, 1991.

Albertini, Francesco. *Opusculum de mirabilis novae et veteris urbis Romae.* In *Five Early Guides to Rome and Florence.* Ed. Peter Murray. Farnborough, Hants.: Gregg International Publishers, 1972.

Alson, Mary Niven. "The Attitude of the Church Towards Dissection Before 1500." *Bulletin of the History of Medicine* 16 (1944): 221–38.

Ames-Lewis, Francis. "Drapery 'Pattern'-Drawings in Ghirlandaio's Workshop and Ghirlandaio's Early Apprenticeship." *Art Bulletin* 63 (1981): 49–61.

Ames-Lewis, Francis, and Joanne Wright. *Drawing in the Italian Renaissance Workshop.* London: Victoria and Albert Museum, 1983.

Ariosto, Lodovico. *Orlando furioso.* Trans. Guido Waldman. Oxford: Oxford University Press, 1983.

Bambach, Carmen C. *Drawing and Painting in the Italian Renaissance Workshop: Theory and Practice, 1300–1600.* Cambridge: Cambridge University Press, 1999.

———. "A Note on Michelangelo's Cartoon for the Sistine Ceiling: Haman." *Art Bulletin* 65 (1983): 661–66.

Barocchi, Paola, ed. *Scritti d'arte del cinquecento.* 3 vols. Milan and Naples: Ricciardi, 1971–77.

Barolsky, Paul. *Infinite Jest: Wit and Humor in Italian Renaissance Art.* Columbia: University of Missouri Press, 1978.

———. "Looking Closely at Michelangelo's Seers." *Source: Notes in the History of Art* (summer 1997): 31–34.

———. *Michelangelo's Nose: A Myth and its Maker.* University Park: Pennsylvania State University Pess, 1990.

Bartalini, Roberto. "Sodoma, the Chigi and the Vatican Stanze." *Burlington Magazine,* September 2001, pp. 544–53.

Battisti, Eugenio, *Rinascimento e Barocca.* Florence: Einaudi, 1960.

———. "Il significato simbolico della Cappella Sistina." *Commentari* 8 (1957): 96–104.

Baxandall, Michael. *Painting and Experience in Fifteenth-Century Italy.* Oxford: Oxford University Press, 1974.

Beck, James. "Cardinal Alidosi, Michelangelo, and the Sistine Ceiling." *Artibus et Historiae* 22 (1990): 63–77.

———. *The Three Worlds of Michelangelo.* New York: W. W. Norton, 1999.

Beck, James, and Michael Daley. *Art Restoration: The Culture, the Business, and the Scandal.* London: John Murray, 1993.

Berenson, Bernard. *Italian Painters of the Renaissance.* 2 vols. London: Phaidon, 1968.

Boccaccio, Giovanni. *The Decameron.* Trans. G. H. McWilliam. 2nd ed. London: Penguin, 1995.

Boehmer, Heinrich. *Martin Luther.* London: Thames and Hudson, 1957.

Borsook, Eve. *The Mural Painters of Tuscany.* Oxford: Clarendon Press, 1980.

———. "Technical Innovation and the Development of Raphael's Style in Rome." *Canadian Art Review* 12 (1985): 127–36.

Brandt, Kathleen Weil-Garris. "Twenty-five Questions About Michelangelo's Sistine Ceiling." *Apollo* (December 1987): 392–400.

Brown, Elizabeth A. R. "Death and the Human Body in the Later Middle Ages: The Legislation of Boniface VIII on the Division of the Corpse." *Viator* 12 (1981): 221–70.

Bruschi, Arnaldo. *Bramante.* London: Thames and Hudson, 1977.

Buck, Stephanie, and Peter Hohenstatt. *Raphael, 1483–1520.* Trans. Christine Varley and Anthony Vivis. Cologne: Könemann, 1998.

Bull, George. *Michelangelo: A Biography.* London: Viking, 1995.

Bull, Malcolm. "The Iconography of the Sistine Chapel Ceiling." *Burlington Magazine,* August 1988, 597–605.

Buonarroti, Michelangelo. *Il Carteggio di Michelangelo.* Ed. Paola Barocchi and Renzo Ristore. 5 vols. Florence: Sansoni Editore, 1965–83.

———. *Complete Poems and Selected Letters of Michelangelo.* Trans. Creighton E. Gilbert. Princeton: Princeton University Press, 1980.

Burchard, Johann. *At the Court of the Borgias, Being an Account of the Reign of Pope Alexander VI Written by his Master of Ceremonies, Johann Burchard.* Ed. and trans. Geoffrey Parker. London: Folio Society, 1963.

Burke, Edmund. *A Philosophical Enquiry into the Origins of Our Ideas of the Sublime and Beautiful.* Ed. James T. Boulton. Notre Dame, Ind.: University of Notre Dame Press, 1986.

Buzzegoli, Ezio. "Michelangelo as a Colourist, Revealed in the Conservation of the Doni *Tondo.*" *Apollo* (December 1987): 405–8.

Cadogan, Jean K. "Michelangelo in the Workshop of Domenico Ghirlandaio." *Burlington Magazine,* January, 1993, 30–31.

———. "Reconsidering Some Aspects of Ghirlandaio's Drawings." *Art Bulletin* 65 (1983): 274–87.

Camesasca, Ettore. *All the Frescoes of Raphael.* Trans. Paul Colacicchi. 2 vols. Complete Library of World Art, 1962.

Carden, Robert W., ed. *Michelangelo: A Record of His Life as Told in His Own Letters and Papers.* London: Constable, 1913.

Cechelli, Carlo. "La 'Psyche' della Farnesina." *Roma* (1923): 9–21.

Cellini, Benvenuto. *The Autobiography of Benvenuto Cellini.* Trans. George Bull. London: Penguin, 1956.

Cennini, Cennino. *Il Libro dell'arte. The Craftsman's Handbook.* Trans. Daniel V. Thompson. New Haven: Yale University Press, 1933.

Chambers, D. S. "Papal Conclaves and Prophetic Mystery in the Sistine Chapel." *Journal of the Warburg and Courtauld Institutes* 41 (1978): 322–26.

Chastel, André. *A Chronicle of Italian Painting.* Trans. Peter Murray and Linda Murray, Ithaca, N.Y.: Cornell University Press, 1984.

———. *Leonardo da Vinci.* London: Penguin, 1961.

Clements, Robert J., ed. *Michelangelo: A Self-Portrait.* New York: New York University Press, 1968.

Colalucci, Gianluigi. "The Technique of the Sistine Ceiling Frescoes." In *The Sistine Chapel: A Glorious Restoration,* ed. Pierluigi de Vecchi and Diana Murphy, pp. 26–45. New York: Harry N. Abrams, 1999.

Cole, Bruce. *The Renaissance Artist at Work: From Pisano to Titian.* London: John Murray, 1983.

Condivi, Ascanio. *The Life of Michelangelo.* Trans. Alice Sedgwick Wohl. Ed. Hellmut Wohl. 2nd ed. University Park: Pennsylvania State University Press, 1999.

Coonin, A. Victor. "New Documents Concerning Perugino's Workshop in Florence." *Burlington Magazine,* February 1999, pp. 100–104.

Cronin, Vincent. *The Florentine Renaissance.* London: Collins, 1967.

Crowe, J. A., and G. B. Cavalcaselle. *Raphael: His Life and Works.* 2 vols. London: John Murray, 1885.

Dante. *The Divine Comedy.* Trans. John D. Sinclair. 3 vols. London: Bodley Head, 1948.

Delumeau, Jean. *The History of Paradise: The Garden of Eden in Myth and Tradition.* New York: Continuum, 1995.

Dorez, Léon. "La bibliothèque privée du Pape Jules II." *Revue des Bibliothèques* 6 (1896): 97–124.

Dotson, Esther Gordon. "An Augustinian Interpretation of Michelangelo's Sistine Ceiling." *Art Bulletin* 61 (1979): 223–56, 405–29.

Ekserdjian, David. "The Sistine Ceiling and the Critics." *Apollo* (December 1987): 401–4.

Elkins, James. "Michelangelo and the Human Form: His Knowledge and Use of Human Anatomy." *Art History* (June 1984): 176–85.

Emison, Patricia. "Michelangelo's Adam, Before and After Creation." *Gazette des Beaux-Arts* 112 (1988): 115–18.

———. "The Word Made Naked in Pollaiuolo's *Battle of the Nudes.*" *Art History* 13 (September 1990): 261–75.

Erasmus, Desiderius. *Erasmus and His Age: Selected Letters of Desidirius Erasmus.* Trans. Hans J. Hillerbrand. Marcus A. Haworth. New York: Harper and Row, 1970.

———. *Opus Epistolarum des. Erasmi Roterdami.* Ed. P. S. Allen. 10 vols. Oxford: Oxford University Press, 1910.

———. *The Praise of Folly and Other Writings.* Ed. and trans. Robert M. Adams. New York: W. W. Norton, 1989.

Ficino, Marsilio. *The Letters of Marsilio Ficino.* Ed. and trans. by the members of the Language Department of the School of Economic Science, London. 6 vols. London: Shepheard-Walwayn, 1975–99.

Filippini, Francesco. "Raffaello e Bologna." *Cronache d'Arte* (1925): 222–26.

Fischel, Oskar. *Raphael.* Trans. Bernard Rackham. London: Kegan Paul, 1948.

———. "Raphael's Auxiliary Cartoons." *Burlington Magazine,* October 1937, pp. 167–68.

Foucault, Michel. *The Uses of Pleasure: A History of Sexuality.* Trans. Robert Hurley. 2 vols. London: Penguin, 1987.

Freedberg, Sidney. *Painting of the High Renaissance in Rome and Florence.* Cambridge, Mass.: Harvard University Press, 1972.

———. *Painting in Italy, 1500–1600.* London: Penguin, 1971.

Gage, John. *Colour and Culture: Practice and Meaning from Antiquity to Abstraction.* London: Thames and Hudson, 1993.

Gaunt, William. *A Companion to Painting.* London: Thames and Hudson, 1967.

Giannotti, Donato. *Dialoghi di Donato Giannotti.* Ed. Deoclecio Redig de Campos. Florence: G. S. Sansoni, 1939.

Gilbert, Creighton E. *Michelangelo on and off the Sistine Ceiling.* New York: George Braziller, 1994.

———. "On the Absolute Dates of the Parts of the Sistine Ceiling." *Art History* 3 (June 1980): 158–81.

Goethe, Johann Wolfgang von. *Italian Journey.* Trans. W. H. Auden and Elizabeth Mayer. London: Penguin, 1970.

Goldscheider, Ludwig. *Michelangelo Drawings.* London: Phaidon, 1951.

Golzio, Vincenzo. *Raffaello nei documenti, nelle testimonianze de contemporanei, e nella letteratura del suo secolo.* Vatican City: Panetto and Petrelli, 1936.

Gombrich, Ernst. "A Classical Question in Michelangelo's Sacrifice of Noah." *Journal of the Warburg Institute* (1937): 69.

———. "Raphael's Stanza della Segnatura and the Nature of Its Symbolism." In *Symbolic Images: Studies in the Art of the Renaissance,* pp. 85–101, London: Phaidon, 1972.

———. "Renaissance and Golden Age." *Journal of the Warburg and Courtauld Institutes* 24 (1961): 306–9.

Gould, Cecil. "The Chronology of Raphael's Stanze: A Revision." *Gazette des Beaux-Arts* 117 (November 1991): 171–81.

———. "Raphael's Papal Patrons." *Apollo* (May 1983): 358–61.

Grömling, Alexandra. *Michelangelo Buonarroti: Life and Work.* Trans. Peter Barton. Cologne: Könemann, 1999.

Guicciardini, Francesco. *The History of Italy.* Ed. and trans. Sidney Alexander. London: Collier-Macmillan, 1969.

Hall, Marcia B. *Color and Meaning: Practice and Theory in Renaissance Painting.* Cambridge: Cambridge University Press, 1992.

———, ed. *Raphael's "School of Athens."* Cambridge: Cambridge University Press, 1997.

Hartt, Frederick. "The Evidence for the Scaffolding of the Sistine Ceiling." *Art History* 5 (September 1982): 273–86.

——. *History of Italian Renaissance Art: Painting, Sculpture, and Architecture.* London: Thames and Hudson, 1987.

——. *"Lignum Vitae in Medio Paradisi:* The Stanza d'Eliodoro and the Sistine Ceiling." *Art Bulletin* 32 (1950): 115–45 and 181–218.

——. *Michelangelo: Drawings.* New York: Harry N. Abrams, 1970.

——. "'L'Ultima Mano' on the Sistine Ceiling." *Art Bulletin* 71 (1989): 508–9.

Haskell, Francis. *Patrons and Painters: A Study of the Relations Between Italian Art and Society in the Age of the Baroque.* Revised ed. New Haven: Yale University Press, 1980.

Henry, Tom. "Cesare da Sesto and Baldino Baldini in the Vatican Apartments of Julius II." *Burlington Magazine,* January 2000, pp. 29–35.

——. "Raphael's Altar-piece Patrons in Città di Castello." *Burlington Magazine,* May 2002, pp. 268–78.

Hirst, Michael. *Michelangelo and His Drawings.* New Haven: Yale University Press, 1988.

——. "Michelangelo in 1505." *Burlington Magazine,* November 1991, pp. 760–66.

——. "Il Modo delle attitudini: Michelangelo's Oxford Sketchbook for the Ceiling." In *The Sistine Chapel: Michelangelo Rediscovered,* ed. Paul Holberton, pp. 208–17 (London: Muller, Blond, and White, 1986).

——. "Observations on Drawings for the Sistine Ceiling." In *The Sistine Chapel: A Glorious Restoration,* ed. Pierluigi de Vecchi and Diana Murphy, pp. 8–25. New York: Harry N. Abrams, 1999.

——. *The Young Michelangelo: The Artist in Rome, 1496–1501.* London: National Gallery Publications, 1994.

Hoogewerff, G. I. "Documenti, in parte inediti, che riguardano Raffaello ed altri artisti contemporanei." *Atti della Pontificia Accademia Roma di Archeologia, Rediconti* 21 (1945–46): 250–60.

Hope, Charles. "The Medallions on the Sistine Ceiling." *Journal of the Warburg and Courtauld Institutes* 50 (1987): 200–204.

Huizinga, Jan. *Erasmus.* New York: Charles Scribner's Sons, 1924.

Hyma, Albert. *The Life of Desiderius Erasmus.* Assen, The Netherlands: Van Gorcum, 1972.

Inghirami, Tommaso. *Thomae Phaedri Inghirami Volterrani orationes.* Ed. Pier Luigi Galletti. Rome, 1777.

Januszczak, Waldemar. *Sayonara Michelangelo: The Sistine Chapel Restored and Repackaged.* Reading, Mass.: Addison-Wesley, 1990.

Joannides, Paul. "On the Chronology of the Sistine Chapel Ceiling." *Art History* 4 (September 1981): 250–52.

——. *Titian to 1518: The Assumption of Genius.* New Haven: Yale University Press, 2001.

Jones, Roger, and Nicolas Penny. *Raphael.* New Haven: Yale University Press, 1983.

Kemp, Martin. *The Science of Art: Optical Themes in Western Art from Brunelleschi to Seurat.* New Haven: Yale University Press, 1990.

Kempers, Bram. "Staatssymbolick in Rafaels Stanza della Segnatura." *Incontri: Rivista di Studi Italo-Nederlandesi* (1986–87): 3–48.

Klaczko, Julian. *Rome and the Renaissance: The Pontificate of Julius II.* Trans. John Dennie. London: G. P. Putnam's Sons, 1903.

Klapische-Zuber, Christiane. *Women, Family and Ritual in Renaissance Italy.* Trans. Lydia Cochrane. Chicago: University of Chicago Press, 1985.

Lanciani, Rodolfo. *The Destruction of Ancient Rome: A Sketch in the History of the Monuments.* London: Macmillan, 1901.

———. *The Golden Days of the Renaissance in Rome.* London: Constable, 1906.

Lawner, Lynne. *Lives of the Courtesans: Portraits of the Renaissance.* New York: Rizzoli, 1986.

Lee, Egmont. *Sixtus IV and Men of Letters.* Rome: Edizioni di Storia e Letteratura, 1978.

Lehmann, Karl. "The Dome of Heaven." *Art Bulletin* 27 (1945): 1–27.

Leonardo da Vinci. *See* Vinci, Leonardo da.

Levey, Michael. *Florence: A Portrait.* London: Pimlico, 1996.

Levin, Harry. *The Myth of the Golden Age in the Renaissance.* Bloomington: Indiana University Press, 1969.

Liebert, Robert S. *Michelangelo: A Psychoanalytic Study of His Life and Images.* New Haven: Yale University Press, 1983.

Lightbown, Ronald. *Sandro Botticelli: Life and Work.* London: Elek, 1978.

Lomazzo, Giovanni Paolo. *Scritti sulle arti.* Ed. Roberto Paolo Ciardi. 2 vols. Florence: Marchi and Bertolli, 1973–74.

Luzio, Alessandro. "Isabella d'Este di fronte a Giulio II." *Archivio Storico Lombardo,* 4th series (1912): 65–81.

Machiavelli, Niccolò. *The Chief Works and Others.* Trans. Allan Gilbert. 3 vols. Durham, N.C.: Duke University Press, 1965.

———. *The Prince.* Trans. George Bull (London: Penguin, 1999).

Mallett, Michael. *Mercenaries and Their Masters: Warfare in Renaissance Italy.* London: Bodley Head, 1974.

Mancinelli, Fabrizio. "Michelangelo at Work: The Painting of the Lunettes." In *The Sistine Chapel: Michelangelo Rediscovered,* ed. and trans. Paul Holberton, pp. 218–59. London: Muller, Blond, and White, 1976.

———. "Michelangelo's Frescoes in the Sistine Chapel." In *The Art of the Conservator,* ed. Andrew Oddy, pp. 89–107. London: British Museum Press, 1992.

———. "The Problem of Michelangelo's Assistants." In *The Sistine Chapel: A Glorious Restoration,* ed. Pierluigi de Vecchi and Diana Murphy, pp. 266–67. New York: Harry N. Abrams, 1999.

———. "Raphael's 'Coronation of Charlemagne' and Its Cleaning." *Burlington Magazine,* July 1984, pp. 404–9.

———. "The Technique of Michelangelo as a Painter: A Note on the Cleaning of the First Lunettes in the Sistine Chapel." *Apollo* (May 1983): 362–67.

Mancinelli, Fabrizio, and Lutz Heusinger. *The Sistine Chapel*. London: Constable, 1978.

Mandelli, Emma. "La realtà della architettura 'picta' negli affreschi delle Stanze Vaticane." In Gianfranco Spagnesi, Mario Fondelli, and Emma Mandelli, *Raffaello, l'architettura 'picta': Percezione e realtà*, pp. 155–79. Rome: Monografica Editrice, 1984.

Marabottini, Alessandro, et al., eds. *Raffaello giovane e Città di Castello*. Rome: Oberon, 1983.

Mariani, Valerio. *Michelangelo the Painter*. New York: Harry N. Abrams, 1964.

Masson, Georgina. *Courtesans of the Italian Renaissance*. London: Secker and Warburg, 1975.

Meiss, Millard. *The Great Age of Fresco: Discoveries, Recoveries, and Survivals*. London: Phaidon, 1970.

Merrifield, Mary. *The Art of Fresco Painting*. London, 1846; reprint, London: Alec Tiranti, 1966.

Michelangelo Buonarroti. *See* Buonarroti, Michelangelo.

Milanesi, Gaetano. "Documenti inediti dell'arte toscana dal XII al XVI secolo." *Il Buonarroti* 2 (1887): 334–38.

Muratore, Giorgio, ed. *Raffaelo in Vaticano*. Milan: Electa, 1984.

Murray, Linda. *Michelangelo: His Life, Work, and Times*. London: Thames and Hudson, 1984.

Néret, Gilles. *Michelangelo, 1475–1564*. Trans. Peter Snowdon. Cologne: Taschen, 1998.

Nesselrath, Arnold. "Lorenzo Lotto in the Stanza della Segnatura." *Burlington Magazine* January 2000, pp. 4–12.

———. *Raphael's "School of Athens."* Vatican City: Edizioni Musei Vaticani, 1996.

Niccoli, Ottavia. "High and Low Prophetic Culture in Rome at the Beginning of the Sixteenth Century." In *Prophetic Rome in the High Renaissance Period*, ed. Marjorie Reeves, pp. 203–22. Oxford: Clarendon Press, 1992.

O'Malley, John W. "Fulfilment of the Christian Golden Age Under Julius II: Text of a Discourse of Giles of Viterbo, 1507." *Traditio* (1969): 265–338.

———. *Giles of Viterbo on Church and Reform: A Study in Renaissance Thought*. Leiden: E. J. Brill, 1968.

———. *Praise and Blame in Renaissance Rome: Rhetoric, Doctrine, and Reform in the Sacred Orators of the Papal Court, c. 1450–1521*. Durham, N.C.: Duke University Press, 1979.

———. *Rome and the Renaissance: Studies in Culture and Religion*. London: Variorum Reprints, 1981.

———. "The Vatican Library and the School of Athens: A Text of Battista Casali, 1508." *Journal of Medieval and Renaissance Studies* (1977): 279–87.

Oppé, A. P. *Raphael*. Ed. Charles Mitchell. London: Elek Books, 1970.

Østermark-Johansen, Lene. *Sweetness and Strength: The Reception of Michelangelo in Late Victorian England*. Aldershot, Hants.: Ashgate, 1998.

Palmer, Allison Lee. "The Maternal Madonna in Quattrocento Florence: Social Ideals in the Family of the Patriarch." *Source: Notes in the History of Art* (spring 2002): 7–14.

Panofsky, Erwin. "The Neoplatonic Movement and Michelangelo." In *Studies in Iconography: Humanistic Themes in the Art of the Renaissance*, pp. 171–230. New York: Oxford University Press, 1939.

Paolucci, Antonio. *Michelangelo: The Pietàs*. Milan: Skira, 1997.

Papini, Giovanni. *Vita di Michelangelo nella vita del suo tempo*. Milan: Garzanti, 1949.

Partner, Peter. *Renaissance Rome, 1500–1559: Portrait of a Society*. Berkeley: University of California Press, 1976.

Partridge, Loren. *Michelangelo: The Sistine Chapel, Rome*. New York: George Braziller, 1996.

———. *The Renaissance in Rome: 1400–1600*. London: Weidenfeld & Nicolson, 1996.

Partridge, Loren, and Randolph Starn. *A Renaissance Likeness: Art and Culture in Raphael's "Julius II."* Berkeley: University of California Press, 1980.

Pascoli, Lione. *Vite de' pittori, scultori ed architetti moderni*. Rome: Reale Istituto d'Archaeologia e Storia dell'Arte, 1933.

Pastor, Ludwig. *The History of the Popes from the Close of the Middle Ages*. Ed. Frederick Ignatius Antrobus et al. 40 vols. London: Kegan Paul, Trench, Trübner, 1891–1953.

Pfeiffer, Henrich. *Zur Ikonographie von Raffaels Disputa: Egidio da Viterbo und die christliche-platonische Konzeption der Stanza della Segnatura*. Rome: Pontificia Universitas Gregoriana, 1975.

Phillips, John A. *Eve: The History of an Idea*. San Francisco: Harper and Row, 1984.

Pissarro, Camille. *Letters to His Son Lucien*. Ed. John Rewald. 4th ed. London: Routledge and Kegan Paul, 1980.

Plumb, J. H., ed. *The Penguin Book of the Renaissance* (London: Penguin, 1991).

Pon, Lisa. "A Note on the Ancestors of Christ in the Sistine Chapel." *Journal of the Warburg and Courtauld Institutes* 61 (1998): 254–58.

Pope-Hennessey, John. *Raphael*. New York: Harper & Row, 1979.

Ramsey, P. A., ed. *Rome in the Renaissance: The City and the Myth*. Binghamton, N.Y.: Center for Medieval and Early Renaissance Studies, SUNY-Binghamton, 1982.

Ravaglia, Emilio. "Il volto romano di Beatrice ferrarese." *Roma* (1923): 53–61.

Redig de Campos, Deoclecio. *Michelangelo Buonarroti nel IV centenario del "Giudizio universale" (1541–1941)*. Florence: G. C. Sansoni, 1942.

———. *Raffaello nelle Stanze*. Milan: Aldo Martello, 1965.

Reeves, Marjorie, ed. *Prophetic Rome in the High Renaissance Period*. Oxford: Clarendon Press, 1992.

Reynolds, Sir Joshua. *Discourses on Art*. Ed. Robert R. Wark. San Marino, Calif.: Huntington Library, 1959.

Ridolfi, Roberto. *The Life and Times of Girolamo Savonarola*. Trans. Cecil Grayson. London: Routledge and Kegan Paul, 1959.

Robertson, Charles. "Bramante, Michelangelo, and the Sistine Ceiling." *Journal of the Warburg and Courtauld Institutes* 49 (1986): 91–105.

Rocke, Michael. *Forbidden Friendships: Homosexuality and Male Culture in Renaissance Florence*. Oxford: Oxford University Press, 1996.

Roettgen, Steffi. *Italian Frescoes.* Trans. Russell Stockman. 2 vols. New York: Abbeville Press, 1997.

Rowland, Ingrid D. *The Culture of the High Renaissance: Ancients and Moderns in Sixteenth-Century Rome.* Cambridge: Cambridge University Press, 1998.

Roy, Ashok, ed. *Artists Pigments: A Handbook of Their History and Characteristics.* Oxford: Oxford University Press, 1993.

Ryan, Christopher. *The Poetry of Michelangelo: An Introduction.* London: Athlone, 1998.

Salvini, Roberto. "The Sistine Chapel: Ideology and Architecture." *Art History* 3 (June 1980), 144–57.

Salvini, Roberto, and Ettore Camesasca. *La Cappella Sistina in Vaticano.* Milan: Rizzoli, 1965.

Sandström, Sven. *Levels of Unreality: Studies in Structure and Construction in Italian Mural Painting During the Renaissance.* Stockholm: Almqvist and Wiksell, 1963.

Sanuto, Marino. *I diarii di Marino Sanuto.* 58 vols. Venice: F. Visentini, 1878–1903.

Saslow, James M. *Ganymede in the Renaissance: Homosexuality in Art and Society.* New Haven: Yale University Press, 1986.

Satkowski, Leon. *Giorgio Vasari, Architect and Courtier.* Princeton: Princeton University Press, 1993.

Schott, Rolf. *Michelangelo.* London: Thames and Hudson, 1964.

Seymour, Charles, ed. *Michelangelo: The Sistine Chapel Ceiling.* New York: W. W. Norton, 1972.

Shaw, Christine. *Julius II: The Warrior Pope.* Oxford: Blackwell, 1993.

Shearman, John. "The Chapel of Sixtus IV." In *The Sistine Chapel: Michelangelo Rediscovered,* ed. Paul Holberton, pp. 22–91. London: Muller, Blond, and White, 1986.

———. "The Organization of Raphael's Workshop. In *The Art Institute of Chicago Centennial Lectures,* pp. 41–57. Chicago: Contemporary Books, 1983.

———. "Raffaello e la bottega." In *Raffaello in Vaticano,* pp. 258–63. Ed. Giorgio Muratore. Milan: Electa, 1984.

———. "Raphael, Rome, and the Codex Excurialensis." *Master Drawings* (summer 1977): 107–46.

———. *Raphael's Cartoons in the Collection of Her Majesty the Queen and the Tapestries for the Sistine Chapel.* London: Phaidon, 1972.

———. "The Vatican Stanze: Functions and Decoration." In *Proceedings of the British Academy,* pp. 369–424. London: Oxford University Press, 1973.

Steinberg, Leo. "Eve's Idle Hand." *Art Journal* (winter 1975–76): 130–35.

———. "Who's Who in Michelangelo's *Creation of Adam:* A Chronology of the Picture's Reluctant Self-Revelation." *Art Bulletin* 74 (1992): 552–66.

Steinberg, Ronald M. *Fra Girolamo Savonarola, Florentine Art, and Renaissance Historiography.* Athens, Ohio: Ohio University Press, 1977.

Steinmann, Ernst. *Die Sixtinische Kapelle.* 2 vols. Munich: Verlagsanstalt F. Bruckmann, 1905.

Stinger, Charles L. *The Renaissance in Rome.* Bloomington: Indiana University Press, 1985.

Summers, David. *Michelangelo and the Language of Art.* Princeton: Princeton University Press, 1981.

Taylor, F. L. *The Art of War in Italy, 1494–1529.* Cambridge: Cambridge University Press, 1920.

Thomas, Anabel. *The Painter's Practice in Renaissance Tuscany.* Cambridge: Cambridge University Press, 1995.

Tolnay, Charles de. *The Art and Thought of Michelangelo.* New York: Pantheon, 1964.

———. *Michelangelo.* 5 vols. Princeton: Princeton University Press, 1943–60.

Trible, Phyllis. *God and the Rhetoric of Sexuality.* London: SCM, 1992.

Turner, Jane, ed. *The Dictionary of Art.* 34 vols. London: Macmillan, 1996.

Vasari, Giorgio. *Lives of the Painters, Sculptors, and Architects.* Trans. Gaston du C. de Vere. 2 vols. London: Everyman's Library, 1996.

———. *Vasari on Technique.* Trans. Louisa S. Maclehose. Ed. G. Baldwin Brown. New York: Dover, 1960.

Venturi, Adolfo. *Storia dell'arte italiana.* 11 vols. Milan: Ulrico Hoepli, 1901–39.

Venturi, Lionello, and Rosabianca Skira-Venturi. *Italian Painting: The Renaissance.* Trans. Stuart Gilbert. New York: Albert Skira, 1951.

Vinci, Leonardo da. *Treatise on Painting.* Trans. A. Philip McMahon. 2 vols. Princeton: Princeton University Press, 1956.

Virgil. *The Aeneid.* Trans. W. F. Jackson Knight. London: Penguin, 1956.

———. *The Eclogues and The Georgics.* Trans. C. Day Lewis. Oxford: Oxford University Press, 1963.

Wallace, William E. *Michelangelo: The Complete Sculpture, Painting, Architecture.* New York: Hugh Lauter Levin Associates, 1998.

———. Michelangelo's Assistants in the Sistine Chapel." *Gazette des Beaux-Arts* 11 (December 1987): 203–16.

Weinstein, Donald. *Savonarola and Florence: Prophecy and Patriotism in the Renaissance.* Princeton: Princeton University Press, 1970.

Welch, Evelyn. *Art in Renaissance Italy.* Oxford: Oxford University Press, 1997.

Whistler, Catherine. *Drawings by Michelangelo and Raphael.* Oxford: Ashmolean Museum, 1990.

Wilde, Johannes. "The Decoration of the Sistine Chapel." *Proceedings of the British Academy* 54 (1958): 61–81.

———. *Venetian Painting from Bellini to Titian.* Oxford: Oxford University Press, 1974.

Wilson, Charles Heath. *Life and Works of Michelangelo Buonarroti.* London, 1881.

Wind, Edgar. "Michelangelo's Prophets and Sibyls." *Proceedings of the British Academy* 51 (1965): 47–84.

———. "Sante Pagnini and Michelangelo: A Study of the Succession of Savonarola." *Gazette des Beaux-Arts* 26 (1944): 211–46.

Wittkower, Rudolf, and Margot Wittkower, eds. *The Divine Michelangelo: The Florentine Academy's Homage on His Death in 1564.* London: Phaidon Press, 1964.

Zucker, Mark J. "Raphael and the Beard of Pope Julius II." *Art Bulletin* 59 (1977): 524–33.

INDEX